Art and the Human Experience

ART

A Personal Journey

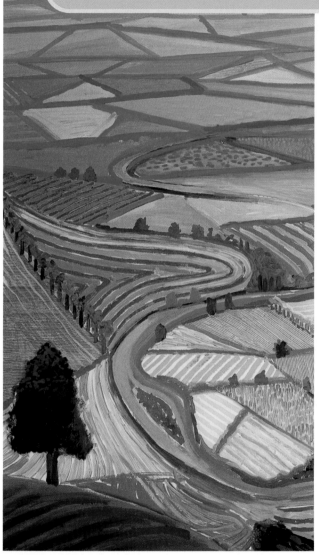

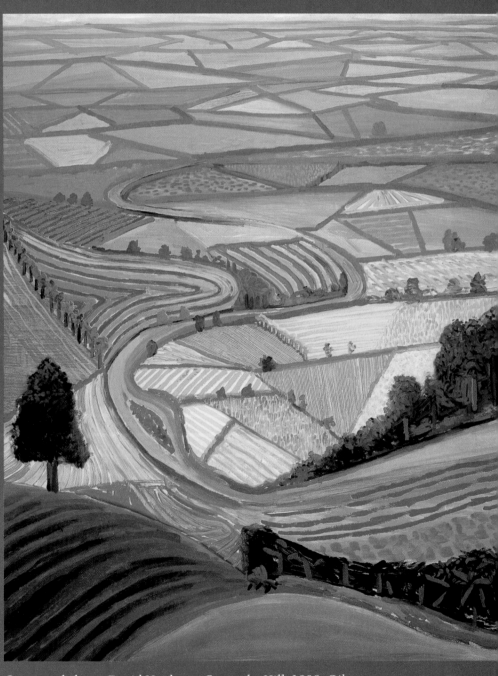

Cover, and above: David Hockney, *Garrowby Hill*, 1998. Oil on canvas, 60" x 72" (152.4 x 182.9 cm). David Hockney No. 1 Trust.

Art and the Human Experience

ART

A Personal Journey

Eldon Katter
Marilyn G. Stewart

Davis Publications, Inc.
Worcester, Massachusetts

Foundations What Is Art?

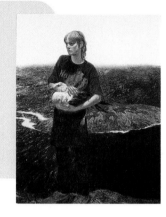

Page 8

Page 19

Page 47

Page 54

Themes Art Is a Personal Journey

Page 71

Page 104

Page 122

Printed in U.S.A.
ISBN: 0-87192-558-3
10 9 8 7 6 5 4 3 2
WPC 05 04 03

Page 163

Page 187

Page 201

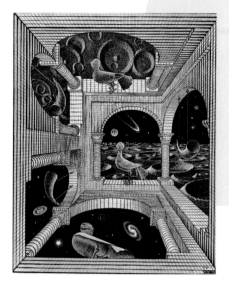

Page 229

Page 253

Page 286

Resources

Motivated by individual insights and beliefs, artists across time have served common roles within their cultures.
Art: A Personal Journey dedicates a chapter to each of these artistic traditions.

Page 100

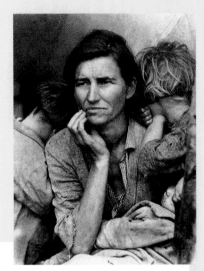

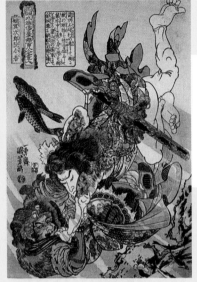

Theme 1 Dynamic images and narrative art extend the tradition of artists as **Storytellers**

Page 77

Theme 2 Through documentaries, photographs, paintings, and prints, artists serve as **Recorders**

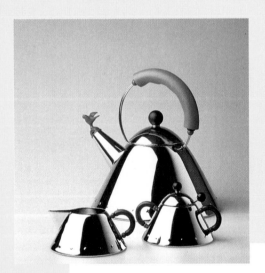

Page 130

Theme 3 By crafting telephones, teapots, cars, and clocks, artists shape our world as **Designers**

Page 156

Theme 4 Puppets, posters, billboards, and murals expand the tradition of artists as **Teachers**

A Personal Journey

Page 183

Theme 6 From cave paintings to music videos, artists use signs and symbols in their role as **Messengers**

Page 202

Page 230

Theme 5 Responding to the forms, patterns, power, and moods of nature, artists act as **Interpreters**

Page 294

Theme 7 By breaking, borrowing, and building on traditions, artists adopt the aura of **Inventors**

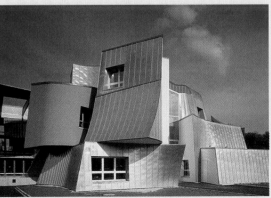

Theme 8 As designers of playgrounds, arenas,plazas, and parks, artists support their communities as **Planners**

Theme 9 Through their exploration of new materials, techniques, subjects, and styles, artists act as **Pioneers**

Page 253

Make the most of each chapter!

A unique CORE PLUS 4 chapter organization provides a structured exploration of art with the flexibility to zoom in on topics that interest you.

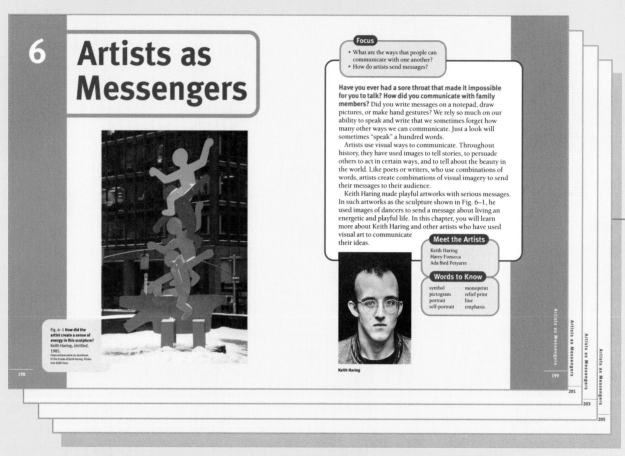

Sample pages from Chapter 6

Each theme opens with a CORE Lesson that provides a comprehensive overview of the topic.

In this theme, you will examine how artists use signs and symbols to communicate a message.

Each theme concludes with a studio activity that challenges you to apply what you have learned in a hands-on art project.

In this studio exercise, you create symbol stamps to be used in a print.

PLUS 4

1 The first lesson examines the theme from the perspective of **art history**. *This lesson studies how artists across time have used symbols in portraits.*

2 The second lesson explores the theme through different **skills and techniques**. *This lesson examines how to use different printmaking styles to communicate a message.*

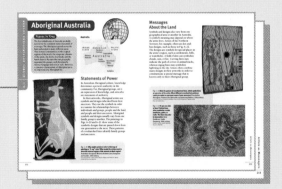

3 The third lesson looks at the theme from a **global or multicultural viewpoint**. *This lesson examines the use of symbols in traditional and contemporary Aboriginal art.*

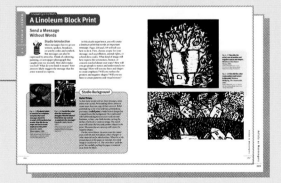

4 The fourth lesson studies the theme through a **studio activity**. *In this project, you create a linoleum block print to send a message.*

At the end of each chapter the themes **Connect to...**
- **Careers**
- **Technology**
- **Other Subjects**
- **Other Arts**
- **Your World**

Make the most of each lesson!

There are a number of carefully crafted features that will help you read, understand, and apply the information in each lesson.

Connecting

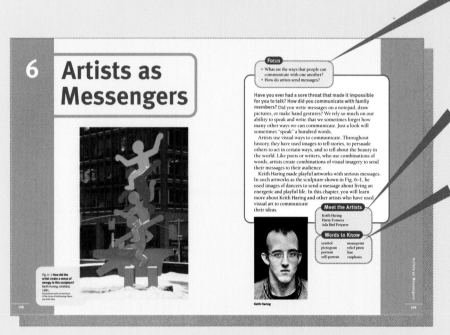

Read with purpose and direction.
Thinking about these Focus questions will help you read with greater understanding.

Meet the Artists.
These are the artists you will study in detail.

Build your vocabulary.
The first time these key terms are used, they are highlighted in bold type and defined. *These terms are also defined in the Glossary.*

Organize your thoughts.
By dividing the lesson into manageable sections, these headings will help you organize the key concepts in each lesson.

"Read" the visuals with the text.
Note how the visuals are referenced in the text. Following these connections will help you understand the topic.

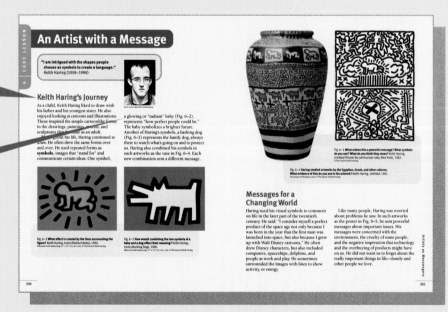

Images and Ideas

Use the captions to "see" the art.

These statements and questions direct you to key aspects of the artwork. Responding to the captions will help you see how the image relates to the text.

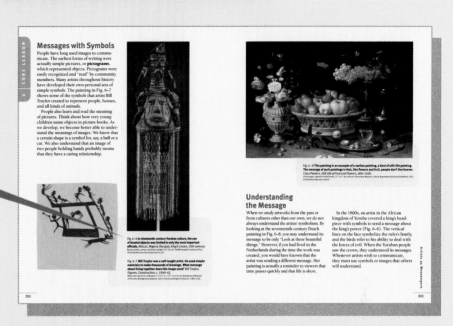

Who made this?
When was it made?
What is it made of?

These and other important questions are answered by the credits that accompany each visual. This information will help you appreciate the art more fully.

Check Your Understanding!

In addition to helping you monitor your reading comprehension, these questions highlight the significant ideas in each lesson.

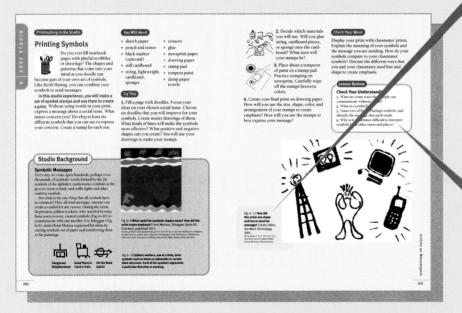

Don't Miss

Timelines

Each **Then and Now** lesson is supported by a timeline that locates the lesson's artworks in history. As you study this timeline, consider how the art reflects the historic events that surround it.

Locator Maps

Each **Global Destinations** lesson is supported by a map that highlights the lesson's location in the world. As you read this map, consider how the art reflects the geography and culture of the place.

Work with Your Mind

Make the most of each studio opportunity!

Core Studio
An expansive studio assignment concludes and summarizes each CORE Lesson.

Studio Lesson
A comprehensive studio lesson caps off each chapter by tying the theme's key concepts together.

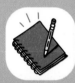

Sketchbook Connections
Quick process-oriented activities help you hone your technical and observation skills.

Studio Connections
Practical real-world studio projects explore concepts through hands-on activities.

Computer Options
An alternative to traditional art materials, the computer can be used to do all or part of the lesson.

Printmaking in the Studio

6·4 STUDIO LESSON

A Linoleum Block Print

Send a Message Without Words

Studio Introduction
Most messages that we get are written, spoken, broadcast, or sent by codes and symbols. But messages can also be expressed by artworks. Think of a drawing, painting, or newspaper photograph that caught your eye recently. How did it make you feel? What do you think it means? Your answers likely suggest the message that the artist wanted to express.

In this studio experience, you will create a linoleum print that sends an important message. Pages 218 and 219 will tell you how to do it. First, choose a topic for your message, such as pollution, animal rights, or school dress codes. What kind of image will best express the seriousness, humor, or concern you feel about your topic? How will you get people to notice and understand your message? How will you use lines and shapes to create emphasis? Will you outline the positive and negative shapes? Will you use lines to create patterns and visual texture?

Fig. 6–25 Elizabeth Catlett is noted for her sculptures and prints that send messages about the strength of African American women. How did she use shape and line to create emphasis in this print? Elizabeth Catlett, *Sharecropper*, 1968.

Fig. 6–26 How did the artist show the heroism and strength of Harriet Tubman? How did she use contrast to emphasize her message? Elizabeth Catlett, *Harriet*, 1975.

Studio Background

Relief Prints
So that many people will see their messages, some artists make prints. Printmaking allows artists to create more than one copy of their artwork. Relief printmaking is one of several basic printmaking processes. A **relief print** is made from a design that is raised from a flat background. Two traditional relief-printmaking processes are woodcuts and linoleum, or lino, cuts. Both involve carving the surface of a block to create an image. The raised areas will create the lines and positive shapes in the print. The areas that are cut away will create the negative shapes.

On the carved block, the artist coats the raised areas with ink and then places a sheet of paper or other material on the inked surface. When he or she presses down on the paper or material, the inked image is transferred to it. The artist then "pulls the print" by carefully peeling the paper or material away from the block.

216

Build background knowledge.
Artists regularly draw from the lessons of history. This background information chronicles how artists from the past approached similar artistic endeavors.

Learn from your peers.
An example of student artwork allows you to see how others responded to these hands-on exercises.

Think with Your Hands

Try This!
These directions and illustrations guide you step-by-step through the studio experience.

Check Your Work
One way to evaluate your art is through constructive group critiques. These strategies help you organize peer reviews.

Fig. 6–27 **Describe the artist's use of positive and negative spaces and shapes.** Wil Johnson III, *Broken Home*, 2001. Linoleum block print, 6 7/8" x 7 1/4" (17 x 18.5 cm). Mount Nittany Middle School, State College, Pennsylvania.

Fig. 6–28 **How did the artist create pattern and texture in this print?** Mathew Wolfgang, *The Country*, 2001. Linoleum block print, 3 1/2" x 7" (9 x 18 cm). Mount Nittany Middle School, State College, Pennsylvania.

[Reproduced textbook page 218–219]

Printmaking in the Studio

Creating Your Print

You Will Need
- sketch paper
- pencil
- linoleum block
- carving tools
- bench hook
- ink
- brayer
- construction paper

Safety Note
Linoleum-carving tools are extremely sharp! To avoid cuts and other injuries, use them with extreme caution. If you are unsure about how to use the carving tools, ask your teacher for help.

Try This

1. On sketch paper, trace the edges of your block. Use a soft-leaded (#2) pencil to draw your design inside the lines of the trace. How will you use lines and shapes to best express your message? What part of the image will you emphasize? Think about which areas will print and which will be the color of the paper. With your pencil, fill in the areas that will print.

2. Carefully lay your design face-down on the linoleum side of the block. Make sure that the edges of the trace line up with the edges of the block. With your hand, rub the back of the paper to transfer your design onto the block. Check the darkness of the image that is now on the block. Darken any lines that you think are too light.

3. Place the block on a bench hook. Carefully carve away the areas of your design that will not print.

4. Use a brayer to roll a thin, even layer of ink onto the raised surface of your block.

5. Carefully place your printing paper over the block. Gently rub the back of the paper. When you see the faint impression of your design on the back of the sheet, slowly pull the print away from the block.

Check Your Work

Display your artwork. Can your classmates "read" the message of your print? Discuss the ways that you and your classmates used lines and shapes to emphasize your message. What kinds of lines did you use? How did you use lines to create pattern and texture? Where do you see positive and negative shapes?

Computer Option
By using computers, artists can quickly create different versions of the same design. They can also simulate some printmaking characteristics. Using a program with drawing tools, create a line drawing. Vary the thickness of the lines to create a more interesting result. If necessary, reduce the size of the image. Then copy and paste the image four times onto one page—two on the top and two on the bottom—to create a composition of fourths. Change the copies—alter the color and value of each—to create four different versions of your drawing.

Elements and Principles

Line and Emphasis

In simplest terms, a **line** is a mark that has length and direction. Line is the most basic element of art, yet it is the foundation from which artists can create shape, pattern, texture, space, movement, form, or emphasis in their artworks. A line may start at one point and bend, wiggle, zigzag, wave, loop, or move straight across an artwork. It can be fat, thin, light, heavy, broken, calm, or energetic. Indeed, line can be used to express any number of moods and ideas in art.

Artists create **emphasis** in artworks by making something—such as an object, shape, or simply white space—more noticeable than other things. For example, an artist may make the main subject of the artwork the largest thing in an image. An artist may also place the subject in a certain spot. He or she may then use lines or other elements of art to lead the viewer's eye to the subject.

An artist may also use contrast, or strong differences between elements, to create emphasis. With any of these techniques, artists create a *center of interest* in the artwork.

Look at some of your own works of art. What kinds of lines did you use? In what ways did you create emphasis?

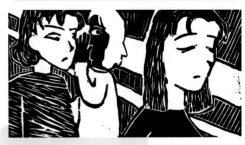

Fig. 6–29 **What makes this a powerful image? What message do you think the artist was trying to send?** Sunyoung Park, *Discrimination*, 2001. Linoleum block print, 3 1/2" x 6 7/8" (9 x 18 cm). Mount Nittany Middle School, State College, Pennsylvania.

This book explores the shared artistic traditions that unite individual artists across time. Through this exploration, you will examine your own beliefs and motivations and learn why the joy of making and perceiving art is a personal journey.

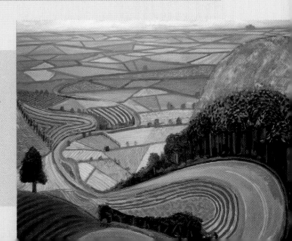

Student Gallery

As you become fluent in the universal language of art, a wealth of studio opportunities will help you find your own voice. The artworks on these four pages show how students just like you express their own unique insights and concerns.

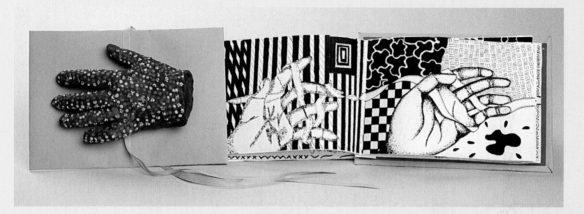

Page 5 Kristin Baker, *Hand Book*, **2000.**
Construction paper, pen, ink, plaster gauze, tempera, 6 1/2" x 9 1/2" (16.5 x 24 cm). Los Cerros Middle School, Danville, California.

Page 30 Matthew Howe, *Falling Leaves*, **2001.**
Watercolor, construction paper, printmaking ink, 12" x 18" (30.5 x 46 cm). Fred C. Wescott Junior High School, Westbrook, Maine.

Page 50 Hannah Parpart, *Lines of Light*, **2000.**
Black and white photograph. Les Bois Junior High School, Boise, Idaho.

Page 92 **Rosie Perkins,**
The Magical Book, **2001.**
Magazine cutouts, construction paper,
typed narrative, tempera paint, marker,
handprinted paper, 12 3/4" x 19 3/4"
(32 x 50 cm). Fred C. Wescott Junior
High School, Westbrook, Maine.

Page 107 **Christopher Berger,**
"Who You Lookin' At?", **2000.**
Marker, 9" x 11 1/2" (21.5 x 29 cm). Penn View
Christian School, Souderton, Pennsylvania.

Page 144 **T. L. Tutor,** *Geometric*
Silverware, **2000.**
Wood, wire, yarn, metal, clay 6" to 7 1/2" long
(15 to 19 cm). Islesboro Central School,
Islesboro, Maine.

Student Gallery

Page 170 **Dennis McClanahan, Karina Ruiz, Rokeisha Joiner, Valarie Garcia, Iris Cuevas, Paul Brown, Shanna Nielsen,** *Views of Historic Galveston*, **2000.**
Latex paint on canvas, 4' x 8' (13 x 26.2 m). Central Middle School, Galveston, Texas.

Page 191 **Wesley King,** *The Fearless Monster*, **2000.**
Driftwood, paint, 18" x 1" (46 x 2.5 cm). Jordan-Elbridge Middle School, Jordan, New York.

Page 219 **Sunyoung Park,** *Discrimination*, **2001.**
Linoleum block print, 3 $^1/_2$" x 6 $^5/_8$" (9 x 18 cm). Mount Nittany Middle School, State College, Pennsylvania.

Page 248 Sara Fischbacher, *Paper Mask*, **2001.**
Paper, tagboard, glitter, 17" x 14" (43 x 35.5 cm). Smith Middle School, Fort Hood, Texas.

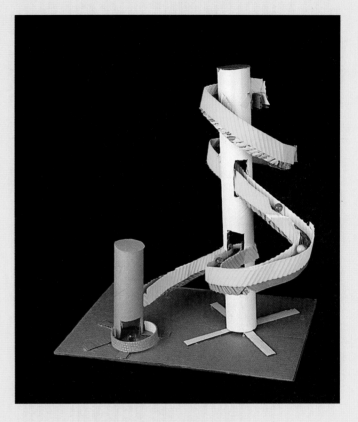

Page 269 Skye Lawrence, *Marble Run*, **2001.**
Corrugated paper and cardboard, 18" x 17" x 11 1/2" (46 x 43 x 29 cm). Islesboro Central School, Islesboro, Maine.

Page 300 Stephen Burrows, *Keyboard Wiring*, **2001.**
Keyboard, wire, rabbit's foot, copper foil, 8 1/4" x 19" (21 x 48 cm). Mount Nittany Middle School, State College, Pennsylvania.

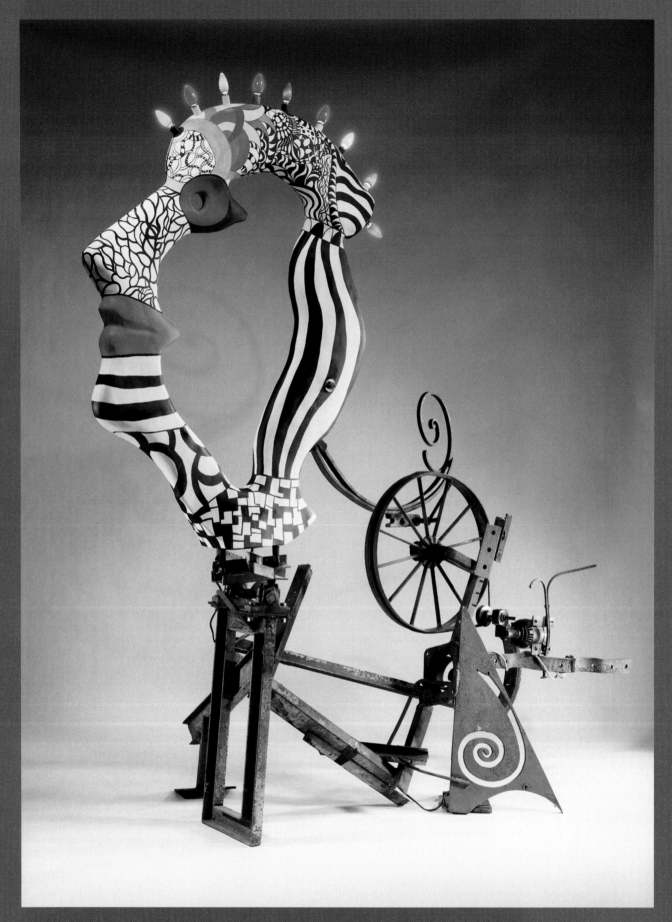

Foundations

What Is Art?

If you ask three friends what art is, they probably won't give the same answer. Throughout history, art has meant different things to different people. And that remains true today.

Many art museums display beautiful objects from different cultures. Even though we call these objects works of art, the people who made them may not have thought of them as art. In fact, some cultures have no word for art. Yet they take great care in making beautiful pottery, jewelry, and masks.

Whether or not it is intended as art, an object made by a person shows that individual's creativity and skill. The artist, designer, or craftsperson must have thought about why he or she was making the object. Something he or she saw or imagined must have provided inspiration. Once the object is made, other people may see it as a work of art, or they may not. How they see and appreciate the object depends on their sensitivity and their own ideas about what art is.

Look carefully at some of the objects pictured in this book. Write down the names of the ones that interest you, including their page numbers. Which objects do you consider works of art? Why? Why do you feel that other objects are not art? Write down your answers. When you are finished with Part 1 of this book, look at the objects again. How have your opinions changed?

The Whys and Hows of Art

Focus

- Why do people all over the world create works of art?
- How do artists make their work unique?

Do you remember the first time you painted a picture? You might have painted an animal or a scene from nature. Or perhaps you just painted swirling lines and shapes because you liked the way the colors looked together. No matter what the subject of the painting, there are many questions we can ask about how your first painting came to be. For example, what made you want to create it? How did you use paint to express your ideas? Why did you decide to paint the picture instead of draw it with crayons or a pencil? How was your painting similar to others you had seen?

These are questions we can ask about any work of art, whether it be your creation or someone else's. When artists work, they might not always think about these questions, but the answers are there. And while the answers might differ from one artist to the next, the whys and hows of art can lead us to a world of wonder.

Words to Know

subject
theme
style

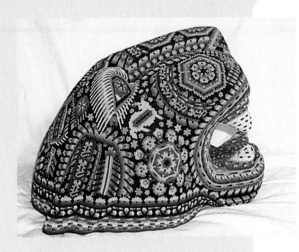

Fig. F1–1 **The Huichol Indians of central Mexico cover objects with intricate patterns of brightly colored beads. What cat features can you locate?** Native American, Huichol Indian, *Beaded Jaguar Head,* 20th century.
Beads, pine pitch, and wax, 11" x 12" (28 x 30.5 cm). Courtesy of Huicholartonline.com.

Fig. F1–2 **This restored statue was discovered in a tomb. Three of its legs had been broken so that it would not harm the deceased in the afterlife.** Egypt, Meir, *Figure of Hippopotamus*, Middle Kingdom (1991–1786 BC).
Faience, height: 4 3/8" x 7 7/8" (11 x 20 cm). The Metropolitan Museum of Art, Gift of Edward S. Harkness, 1917 (17.9.1). Photograph © 1997 The Metropolitan Museum of Art.

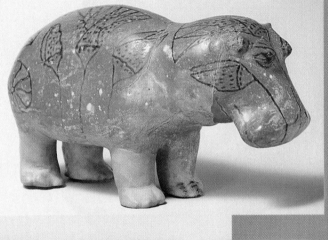

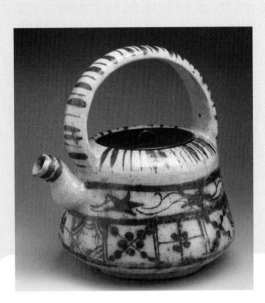

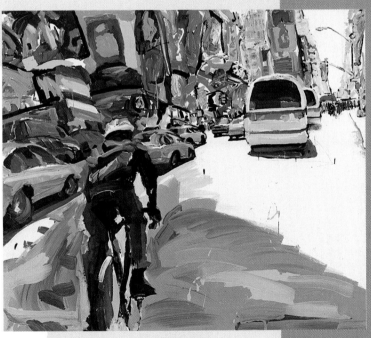

Fig. F1–3 **How might the shape of a ewer affect its use?** Japan, Momoyama period (1568–1615), *Ewer for Use in Tea Ceremony,* early 17th century.
Shino-Oribe ware. Stoneware with overglaze enamels, 7 3/4" (19.7 cm) high. The Metropolitan Museum of Art, Purchase, Friends of Asian Art Gifts, 1988 (1988.156ab). Photograph © 2001 The Metropolitan Museum of Art.

Fig. F1–4 **How would you describe the colors in this painting? What colors would you use to paint your hometown?** Tom Christopher, *Broadway Steps*, 1998.
Oil on canvas, 62" x 74" (157.5 x 188 cm). Courtesy the David Findlay Galleries (#C4288).

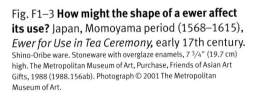

The Functions of Art

Although people create art for many reasons, most artworks belong to one of three broad categories: practical, cultural, or personal. These categories describe the function, or role, of an artwork.

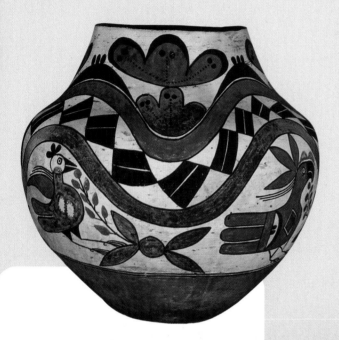

Practical Functions

Much of the world's art has been created to help people meet their daily needs. For example, architecture came from the need for shelter. People also needed clothing, furniture, tools, and containers for food. For thousands of years, artists and craftspeople carefully made these practical objects by hand. Today, almost all everyday objects that are designed by artists are mass-produced by machines.

Think about the clothes you wear and the items in your home and school. How do they compare to similar objects from earlier times or from other cultures? Which do you think are beautiful or interesting to look at? Why?

Fig. F1–5 **Practical. The Acoma are Pueblo people of the semidry American Southwest. How has this artist included information about their homeland?**
North American Indian, *Acoma Polychrome Jar*.
Museum of Indian Arts and Culture/Laboratory of Anthropology, Museum of New Mexico. Photograph by Douglas Kahn. (18947/12).

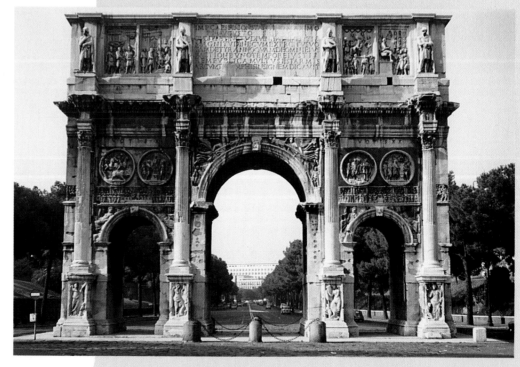

Fig. F1–6 **Cultural. Roman emperors built large triumphal arches to celebrate their greatest achievements.**
Roman, *Arch of Constantine*, 312–315 AD.
Located in Rome, Italy. Photo courtesy Davis Art Slides.

Cultural Functions

We can learn a lot about different cultures by studying their art and architecture. Some buildings and artworks were made to honor leaders and heroes. Other works help teach religious and cultural beliefs. Sometimes art commemorates important historical events or identifies an important person or group.

Many artists continue to create artworks for cultural reasons. What examples can you think of in your community or state that serve a social, political, religious, or historical purpose? How are they different from artworks that have a practical function?

Personal Functions

An artist often creates a work of art to express his or her thoughts and feelings. The materials an artist chooses and the way he or she makes the artwork reflect the artist's personal style. The work might communicate an idea or an opinion that the artist has about the subject matter. Or it might simply record something that the artist finds particularly beautiful. Such personal works are created in many forms, including drawing, painting, sculpture, cartooning, and photography. What artworks do you know about that were created for personal expression or sheer beauty?

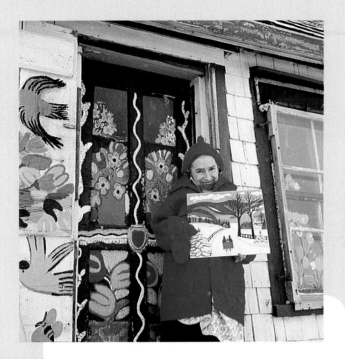

Fig. F1–7 **Personal. Folk artist Maude Lewis brightened her home by painting colorful designs on the outside of her house. She also painted many of her household objects. How could you personalize your surroundings?** *Nova Scotian Folk Artist Maud Lewis in Front of Her House,* 1965.
© Photo by Bob Brooks Illustrative Photography.

Try This

Create a three-dimensional paper artwork that meets two of the three art functions described in this section. You may decide to draw on your paper before folding, bending, and tearing it. Tape or glue it together. Write a description of your artwork that will help viewers understand its function.

Fig. F1–8 **Artists may use unusual materials to create personal meaning in their artworks. What did student artist Kristen Baker express in her artwork?** Kristin Baker, *Hand Book*, 2000.
Construction paper, pen, ink, plaster gauze, tempera, 6 1/2" x 9 1/2" (16.5 x 24 cm). Los Cerros Middle School, Danville, California.

Lesson Review

Check Your Understanding
1. Select one artwork from page 3 that meets two of the three broad functions of art. Explain its possible uses.
2. Name and describe an object in your home or school that serves a practical function and could also be considered art.

Subjects and Themes for Artworks

Artists are observers. They find subjects and themes for their work in almost everything they see and do. The **subject** of an artwork is what you see in the work. For example, the subject of a group portrait is the people shown in the portrait. Other familiar subjects for artworks include living and nonliving things, elements of a fantasy, historical events, places, and everyday activities.

You can usually recognize the subject of an artwork. Sometimes, however, an artist creates a work that shows only line, shape, color, or form. The artwork might suggest a mood or feeling, but there is no recognizable subject. This kind of artwork is called *nonobjective*.

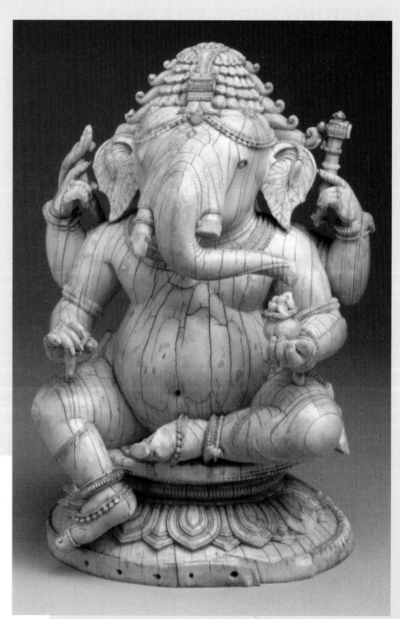

Fig. F1–9 **The subject of this sculpture is a four-armed elephant that represents the Hindu god Ganesha.** India, Orissa, *Seated Ganesha*, 14th–15th centuries.
Ivory, height: 7 1/4" x 4 3/4" (18.4 x 12.1 cm). The Metropolitan Museum of Art, Gift of Mr. and Mrs. J. J. Klejman, 1964 (64.102). Photograph © 2001 The Metropolitan Museum of Art.

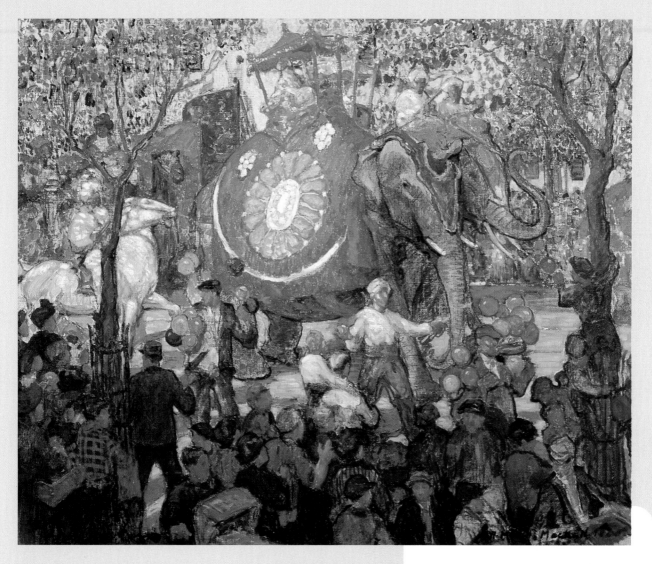

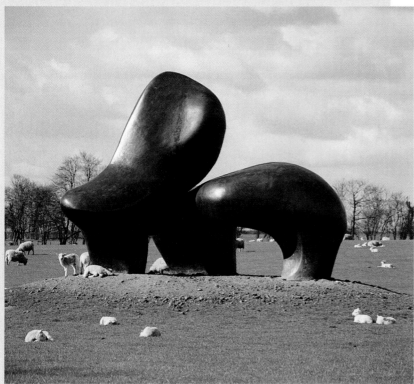

Fig. F1–10 **Compare the subject of this painting to that of _Seated Ganesha_. How are they alike and different?** Robert McGill Mackall, _Circus Parade_, n.d.
Oil on canvas, 32" x 39 1/2" (81.3 x 100.3 cm). Maryland Historical Society, Baltimore. Photo by Jeff Goldman.

Fig. F1–11 **This is a nonobjective sculpture. What mood does this work suggest?** Henry Moore, _Sheep Piece_, 1971–72.
Bronze edition of three, 18' 8" (5.7 m). Reproduced by permission of The Henry Moore Foundation. Photograph by Michel Muller.

Fig. F1–12 **The landscape behind the boy is Monhegan Island, off the coast of Maine. What did Wyeth tell us about Orca Bates?**
Jamie Wyeth, *Portrait of Orca Bates*, 1989.
Oil on panel, 50" x 40" (127 x 101.6 cm). The William A. Farnsworth Library and Art Museum, Rockland, Maine. Gift of Mrs. John S. Ames by exchange.

The **theme** of an artwork is the topic or idea that the artist expresses through his or her subject. For example, the theme of the group portrait might be family togetherness or community support. Themes in art can be related to work, play, religion, nature, or just life in general. They can also be based on feelings, such as sadness, love, anger, and peace.

Artworks all over the world can reflect the same theme, but will still look entirely different. Why? Because the subjects used to express the theme probably won't be the same. For example, imagine that an artist in Australia and an artist in Canada each create a painting about natural beauty. Would the Canadian artist show a kangaroo? Probably not.

Look at the artworks in this lesson. What subjects do you see? What themes are suggested?

Try This

With a small group of students, create a series of drawings based on the same theme. Plan how each of you can use different subjects to show the same theme. Display your group's art together. Can other students guess the theme of your group?

Computer Option

With a partner, browse art museum websites (virtual museums). Tour the sites, noting images that use similar themes but feature different subjects. Try to find examples that differ not only in subject matter but also in the artist's nationality or geographic location. Discuss with your partner some ideas for developing a series of slides that are based on a theme but are created in different styles, featuring different subjects, media, and cultural influences.

Using the copy/paste command, create a slide show of five to ten slides to share and discuss with your classmates. The last slide can state the theme and the producers. You may wish to add special effects and sound.

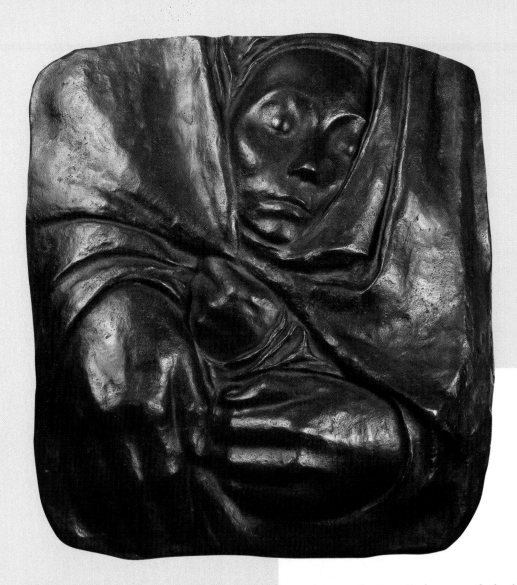

Fig. F1–13 **What is the theme of this sculpture? How is it similar to the theme of Wyeth's portrait?** Käthe Kollwitz, *Rest in the Peace of His Hands*, c. 1936.
Bronze relief, 13 1/2" x 12 1/8" x 1 1/4" (33.7 x 31.8 x 2.7 cm). The National Museum of Women in the Arts, Gift of Wallace and Wilhelmina Holladay. © 2001 Artists Rights Society (ARS), New York/VG Bild-Kunst, Bonn.

Fig. F1–14 **Each autumn, the landscape around this artist's home is covered with bright-colored leaves. If you created an artwork with a theme about nature near your home, what subject would you use?** Amanda Winkler, *The Leaf Mosaic*, 2000.
Construction paper, 12" x 12" (30.5 x 30.5 cm). Chocksett Middle School, Sterling, Massachusetts.

Foundation Lesson 1.2

Check Your Understanding

1. What are the theme and subject of Fig. F1–12, *Portrait of Orca Bates* by Jamie Wyeth? How are they similar to Fig. F1–13, *Rest in His Hands* by Käthe Kollwitz?

2. What do you think are the theme and subject of *Illumination*, shown on the Foundations chapter opener, page xx? Explain why you think this.

Styles of Art

A **style** is a similarity you can see in a group of artworks. The artworks might represent the style of one artist or that of an entire culture. Or they may reflect a style that was popular during a particular period in history.

You can recognize an artist's *individual* style in the way he or she uses art materials, such as paint or clay. An artist can adopt certain elements of design and expression that create a similar look in a group of his or her works. An artist might use the same kind of subject matter again and again.

Artworks that reflect *cultural* and *historical* styles have features that come from a certain place or time. For example, Japanese painters often use simple brushstrokes to depict scenes from nature. From a historical perspective, the columns used in ancient Greek architecture have characteristics that are immediately recognizable.

As explained in the following pages, there are also four *general* style categories that art experts use to describe artworks from very different times and cultures.

Expressionism

In an expressionist artwork, the mood or feeling the artist evokes in the viewer is more important than creating an accurate picture of a subject. The artist might use unexpected colors, bold lines, and unusual shapes to create the image. Expressionist artists sometimes leave out important details or exaggerate them. When you look at an expressionist work of art, you get a definite feeling about its subject or theme.

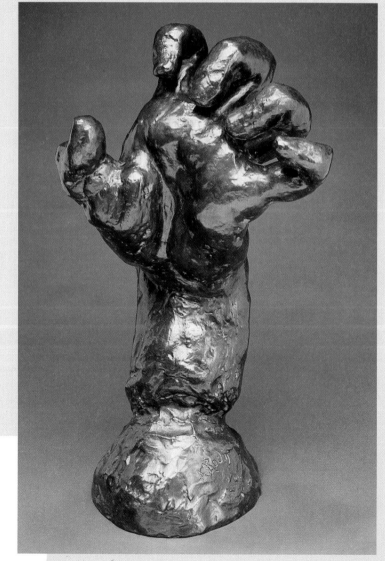

Fig. F1–15 **Try holding your hand like this. What emotion does this hand seem to express? How does the texture of the sculpture add to this feeling?** Auguste Rodin, *Large Tense Hand*, 19th century.
Bronze. Christie's Images, New York/SuperStock.

Realism

Some artists want to show real life in fresh and memorable ways. They choose their subjects from everyday objects, people, places, and events. Then they choose details and colors that make the subjects look real.

A particular mood may be suggested in the artwork. Artists who work in this style often make ordinary things appear extraordinary. Some of their paintings and drawings look like photographs.

Abstraction

Artists who work in an abstract style arrange colors, lines, and shapes in fascinating ways. They find new ways to show common objects or ideas. Their artworks appeal to the mind and senses. For example, most people see and feel flowing curved lines as graceful. Jagged lines remind people of sharp objects or sudden, unexpected events, such as lightning. Nonobjective artworks usually fall into this style category.

Fig. F1–17 **Notice how Keith Haring abstracted his subject. Even though the image is simplified, how can you still tell that it is a hand?** Keith Haring, *Untitled (for Cy Twombly)*, 1988.
Acrylic on canvas, 36" x 36" (91.4 x 91.4 cm). © The Estate of Keith Haring.

Fantasy

The images you see in fantasy art often look as though they came from a dream. When fantasy artists put subjects and scenes together, they create images that appear unreal. While the subject might be familiar, the details in the artwork may not seem to make sense.

Sketchbook Connection

Make several sketches of your hand. You may decide to hold an object in your hand. Begin sketching quickly and lightly to find the shape of the hand. Then add darker lines. Add shading to one of your sketches to create the illusion of depth.

Try This

Draw your hand as realistically as you can. Before you begin, experiment holding your hand in different poses until you find an interesting one to sketch. Draw a second view of your hand in a style that is abstract or fantasy. Which drawing better expresses your personality?

Foundation Lesson 1.3

Check Your Understanding

1. How is realistic art different from fantasy art?
2. Explain how the hands in the artworks on pages 10–13 express different themes.

The Whys and Hows of Art

13

Connect to...

Careers

Are there any large public paintings on the walls of buildings in your community? These paintings are called murals, and artists who make such works are **muralists** or **mural artists.** Muralists create art with a public audience in mind. They work with paint, clay, or other materials that can be applied to walls. Most often, murals are public works of art that are site-specific; that is, they are designed for a specific space or place. Muralists receive a commission from a patron to create their work. The patron may be a corporation, government agency, or individual who assigns and pays for the work. Muralists must be skilled in design and also must know how the weather will affect certain materials. Mural artists may major in fine arts in college or complete an apprenticeship with established mural artists.

F1–19 Murals beautify public spaces and often reflect the people who live in a neighborhood. What are some things an artist would need to think about before painting the mural? Daniel Galvez, *Crosswinds*, 1992. Located in Cambridge, Massachusetts. Photo courtesy April Dawley.

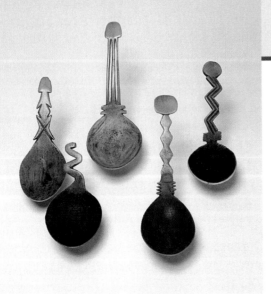

Daily Life

What does art mean to you? When you hear the term *art*, what images come to mind? Think of an object you see every day that you believe qualifies as a work of art. What are the **criteria** that are necessary for it **to be considered art**? Does the object have to be original and handmade? Or can it be a mass-produced item? Does it have to be a painting, or could it be a ceramic vase or quilt? Does it fill a practical, cultural, or personal function? Make a list of the artworks you encounter on a daily basis, and write down the artistic criteria they share.

F1–20 What makes an object a work of art? Does displaying something in a museum mean that it is a work of art? Native American, from California, *Karuk Spoons*, late 19th–early 20th centuries. Carved elk horn, lengths: 4 3/4" to 15 1/2" (12 to 18.3 cm). National Museum of the American Indian.

Social Studies

Public memorials to great leaders serve a **cultural function.** For example, a recently dedicated memorial in Washington, D.C., honors Franklin D. Roosevelt, the 32nd president of the United States. Roosevelt is honored for leading the United States through the Great Depression and World War II. The life-sized bronze sculpture depicts Roosevelt in the wheelchair he designed himself. This sculpture replaces an earlier ten-foot bronze statue that showed the president in a straight chair with two tiny wheels on the back. A broad cape covered most of the chair. Although confined to a wheelchair, Roosevelt was almost never shown that way in photographs or newsreels of the time. Why would some contemporary groups be appreciative of the newer sculpture?

Language Arts

Think of a way that **words can become art.** Contemporary multimedia artists, such as Barbara Kruger and Jenny Holzer, use words and phrases as the subject and media of their artworks. They take words and pictures from mass media—advertisements, television, movies, newspapers, magazines—and display them in public places, such as on posters, billboards, theater and electronic signs, virtual

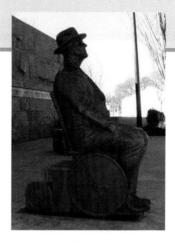

F1–21 **One important feature of this statue is its placement. It is at ground level so that people in wheelchairs are able to touch it.** *FDR Memorial* (detail), 2001.
Located in Washington, DC. Photo courtesy Brewster Thackeray, National Organization on Disability.

reality installations, and the Internet. The words themselves express social and political views and ideas. Why would an artist choose to use words? How can the use of words affect an artwork's meaning?

Mathematics

Do you think art can be found in mathematics? What **mathematical ideas have interested both artists and mathematicians** through time? The concepts of geometry may best connect the two subjects. These concepts include two-dimensional shapes, three-dimensional forms, the drawing system of perspective, symmetrical balance, and patterns made from repeating shapes. Many of these concepts may best be learned through experiences in art. Is it possible to learn about geometry without looking at any pictures or images, making any drawings, or handling any geometric forms?

Music

People make and play music for many different reasons. Music has long been linked to religious ceremonies in cultures worldwide. The sounds and rhythms help people connect to the spiritual world. Music has also told stories through the ages. For example, folk songs from all cultures transmit lessons in history, values, and beliefs. People also create music simply for entertainment. Music is often an important element of social gatherings, festivals, and holidays.

Internet Connection
For more activities related to this chapter, go to the Davis Website at **www.davis-art.com.**

Portfolio

"When I made this drum, my idea was to create a Celtic-looking design on the outer part. Originally it was going to resemble the sea, and there were going to be starfish on it. That idea soon passed over and I ended up with the green drum."
Kira Christensen

F1–22 **How is this artwork a combination of practical, cultural, and personal functions?** Kira Christensen, *Celtic Drum*, 2001.
PVC pipe, rawhide, leather, feather, acrylic paint, 10 ½" x 6 ½" x 6 ½" (26.5 x 16.5 x 16.5 cm). Les Bois Junior High School, Boise, Idaho.

"This piece of artwork I feel is sort of mysterious. What is going through this lion's head? Why is he all crouched up? The part I like best is the eyes. It is almost as if there is some untold story in them."
Veronica Schims

F1–23 **What is the subject of this artwork? After reading the artist's comment, what would you say is the theme?** Veronica Schims, *Lurking*, 2001.
Oil pastel, 18" x 12" (46 x 30.5 cm). Fairhaven Middle School, Bellingham, Washington.

CD-ROM Connection
To see more student art, view the Personal Journey Student Gallery.

F1–24 **The class assignment was to begin with a flower close-up that could be viewed as abstract (or nonobjective) as well as realistic, and to work on a large scale. Note the size of the painting, listed in the credit information below.** Ryan Brower, *Flower Up-Close*, 2000.
Tempera, 18" x 24" (46 x 61 cm). Los Cerros Middle School, Danville, California.

Foundation 1 Review

Recall

List four general categories of art styles.

Understand

Explain the possible functions of a Japanese ewer. (*See example below.*)

Apply

Design a piece of art to serve a cultural function. Write a description of your artwork's subject, theme, and art style. Describe how it would serve its cultural function.

Analyze

Compare and contrast the functions, art styles, subjects, and themes of the artworks on pages 6 and 7.

Synthesize

Suggest music that would go with each of the artworks on pages 10–13. How are the music and art styles of each work alike?

Evaluate

Imagine that you are on a committee to select a piece of art for your school's entrance area. What artwork from this chapter would you choose? Explain why this artwork's subject, theme, and style would make this an appropriate choice.

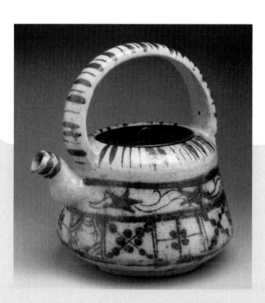

Page 3

Keeping a Sketchbook

Artists keep sketchbooks, which they fill with drawings, sketches, doodles, plans, ideas, and notes. Begin your own sketchbook by planning artworks that you may later store in your portfolio. Carry your sketchbook with you so that you can draw and record your thoughts any time. The more you sketch, the quicker you will build your drawing skills. Date your drawings to keep a record of your progress.

Keeping a Portfolio

Artists keep their artworks in art portfolios. Some portfolios are folders of artists' actual artworks, whereas others are digitized collections that can be viewed on a computer. Such a collection of artworks becomes a record of an artist's work. When artists apply for jobs, clients usually expect to see a portfolio of work so that they can see that artist's style. Begin a portfolio of your artworks. Store your art, as well as your art essays, reports, and statements in your portfolio.

For Your Portfolio

As you complete each chapter, write a statement about what you learned. Store the statements in your portfolio along with your artwork from that lesson. Review your art and writings to see how they change over time. You may notice that you begin to develop your own individual style.

Forms and Media

Focus

- What are the differences between two-dimensional art forms and three-dimensional art forms?
- What materials do artists use to create two-dimensional and three-dimensional artworks?

When you tell someone that you have just created a painting or a sculpture, you are naming the art form you used to express yourself. **Art forms** can be two-dimensional, as in painting, drawing, printmaking, and collage. Or they can be three-dimensional, as in sculpture, architecture, and even furniture.

When artists plan a work of art, they decide which art form will best express their idea. Then they work in that art form. For example, an artist who wants to express an opinion about nature might create a painting or a drawing. An artist who wants to honor an important person might create a sculpture.

The differences you see between artworks of any one form are vast. This is because artists use a wide variety of materials, or **art media,** to create their artworks. For example, a painter might choose to use oil paints or watercolor. He or she might paint on paper, canvas, or even glass. Similarly, a sculptor might work with clay, stone, or any object that best expresses his or her idea. Imagine seeing a sculpture made from a beach umbrella or a car!

The lessons in this chapter explore art forms and the media most commonly used by artists.

Words to Know

art form	mobile
art media	relief sculpture
fresco	ceramics
montage	mosaic

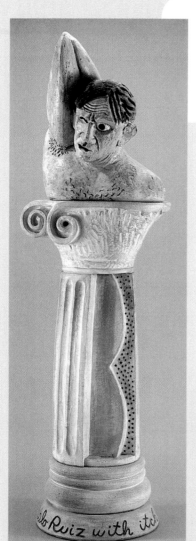

Fig. F2–1 **What idea does this sculpture express?** Robert Arneson, *Pablo Ruiz with Itch,* 1980.
Glazed earthenware, 87 ½" (222.3 cm). Gift of the Friends of Art (F82-38 a,b). The Nelson-Atkins Museum of Art, Kansas City, Missouri. © Estate of Robert Arneson/Licensed by VAGA, New York, New York.

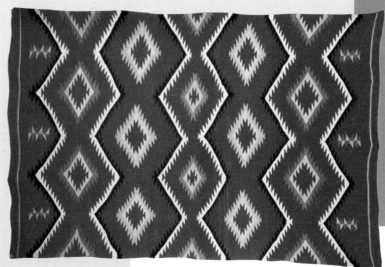

Fig. F2–2 **What does this work tell you about the Navajo culture?** North American Indian, Navajo, *Arizona/New Mexico Blanket,* c. 1800.
Aniline dyes and wool, 84 ½" x 55 ½" (215 x 141 cm). Photo by R. Gray Gallery, Chicago, Illinois.

Fig. F2–3 **The medium of this two-dimensional art is oil pastel. What is its art form?** Nicole Day-Bazhaw, *Untitled,* 1999.
Oil pastel, 17" x 24" (42.5 x 62 cm). Fairhaven Middle School, Bellingham, Washington.

Two-Dimensional Artworks

Drawing, painting, and other two-dimensional (2-D) art forms have height and width but no depth. To create 2-D artworks, such as those you see in this lesson, artists work with different types of art media.

Drawing and Painting

The most common media for drawing are pencil, pen and ink, crayon, charcoal, chalk, pastel, and computer software programs. Artists who draw choose from a wide range of papers on which to create their images. Although many artists use drawing media to plan other artworks, drawings can also be finished works of art.

Oils, tempera, watercolor, and acrylics are common media used to create paintings. An artist might apply paint to a variety of surfaces, including paper, cardboard, wood, canvas, tile, and plaster. A **fresco,** for example, is a tempera painting created on a wet plaster surface.

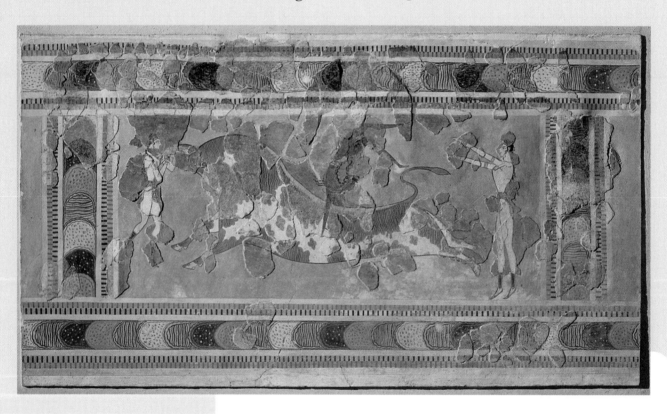

Fig. F2–4 **Bulls were probably sacred animals to the ancient Minoans. This artwork shows two girls watching a boy vault over a bull.** Minoan, from the palace at Knossos, *Bull-Leaping (Toreador Fresco)*, c. 1450–1400 BC.
Fresco, height: 31 ½" (80 cm), including border. Archaeological Museum, Heraklion, Crete, Greece. Nimatallah/Art Resource, New York.

Collage

To create a collage, an artist pastes flat materials, such as pieces of fabric and paper, onto a background. Some artists combine collage with drawing and painting. Others use unexpected materials, such as cellophane, foil, or bread wrappers. A collage made from photographs is called a **montage**.

Printmaking

This form of art can be broken down into several different kinds of processes. The main idea is the same for all: transferring an inked design from one surface to another. The design itself might be carved into wood or cut out of paper before it is inked. Then it is pressed by hand onto paper, fabric, or some other surface.

The most common printmaking processes are gadget, stencil, relief, and monoprint. Other more complex processes include lithography, etching, and silkscreen. An artist can print a single image many times, using any printmaking process, except monoprinting; as the "mono" in its name suggests, an image can be printed only once.

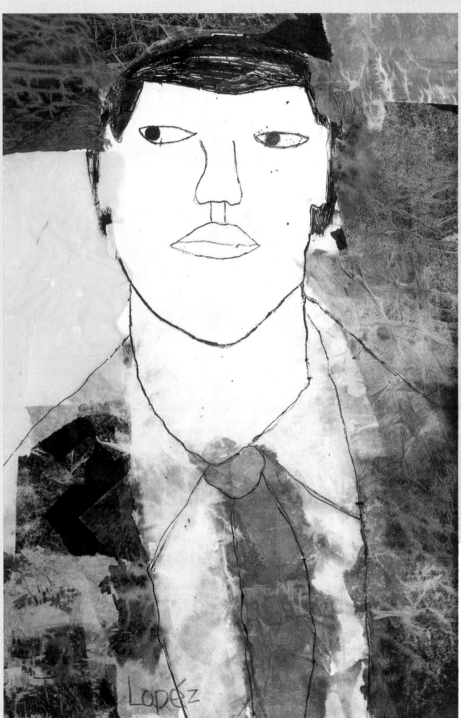

Fig. F2–5 **The student artist glued brilliant-colored tissue paper on an ink drawing to produce a mixed-media collage. Why do you think she added color to her portrait?** Ileana Lopez, *Untitled*, 1998. Pen, ink, tissue collage on paper, 16" x 11" (40.5 x 28 cm). Gates Lane School, Worcester, Massachusetts.

Graphic Design

Graphic designers create original designs. Some of them print their designs by hand. They combine type and pictures to create posters, signs, corporate logos or symbols, advertisements, magazines, and books.

Most graphic designs are mass-produced on high-speed printing presses. Look around you. What examples of graphic design can you find in your classroom?

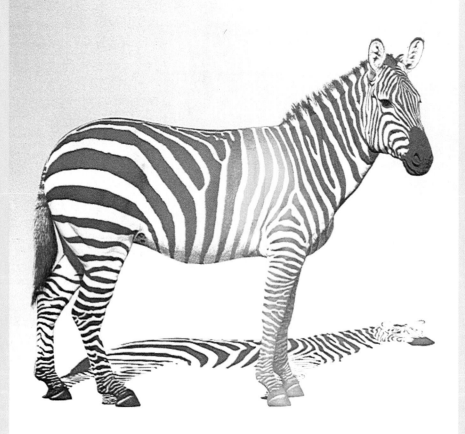

Fig. F2–6 **How does a rainbow zebra express "to be good is not enough"?** Marvin Mattelson (illustrator), *Subway Poster for School of Visual Arts.* Art Director: Silas H. Rhodes; Designer: William J. Kobasz; Copywriter: Dee Ito.

Fig. F2–7 **Cindy Sherman uses photography and film to express her ideas. She often disguises herself with makeup and elaborate costumes. How could you use photography to express your ideas?** Cindy Sherman, *Untitled Film Still*, 1979.
Gelatin silver print. Courtesy Cindy Sherman and Metro Pictures.

Photography, Film, and Computer Art

These 2-D art forms are fairly new in the history of art. The camera was invented in the 1830s, followed by moving pictures about sixty years later. Since their invention, photography and film have become two of the most popular media. Today, video cameras and computers offer even more media for artists working in the film or TV industry. Although individuals may use a single camera or computer to create art, feature films and television shows are usually created by a team of artists.

Try This

Create a poster for a school or community event. Use at least two of the two-dimensional media described in this section. As you design your poster, think about which art forms will catch people's attention and make your message understandable.

Computer Option

Design a poster about yourself. To begin, either create a self-portrait with a digital camera or scan an existing photograph of yourself. Import your image into a program used for digital painting or drawing. Change the image in any way you wish. If you use a filter such as pointillism, charcoal, or embossing, consider how this will affect the poster's impact. Complete the poster by adding a large headline and, in smaller type, information about yourself.

Sketchbook Connection

Look at one of your favorite places from different angles and viewpoints. Using pencil, sketch an interesting view of it. On another sheet of paper, recreate your scene in a different medium. You might choose to draw it with pastels or colored markers, paint it, or create a montage of cut paper and photos.

Lesson Review

Check Your Understanding

1. List several media that can be used to create drawings and paintings.
2. Explain the difference between a collage and a montage.

Three-Dimensional Artworks

Architecture, sculpture, and other three-dimensional (3-D) art forms have height, width, and depth. To create 3-D artworks, such as those you see in this lesson, artists work with different types of art media.

Architecture and Environmental Design

Architects design the buildings in which we live, work, and play. They think about what a building will be used for, how it will look, and the way it will relate to its surroundings. Architects combine materials such as wood, steel, stone, glass, brick, and concrete to create the buildings they design. Then interior designers plan how spaces inside the buildings will look. They choose paint colors or wallpaper, carpeting, and upholstery fabrics. They also suggest how the furniture should be arranged.

Environmental and landscape designers plan parks, landscape streets, and design other outdoor spaces. They use trees, shrubs, flowers, grasses, lighting fixtures, and benches. They also use materials such as stone, brick, and concrete to create paths, sidewalks, and patios.

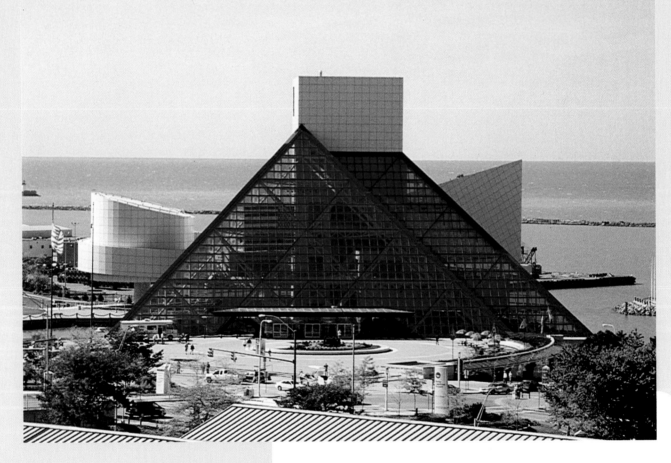

Fig. F2–8 **The Rock and Roll Hall of Fame is located in Cleveland, Ohio. How does the design of this building suggest its use?** I. M. Pei, *Rock and Roll Hall of Fame and Museum*, 1998.
© Rock and Roll Hall of Fame and Museum. Design Photography, Inc. Cleveland, Ohio.

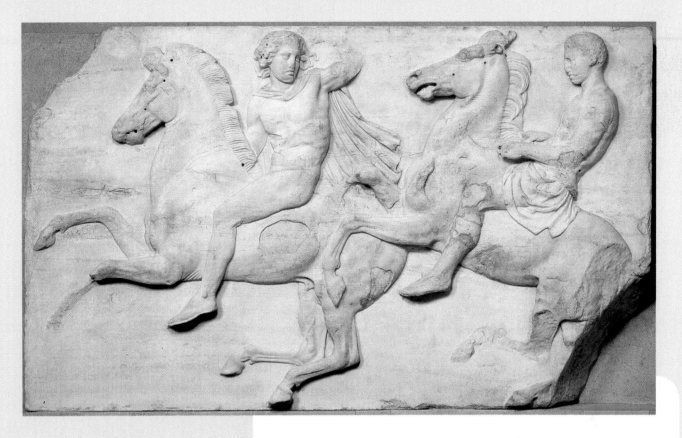

Fig. F2–9 **These restless horses were once part of a larger sculpture of a procession. The procession was carved in marble relief near the top of the inner walls of the Parthenon, a Greek temple.** Greek, *Frieze of the Parthenon: Mounted Procession* (detail, west II), 432 BC.
Marble, height: 42" (106 cm). Courtesy the British Museum. © The British Museum, London, England.

Sculpture

Sculptures come in many forms. Most are designed to be viewed from all sides. You are probably most familiar with statues. A statue is a sculpture that stands alone, sometimes on a base. It can be life-size, as are the monuments you see in some parks. Or it can be small enough to place on a table or mantelpiece. A **mobile** is a hanging sculpture that has moving parts. The design on a **relief sculpture** is raised from a background surface and is intended to be viewed from only one side.

In addition to having many forms of sculpture to choose from, a sculptor can select from a great variety of media. Traditional materials include wood, clay, various metals, and stone such as marble. Sculptors also work with glass, plastic, wire, and even found objects.

Crafts

The term *crafts* applies to artworks made by hand that are both practical and beautiful. Among the many crafts are ceramics, fiber arts, mosaics, and jewelry making. **Ceramics** are objects that have been made from clay and then fired in a kiln. Fiber arts include objects that have been woven, stitched, or knotted from materials such as wool, silk, cotton, and nylon. A **mosaic** is a design made of tiny pieces of colored glass, stone, or other materials. Artists who make crafts such as jewelry and other personal adornments might use gold, silver, wood, fabric, leather, and beads. Look at the clothing and jewelry your classmates are wearing. What materials are they made of?

Fig. F2–10 **Do you think the artist placed the pebbles in the bird or the background first?** Byzantine, *Fragment with Bird*, 6th century. Stone mosaic, 13.8" x 20.5" (35 x 52 cm). Courtesy Davis Art Slides.

Fig. F2–11 **Why was this car designed with this shape? What factors should industrial designers think about as they design cars?** The New Volkswagen Beetle. Courtesy Arnold Worldwide. Reproduced with permission.

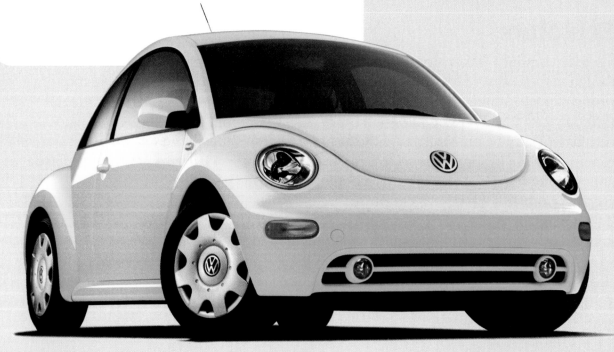

Industrial Design

Artists who design three-dimensional products for mass production are called industrial or product designers. They design everything from spoons and chairs to bicycles and cruise ships. Industrial designers pay great attention to a product's function and appearance. They use materials such as metal, plastic, rubber, fabric, glass, wood, and ceramics. The next time you're in a grocery or department store, note the many examples of industrial design all around you.

Try This

Choose a two-dimensional artwork shown in this book. Recreate it in three dimensions. For example, you might use clay to form a bull dance like the one shown on page 20 or cut and paste cardboard figures that stand up. Display your art near a reproduction of the original artwork.

Computer Option

Using the computer, create an environment. You may choose to show a place in nature, a building, or a fantasy environment that exists only in your imagination. Try to include some sense of scale in your environment through the use of a reference such as a person or animal.

Sketchbook Connection

Sketch an object designed by an industrial designer. What materials were used to create the object? What function does it serve? If you were to design a similar item for yourself, how would you change it? Draw your modified design.

Lesson Review

Check Your Understanding

1. What is the difference between two-dimensional and three-dimensional artworks?
2. What are some crafts that are sometimes two-dimensional?

Fig. F2–12 **This student artwork is similar to yarn paintings (*nierika*) made by the Huichol Indians of central Mexico.** Ramon A. Gonzalez, *Mexican Yarn Painting*, 2000.
Yarn, 10" x 12" (25.5 x 30.5 cm). Desert Sands Middle School, Phoenix, Arizona.

Connect to...

Careers

When you think of an *artist*, what image comes to mind? A painter wearing a beret and a smock, holding a paintbrush and a palette? Artists today have many more choices of art forms and media available to them. For example, **woodworkers** may be fine artists or artisans (skilled craftspeople), depending on the approach they take. Fine artists may work as sculptors or artists in three-dimensional design. An artisan may choose to use wood to make furniture, custom cabinetry, staircases, or practical household items. Each approach requires mastery of the techniques of cutting, joining, and finishing woods. Woodcarvers may earn a sculpture degree in college or learn their trade through apprenticeship programs.

F2–13 **How is this lamp similar to and different from lamps you have seen? What makes it a work of art?**
Leah Woods, *Lamp*, 2000.
Cherry and copper, 22" x 4" x 7" (56 x 10 x 18 cm). Courtesy of the artist.

Other Arts

Dance

Each dance form uses its own movement vocabulary, just as art styles rely on a visual vocabulary. The vocabulary is simply those movements that fit a particular dance. Many dance forms often borrow movements from earlier dances. For example, steps, rhythms, and movements of European folk dances became the basis for modern ballet. In the early twentieth century, however, some choreographers (composers of dance) resisted the delicate, lighter-than-air movements of ballet. They created new movements that were close to the ground and had the body demonstrate weight, or heaviness. From boogie-woogie and disco to hip-hop and swing, each dance form contributes new movement vocabulary.

Internet Connection
For more activities related to this chapter, go to the Davis Website at **www.davis-art.com**.

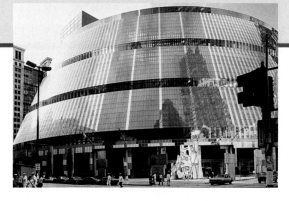

F2–14 **Architecture is one of the art forms we experience every day. From the buildings in which we live and are educated to office buildings and stores, architecture is an important part of our daily lives.**
Helmut Jahn, *State of Illinois Center*, 1985.
Located in Chicago, Illinois. Courtesy Davis Art Slides.

Daily Life

What art forms and media do you come upon throughout your day? Make a list of them over the course of a day. Don't forget to look for a wide range of objects, such as posters, paintings, art photography, public sculpture, ceramics, quilts or weavings, and computer graphics. What other forms of art can you find? How many of these forms were available when your parents were teenagers?

Other Subjects

Social Studies

Historians use different forms of primary and secondary sources for research and study. Primary sources are original materials, such as artworks, photographs, diaries, letters, and other artifacts. Secondary sources, such as your social studies textbook, are usually considered to be interpretations of primary sources. Look through your social studies textbook to see how many primary and secondary sources you can find. Which of these sources could be considered works of art?

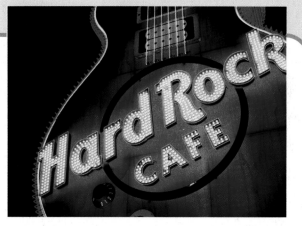

F2–15 **The element neon is used to create the red color in bright signs like this one. Have you seen artworks created using neon?**
Photo courtesy SuperStock.

Mathematics

What forms does art most often take in mathematics? In math, a figure is a geometric element. In art, two-dimensional figures are called shapes, and three-dimensional figures are called forms. In math, two-dimensional figures are known as plane figures, whereas three-dimensional figures are known as space, or solid, figures. Why would it be helpful for you to understand both sets of terms?

Science

You may recall from science that an atom is the smallest particle of a chemical element that can exist and still retain its particular chemical properties. The **forms that chemical elements take** are determined by the way their atoms combine. For example, carbon atoms can become charcoal, pencil lead, or diamonds, depending on the way they join.

Portfolio

"I learned a lot, like how to sew. I really liked making my doll. The head gave it character and made it stand out."
Titus L. Boehm

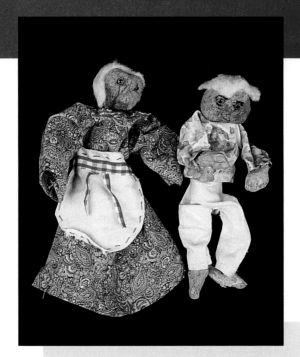

F2–17 Sometimes artforms and media overlap. This artwork combines aspects of printmaking, collage, and weaving. Matthew Howe, *Falling Leaves*, 2001.
Watercolor, construction paper, printmaking ink, 12" x 18" (30.5 x 46 cm). Fred C. Wescott Junior High School, Westbrook, Maine.

F2–16 Apple-head dolls are a traditional craft in western North Carolina. The head of each doll is carved from a dried apple. What crafts are popular in your hometown? Geneva Butler (left) and Titus L. Boehm (right), *Apple-Head Dolls*, 2001.
Apple, wire, fabric, papier mâché, paint, cotton, thread. Each doll is about 10" (25.5 cm) tall. C. D. Owen Middle School, Swannanoa, North Carolina.

CD-ROM Connection
To see more student art, view the Personal Journey Student Gallery.

"Our teacher told us to use the curves in our sculpture as pathways for blending color. I experimented with blues and purples. The effect reminded me of the colors of water and twilight. It took only one day to make the sculpture, but two weeks to paint it." **James Chang**

F2–18 Sculptures can be made from surprising materials. In this case, a section of panty-hose was stretched over a wire framework attached to a wooden base, then painted. James Chang, *Evening Tide*, 2000.
Pantyhose, wood, wire, tempera, height 11" (28 cm). Los Cerros Middle School, Danville, California.

Foundation 2 Review

Recall

List two examples of two-dimensional media and two examples of three-dimensional media.

Understand

Explain the difference between two- and three-dimensional art forms.

Apply

Select a three-dimensional artwork from this chapter. Recreate your own version of this artwork in a two-dimensional media. Write a description of the artwork you selected. Explain what type of art form it is and the media it is made from. Describe the art form and media of your two-dimensional artwork.

Analyze

Compare and contrast the art forms and media of the *Bull-Leaping* fresco on page 20 and the mosaic on page 26 (Fig. F2–10, *shown at right*). How does the medium of each of these artworks influence its message?

Synthesize

Select one artwork from Foundation 1 and one from Foundation 2 that are the same art form or medium. Write a description of both artworks' art form and medium.

Evaluate

From the chapter, select one artwork that you would like to hang on your bedroom wall. Explain why the medium, art form, subject, and theme would be appropriate for your room. Do you have a wall large enough for this art?

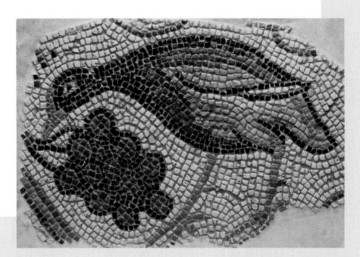

Page 26

For Your Sketchbook

Look carefully at a three-dimensional object, and then draw it in your sketchbook. Draw the same object again, but this time use a different medium. For example, if you drew it with pencil, try drawing it a second time with crayon, marker, or ink. With which medium were you able to draw the smallest details? Which medium would be better for large or fast sketches?

For Your Portfolio

Select artwork to include in your portfolio. You might decide to choose pieces done in a variety of media and techniques, or ones that show how your artistic skills are growing. Write your name and date on each artwork that you keep in your portfolio. Also write the assignment's purpose, what you learned, and why you selected the piece.

Elements and Principles of Design

Focus

- What are the elements and principles of design?
- How do artists use the elements and principles of design in their artworks?

Artists use their imagination when they work. They experiment with ideas and art media, and invent new ways to create artworks. But before they actually get down to making a work of art, they must have a plan, or design, in mind.

In art, the process of design is similar to putting a puzzle together. The basic pieces or components that an artist has to choose from are called the *elements of design*. Line, shape, form, color, value, space, and texture are the elements of design. The different ways that an artist can arrange the pieces to express his or her idea are called the *principles of design*. Balance, unity, variety, movement and rhythm, proportion, emphasis, and pattern are the principles of design. When an artist is happy with the arrangement, the design is complete.

As you learn about the elements and principles of design, think about how they can help you plan and create your own art. Soon you will see that they can also help you understand and appreciate the artworks of others.

Words to Know

Elements of Design		Principles of Design	
line	value	balance	pattern
shape	space	unity	proportion
form	texture	variety	movement
color		emphasis	rhythm

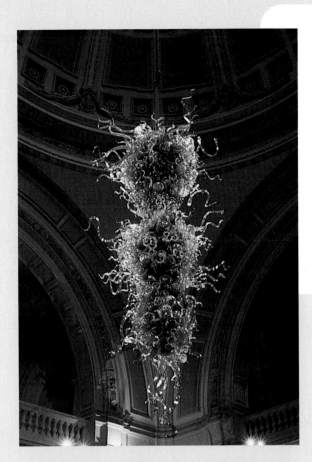

Fig. F3–1 **Dale Chihuly creates huge chandeliers from hundreds of colored blown-glass shapes. How do you think light affects the look of this artwork?** Dale Chihuly, *Victoria and Albert Rotunda Chandelier,* 1999.
Blown glass and steel, 18' x 8' x 8' (5.3 x 2.4 x 2.4 m). Victoria and Albert Museum, London, England. Photo: Terry Rishel. Courtesy Chihuly Studio.

Fig. F3–3 **The student artist arranged shapes around a central point to create a design with radial balance. How many radial patterns can you find?** Adam Price, *Tessellating Figures,* 2000.
Ink, markers, 24" x 24" (61 x 61 cm). Los Cerros Middle School, Danville, California.

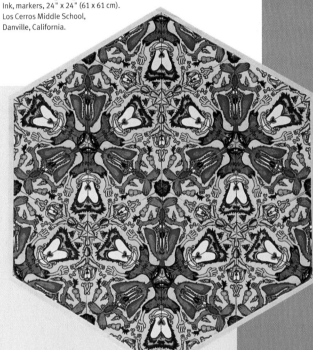

Fig. F3–2 **How did Deborah Oropallo create a sense of depth in some parts of this piece? Compare these lines to the lines of Chihuly's chandelier.**
Deborah Oropallo, *Amusement,* 1997.
Oil on canvas, 120" x 52" (304.8 x 132.1cm). Collection of the San Jose Museum of Art, San Jose, CA. Museum purchase with funds from the Council of 100. Photo by Sue Tallon.

The Elements of Design

Line

Many people think of a **line** as the shortest distance between two points. To artists, a line is a mark that has length and direction. Lines can have many different qualities that help artists express their ideas. They can be thick or thin, wavy, straight, curly, or jagged. Artists use lines to outline shapes and forms or to suggest different kinds of movement. Sometimes artists use *implied* line. An implied line is not actually drawn, but is suggested by parts of an image or sculpture, such as a row of trees or a path of footprints.

If you look closely, you can find examples of line in every work of art you see. Notice how they affect the mood of an artwork. For example, how might a drawing with thick, zigzag lines be different from one with light, curved lines?

Fig. F3–4 **How did Wayne Thiebaud make the shapes of the numbers seem flat but indicate that the body is a three-dimensional form?** Wayne Thiebaud, *Football Player*, 1963.
Oil on canvas, 72" x 36" (183 x 91.5 cm). Virginia Museum of Fine Arts, Richmond. Gift of the Sydney and Frances Lewis Foundation. Photo: Katherine Wetzel. © Virginia Museum of Fine Arts. © Wayne Thiebaud/Licensed by VAGA, New York, New York.

Fig. F3–5 **Romaine Brooks used contour lines to draw a soldier, child, and dog. What kinds of shapes are formed by the lines?** Romaine Brooks, *The Soldier at Home*, 1930.
Pencil on paper, 9 9/16" x 7 1/8" (24 x 18 cm). Gift of Romaine Brooks. Smithsonian American Art Museum, Washington, DC/Art Resource, New York.

Shape and Form

A line that surrounds a space or color creates a **shape.** Shapes are flat, or two-dimensional. A circle and a square are both shapes. A **form** is three-dimensional: It has height, width, and depth. A sphere and a cube are examples of forms.

Shapes and forms may be organic or geometric. *Organic* shapes and forms—such as leaves, clouds, people, ponds, and other natural objects—are often curved or irregular. *Geometric* shapes and forms—such as circles, spheres, triangles, and pyramids—are usually precise and regular.

Most two-dimensional and three-dimensional designs are made up of both *positive* shapes and *negative* shapes. The figure in a painted portrait is the painting's positive shape. The pieces of fruit in a still-life drawing are the positive shapes in the drawing. The background or areas surrounding these objects are the negative shapes. The dark, solid shape of a statue is a positive shape. The areas around and inside the forms of the statue make the negative shapes. Artists often plan their work so that the viewer's eyes move back and forth between positive and negative shapes.

Fig. F3–6 **This vase is made of geometric forms. The artist carved a design into the surface. Are the lines and shapes in the surface design geometric or organic?** Bryan Stauffer, *Vase,* 1999.

Red earthenware, commercial glazes, 6 1/2" x 3" x 3" (16.5 x 7.5 x 7.5 cm). Mount Nittany Middle School, State College, Pennsylvania.

Color and Value

Without light, you cannot experience the wonderful world of **color.** The wavelengths of light that we can see are called the color spectrum. This spectrum occurs when white light, such as sunlight, shines through a prism and is split into bands of colors. These colors are red, orange, yellow, green, blue, and violet.

In art, the colors of the spectrum are recreated as dyes and paints. The three *primary hues* are red, yellow, and blue. *Primary* means "first" or "basic." *Hue* is another word for "color." You cannot create primary colors by mixing other colors. But you can use primary colors, along with black and white, to mix almost every other imaginable color.

Fig. F3–7 **The location of colors in a color wheel indicates their relationship to each other. Find the triangle with the primary colors on its points. Next, find the triangle with the secondary colors. Use this color wheel to help plan which colors to use in your artworks.**

Key to the Color Wheel

Y = yellow	V = violet
G = green	R = red
B = blue	O = orange

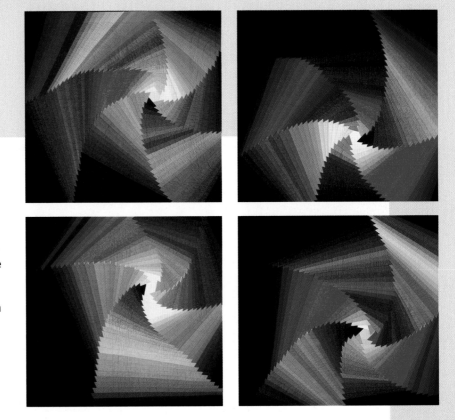

Fig. F3–8 **How are these quilts like a color wheel? Where do you see the darkest shades of color?** Caryl Bryer Fallert, *Refraction #4–#7.*
Hand-dyed cotton fabric, machine pieced and quilted, 88" x 88" (224 x 224 cm). Courtesy of the artist.

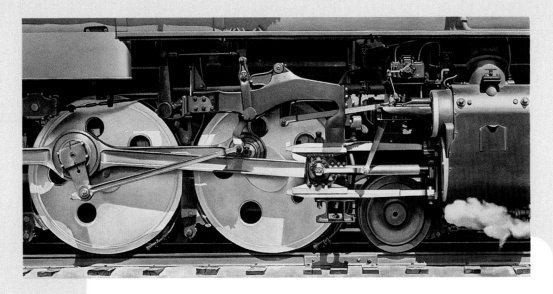

Fig. F3–10 **How did American artist Charles Sheeler use value to show the forms and texture of a locomotive?** Charles Sheeler, *Rolling Power*, 1939.
Oil on canvas, 15" x 30" (38.1 x 72.6 cm). Smith College Museum of Art, Northampton, Massachusetts. Purchased, Drayton Hillyer Fund, 1940.

The *secondary* hues are orange, green, and violet. You can create these by mixing two primary colors: red and yellow make orange; yellow and blue make green; red and blue make violet.

To create *intermediate* hues, you mix a primary color with a secondary color that is next to it on the color wheel. For example, mixing yellow and orange creates the intermediate color of yellow-orange.

Value refers to how light or dark a color is. A light value of a color is called a *tint*. A tint is made by adding white to a color. Pink, for example, is a tint made by adding white to red. Artworks made mostly with tints are usually seen as cheerful, bright, and sunny.

A dark value of a color is called a *shade*. A shade is made by adding black to a color. For example, navy blue is a shade made by adding black to blue. Artworks made mostly with dark values are usually thought of as mysterious or gloomy.

Elements and Principles of Design

37

The intensity of a color refers to how bright or dull it is. Bright colors are similar to those in the spectrum. You can create dull colors by mixing complementary colors. *Complementary* colors are colors that are opposite each other on the color wheel. Blue and orange are complementary colors. If you mix a small amount of blue with orange, the orange looks duller. Many grays, browns, and other muted colors can be mixed from complementary colors.

When artists plan an artwork, they often choose a *color scheme*—a specific group of colors—to work with. An artist might use a primary, secondary, intermediate, or complementary color scheme. Or the artist might choose any of the color schemes illustrated in the chart below.

Common Color Schemes

warm: colors, such as red, orange, and yellow, that remind people of warm places, things, and feelings.

cool: colors, such as violet, blue, and green, that remind people of cool places, things, and feelings.

neutral: colors, such as black, white, gray, or brown, that are not associated with the spectrum.

monochromatic: the range of values of one color (monochrome means "one color").

analogous: colors that are next to each other on the color wheel; the colors have a common hue, such as red, red-orange, and orange.

split complement: a color and the two colors on each side of its complement, such as yellow with red-violet and blue-violet.

triad: any three colors spaced at an equal distance on the color wheel, such as the primary colors (red, yellow, blue) or the secondary colors (orange, green, violet).

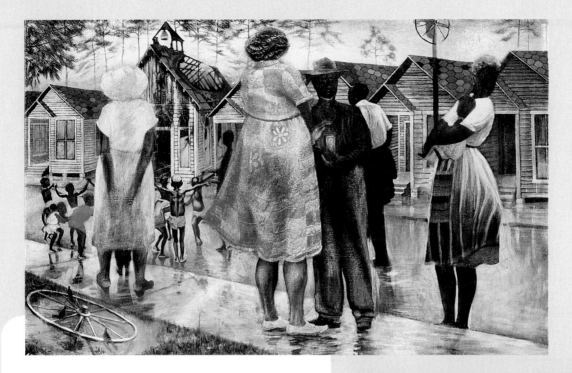

Fig. F3–11 **African American artist John Biggers used a limited number of colors in this scene. What effect do these colors create?** John Biggers, *Shotgun, Third Ward #1*, 1966.
Oil on canvas, 30" x 48" (76.2 x 121.9 cm). Smithsonian American Art Museum, Washington, DC/Art Resource, New York.

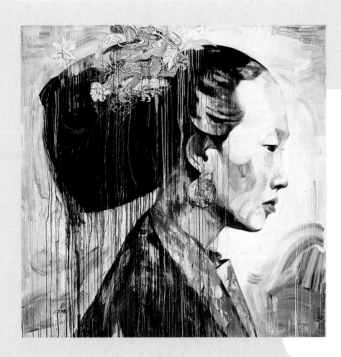

Fig. F3–13 **The warm colors in the flower create a contrast with the cool blue background. Where do you see analogous colors in this design?** Hannah MacDonald, *Flower on Fire*, 2000.
Tempera, 18" x 24" (46 x 61 cm). Chocksett Middle School, Sterling, Massachusetts.

Fig. F3–12 **Match the color scheme in this painting to the color schemes in the chart on page 38.** Hung Liu, *Chinese Profile II*, 1998.
Oil on canvas, 80" x 80" (203.2 x 203.2cm). Collection of San Jose Museum of Art, San Jose, California. Museum purchase with funds from the Council of 100. Photo by Sue Tallon.

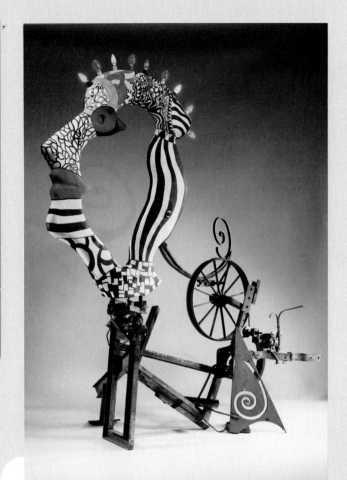

Space

Sculptors and architects work with actual **space.** Their designs occupy three dimensions: height, width, and depth. *Positive* space is filled by the sculpture or building itself. *Negative* space is the space that surrounds the sculpture or building.

In two-dimensional (2-D) art forms, artists can only show an illusion of depth. They have simple ways of creating this illusion. For example, in a drawing of three similar houses along a street, the one closest to the viewer appears larger than the middle one. The house farthest away appears smaller than the middle one. Artists can also create the illusion of depth by overlapping objects or placing distant objects higher in the picture.

Artists working in two dimensions also use linear perspective, a special technique in which lines meet at a specific point in the picture, and thus create the illusion of depth.

Fig. F3–14 **Locate the negative spaces within this mobile sculpture. What do you think the lightbulbs and wheel represent?** Niki de Saint Phalle and Jean Tinguely, *Illumination*, 1988.
Mobile sculpture, mixed media, height: 9' (2.75 m).
Courtesy Galerie Bonnier, Geneva. © 2001 Artists Rights Society (ARS), New York/ADAGP, Paris.

Fig. F3–15 **David Hockney used lighter, bluer colors to indicate distance in this painting of an English landscape. What techniques did he use to show depth?** David Hockney, *Garrowby Hill*, 1998.
Oil on canvas, 60" x 72" (152.4 x 182.9 cm). David Hockney No. 1 Trust.

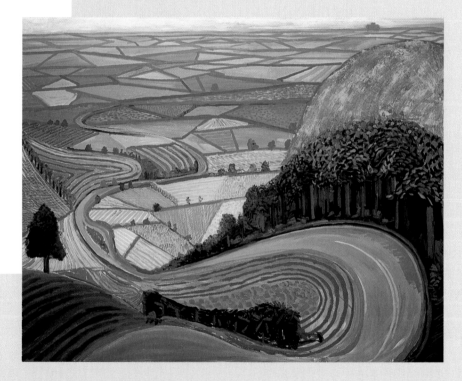

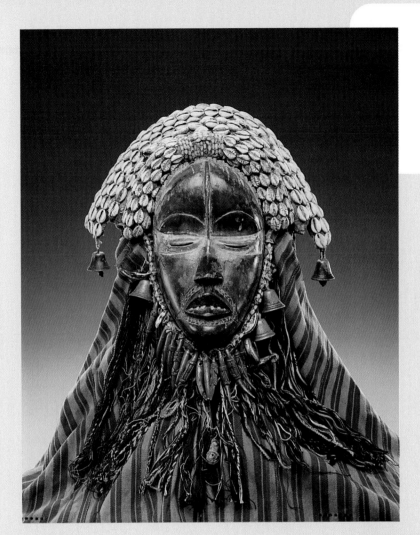

Fig. F3–16 **Imagine running your fingers over this African mask and its attachments. What textures would you feel?**
Africa, Dan Culture (Liberia, Ivory Coast), *Ga-Wree-Wre-Mask*, 20th century.
Wood, metal, fiber, cowrie shells, glass beads, brass, bone, handwoven cloth, 47"x 16" x 22" (119.4 x 40.6 x 55.9 cm). Virginia Museum of Fine Arts, Richmond. The Adolph D. and Wilkins C. Williams Fund. Photo: Katherine Wetzel. © Virginia Museum of Fine Arts.

Texture

Texture is the way a surface feels or looks, such as rough, sticky, or prickly. *Real* textures are those you actually feel when you touch things. Sculptors, architects, and craftspeople use a variety of materials to produce textures in their designs. These textures can range from the gritty feel of sand to the smooth feel of satin.

Artists who work in the two-dimensional art forms can create *implied* textures, or the illusion of texture. For example, when an artist paints a picture of a cat, he or she can create the look of soft fur by painting hundreds of tiny fine lines. What kinds of implied texture have you created in paintings or drawings of your own?

Try This

Draw a landscape with oil pastels. To create an illusion of space, make distant objects smaller and place them higher on the page. Use lighter values and cooler colors than objects in the foreground. Try using lines and dots to create textures.

Lesson Review

Check Your Understanding

1. What are the elements and principles of design?
2. Explain how David Hockney created an illusion of space in *Garrowby Hill*, Fig. F3–15.
3. Describe the negative space found in *Illumination*, Fig. F3–14.
4. Locate an artwork in this book that uses a warm color scheme. How do the colors add meaning to the art?

Elements and Principles of Design

41

Principles of Design

Balance

Artists use **balance** to give the parts of an artwork equal "visual weight" or interest. The three basic types of visual balance are symmetrical, asymmetrical, and radial. In *symmetrical* balance, the halves of a design are mirror images of each other. Symmetrical balance creates a look of stability and quiet in an artwork.

In *asymmetrical* balance, the halves of a design do not look alike, but they are balanced like a seesaw. For example, a single large shape on the left might balance two smaller shapes on the right. The two sides of the design have the same visual weight, but unlike symmetrical balance, the artwork has a look of action, variety, and change.

In *radial* balance, the parts of a design seem to "radiate" from a central point. The petals of a flower are an example of radial balance. Designs that show radial balance are often symmetrical.

Try This

Draw an asymmetrical picture of an animal. Make this drawing very unified by creating a single shape as the main part of the design and repeating shapes and textures. When you have completed your drawing, explain to other classmates how you created unity and balance in your drawing. How could you add variety to this drawing?

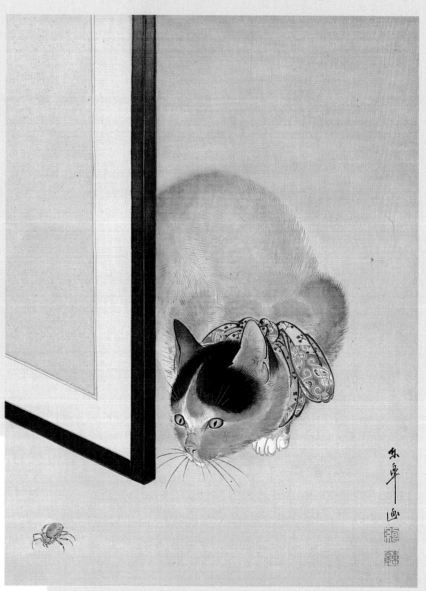

Fig. F3–17 **In this asymmetrical composition, space on the right balances the wall and bug on the left. The cat's gaze leads us to the insect.** Japanese, Toko, *Cat and Spider*, 19th century.
Album leaf, colors and ink on silk, 14 ³/₄" x 11" (37.5 x 28 cm). The Metropolitan Museum of Art, Charles Stewart Smith Collection, Gift of Mrs. Charles Stewart Smith, Charles Stewart Smith, Jr. and Howard Caswell Smith, in memory of Charles Stewart Smith, 1914 (14.76.61.73). Photograph © 1981 The Metropolitan Museum of Art

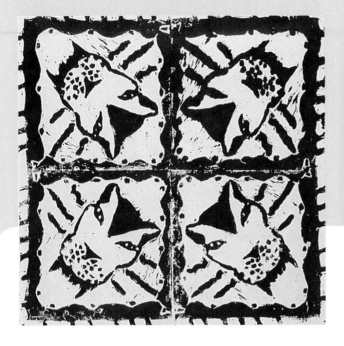

Fig. F3–18 **Student artist Victoria Sample created a feeling of unity by repeating shapes and using limited color. Why could this also be considered a radial design?**
Victoria Sample, *Untitled*, 1996.
Linoleum block print, 18" x 18 1/2" (46 x 47 cm). Grafton Middle School, Grafton, Massachusetts.

Fig. F3–19 **Textile artist Frances Hare used a variety of materials, patterns, and textures to express her passion for dance. How did she also create a feeling of unity?**
Frances Hare, *Sixteen Feet of Dance: A Celebration, A Self-Portrait*, 1996.
Cotton fabrics, beads, braided cloth, 69" x 56" (175.2 x 142.2 cm). Courtesy the artist.

Unity

Unity is the feeling that all parts of a design belong together or work as a team. There are several ways that visual artists can create unity in a design.

- repetition: the use of a shape, color, or other visual element over and over
- dominance: the use of a single shape, color, or other visual element as a major part of the design
- harmony: the combination of colors, textures, or materials that are similar or related

Artists use unity to make a design seem whole. But if an artist uses unity alone, the artwork might be visually boring.

Variety

Variety adds visual interest to a work of art. Artists create variety by combining elements that contrast, or are different from one another. For example, a painter might draw varying sizes of circles and squares and then paint them in contrasting colors such as violet, yellow, and black. A sculptor might combine metal and feathers in an artwork or simply vary the texture of one material. Architects create variety when they use materials as different as stone, glass, and concrete to create the architectural forms of a building.

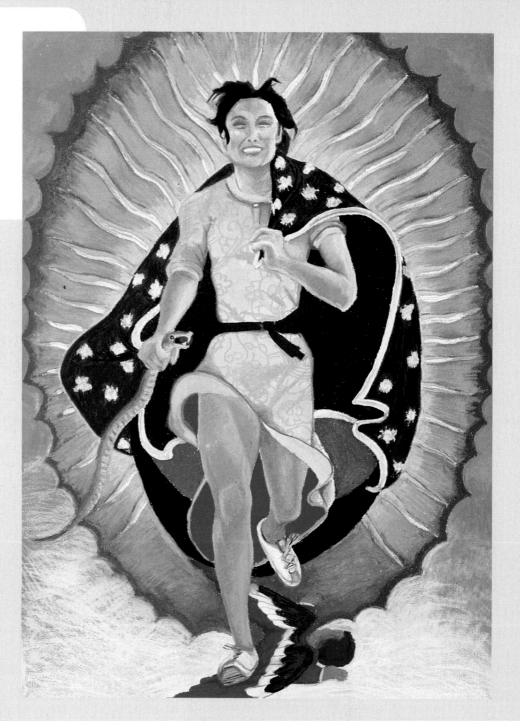

Fig. F3–20 **Yolanda Lopez based her drawing on a traditional religious icon from her Mexican heritage. How did she emphasize her subject?** Yolanda M. Lopez, *Portrait of the Artist as the Virgin of Guadalupe*, 1978. Oil pastel on paper, 22 ½" x 32 ½" (57 x 82.5 cm). Courtesy of the artist.

Emphasis

Look at *Portrait of the Artist as the Virgin of Guadalupe* (Fig. F3–20). What is the first thing you see? Of course, you probably see the woman first. Now see if you can explain why you noticed her first. Here are some clues.

When artists design an artwork, they use emphasis to call attention to the main subject. The size of the subject and where it is placed in the image are two key factors of emphasis. You probably noticed the woman first because she is larger than most of the other objects in the painting. She is also placed in the middle of the work. Sometimes artists create emphasis by arranging other elements in a picture to lead the viewer's eyes to the subject. Or they group certain objects together in the design.

Pattern

An artist creates a **pattern** by repeating lines, shapes, or colors in a design. He or she uses patterns to organize the design and to create visual interest. You see patterns every day on wallpaper, fabric, and in many other kinds of art.

Patterns are either planned or random. In a *planned* pattern, the element repeats in a regular or expected way. A *random* pattern is one that happened by chance, such as in a sky filled with small puffy clouds or in the freckles on a person's face. Random patterns are usually more exciting or energetic than planned ones.

Try This

Select a magazine photograph of an object that has special meaning to you. Carefully trim away the paper around the object. Glue the object onto a sheet of paper. Then create a design and emphasize the object by adding a background with either colored papers or by drawing. Before you begin, think about how you can emphasize your object. Will you locate the object near the center of the composition, use contrasting colors behind it, or draw lines leading to it? Explain how you emphasized the main object in your completed design.

Computer Option

Use a computer to create a design with a strong center of interest. Either draw a shape or place a clip art object near the center of your page. Add textures, colors, and lines to draw the viewer's gaze to this part of your composition.

Fig. F3–21 **What did the student artist repeat in her design to create a planned pattern? What might you cover with a pattern like this?** Stacey Fong, *Pattern*, 1996.
Torn paper collage, 9" x 12" (23 x 30.5 cm). Los Cerros Middle School, Danville, California.

Proportion

Proportion is the relationship of size, location, or amount of one thing to another. In art, proportion is mainly associated with the human body. For example, even though your body might be larger, smaller, or shorter than your best friend's, you both share common proportions: Your hips are about halfway between the top of your head and your heels; your knees are halfway between your hips and your feet; and your elbows are about even with your waist.

Scale is the size of one object compared to the size of something else. An artist sometimes uses scale to exaggerate something in an artwork. Look at *Kitchenetic Energy* (Fig. F3–22). How did Doug Webb manipulate scale to give a kitchen sink a new function?

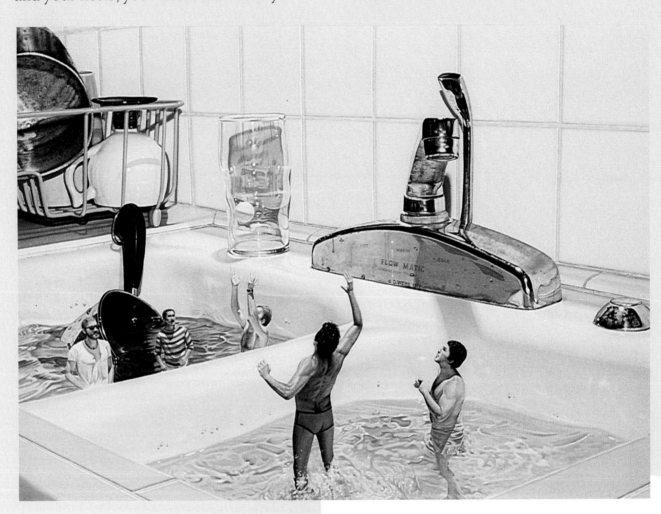

Fig. F3–22 **How did the artist use scale in this painting? Why do you think he chose to change the scale of the people and the sink? What effect does this create?** Doug Webb, *Kitchenetic Energy*, 1979.
Acrylic on linen, 30" x 40" (76.2 x 101.6 cm). Courtesy of the artist.

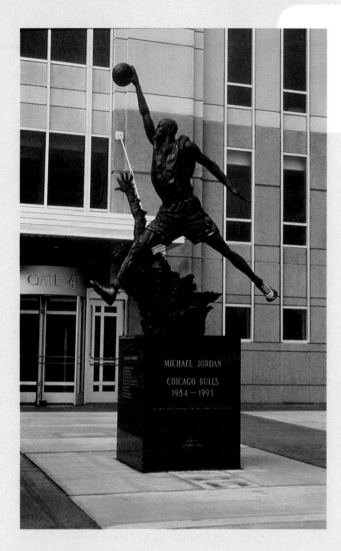

Fig. F3–23 **This bronze statue is a tribute to basketball player Michael Jordan. Describe the movement in the sculpture. How did the artists emphasize this movement?** Omri Amrany & Julie Rotblatt-Amrany, *The Spirit, Michael Jordan*, 1994.
Bronze, height (including base): 16' (5 m). United Center, Chicago, Illinois.

Sketchbook Connection
Sketch people in motion in a sports event, physical education class, or dance. Try to capture their movement with many quick sketches. Look for the stretch in their bodies and clothes. Experiment by drawing just a few lines in some figures and many quick lines in others.

Lesson Review

Check Your Understanding
1. How did Yolanda Lopez emphasize the main figure in *Portrait of the Artist as the Virgin of Guadalupe*, Fig. F3–20?
2. Is the balance in *The Spirit, Michael Jordan*, Fig. F3–23, symmetrical or asymmetrical? Why is balance so important in the design of this statue?
3. Describe the unity and variety in *Sixteen Feet of Dance: A Celebration, A Self-Portrait*, Fig. F3–19.
4. From this chapter, select an artwork that appeals to you. Describe the art elements and principles that are most important in this work's design.

Movement and Rhythm

Rhythm is related to both movement and pattern. Artists use rhythm, like pattern, to help organize a design or add visual interest. They create rhythm by repeating elements in a particular order. Rhythm may be simple and predictable, or it may be complex and unexpected.

For example, look at *The Spirit, Michael Jordan* (Fig. F3–23). How does your eye move across this sculpture? First your eye probably sweeps quickly from the ball down through his extended back leg. Notice how the artists created a rhythm by repeating this line in the shape of the opponent, and in Jordan's back arm. Find other repeated lines that create rhythms within this sculpture.

Connect to...

Careers

What well-designed Websites can you think of? Graphic design is most likely the first thing you notice when you visit a Website. This makes the role of the **computer graphic artist** quite important. Not long ago, graphic designers drew by hand, painted with airbrushes, used press-on type, and made "paste-ups" of art and text for a camera. Today, a successful graphic designer must be skilled not only in painting and drawing, but also in computer software programs and photo manipulation. A graphic artist must come up with original ideas, and he or she must be able to translate a client's wishes into computer media. Computer graphic artists may create Web pages, computer animation or other special effects, illustrations, presentations, packaging, ads, newspapers, and books. Many colleges and universities offer degrees in computer graphics, often called communication design.

Other Arts

Dance

Many of the elements and principles of the visual arts apply to dance as well. The bodies of dancers can create lines, shapes, and forms in space. Choreographers might have dancers twist and move their body into a tight ball or jump to form a starlike shape in space.

Several dancers might join together to create cubes or other forms. The choreographer might have all the dancers perform the same moves to create a sense of unity, or some dancers might perform contrasting movements to create variety or emphasis.

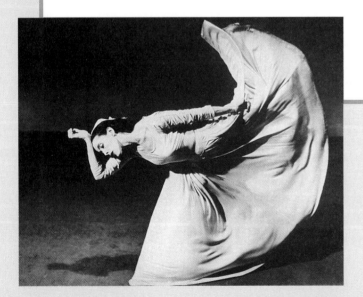

F3–24 **A photograph is one way to capture a dance performance. What elements and principles of design do you see in this photograph?** Barbara Morgan, *Martha Graham: Letter to the World (Kick)*, 1940. Gelatin silver print. SuperStock. Underwood Photo Archives/SSI.

Internet Connection
For more activities related to this chapter, go to the Davis Website at **www.davis-art.com.**

Daily Life

What evidence of the elements and principles of design do you see in your daily life? Where do you see line, color, value, space, texture, balance, unity, variety, emphasis, and pattern? We often do not take the time to pay close attention to art in our surroundings. Can you identify at least one example of each of the elements and principles? Make a list of your findings.

F3–25 **If you owned this chair, would you consider it a work of art or a functional piece of furniture? Why?**
Frank O. Gehry & Associates, *Wiggle Side Chair*, 1969–72.
Corrugated cardboard. Courtesy Frank O. Gehry & Associates.

Other Subjects

Social Studies

Artworks can give us visual clues about different cultures. We can learn much about the cultural roots of African American artist John Biggers from his paintings of "shotgun" houses. The houses were called such because people believed that a bullet fired through the front doorway would go straight out the back. This house style is now considered an important African American contribution to architecture. Biggers grew up in such a house and his paintings emphasize the geometric shapes on which the shotgun house is based. The artist also believes that the term *shotgun* is taken from *shogun*, a West African term for "king's house."

Language Arts

In art, pattern is a principle of design in which combinations of lines, colors, and shapes are used in a particular order to make a repeating image. **In poetry, the rhythmical pattern of a poem is called its meter.** The number and types of stresses or beats (weakly or strongly stressed syllables) in each line of a poem determines its meter. How could you use these similarities to write a poem about a work of art that depicts pattern?

F3–26 **What role do the shotgun houses play in this work?**
John Biggers, *Shotguns, Fourth Ward*, 1987.
Acrylic and oil on board, 41 ¾" x 32" (106 x 81 cm). Hampton University Museum, Hampton, Virginia.

Science

Have you ever seen the rainbow of colors when white light passes through a prism? The individual colors separate within the prism while the different wavelengths of the rays of light are bent or refracted. To produce a rainbow, turn on a hose or sprinkler so that the water comes out as a fine spray. Stand so that you face the spray and have your back to the sun. Move about slightly until you find the right angle to see the rainbow.

Portfolio

"I took this photo when trying to find naturally occurring lines. Here the log overhang and bright sunlight creates distinct patterns of light and dark. The lines connect all parts of the photo together to make a normal scene abstract." **Hannah Parpart**

F3–27 **Photography is a great medium for capturing patterns of shadow and light.** Hannah Parpart, *Lines of Light*, 2000.
Black and white photograph. Les Bois Junior High School, Boise, Idaho.

"I love butterflies, and I love to show things in motion. So I did a butterfly flying across the paper. My favorite thing about this picture is the colors. I wanted the colors to be bright and vivid." **Vanessa Stassen**

F3–28 **Arms and legs were added to a simple conelike body shape, with wings for balance. How does the use of color bring harmony to the piece?** Ashley Anderson, *Wish Dragon*, 2000.
Clay, glaze, 8" x 10 1/2" x 6 1/2" (20 x 26.5 x 16.5 cm). South Junior High School, Boise Idaho.

F3–29 **A simple stencil print can be overlapped and repeated to create a sense of motion and rhythm.** Vanessa Stassen, *Butterflies*, 2000.
Compressed tempera, 12" x 18" (30.5 x 46 cm). Northview Middle School, Indianapolis, Indiana.

CD-ROM Connection
To see more student art, view the Personal Journey Student Gallery.

Foundation 3 Review

Recall

Make a list of the elements of design and another of the design principles.

Understand

Explain the difference between the elements and principles of design.

Apply

Fold a sheet of paper into eight equal rectangles. In each rectangle, draw a diagram illustrating an art element and principle. For example, you might draw lines leading to the center of the design to show line and emphasis, or draw many different kinds of shapes for shape and variety. Because there are only seven art elements, repeat one of them. Label each drawing with the element and principle featured in it.

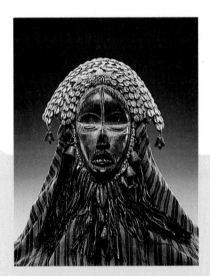

Page 41

Analyze

Write an analysis of the art elements and principles in *Ga-Wree-Wre Mask*, Fig. F3–16 (*see below*). Which element and principle seem to be most important in this piece? What type of lines, shapes, and forms did the artist use? Describe the textures, values, colors, and color schemes you see. What type of balance does it have? How did the artist create unity and variety? What did the artist emphasize?

Synthesize

Create an advertisement for your favorite sport or activity. Use color, line, texture, value, form, and shape to suggest the sport. Use these elements to emphasize your main subject. What type of balance will you use in your design?

Evaluate

Imagine that a children's museum has asked you to select one of the artworks from this chapter to purchase for their collection. The museum wants to use this artwork to teach young children about rhythm in art. For your choice, write a label that explains how the artist created rhythm in this work.

For Your Sketchbook

Sketch one of your personal belongings, such as a bag, book, shoe, or piece of sports equipment. Describe the art elements and principles in your drawing. What type of shapes, forms, colors, lines, values, space, and textures does it have? Imagine how it would look if you changed one of these.

For Your Portfolio

Select one of your artworks that demonstrates your understanding of one of the art elements or principles. Write a description of this artwork, explaining how you emphasized that art element or principle.

Approaches to Art

Focus

- What do people want to know about art?
- What kinds of questions do people ask about art?

Imagine finding an object that's unlike anything you've ever seen before. You turn the object over in your hands and ask yourself, "What is this? Who made it? How was it made?" Suppose something about the object suggests that it was made a long time ago. You might wonder why the object was important to the people who lived at that time. What did they use it for? How is it different from objects that you normally see or use?

For thousands of years, people have wondered where objects and artworks come from and why they were made. It's human nature to be curious. We can be as curious about the function of an artwork as we are about its meaning. Asking questions about the artwork helps us understand it. The information we learn about the artwork can also teach us something about the times and cultures of our world and where we fit in.

This chapter will introduce you to the kinds of questions people ask about artworks. As you read the chapter, you will see that the questions fall into four categories: art history, art criticism, the making of art itself, and the philosophy of art.

Words to Know

art historian	artist
art critic	aesthetician

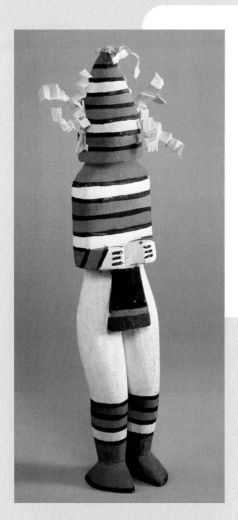

Fig. F4–1 **Hopi people of the American Southwest use Kachina figures to teach children about their culture's beliefs and values.** Willie Coin, *Aholi Kachina*, *Hopi*, 1952.
Cottonwood, paint, corn husk, 11 1/4" x 2 1/2" (28.6 x 6.4 cm). Denver Art Museum Collection: Purchase from Alfred Whiting, 1948.336. © Denver Art Museum.

Fig. F4–2 **We do not know exactly why prehistoric people painted huge animals on cave walls. Archaeologists and art historians are still fitting together clues.** France, Périgord, Lascaux caves, *Cave Painting (serigraph transcription): Horse*, original paintings date from c. 15,000–13,000 BC.
Douglas Mazonowicz/Art Resource, New York.

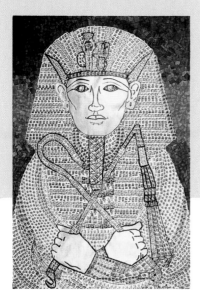

Fig. F4–3 **Middle-school students used canceled stamps to create their own version of Egyptian pharaoh Tutankhamun's gold coffin. How does the use of this unusual medium affect the message of the artwork?** Group Student Work, *King Tut Stamp Mosaic*, 2000.
Stamps, tissue paper, marker, 70" x 48" (178 x 122 cm). Chocksett Middle School, Sterling, Massachusetts.

Fig. F4–4 **Imagine how Jackson Pollock moved his arm as he drizzled and splattered paint across this huge canvas, dripping and slinging paint from sticks and brushes. Describe the rhythm in this piece.** Jackson Pollock, *Blue Poles*, 1952.
Enamel and aluminum paint with glass on canvas. 6' 10 7/8" x 15' 11 5/8" (212.09 x 488.95 cm). Collection: National Gallery of Australia, Canberra (NGA Acc. No. 74.264). © The Pollock-Krasner Foundation/Artists Rights Society (ARS), New York.

Art History

The Stories Behind Art

Art history is just what you'd expect: the history of art. **Art historians**—people who study the history of art—want to know where artworks began. They research the cultures from which artworks spring. They learn about the people, the politics, and the economic conditions at the time and place where artworks were made. They try to figure out why artists created artworks and how the artworks are different from others. And finally, when all of their research is done, they piece together the stories of art.

Do you ever wonder where artworks come from or what their story is? If you do, then you have begun investigating their history.

Looking at Art

There are certain basic questions that will get you started on the search for an artwork's story.

1. What is the artwork? What is it about? What is its purpose?

2. When and where was it made?

3. Has the artwork always looked like this? Or has it changed somehow over time?

Finding the Story

The next set of questions will help you find out what an artwork meant to the artist and to the people who lived at the time it was made. By asking these questions, you can learn how the artwork reflects the cultural traditions of The time. Your answers will also help place the artwork in history.

1. What was happening in the world when the artwork was made? How is the world different now?

Fig. F4–5 **Pop artist Robert Rauschenberg created** *Retroactive I* **soon after President John F. Kennedy was assassinated. From this painting, what can you discover about American culture in the 1960s?** Robert Rauschenberg, *Retroactive I*, 1964.
Oil, silk-screen ink on canvas, 84" x 60" (213 x 152 cm). Wadsworth Atheneum, Hartford. Gift of Susan Morse Hilles (1964.30). © Robert Rauschenberg/Licensed by VAGA, New York, New York.

Fig. F4–6 **This statue of a Roman emperor is the only well-preserved equestrian (horse and rider) statue to survive from antiquity. How did the artist show the importance of the emperor?** Roman, *Marcus Aurelius, Equestrian*, c. 175 AD.
Bronze, over lifesize. Piazza del Campidoglio, Rome. SEF/Art Resource, New York.

Fig. F4–7 **What is the story in this artwork? Where has the artist seen lions?** Lisa Ball, *Trapped Lion*, 2000.
Colored pencil, 9" x 9" (23 x 23 cm). Los Cerros Middle School, Danville, California.

You can ask any of these sample questions about a specific artwork or artist. You can also ask similar questions about an entire art period or about the value and use of artworks in general.

See if you can find out what art historians have said about artworks and artists that interest you or about when and where the artworks were created.

2. How do the customs and traditions of the artist's family or culture add to the meaning of the artwork?
3. What other kinds of art did people make at that time?

Introducing the Artist

As the story of an artwork unfolds, questions about the artist begin to surface. Some art historians focus their investigations mainly on the life and work of a single artist. Imagine the accomplishment of having discovered something new and interesting about an artist!
1. Who made this artwork?
2. What role did artists play in the community in which this work was made?
3. How does this artist's style compare to the style of other artists during that time?
4. What decisions was the artist faced with as he or she created this artwork?

Try This

Create an artwork about a local or national leader from the past or present. Include information about the leader's culture to provide viewers with clues about who it is and when and where this person lived. What objects are associated with this person? How and where would most people have seen this person?

Lesson Review

Check Your Understanding
1. How do art historians learn about the history of artworks?
2. From this lesson, select a piece of artwork that appeals to you. Analyze it by answering one or two questions from each category in the lesson.

Art Criticism

Searching for Meaning

Art critics want to know what artworks mean. They can help us learn about artworks by describing them and pointing out interesting things to look for. They judge the quality of artworks and suggest why they are valuable or important. Art critics often write about art in newspapers or magazines. Their views can influence the way we look at and think about artworks.

You have already asked questions like an art critic, perhaps without even realizing it. You may have looked at artworks in this book and wondered about their meaning. You have expressed your thoughts and opinions about objects and artworks around you. And you have compared them to other objects or artworks you're familiar with. Your views may have affected the way your classmates or others think about artworks.

Finding Clues

As an art critic, you need to observe certain things about an artwork before you can begin to think about its possible meaning. Here are some questions that will help get you started.

1. What does the artwork look like?
2. How was it made?
3. How are the parts of the artwork arranged?
4. Does it seem to suggest a mood or feeling? An idea or theme?

Making Connections

Once you understand how the artwork is put together, you can focus more on its meaning and ask questions such as these:

1. What is the artwork about?
2. What message does it send? How does it make me think, feel, or act when I see it?
3. How is the artwork related to events in the artist's life? How is it related to events that happened at the time it was made?

Judging Importance

Suppose you have learned enough about the artwork to decide that it is important. Next, you need to support your judgment. Ask yourself:

1. What aspects of the artwork—such as artist, culture, message, or function—make it important? Why?
2. What sets this artwork apart from similar artworks?
3. How is my response to this artwork different from my response to similar artworks?

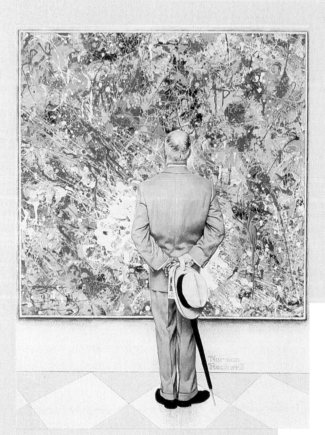

Fig. F4–8 **When *Connoisseur* appeared as a magazine cover, art critics considered it just an illustration, whereas abstract paintings such as Pollock's (Fig. F4–3) were thought of as fine art. Do you agree with that judgment?** Norman Rockwell, *Connoisseur*, 1962. Cover illustration for the *Saturday Evening Post*, 13 January 1962. Printed by permission of the Norman Rockwell Family Trust. © 2001 The Norman Rockwell Family Trust.

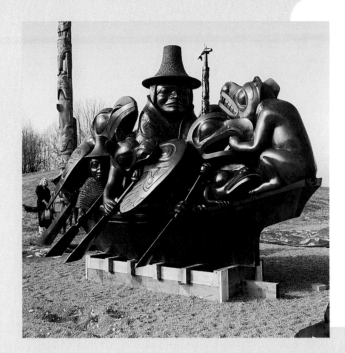

Fig. F4–9 **Canadian artist Bill Reid is often inspired by myths from his heritage. In this work, Bear faces the past while Raven steers the canoe. The wise Haida chief stands in the center as Beaver, Human Warrior, and Magical Dogfish Woman paddle.** Bill Reid, *The Spirit of Haida Gwaii, The Jade Canoe*, 1994.
Bronze cast with jade green patina, 12' 9" x 11' 5" x 19' 10" (388.6 x 348 x 604.5 cm). Collection of the Vancouver Airport Authority, Vancouver, Canada. Photo: Bill McLennan.

Fig. F4–10 **What do you think this artwork is about? To create this batik, the artist used wax to draw on cloth. The wax blocks the color dyes from certain areas of the design.** Lisa Hough, *Indian Symbolism*, 2000.
Batik, 18" x 24" (46 x 61 cm). Laurel Nokomis School, Nokomis, Florida.

You can see the kinds of things art critics say about art when you read a review of an art exhibit in your local newspaper. Try to visit the exhibit yourself. Do you agree with what the critic says about it? Why or why not?

Try This

Create an artwork about a journey or event that is part of your family's history or your community's heritage. Include symbols to help viewers identify your cultural history. These symbols might be landmarks, clothing, or an artistic style. Then write a description of the meaning and message of your artwork.

Sketchbook Connection
Sketch a monument or building in your area. Then critique the structure by using the questions on these two pages as a guide. Write your art criticism of the monument or building in your sketchbook.

Lesson Review

Check Your Understanding
1. What do art critics look for as they study artworks?
2. Choose an artwork in this chapter. Write an art criticism about it by answering at least one question in each category on these two pages.

Art Production

Making Art

Artists all over the world make artworks for decoration, to celebrate important events, and to communicate ideas or feelings. When artists plan a work of art, they think about its purpose and meaning. As they create the work, they explore their ideas and sometimes test the limits of the materials they use. In the end, they create a work that satisfies their personal and social needs, interests, values, or beliefs.

You think like an artist every time you explore the things you can do with pastels, a lump of clay, or any other art material. You might have an idea when you start, or your exploration might lead you to one. When you are finished expressing your idea, you have a work of art that is all your own.

Reflecting on Your Art and Yourself

As you create art, you will begin to realize what art and making art mean to you. Asking questions about your art-making experience will help you uncover that meaning.

1. What artworks are important to me? How do they affect the way I make art?
2. What feelings or ideas do I like to express in my artwork? What does my art say about me?
3. What process do I go through when I make art?

Considering Your Art and the World

When you have a better understanding of your own art, you can think about how it fits into the big picture. Ask yourself:

1. What does my artwork tell others about the place and time in which I live? What special events, people, or things does it suggest?
2. What do my choices of materials and techniques tell others about my world?
3. How is my artwork similar to or different from art that was made in other times and places?

Fig. F4–11 **Vietnamese-American artist Hoang Vu is inspired by natural forms. He says he wants his sculptures to be fragile but strong, like leaves in wind.** Hoang Vu, *Nghe*, 1998. Wire, 16" x 10" x 14" (40.6 x 25.4 x 35.6 cm). Courtesy the Frumkin/Duval Gallery, Santa Monica, California.

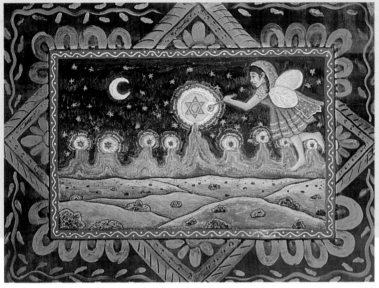

Fig. F4–12 **Diana Bryer has an Eastern European Jewish heritage but lives in New Mexico. Can you locate symbols of both cultures within her artwork?** Diana Bryer, *The Jewish Fairy Blessing the Menorah of the Southwest*, 1986.
Mixed media, 20" x 30" (50.8 x 76.2 cm). Private Collection.

Fig. F4–13 **Imagine how this student artist went about creating this artwork. Have you ever made a portrait? How did you begin?** David Yates, *Untitled*, 1999.
Mixed media, 18" x 12" x 3" (46 x 30.5 x 7.5 cm). Chocksett Middle School, Sterling, Massachusetts.

Comparing Your Art to Other Art

As an artist, you are probably aware of ideas and concerns that other artists have. When you compare your work to theirs, you might see a connection.

1. How is my artwork similar to or different from artworks made by others? How has their work affected my work?

2. If I could create an artwork with another artist, whom would I choose to work with? Why?

3. What materials and techniques have other artists used that I would like to explore? Why?

The next time you create a work of art, ask yourself the questions in this lesson. See what answers you come up with. You'll probably learn something surprising about the artist in you!

Try This

Choose one artwork in this chapter that most appeals to you. Create a similar piece of art, using the same theme or media or style. Do not copy the artwork. Instead, express something about your interests. When you have completed your work, reflect on it by answering some of the questions on these two pages.

Lesson Review

Check Your Understanding

1. List some reasons that artists create art. Why have you made a specific piece of art in the past?

2. Select a piece of art that you have created. Explain how you feel about it. What does it say about your world? How does it compare to other art?

Aesthetics

Investigating Art

Aesthetics is the philosophy, or investigation, of art. **Aestheticians** can be called art philosophers. They ask questions about why art is made and how it fits into society. They're interested in how artworks came to be.

Every time you wonder about art or beauty, you think like an aesthetician. The questions that come to your mind about art are probably like the questions that aestheticians ask. All you need is a curious mind and probing questions to be an art philosopher yourself.

Thinking About Artworks

At some time or another, you have probably wondered what artworks are. Like an aesthetician, you can ask certain questions that will help you think more carefully.
1. Are all artworks about something?
2. In what ways are artworks special? What makes some artworks better than others?
3. Do artworks have to be beautiful or pretty? Why or why not?
4. What makes one kind of artwork different from another?

Thinking About Artists

As an aesthetician, you might wonder about the people who make art, why they make it, and why some people, but not all, are called artists. You might ask:
1. What do artworks tell us about the people who made them? What do they tell us about the world in which they were made?
2. What do people express through making art? Do artworks always mean what the artist intends them to mean?
3. Should there be rules that artists follow to make good artworks?

Fig. F4–14 **What, do you think, was the artist most interested in as he created this painting?** Lawrence Leissner, *The Second Trigram*, 1995.
Watercolor, 21" x 26" (53.3 x 66 cm). Courtesy of the artist.

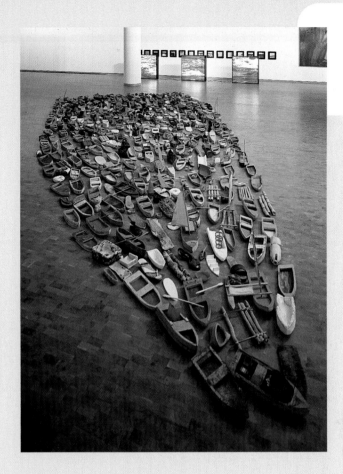

Fig. F4–15 **The installation represents the large groups of people who leave Cuba by boat for Florida. What can this work tell you about this artist?** Kcho, *The Regatta*, 1994.
Mixed media, dimensions variable. Stadt Köln, Rheinisches Bildarchiv Köln.

The questions that aestheticians ask do not necessarily investigate a specific artwork. Instead, they investigate the larger world of art in general.

Try This

Create an artwork about a news event that concerns you. Try to use an abstract or nonobjective style to show the emotions surrounding this event and your feelings about it. Show your work to a partner. Does he or she understand the work in the way you wanted? Have your partner point to specific details in your work to support his or her interpretation. Why, do you think, people can have different reactions to the same work of art?

Thinking About Experiences with Art

When you talk about art, you probably discuss whether or not you like an artwork. And you probably talk about how an artwork makes you feel. These questions will help you dig deeper into your experience with an artwork.

1. How do people know what an artwork means?

2. Is it possible to dislike an artwork and still think it is good?

3. How is the experience of looking at an artwork like the experience of looking at a beautiful sunset? Or are these experiences completely different?

4. How do beliefs about art affect the way people look at and explore artworks?

Computer Option

Locate one of the artworks in this chapter on the Internet or a CD. Download the image into a file. Use filters and drawing tools to transform it into your own artwork based on the famous piece. Using another's artwork in this way is called *appropriation*.

Lesson Review

Check Your Understanding

1. What is another term for an aesthetician?

2. How is an aesthetician different from an art historian?

Connect to...

Careers

Have you ever taken part in a guided tour in an art museum? Most likely, your guide was a **museum educator**. A museum educator may be a member of the museum's education department or a community volunteer called a docent. Most large museums have an education department. The staff works with public and private schools in the community and arranges visits and tour schedules. The department may also provide outreach programs, such as lectures, films, and other programs that travel outside the museum. Museum educators often plan and develop tours for special exhibitions or the permanent collection. Most museum educators approach the study of art through art history. This requires them to have a degree in art history or museum education.

F4–16 **What guided tours have you been on? How did they help you understand a site or collection of objects?**
Photo courtesy Eldon Katter.

Other Arts

Theater

There are **different approaches to theater**, just as there are approaches to the visual arts. For example, a theater historian examines a play within its context. When was it written? What other events were going on when the play was written? The theater critic searches for the performance's meaning. The critic describes the play and makes a value judgment—whether the piece was good or bad and why. Finally, a theater aesthetician examines the larger questions or issues: Why was the work made? What is its relationship to society and culture?

F4–17 **The *commedia dell'arte* was a type of comedic play. It was first performed in Italy in the sixteenth and seventeenth centuries and reflected the lives of ordinary people of the time.** André Rouillard, *Commedia dell 'Arte*, 1991.
Acrylic on canvas. Courtesy SuperStock.

Other Subjects

Social Studies

Do you know that **different approaches towards certain artifacts** can affect the kind of museum in which an object is placed? For example, an art historian and an anthropologist (a scientist who studies human culture) might differ on the kind of museum in which a Native American artwork should be placed. The art historian might say the work belongs in an art museum. The anthropologist might choose a museum of natural history or ethnography (the study of culture). Why, do you think, do different museums exist?

Science

Sir Isaac Newton first proposed the **scientific method, an approach to scientific study**, in 1687. This step-by-step approach is now the standard used when conducting scientific experiments. Researchers using the scientific method first ask a question based on observation. Next, they state a testable hypothesis or interpretation, design a study to answer the hypothesis, and collect data through observation and experiment. Last, they interpret the results and draw conclusions. Can you think of any way such an approach could be adapted to interpret a work of art?

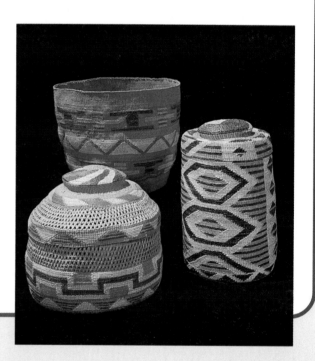

F4–18 **Which would you choose as the most appropriate museum for a work such as the one pictured here? Why?** Native American, Tlingit, *Group of Three Baskets*, early 20th century.

Internet Connection

For more activities related to this chapter, go to the Davis Website at **www.davis-art.com.**

Daily Life

When you recommend music, movies, computer games, or books to your friends, you are acting as a critic. Art critics approach art through a focus on interpretation and judgment. You are doing exactly that when you share your opinions with your friends. What are the guidelines or criteria you use in forming your opinions and judgments?

Portfolio

F4–19 This painting was inspired by an ancient art-form that involved painting on bark. Austin Pines, *Bark Painting*, 2001.
Watercolor, shoe polish, colored inks, and charcoal, framed with sticks and raffia, 12" x 15 ¼" (30.5 x 39 cm). Hillside Junior High School, Boise, Idaho.

F4–20 What sets this artwork apart from other paintings of a house? Michael Baldwin, *Photo Phantom Home*, 2001.
Watercolor, marker, 10 ¼" x 14 ¼" (26 x 36 cm). Plymouth Middle School, Plymouth, Minnesota.

"When I made the piece, I was thinking mostly about detail. I wanted to add additional parts, like pictures or slippers, but my time was limited. I would have to say the hardest part was the floor. I had to measure each tile to get them to look somewhat the same."
Pat Chybowski

"My structure is a space home for many kinds of people, old or young, big or small. Each home comes complete with a food, air, and water making machine to help you and your family live as long as possible. The roof is made purely of solar panels to make it run forever. The house can land on any surface or stay in space." **Michael Baldwin**

CD-ROM Connection
To see more student art, view the Personal Journey Student Gallery.

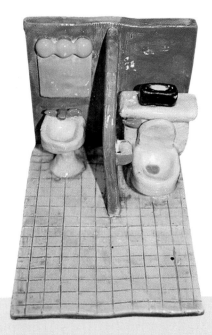

F4–21 What makes this artwork unusual? How has the artist's attention to detail made a difference? Pat Chybowski, *Porcelain Palace*, 2000.
Clay, glaze, 7" x 5 ½" x 5 ¼" (18 x 14 x 13 cm). Antioch Upper Grade, Antioch, Illinois.

Foundation 4 Review

Recall

What does the term *aesthetics* mean?

Understand

Explain how art critics can help people. What do art critics do in their jobs?

Apply

Make a list of questions that art historians might ask about *Kachina*, Fig. F4–1 (*see below*), and then try answering them.

Analyze

Pretend that you are an art critic writing for your school newspaper. An art exhibit featuring the artworks on pages 60 and 61 has recently opened in your community. Describe and critique these artworks. (Use the questions in lesson F4.2 to guide your critique.) How strongly would you recommend that students see this show?

Synthesize

Research prehistoric cave paintings from southern Europe, such as those in France near Lascaux (see Fig. F4–2) or the Ardèche region. Write an imaginary diary description about painting in these deep, dark caves. Include drawings like those of the early artists, and suggest why these artists might have painted such animals and figures.

Evaluate

As an aesthetician, write an essay based on Niki de Saint Phalle and Jean Tinguely's *Illumination* on page 40. Discuss whether all art has to be beautiful. Use the questions on pages 60 and 61 to guide your discussion. Explain why you think *Illumination* was a good choice for the beginning of this book. Or, from the Foundation chapters, select another artwork that you feel would be a better choice, and explain why.

Page 53

For Your Sketchbook
Select the most interesting page of drawings from your sketchbook. Write several questions that an art critic and an art historian each might ask about this page. Write a statement about this page of art from your viewpoint as the artist.

For Your Portfolio
Select an artwork from your portfolio that an art historian, art critic, or aesthetician might be interested in. Write a description of your artwork from this person's point of view. Use the questions in the lesson about art history, art criticism, or aesthetics to guide your discussion.

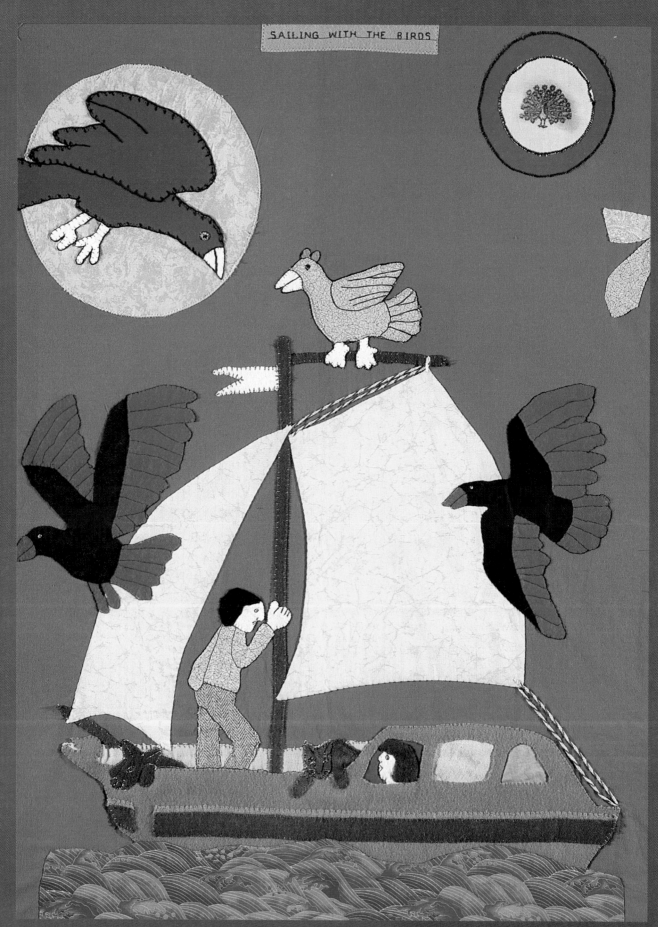

SAILING WITH THE BIRDS

Rakhel Biller Klinger, *Sailing with the Birds* (detail), 1999.
Cloth, hand and machine appliquéd with embroidery, 59" x 38" (147 x 97 cm). Courtesy of the artist.

Art Is a Personal Journey

Have you ever been on a journey? You probably take little journeys all the time: you go to school, to the grocery store. Maybe you walk down the block to play basketball. Or perhaps you wander from one side of a quiet forest to the other.

Long journeys—say, a trip to another state—can show you new things, make you think in a new way. But even short trips can change your point of view. On your walk to play basketball, you might see a new sign or a newly painted building. Spring rains might have flooded a stream in the forest. Suddenly, a familiar scene looks different to you.

An artist's first scribble is the start of a long journey. As young children, artists draw what they see around them. As they grow and change, their artwork changes. They meet people who make them think differently about what they see. They find new materials to work with. They explore new ideas and ask new questions. An artist's journey goes in many different directions.

In this part of this book, you'll learn about many artists and their journeys. You'll find out what they like and how they think. You'll read about people or places that have changed the way they work. And you'll meet artists who are storytellers or designers, artists who want to teach us, show us magic, or send us messages.

As you travel through these chapters, think about journeys you have taken. How have they changed you? How can you show those changes through your art? And how can the art around you help change the way you see?

Artists as Storytellers

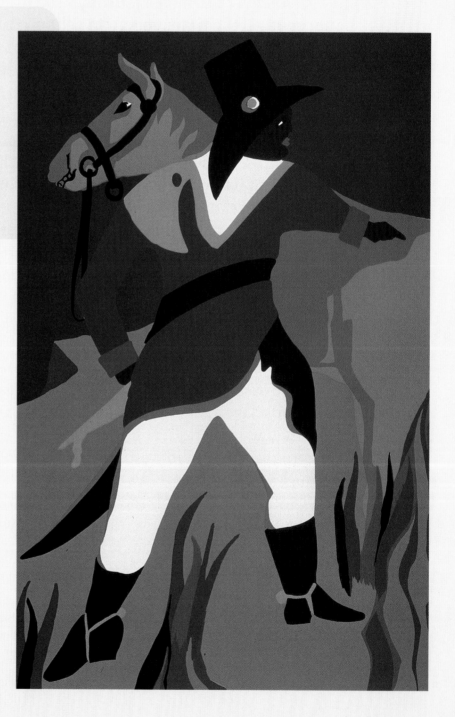

Fig. 1–1 **Toussaint L'Ouverture was a slave who led a revolt and founded the Republic of Haiti. Lawrence, in his first series, told the story of this hero.** Jacob Lawrence, *St. Marc (Toussaint L'Ouverture)*, 1994.
Screenprint, 32 1/4" x 22 1/3" (82 x 56.6 cm). Courtesy the Estate of Jacob Lawrence and the Francine Seders Gallery. Photo by Spike Mafford.

Focus

- Why are stories important in our lives?
- How do artists tell stories?

Think about a time when you couldn't wait to get to school to tell a friend about something that happened to you, perhaps just the night before. Remember how you included the important parts of the story, adding as much detail as possible? You probably shared your story more than once. Each time, you may have changed the way you told it—even just a little bit—to make it a more exciting story.

People have been sharing stories with their friends and family for thousands of years. The very young, the very old, and all those between, love to hear stories. Stories allow us to visit faraway lands, meet fascinating characters, and imagine the way people lived in the past. When a storyteller tells a tale, we follow the words and create pictures in our mind.

Some storytellers create the actual pictures for us. Artist Jacob Lawrence, whose work is shown in Fig. 1–1, is known for telling stories based on the lives of people who lived and worked in the past. In this chapter, you will learn about Jacob Lawrence and other artists who have discovered the power of images to continue the ancient art of storytelling.

Meet the Artists

Jacob Lawrence
Roger Shimomura
The Yemadje Family

Words to Know

series	guild
tapestry	bas-relief
narrative art	model
woodcut	shape
contour drawing	unity
gesture drawing	variety

Photo: Timothy Greenfield-Sanders.

Jacob Lawrence

An American Storyteller

Jacob Lawrence's Journey

Jacob Lawrence grew up during the Great Depression in Harlem, a neighborhood in New York City. As a teenager, he enrolled in after-school art classes. His teachers encouraged him to work hard as an artist.

Lawrence loved to visit the Metropolitan Museum of Art to see artworks from all over the world. He particularly liked the artworks that told stories.

The young artist spent many hours in the library. There, he read about the kingdoms of Africa and about heroic African Americans. He was always interested in people—what they cared about and what they accomplished. The more he learned, the more he wanted to find a way to tell the rest of us about their lives.

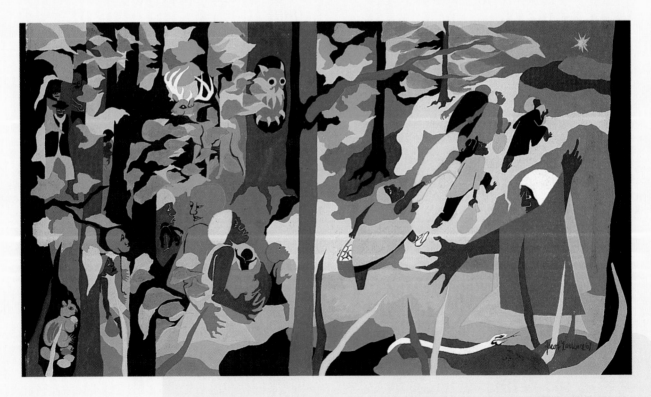

Fig. 1–2 **The artist created two series of images about the work of Harriet Tubman. Tubman escaped slavery but returned repeatedly to the South to help others escape to the North.**
Jacob Lawrence, *Through Forest, Through Rivers, Up Mountains*, 1967.
Tempera, gouache and pencil on paper, 15 11/16" x 26 7/8" (40 x 68 cm). Hirshhorn Museum and Sculpture Garden, Smithsonian Institution, The Joseph H. Hirshhorn Bequest, 1981. Photo: Lee Stalsworth.

Retelling History in Art

The challenge for any storyteller is to tell a story in such a way that an audience stays interested. Lawrence met this challenge by working with brightly colored paint to create pleasing shapes and patterns for the characters and settings in his paintings.

If a story had too many parts to tell in one image, Lawrence created a **series** of several paintings. The artworks on these pages—Figs. 1–2, 1–3, and 1–4—show you three examples from series he created. Before he began a series, Lawrence first had to decide how to attract his audience's attention. Then he decided what to show as the story continued, and how to bring it to an interesting end. The artist's paintings seem like little stages where action takes place, just as in a theater.

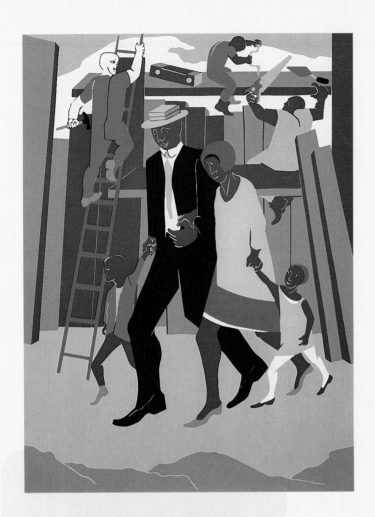

Fig. 1–3 **Lawrence's paintings are small, but the message is monumental. His message in the Builders series is that people can live and work together to build a better world.** Jacob Lawrence, *The Builders*, 1974.
Screenprint, 34" x 25 ¾" (86.4 x 65.4 cm). Courtesy the Estate of Jacob Lawrence and the Francine Seders Gallery. Photo by Spike Mafford.

Fig. 1–4 **In his Migration series, Lawrence told about a time when many African Americans moved from the rural South to the industrial North.** Jacob Lawrence, *The Migration of the Negro*, 1940–41.
Panel No. 1. Casein tempera on hardboard, 12" x 18" (30.5 x 45.7 cm). Acquired 1942, The Phillips Collection, Washington, DC.

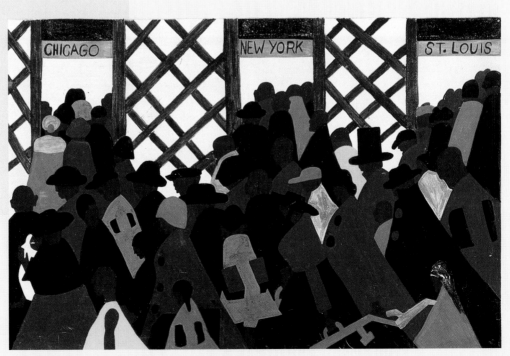

Stories for Different Purposes

When Jacob Lawrence told stories about things that really happened in the past, he was following an ancient storytelling tradition. Much of what we know about the past has come to us in the form of stories, often told by older members of our family or community. Artists have always created visual stories to tell about the past. Look at the artworks in Figs. 1–5 and 1–6. How can you discover more about the stories these artworks tell?

Another reason for storytelling in art is to communicate a special message. Some messages in art are meant to teach us how to behave or what to think. All over the world, stories with messages are carved in stone or painted on the walls of public buildings, where many people can see them.

Artists also tell stories for the simple purpose of delighting an audience. Such stories may be scary or funny tales of mystery or horror. They may take place in familiar settings or in places that exist only in our imagination. The characters in such stories might be people, or they might be animals or objects brought to life by the artist.

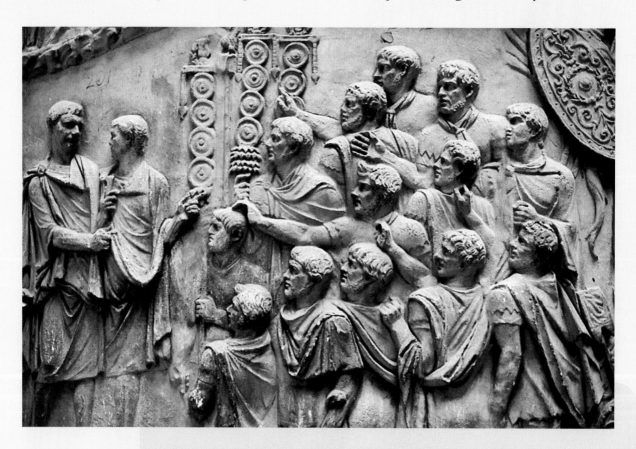

Fig. 1–5 **This is a close-up look at a large column that celebrated how the emperor Trajan led his Roman soldiers to victory in battle. What might be happening in this part of the story?** Apollodorus of Damascus, *Column of Trajan* (detail: Trajan addressing his troops), AD 113. Located in Rome, Italy. Marble, column height: 128' (39 m); each band: 36" (91 cm). Photo courtesy Davis Art Slides.

Stories in Many Forms

Artists use art forms such as drawing, printmaking, photography, and sculpture to tell stories. Artists who tell stories may do so in a series of images or in a single image. A single image may tell a complete story or show only one scene, leaving the viewer to imagine what happened before and what will occur after. Stories are told in visual form in movies, such as in Fig. 1–7, on television, and in magazines and newspapers. Look around your world for the many ways stories are told.

Fig. 1–6 **This small, detailed painting is called a miniature. Many miniature paintings told stories about the lives of emperors in the Persian empire.** Persian (Herat School), *A Court Scene from the "Chahar Maqaleh,"* c. 1431.
Ink, colors, and gold on paper. The Minneapolis Institute of Arts, Bequest of Margaret McMillan Weber in memory of her mother, Katherine Kittredge McMillan (51.37.30).

Fig. 1–7 **Movies are made of thousands of individual frames. What story can you imagine from looking at this frame?** *Still from the Warner Bros. Cartoon "Feed the Kitty,"* 1952.
Looney Tunes characters, names, and all related indicia are trademarks of Warner Bros. © 2001.

Picture a Story

Have you ever thought about using only pictures to tell a story? What about creating a visual fantasy story that tells about people and places from your imagination?

In this studio experience, you will paint a series of three pictures that tells a story. Think of a story that you want to tell in pictures. How will you show the beginning, middle, and end of your story? How will you create pictures that look as though they belong together? Think about how to make your picture story interesting to viewers.

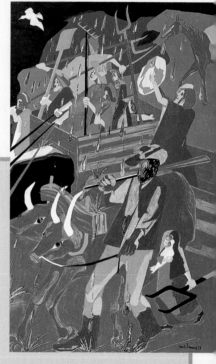

Studio Background

Plotting Pictures

When Jacob Lawrence decided to paint a series, he created the story's plot in pictures, sketching each scene with a pencil on sketch paper. After copying the sketches onto paper or board, Lawrence chose all the colors. He used one color at a time to paint the images. He painted the first color on all the boards. Then he added the second color, then the third, and so on, until he finished the images. By using many of the same colors in all the boards, he created a series of images that look as though they belong together. Lawrence used this system of working whenever he made a series of pictures.

Fig. 1–8 (top) **Notice the strong lines in this sketch.** Jacob Lawrence, *In the Iowa Territory* (sketch), 1973. Sketch for panel 2 from the *George Washington Bush* series. Ink on paper, 31 1/2" x 19 1/2" (80 x 49.5 cm).

Fig. 1–9 (bottom) **This image illustrates the artist's technique of painting a picture one color at a time.** Jacob Lawrence, *In the Iowa Territory* (unfinished), 1973. Casein gouache on paperboard, 31 1/2" x 19 1/2" (80 x 49.5 cm). Both images: Photo: Grace Carlsen. Courtesy the University of Washington Art Slide Library.

Fig. 1–10 **How is this finished artwork different from the sketch? How is it different from the unfinished painting?** Jacob Lawrence, *In the Iowa Territory*, panel 2 from the *George Washington Bush* series, 1973. Casein gouache on paperboard, 31 1/2" x 19 1/2" (80 x 49.5 cm). Washington State Historical Society, Tacoma. State Capital Museum Collection.

1. Decide what scene you will show for the beginning, middle, and end of your story. Create a pencil sketch of each scene on drawing paper. How can you use shapes to express your ideas? How can you make your sketches look as though they belong together?

2. Think about the mood you want to create in your series. Choose paint colors that best express that mood. Which colors are joyful? Which are serious? Will you use many colors or just a few? Remember: using many of the same colors in each scene will create unity in the series.

3. Carefully paint the shapes. Will you finish each scene before moving to the next? Or will you use Jacob Lawrence's system of adding colors one at a time to the whole series?

Check Your Work

Discuss your work with your classmates. Take turns describing the stories you see. Discuss how each artist used shape and color to tell a story. Do the pictures in each series look as though they belong together? Why? What makes each story interesting?

Lesson Review

Check Your Understanding
1. What kinds of stories did Jacob Lawrence tell in his artworks?
2. Name three different purposes that artists may have for creating storytelling artworks.
3. How might an artist tell a story in one image?
4. What is the importance of having a system for creating a storytelling series of images?

Fig. 1–11 **How did this artist create unity in her series?**
Heather Golding, *The Hill Town*, 2001.
Tempera, each panel: 9 ½" x 7" (24 x 18 cm). Thomas Prince School, Princeton, Massachusetts.

Narrative Art

1828–29
Kuniyoshi,
Tameijiro dan Shogo

1980
Shimomura,
Diary: Dec. 12, 1941

Middle Ages **19th-Century Japan** **20th Century**

11th century
Bayeux Tapestry

1963
Lichtenstein,
Whaam!

1985
Shimomura,
Untitled

Travels in Time

Throughout history, people have told stories with pictures. Long ago, people drew and painted stories on the walls of caves and tombs. They even carved stories in stone. In the Middle Ages, women used needles and thread to embroider a story on a very long piece of cloth (Fig. 1–12). The stitched cloth, called a **tapestry**, told the story of a great battle of their time. The battle scenes were arranged in a series of connected pictures, or frames. This method of linking scenes together led to popular ways of telling stories in the twentieth century: the newspaper comic strip and comic books.

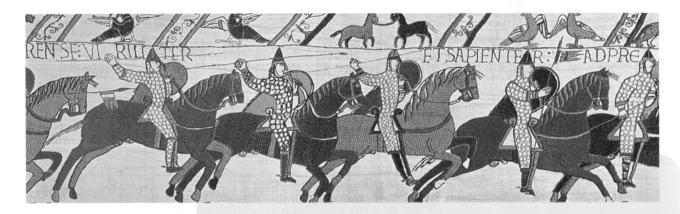

Fig. 1–12 **This is just one scene in the *Bayeux Tapestry*. Notice how the shapes were repeated and overlapped in an orderly way. Is this scene at the beginning, middle, or end of the battle? Why do you think so?** English, *Bayeux Tapestry* (detail: The Norman cavalry rushes into battle), 11th century.
Embroidered wool on linen, entire fabric: 20"x 230' (.51 x 70 m). Musée de la Tapisserie, Bayeux, France. Erich Lessing/Art Resource, New York.

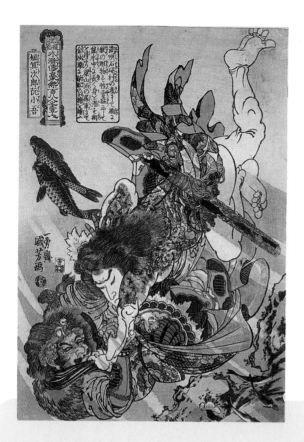

Stories of the Past and the Popular

Art that tells a story is called **narrative art**. These visual stories are a way to remain connected to the past. In the nineteenth century, the Japanese printmaker Kuniyoshi used the technique of **woodcut** to tell stories. Woodcuts are prints made by carving into a block of wood, inking the wood, and pressing paper against the wood.

The stories in Kuniyoshi's prints, such as the one shown in Fig. 1–13, were based on legends of great warriors. His images look like the superheroes of twentieth-century comic books. Kuniyoshi's popular woodcut prints were published both as illustrations in novels and as series.

In the twentieth century, American artist Roy Lichtenstein created a series of story-telling paintings based on the images and style of comic-book art (Fig. 1–14). His work is known as Pop Art, because it borrows from images that are widely popular. In what ways is his work *Whaam!* similar to and different from the cartoon characters shown in Fig. 1–7?

Fig. 1–13 **What is the largest shape in this artwork? Which figure is Tameijiro dan Shogo? Do you think he is the hero in the visual story?** Utagawa Kuniyoshi, *Tameijiro dan Shogo Grapples with His Enemy under Water,* 1828–29. Folio from *The Heroes of Suikoden.* Woodcut on paper. Private Collection. Courtesy Bridgeman Art Library.

Fig. 1–14 **This artwork is two separate paintings placed side by side. In the first frame, the pilot takes aim. What happens in the second frame? Note the shapes in each canvas. How would you describe the differences?** Roy Lichtenstein, *Whaam!* 1963. Acrylic and oil on two canvases, 67 1/2" x 158 1/4" (170.2 x 402 cm). Courtesy The Tate Gallery, London, England. © Tate London, 2001.

Personal Stories

"My interest in art started early. Art was always my first love, and my family and teachers reinforced that I was good in art. My grandmother kept my drawings from first through sixth grade."
Roger Shimomura (born 1939)

Photo by Robert Hickerson.

Artists sometimes tell stories that relate to their personal life. The stories may be based on their own experiences, on the lives of people or ancestors who are important to them, or on events from their time.

Contemporary artist Roger Shimomura is a second-generation American of Japanese descent. He created many of his paintings, prints, and performance-art pieces about events in his early life and about social and political issues affecting Japanese Americans. Several of his artworks, such as the work shown in Fig. 1–15, are narratives inspired by diaries his immigrant grandmother wrote during her lifetime.

Fig. 1–15 **What geometric shape is repeated in this scene? What does the woman seem to be doing?** Roger Shimomura, *Diary: Dec. 12, 1941,* 1980.
Acrylic on canvas, 50" x 60" (127 x 152.4 cm). Smithsonian American Art Museum, Washington, DC/Art Resource, New York.

Stories in a Personal Style

In elementary school, Shimomura made many drawings of comic-book characters, such as Donald Duck and Mickey Mouse. As a teenager, he collected comic books: Superman, Dick Tracy, and Wonder Woman were his favorites.

Shimomura has developed a style that is influenced by American comic books, Pop Art, and Japanese woodcut prints. His artwork *Untitled* (Fig. 1–16) is an example of his large, early canvases filled with the shapes of comic-book characters. Notice how he outlined the shapes of color in black. Shimomura's work shows not only the influence of such Pop artists as Roy Lichtenstein, but also the elegant lines and decorative details like those in Japanese woodcut prints.

Studio Connection

How could you make a collage that tells a personal story? One way might be to collect or draw pictures of things that really interest you. Your pictures might include your favorite food, clothing you like, people you admire, popular sports or television personalities, things that represent your cultural heritage, or something you do for fun.

Lesson Review

Check Your Understanding

1. What is narrative art?
2. How is the *Bayeux Tapestry* like a twentieth-century comic strip?
3. What kinds of art influenced Roger Shimomura's artistic style?
4. How are the artworks by Roger Shimomura and Roy Lichtenstein similar? How are they different?

Artists as Storytellers

79

Contour and Gesture Drawing

For hundreds of years, artists have relied on two basic approaches to drawing: contour drawing and gesture drawing. A **contour drawing** describes the shape of an object or figure. It also includes interior details. This kind of drawing is usually done slowly. A **gesture drawing** captures the movement or position of an object or figure. This kind of drawing is the opposite of contour drawing. It is done quickly, without any attention to details.

Contour Drawing

Creating contour drawings can help you develop your ability to observe and record the world around you. Continued practice will also improve your eye-hand coordination. You may use contour drawing to create a sketch for a print or painting or to create a finished drawing. A drawing tool with a sharp point—such as a pencil, marker, or ballpoint pen—is a good choice for a contour drawing.

Ask a classmate to sit in a relaxed pose for you. Make a contour drawing that captures the pose. As you work, keep the following ideas in mind:

- Draw slowly and carefully. As you work, imagine that your drawing tool is touching and slowly moving along each edge of your subject.
- Concentrate on the edges and interior details of your subject, such as pockets or buttons on a shirt.
- Keep your eyes on your subject. Look at your paper only when you begin to draw a new edge.

Fig. 1–17 **Notice how the artist incorporated her signature into the work.** Sarah Nixon, *Single Line Contour Drawing*, 2000. Pen, 6 1/2" x 9" (16.5 x 23 cm). Kamiakin Junior High School, Kirkland, Washington.

Fig. 1–18 **The artist chose to include only certain features of the subject. What features were left out?** Cheng Lor, *Untitled*, *Single Line Contour Drawing*, 2000. Pen, 7" x 9 1/2" (18 x 24 cm). Kamiakin Junior High School, Kirkland, Washington.

Fig. 1–19 **In gesture drawings, artists can "stop" a figure's action. What actions are taking place in these drawings?**
Drawings courtesy of Kaye Passmore.

Gesture Drawing

You can use gesture drawing as a way to quickly capture the main parts of a subject before something moves or changes. Most gesture drawings are thought of as sketches rather than as finished drawings. You may use them to help you plan a painting, sculpture, or print. Practice making gesture drawings by using a wide, soft pencil or the side of a crayon or piece of chalk.

Ask a classmate to strike and hold an action pose, such as jumping up to catch a ball or running. Make a gesture drawing that captures the movement of the pose. As you work, remember these points:

- Draw quickly. You can add details later, if you want.
- Take in the overall action of the scene and the position of your subject.
- Use large, swift strokes to help you capture shapes, angles, and positions.

Studio Connection

Design and create a comic strip that tells a simple story. The strip should include a sequence of three or four frames. You may ask classmates to pose for you or base your story on a scene from a television show or movie. Use contour drawings and gestures drawings, as appropriate, to help you plan each frame.

Lesson Review

Check Your Understanding

1. Define *contour drawing*. Name two subjects that would make good contour drawings.
2. In what type of situation would you want to use gesture drawing instead of contour drawing?

The Kingdom of Dahomey

Africa

AFRICA

Niger

Burkina Faso

Benin

Nigeria

Togo

• Abomey

• Porto-Novo

Places in Time

In the late 1600s, the Fon people of West Africa formed the kingdom of Dahomey, which thrived for over 200 years. Abomey was the kingdom's capital city. The region is now part of the Republic of Benin.

Stories in Memory of Kings

In Dahomey, the Fon royal court controlled the artists. Each artist belonged to a **guild**, a group of people in the same occupation. One Fon guild created life-size wood sculptures for the royal court, such as the one shown in Fig. 1–20. Another guild worked with metal. Still other guild artists decorated the palace walls with stories of historical events in bas-relief (Fig. 1–21). A **bas-relief** is a sculpture in which parts of the design stand out from the background.

The kingdom's most important arts were part of annual court ceremonies. People from every village came to see exhibits of the king's wealth and accomplishments. These displays were made even grander by the addition of colorful appliquéd tents, banners, umbrellas, and decorated hats made by the guild of royal tailors.

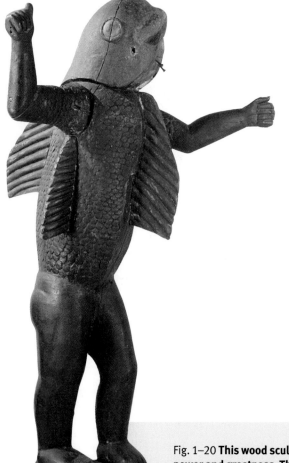

Fig. 1–20 **This wood sculpture relates to a story of a king's power and greatness. The sculpture was made by joining many different carved shapes. Which shapes were added?**
Africa, Benin, *Wooden Statue of Behanzin, King of Dahomey as the Figure of a Shark*, 19th century.
Wood, height: 5'2" (1.6 m). Collection, Musée de l'homme, Paris, France.

Storytelling Banners in Appliqué

Upon taking office, a king received a gift of imported cloth from his subjects. Royal tailors appliquéd the cloth with images that tell the stories of the king's power and great deeds. In the banner shown in Fig. 1–22, the lion represents one of the nineteenth-century kings of Dahomey. The tailors used templates to cut a variety of symbolic shapes. These were then hand-stitched to a background cloth.

In the more than 100 years since the French colonial powers brought an end to Dahomey, the art of appliqué has continued. The memory of the kings and their influence on Fon culture is still strong. However, French colonists persuaded some artists to tell stories other than those about the former Fon kings. As a result, stories about daily life, farming, and hunting are now part of the new subjects in appliquéd cloths being made in Abomey and other cities in Benin.

Fig. 1–21 **Bas-relief mud sculptures on the palace walls served as illustrations for storytellers who recited the history of the great kings of Dahomey. This relief symbolizes a call for unity by a king of Dahomey.** Africa, Benin, Abomey, *Earthen Relief #1*, after conservation in March 1996.
Musée Historique d'Abomey. Photograph: Susan Middleton. © The J. Paul Getty Trust.

Fig. 1–22 **The shapes in this banner were cut from patterns and sewn to a background. What story do you think this banner tells?** Africa, Benin, Fon kingdom, *Wall Hanging Representing* Da, *A Symbol of Property, in Human Form,* 19–20th centuries.
Appliquéd cloth, height: 86 5/8" (220 cm). © Musee de l'homme, Photo D. Ponsard. Musée de l'homme, Paris, France.

A Family of Storytellers

"We divide the work. One uses patterns to cut the shapes. Another does the tacking. Someone else does the final stitching. Then an apprentice attaches the border."
Yemadje family member

Joseph Yemadje and his family are descendants of the nineteenth-century Fon royal court artists. They continue the storytelling tradition in appliqué workshops in Abomey and other Benin cities. Although they still copy the old forms of royal symbols, the Yemadje artists combine some of the old images with new ones. However, for much of their work, they preserve a very pure form of appliqué by using traditional royal colors and symbols.

In creating appliquéd cloth, the Yemadje family of artists follow the basic Fon artistic principle of *nu ta do nu me*, which means "the highlighting of one thing by another." The artists highlight a background cloth with different colors of other cloth. Look at the banner in Fig. 1–23. What makes the shapes stand out against the background?

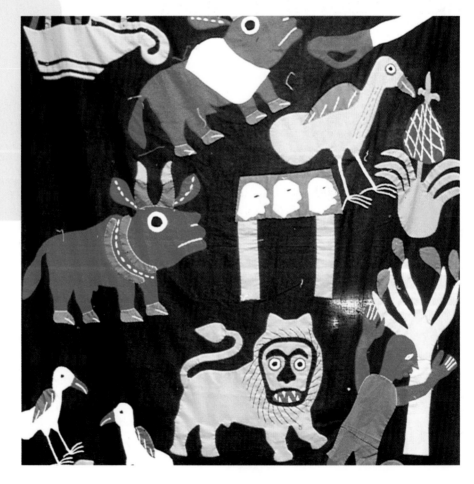

Fig. 1–23 **Compare this banner to the one shown on page 83. What differences do you see? How are the two banners alike?**
Africa, Benin, Abomey, *Fon Appliqué Cloth* (detail), c. 1971.
Photograph by Eliot Elisofon. Image no. H FON 10.1 (7021) Eliot Elisofon Photographic Archives, National Museum of African Art, Smithsonian Institution.

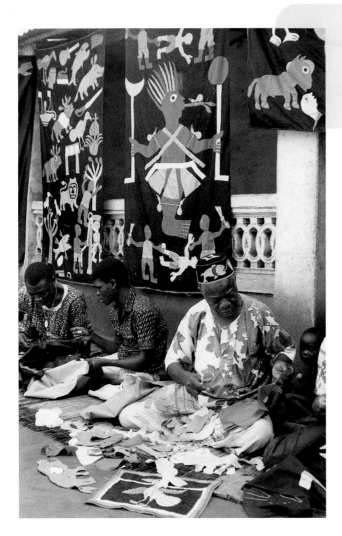

Fig. 1–24 **Family members divide the work when they create banners. Some banners are made with new and different shapes created upon request.** Benin, Abomey, *Fon Men Making Appliqué Cloth*, 1971.
Photograph by Eliot Elisofon, March 1971. Image no. H 2 FON 10.1 EE 71. Eliot Elisofon Photographic Archives, National Museum of African Art, Smithsonian Institution.

Studio Connection

Characters are a part of almost every story. In Fon stories, a king is often represented by an animal. The kings of Dahomey, who often identified themselves with wild animals because of their strength or wisdom, were represented by lions, elephants, sharks, and chameleons. What animal would you select to represent yourself in your life story? Choose an animal whose qualities you admire. Use the animal character to create a banner of part of your life story. If possible, use cloth, needle, and thread, and follow the traditional way of working with appliqué. You could also cut shapes from felt and then glue them to a background cloth, or you may make a cut-paper banner.

Creating Stories in Cloth

The artists also follow the Fon principle of spreading the cutout patterns over the surface of the background cloth. Several steps are involved. The story's characters and images are pinned to the background to hold them in position. This temporary placement allows changes to be made. When the artist is satisfied with the composition, the cut edges of each shape are turned under and then carefully hand-stitched to the background. Because the borders of the whole cloth frame the entire story, an artist makes decisions about the color and width of the bands of cloth. Look closely at Fig. 1–24 to see some of the steps artists take when creating a Fon banner.

Lesson Review

Check Your Understanding

1. Name two examples of the kinds of guilds in the kingdom of Dahomey.
2. In the region that was once Dahomey, how has the making of appliqué banners changed over the past 300 years?
3. What are the steps involved in making an appliqué?
4. How are the Dahomey banners similar to and different from the banners or flags that people hang from their homes or in the streets of your community today?

Artists as Storytellers

Sculpting a Scene

Story Under Construction

Studio Introduction

For a storytelling artwork, artists first decide which special moment of the story to show— a moment from the story's beginning, middle, or end. **In this studio experience, you will construct a scene that shows a special moment from a story.** Pages 88 and 89 will show you how to do it. How can you capture a moment and show it in a sculpture? First, decide what kind of story you want to show. Will you show a moment from a story that really happened?

Or will you show a moment from an imaginary story? Next, imagine stopping the action of the characters in that moment. What are they doing? How are they posed? What is the scene? Create simple sketches: they can guide the sculptural construction of your story.

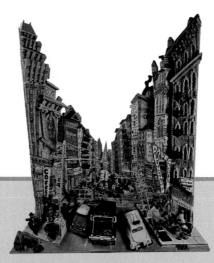

Fig. 1–25 **How do you think the mood and feeling of this setting would change if the shapes were straight and regular?** Red Grooms, *Looking along Broadway towards Grace Church*, 1981. Mixed media, height: 71" (180.3 cm). © The Cleveland Museum of Art, 2001, Gift of Agnes Gund in honor of Edward Henning, 1991.27. © 2001 Red Grooms/Artists Rights Society (ARS), New York.

Studio Background

Three-Dimensional Freeze Frame

Red Grooms and Viola Frey are two contemporary artists who have created storytelling sculptures. Although their stories are about everyday life, each artist's journey through telling the story has been different.

In his stories, Red Grooms emphasizes setting (Fig. 1–25). He often uses cardboard, wood, and foamcore to build his scenes. He is best known for constructing exaggerated environments—from city streets to subway cars—that viewers can actually walk through. Viola Frey focuses on characters and creates life-size clay figures (Fig. 1–26). Her work is influenced by the Japanese porcelain figurines she played with as a child.

Each artist's works seem frozen in time and thereby excite the viewer's imagination. You might imagine that, if you flipped a switch, everything would start moving and the story would go on.

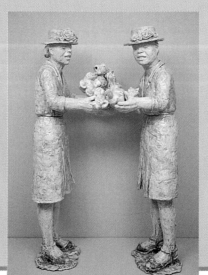

Fig. 1–26 **If these sculpted figures were characters in a play or movie, what might they be saying to each other?** Viola Frey, *Double Grandmother*, 1978–79. Glazed white clay, height: 61 1/6" (156 cm). The Minneapolis Institute of Arts, Gift of the Regis Corporation (81.29.1,2).

Fig. 1–27 **How has this student created unity and variety in his sculpture?** Michael Giancoli, *Snowboarding*, 2001. Clay figure with glaze, cut-paper and cardboard setting, 12" x 12" x 8" (30.5 x 30.5 x 20 cm). Colony Middle School, Palmer, Alaska.

Fig. 1–28 **What modeling techniques do you think this artist used?** Emily Dougherty, *Volley Ball*, 2001. Clay figure with glaze, cut-paper and cardboard setting, 12" x 8" x 17" (30.5 x 20 x 43 cm). Colony Middle School, Palmer, Alaska.

Constructing Your Scene

You Will Need

- prepared cardboard box
- colored construction paper
- cardboard scraps
- scissors
- white glue
- clay
- tools for creating surface textures

Try This

1. Start by creating your background scene with the box and construction paper. Will you create an indoor scene or an outdoor one? How can you use shapes and forms to create background details? Think of ways to cut, fold, curl, or crumple construction paper to make colorful shapes and forms. Carefully glue the details to the sides and floor of the box.

2. Make your characters out of a ball of clay. Create a five-point star by pulling out a point for the head, each arm, and each leg.

3. Model, or shape, the head and limbs by pinching and pulling the points. As you work, think about the pose you want each character to have. Do any of your figures have to be bent or twisted at the waist? Do arms or legs have to be bent to create the desired pose?

4. Add details, such as facial features, hair, and clothing patterns. Will you carefully press tiny coils, balls, or other bits of clay onto the figures? Or will you create details by pressing textures onto the surfaces?

5. When your characters are finished, decide whether you would like to create props for your scene. Does your indoor scene need simple furniture? Does your outdoor scene need trees or cars that aren't part of the background? Do your characters need to hold special objects, such as a broom or a baseball bat? Make props from scraps of cardboard or construction paper.

6. Add whatever props are necessary to the characters. Then place the characters in the scene.

Check Your Work

Discuss your completed sculpture with your classmates. What part of your story does your artwork tell? Ask your classmates what they think happened before and after this scene. How did you use shapes and forms in your artwork?

Computer Option

Use your constructed scene and clay characters to produce a short animation sequence. You can capture simple motions and actions by taking a series of still pictures, so that a character appears slightly different in each frame. You may use any digital camera or stop-action video. Set up the scene and then gradually—one tiny movement at a time—capture the movements or actions of your character. Import the images into a multimedia software program to create a digital clip of your characters acting within the environment you have created. Finish your animation by adding title, credits, and sound effects.

Fig. 1–29 **What story comes to mind when you look at this sculpture? Is this artist showing the beginning, middle, or end of the story?** Krystina Hagen, *Hobo Frighte*, 2001. Clay figure with glaze, cut-paper and cardboard setting, 12" x 12" x 18" (30.5 x 30.5 x 46 cm). Colony Middle School, Palmer, Alaska.

Shape, Unity, and Variety

A line that surrounds a space or color in a drawing, painting, or other two-dimensional artwork creates a **shape**. Some shapes are *geometric*, such as a circle, square, or triangle. Leaves, seashells, or other objects found in

Geometric Organic

Positive Negative

nature have *organic shapes*. Organic shapes are irregular and often have curves. The shapes you notice first in an artwork are *positive shapes*. The area surrounding the positive shapes creates the *negative shapes*.

Artists can use shape and other design elements to create unity and variety in an artwork. **Unity** is the feeling

that all parts of an artwork belong together. One way artists create unity is by repeating a shape, color, or other element. They can also use a dominant shape, color, or other element to unify the work. Similar colors, textures, or materials in an artwork also help create unity.

Variety adds visual excitement to an artwork. Artists create variety by including

shapes or other elements that contrast. Most artists combine unity and variety. Say, for example, you see a painting that shows circles and squares repeated throughout the canvas. The repetition of shapes creates unity. But the different sizes and colors of the shapes create variety.

Artists as Storytellers

89

Connect to...

Careers

Have you ever seen a painting that told a story? Did it make you want to know more about the artist? The old cliché "a picture is worth a thousand words" is especially true in narrative paintings that have realistic images. **Painters** develop their own individual style and may use different media and materials, such as oil, acrylic, or water-based paints. They may paint on canvas, paper, or wood. Many painters receive master of fine arts degree from a college, university, or art school; others are self-taught. Some contemporary painters focus on nonobjective works, whereas others produce narrative art—art that tells a story.

Fig. 1–30 **This artist is known for creating narrative artworks based on the lives of people he knew. What story does this painting tell?** Romare Bearden, *Serenade*, 1941.
Gouache/casein on Kraft paper, 30" x 47" (78 x 119 cm). © Grant Hill/Licensed by Grant Hill.

Other Arts

Theater

Theater is an excellent way to experience the art of storytelling. The theater offers stories played out by live actors. Many cultures have developed unique forms of theater. In Japan, for example, the traditional dance-drama called *kabuki* has delighted audiences since about 1600. Kabuki performers act out dramatic stories of historical events and every-day life in an exaggerated style. Spectacular scenery, color costumes, and a large orchestra enhance the sensational tales.

Fig. 1–31 **In traditional Kabuki theater, female roles are played by men. The male actors who play female characters are called *onnagata*.** Utagawa Kunisada, *Scene from a Kabuki Play*, c. 1842.
Published by Yamatoya Heikichi (Eikudo). Color woodblock print. Museum Collections, the Bayly Art Museum, University of Virginia.

Fig. 1–32 **Each panel in this quilt tells a story from the Christian Bible. Why is appliqué a useful technique for telling stories in cloth?** Harriet Powers, *Bible Quilt*, c. 1886. Pieced and appliqued, plain and roller-printed cotton, 75" x 89 3/8" (191 x 227 cm). Smithsonian Museum of American History, Gift of Mr. and Mrs. H. M. Heckman.

Social Studies

As cultural traditions pass through time, they may stay the same, adopt or adapt new characteristics, or undergo transformation into completely new forms. **The traditions of storytelling often appear in artifacts and artworks.** For example, Fon tailors in West Africa made appliquéd banners about events in the history and daily life of their kingdom of Dahomey. The Fon techniques of using appliquéd designs to illustrate a story are closely related to similar practices in the United States. Harriet Powers, an African American woman born a slave in 1837, made story quilts that closely resemble Fon traditions. As in the Fon banners, Powers used large, simple cutouts of people and animals. Her quilts also recall the Fon techniques of contrasting foreground and background colors, balanced placement of figures across the background, and the addition of borders.

Language Arts

Do you have a favorite book that tells a story? Do you prefer a storybook with illustrations, or would you rather visualize mental images on your own? **Reading stories is one way people develop an understanding of others.** Stories allow us to share the thoughts, feelings, hopes, and fears of others. Storytellers are respected in many communities because they preserve and pass on tales about real or imagined events in the past. If you were an author, what story would you tell? Would you want your story to have illustrations?

Daily Life

What stories do you come across throughout your day? You encounter different kinds of stories when you listen to the radio, pay attention in class, talk to your friends, read a book or magazine, watch television, surf the Internet, or go to a movie. Think of the stories you hear and the stories you tell in just one day. Are they more fiction than fact? Are you more likely to *tell* or *hear* stories?

Internet Connection
For more activities related to this chapter, go to the Davis Website at **www.davis-art.com**.

Portfolio

"I got my idea from looking through animal picture books. I decided to make the book larger than life, and I had the animals come to life off the page." **Rosie Perkins**

Fig. 1–33 **This artwork tells a story in more ways than one. Both words and pictures are used in the design.** Rosie Perkins, *The Magical Book*, 2001.
Magazine cutouts, construction paper, typed narrative, tempera paint, marker, handprinted paper, 12 3/4" x 19 3/4" (32 x 50 cm). Fred C. Wescott Junior High School, Westbrook, Maine.

"After my house burnt down I felt sad, but I knew we were going to start building right away. Everything would be fine again. It's just going to take time. I wanted to do something with a fire and my new house being built by a staple gun."
Zachary Wilson

Fig. 1–34 **How does the outline of a staple gun change the focus of the story told in this picture?** Zachary Wilson, *The Powerful Tool*, 2001.
Tempera, 17 3/4" x 23" (45 x 58.5 cm). Victor School, Victor, Montana.

"I wanted to tell a story about a dog. I was thinking about my dog. His name is Pepper. I wanted to make a place in my art where Pepper could run and play without getting hurt by chasing cars." **Michael Whatley**

Fig. 1–34 **One thing that makes this collage exceptional is its size—it is five feet tall. Artwork like this can also be made from cut pieces of fabric and hung as a banner.** Michael Whatley, *Dog in the Country*, 2001.
Cut paper, 5' x 3' (16.4 x 9.8 m). Fletcher-Johnson Educational Center, Washington, DC.

CD-ROM Connection
To see more student art, view the Personal Journey Student Gallery.

Chapter 1 Review

Recall

Define narrative art.

Understand

Explain why stories are important to people.

Apply

Give at least three examples of visual stories in your everyday life.

Analyze

Consider the Fon banner shown below. Discuss how the artist used shapes to hold the interest of the viewer.

Page 84

Synthesize

Create a list of "Things to Think About" for someone who wants to tell a story with images, but no words.

Evaluate

Focus on one aspect of a story—either character, situation, or setting. Find an artwork in this chapter in which the artist showed this aspect in an especially interesting way. Give reasons for your selection.

For Your Portfolio

You can use your portfolio to keep track of your personal journey in art by keeping your artworks, essays, and other art-related work in it. Write one statement about what you wanted to say in an artwork that you made in this chapter. Write another statement that explains what you learned.

For Your Sketchbook

Your sketchbook is a good place to explore new ideas about art. For this chapter, explore different ways to tell stories with shapes, colors, and lines.

2 Artists as Recorders

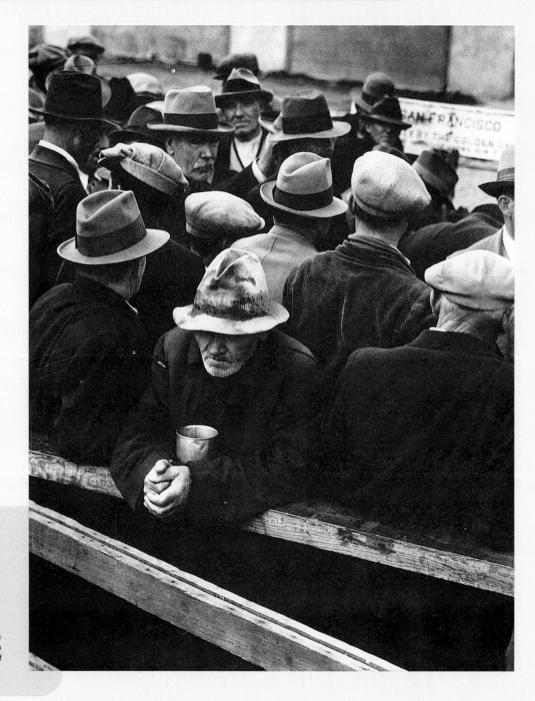

Fig. 2–1 **How did the artist use lights and darks to direct the viewer's attention?** Dorothea Lange, *White Angel Breadline, San Francisco*, 1933. Gelatin silver print. © The Dorothea Lange Collection, Oakland Museum of California. City of Oakland. Gift of Paul S. Taylor.

- Why are the events of daily life important to people?
- How do artists record the details of our daily lives?

Many people worldwide keep diaries to track the events of their day-to-day life. Historians may use diaries to learn how people lived and what they thought about in the past. When individuals write in their diary, they do not usually think that someone in the future will use what they've written. They don't think of themselves as recorders of their time.

Artworks, like diaries, also can tell us about times gone by. We can look at artworks for clues about how people lived and what they cared about. Although all artists don't create their artworks to be historical records, some are especially interested in documenting the people and events of their time.

Dorothea Lange used photography as a way to record what she saw in the world around her. She is known for her photographs of people who faced hardships in their daily life, like the unemployed men waiting in line for a free meal (Fig. 2–1). In this chapter, you will learn more about Dorothea Lange and other artists who have recorded the way we live.

Meet the Artists

Dorothea Lange
Whitfield Lovell
Inatace Alphonse

Words to Know

crop	tonal drawing
genre scene	still life
Harlem	value
Renaissance	contrast
installation	

Dorothea Lange

Recorder of Daily Life

> "You put your camera around your neck along with putting on your shoes, and there it is, an appendage of the body that shares your life with you. The camera is an instrument that teaches people how to see without a camera."
> Dorothea Lange (1895–1965)

Dorothea Lange's Journey

As a teenager, Dorothea Lange decided to be a photographer. She learned her craft as a helper in portrait-photography studios in New York. Eventually, she set out on a journey to see the world, selling her photographs along the way. When she ran out of money, she found a job and later opened her own studio in San Francisco. However, after several years, Lange realized that she was no longer interested in photographing people who posed for their portrait. She was much more concerned with recording the people she saw on the streets. Many of these people were homeless and out of work.

Fig. 2–2 **During the depression, families lived as best as they could while they traveled throughout the country looking for work. The families shown here lived beneath a giant billboard. Why did Lange photograph the families from a distance?** Dorothea Lange, *Three Families, Fourteen Children on U.S. 99, San Joaquin Valley, California*, 1938. Gelatin silver print, 9 5/8" x 7 1/2" (24.5 x 19.1 cm). The St. Louis Art Museum. Purchase: Museum Shop Fund, 148:1987.

Fig. 2–3 **Where do we usually find things with tags on them? Why do you think the artist chose to take this picture?** Dorothea Lange, *Tagged Girl, Oakland*, 1942. Gelatin silver print. From the National Archive and Records Administration, taken for the War Relocation Authority. The Oakland (CA) Public Library.

Recording the Human Spirit

Lange had much compassion for the people she recorded in her photographs. She used photography to document those whose lives were changed because of the Great Depression and a drought. Many were forced to move around the country in search of work. In such photographs as *Three Families, Fourteen Children* (Fig. 2–2), Lange helped show the government the urgent need to help Americans in distress. When World War II began, Lange photo-graphed the Japanese Americans who were sent to live in camps until the end of the war (Fig. 2–3).

Throughout her life, Lange carefully observed people alone and with others. She watched them as they rested or moved about. She noticed little things, like their gestures or the way they held their head. She saw not only how they looked, but also how they felt. And she used her camera to record these feelings for the rest of us to see.

Records in Many Forms

Dorothea Lange recorded life with a camera. Since its invention, over 150 years ago, the camera has provided us with photographic images of our world. In newspapers, magazines, and television, we see visual records of our life as we live it day to day.

Artists living today and in the past, working with materials ranging from paint to stone, have documented the way we live. We can look at artworks for clues about how people dressed for different occasions, what games they played, what work they did, and even what they liked to eat.

Fig. 2–4 **This newsstand in Mexico City, like newsstands worldwide, displays magazines and newspapers filled with photographic records of daily-life events. In magazines that you enjoy, look for images of people working and playing.**
Photo courtesy Eldon Katter.

Fig. 2–5 **Ben Shahn is noted for his paintings and prints of events from his time. What does this image tell about the way people lived?** Ben Shahn, *Handball*, 1939.
Tempera on paper over composition board, 22 ³/₄" x 31 ¹/₄" (57.8 x 79.4 cm). The Museum of Modern Art, New York. Abby Aldrich Rockefeller Fund. Photograph © 2001 The Museum of Modern Art, New York. © Estate of Ben Shahn/ Licensed by VAGA, New York, NY.

Selecting What to Show

All artists must select what they want to record. Some artists focus on special events or important people. Others show ordinary people doing ordinary things, such as young men playing handball in Ben Shahn's artwork (Fig. 2–5). But how do artists who work without a camera remember what they have seen? Some artists train themselves to observe carefully. They keep the scene in their "mind's eye" and then later record what they remember. Other artists make quick sketches on the spot; later, they select what to feature in their final artwork.

After selecting a subject, an artist must decide how to show it. As Dorothea Lange did, an artist may choose to record close-up views of just a few people or views of a faraway crowd. Settings are also important. The addition of buildings, scenery, or objects helps put people and events into a recognizable world. To highlight certain features or draw attention to certain parts of an artwork, the artist can create contrast by experimenting with light and dark.

Fig. 2–6 **What does this image, created in the 1400s, tell us about the way some people lived?** Limbourg Brothers, *Les Très Riches Heures du Duc de Berry* (detail), 15th century. Manuscript (Ms. 65/1284, fol.7v), approx. 8 1/2" x 5 1/2" (21.6 x 14 cm). Musée Condé, Chantilly, France. Giraudon/Art Resource, New York.

Recording Daily Life

Dorothea Lange said that she lived a "visual life." As she went about her daily routine, she paid attention to what she saw happening around her. What do you see happening when you go out into the world each day?

In this studio experience, you will create a drawing that records a moment from daily life around you. When you leave your home, look around. Notice people's activities, gestures, and body positions. Be aware of settings—the objects, buildings, or scenery surrounding the people. Think of ways to show these details in your drawing.

You Will Need

- sketch paper
- pencil
- eraser
- drawing paper

1. Make several sketches of your subject. Will you show many details or focus on the overall shapes and forms?

2. Decide whether you want to show your subject up close or from a distance. Experiment with ways to refine your sketches. Try using strips of paper to frame, or **crop**, them. Cropping to the outside edges of a sketch can give you a distance view. Cropping to a smaller part of a sketch can give you a close-up view.

3. Look at all of your sketches and cropping ideas before selecting an image for your final drawing. As you work on your drawing, pay particular attention to *value*—light areas and dark areas. Where will you place shadows? Where will you place highlights?

Studio Background

Dorothea Lange almost always had her camera with her, but she didn't photograph everything she saw. Known for her "compassionate eye," she carefully observed the world and selected scenes that she thought were important to record. She often shot more than one photograph of a scene. She sometimes stood back and shot from a distance, and then moved in for closer views. In the darkroom, she refined, or improved, the photographs she selected. To do this, she often cropped the images to eliminate some parts and emphasize others.

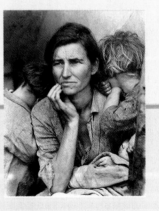

Fig. 2–7 **When Lange came upon this family, the strong and determined mother had just sold her car tires to buy food. The artist took six photographs, moving closer for each image.** Dorothea Lange, *Migrant Mother, Nipomo, California*, 1936.
Gelatin silver print. Reproduced from the Collections of the Library of Congress.

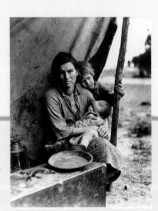

Fig. 2–8 **This photograph is one of the six that Lange took of this family. Why may viewers think this photograph is less dramatic than *Migrant Mother*?** Dorothea Lange, *Migrant Agricultural Workers Family*, 1936.
Gelatin silver print. Reproduced from the Collections of the Library of Congress.

Note how contrast, or big differences in value, can help direct the viewer to what you wish to give special attention in the drawing. Fill the page with your drawing.

Check Your Work

Share your finished drawing, along with your original sketches, with a group of classmates. Take turns telling why you chose to refine the particular sketch with which you worked. Talk about your subject-matter decisions. Make sure to tell about your decisions to include some parts or exclude others. Invite your classmates to share their ideas about your artwork.

Lesson Review

Check Your Understanding

1. During what great event in American history did Dorothea Lange make many of her photographs?

2. Select an artwork in this lesson, and describe how the artist recorded the way people lived in the past and what they cared about.

3. What kinds of selections must a photographer make before completing an artwork?

4. If you wanted to make artworks that record the way people live their daily life, would you choose to be a painter or a photographer? What are the advantages and disadvantages of each?

Fig. 2–9 **This student artist shows the unique view of sitting on the school bus. She commented, "The most difficult part . . . was making the view outside the window in the correct proportion. The houses . . . were so small, it seemed like the bus was 50 feet tall!" Notice how the highlight areas are closest to the windows.** Anna Boch, *A Backseat View*, 2001. Pencil, 8 1/2" x 11" (21.5 x 28 cm). Northview Middle School, Indianapolis, Indiana.

Documenting Daily Life

1838
First permanent
photographic image

1992
Weems,
Untitled

17th-Century Holland

20th Century

1662–65
Metsu,
Letter Reader

1915
VanDerZee,
Miss Suzie Porter

1999
Lovell, *Whispers
from the Walls*

Travels in Time

We can learn a lot about the way people live, work, and play just by looking at art-works. Throughout history, artists have recorded the daily-life activities of the people around them. Art historians call such artworks **genre scenes**. From artworks, we know about work in ancient Egypt and games in ancient Greece. We also have some idea of what the interior of people's homes looked like in seventeenth-century Holland (Fig. 2–10). For some twentieth- and twenty-first-century artists, photography has been a way of recording daily life.

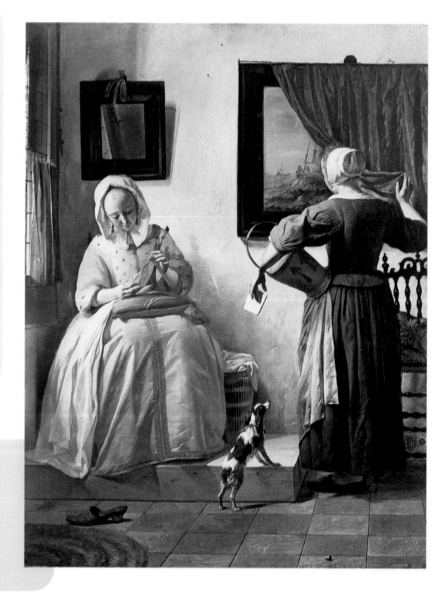

Fig. 2–10 **What makes this painting a genre scene? Does it give you an idea about what homes were like in seventeenth-century Holland?**
Gabriel Metsu, *The Letter Reader*, 1662–65.
Oil on panel, 20 1/2" x 16" (52.07 x 40.6 cm). Reproduced courtesy of the National Gallery of Ireland.

Recording Urban Life

In the first half of the twentieth century, New York artist James VanDerZee looked at urban African American culture through the lens of a camera. His black-and-white photographs display a wide range of values, from dark to light (Fig. 2–11). VanDerZee's work records life in New York City during the 1920s and 1930s. This era is called the **Harlem Renaissance**, a renewal of the creative and intellectual contributions of African Americans.

Contemporary artist Carrie Mae Weems uses the camera to make documents, or records, of human situations. Since the 1970s, Weems has been using her camera to document the activities of political groups, families, and people on the street. She examines issues related to African American culture. She sometimes photographs objects, without people, to document an idea about culture. Her use of strong contrast between dark and light areas makes her images sharp and clear. Note the range of values in her photograph in Fig. 2–12. How does this photograph give you a sense of daily life?

"I enjoyed the fact that my father and I shared the trait of being particular about visual things."
Whitfield Lovell (born 1959)

Whitfield Lovell is another artist who documents African American life. He creates records of daily life by constructing life-size environments. These stagelike settings are called **installations**. Two views of his installation *Whispers from the Walls* are shown in Figs. 2–13 and 2–14. Artists create installations with real objects in a section of a museum or gallery. Installations are usually temporary, which means they do not remain in one place for very long. A photograph of the installation becomes the permanent record of the artist's creation.

Records of the Past

Unlike James VanDerZee, who looked at city life, Lovell documents the rural life of the past. He uses old photographs of people as inspiration for his charcoal drawings in his installations.

Lovell's interest in photographs began at an early age. He learned about photography from his father, an amateur photographer. From his father, he also learned to pay attention to the way shapes, values, and colors work together. Study Lovell's use of value in Fig. 2–13. His control of the dark and light values makes the people in his drawings seem like ghosts coming through the walls. He also uses carefully placed spotlights to create contrast between highlights and shadows.

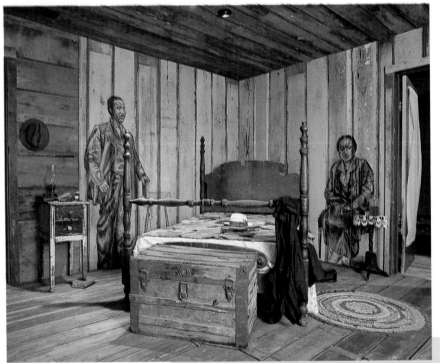

Fig. 2–13 **What catches your eye in this bedroom scene? How does the contrast between the hat and the bedcover compare with that in the photograph by Carrie Mae Weems on page 103?** Whitfield Lovell, *Whispers from the Walls* (bedroom installation view), 1999.
Photo by Steve Dennie/University of North Texas Press. Courtesy DC Moore Gallery, New York.

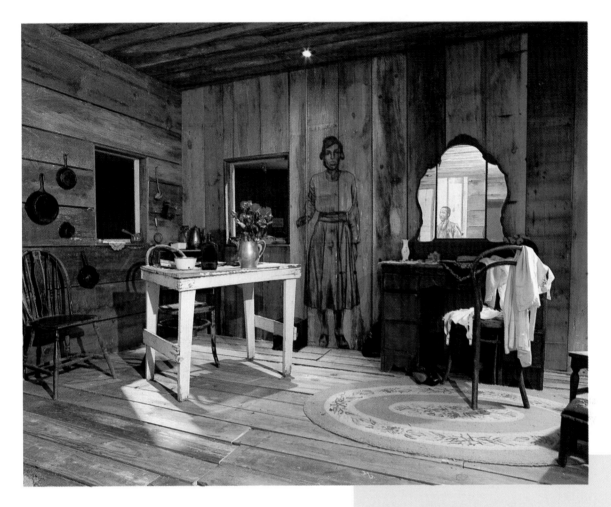

Fig. 2–14 **The artist installed this scene in a museum gallery. Why might he have been interested in controlling the lighting to create highlights and shadows?** Whitfield Lovell, *Whispers from the Walls* (table and vanity installation view), 1999.
Photo by Steve Dennie/University of North Texas Press. Courtesy DC Moore Gallery, New York.

Lovell forms his scenes with objects collected from flea markets. Being selective and collecting visual things is important to the way Whitfield Lovell works. Examining the past is also important to him. The old photographs and objects he collects for his artworks are records of daily life of people in the past.

Studio Connection

What kinds of activities are part of daily life in your home or community? For a series of pencil drawings that record daily life, what people and objects will you include? Can you find photographs of people to uses? If not, you may use pictures from magazines or newspapers. Will you make drawings from the pictures you collected? What kind of background setting will you draw? You may choose to cut out and arrange the drawings into a setting that you draw on a separate sheet of paper.

Lesson Review

Check Your Understanding

1. What are genre scenes? What are installations?
2. What and when was the Harlem Renaissance?
3. How is the work of Whitfield Lovell similar to and different from the artwork of James VanDerZee, Carrie Mae Weems, and the genre scenes painted in seventeenth-century Holland?
4. Why is photography a good way to document daily life?

Tonal Drawing and Shading

Tonal drawing is a method that artists use to create the illusion of three-dimensional form on a flat surface. They use value, or various tones of color, to create the illusion. In a black-and-white drawing, for example, black is the darkest value, and white is the lightest value. There are many values of gray between black and white. The principles of value also apply to a color drawing. Every imaginable color has a darkest value, a lightest value, and a range of values between.

Shading is a gradual change in value. Where an artist places values in an artwork is determined by the actual or suggested source of light. Shading, highlights, shadows, and cast shadows are clues to the location of the light source.

Fig. 2–15 **This value scale shows a range of values for purple. See also the gray scale on page 115.**

Fig. 2–16 **The highlight areas in this drawing suggest that the light source is on the right.**

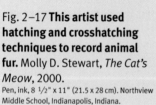

Fig. 2–17 **This artist used hatching and crosshatching techniques to record animal fur.** Molly D. Stewart, *The Cat's Meow*, 2000.
Pen, ink, 8 ¹/₂" x 11" (21.5 x 28 cm). Northview Middle School, Indianapolis, Indiana.

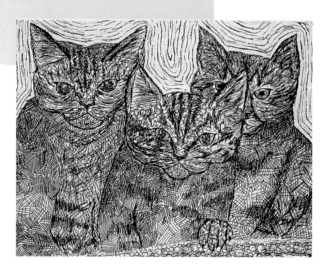

Tonal Drawing Techniques

Tonal drawing techniques, such as linear hatching, stippling, and blending and smudging, allow artists to create gradual changes between light and dark areas. Some techniques work better with some drawing materials than others, so it's important to practice various techniques when using various drawing materials.

Linear Hatching

You can use fine-tipped drawing tools, such as pencils, markers, and pen and ink, to practice linear hatching techniques. Hatched lines go in one direction and usually follow an edge or contour of the object that the artist is drawing. The lines are parallel to one another.

hatching

If placed close together, they create a dark area. If placed farther apart, they create a lighter area.

Crosshatched lines go in two different directions. When crosshatching, an artist begins by creating hatched lines. Then the artist crosses them with another set of lines. Look at the illustrations in this lesson, and practice using both linear hatching techniques to draw an object. Do you prefer one technique over the other? Why?

cross-hatching

Stippling

A stipple drawing is made of tiny dots. The closer the dots, the darker the tone. To prac- tice stipple, use a fine tipped drawing tool. Begin with wide spaces between the dots. Then gradually add more dots. Now use the stipple technique to practice drawing an object.

stippling

Blending and Smudging

To practice blending and smudging techniques, switch to a soft drawing tool, such as a soft lead pencil, charcoal, or colored chalk. Using one tool at a time, create an area of color on drawing paper.

Smudge or blend the area with your fingers, a tissue, or a cotton swab. Work from dark to light to show a

smudging

gradual change in value. Then choose one of the tools and create a practice drawing of an object. Try using an eraser to remove smudges and to create highlights.

Studio Connection

Create a still-life arrangement of your favorite snack foods. Draw the arrangement by using any one of the techniques described in this lesson. Choose the appropriate drawing tools for creating the tonal areas and illusion of three-dimensional form that are characteristic of the technique you selected. Do not worry about the details of package labels. Concentrate just on creating tonal areas. Try to achieve a full range of value in your drawing.

Lesson Review

Check Your Understanding

1. What drawing tools are most suitable for blending and smudging techniques? For hatching and stippling?
2. Which type of drawing do you think needs to be carefully protected from damage by an accidental swipe of the hand?

Fig. 2–18 **How does the effect created by stippling compare to the effect created by hatching and crosshatching?** Christopher Berger, *"Who You Lookin' At?"*, 2000.
Marker, 9" x 11 ½" (23 x 29 cm). Penn View Christian School, Souderton, Pennsylvania.

Art of Haiti

Haiti

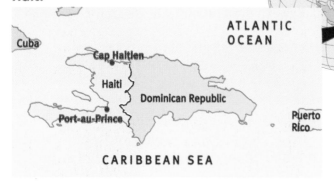

Paintings as Records

Throughout much of Haiti's history, the people who worked in the fields did not have an opportunity to learn to read and write. If people do not have a history of reading and writing, making pictures is a way to keep records of daily life. This may explain why Haiti has been called a "nation of painters." Farmers paint. Cooks paint. Plumbers and mechanics paint. Painting, like any other

Places in Time

Haiti is a small country in the Caribbean's West Indies. It covers the western third of the island of Hispaniola. Christopher Columbus started a Spanish colony there in 1492, but most of Haiti's people are descendants of Africans brought to the island as slaves in the sixteenth century. Haiti became a rich French colony but has been independent since 1804. Today, most of the people are farmers who grow such crops as coffee, corn, sugar cane, and sisal.

work, is an important part of daily life. Sometimes, Haitian painters must choose between buying paint or buying bread.

Fig. 2–19 **What does this picture show about daily life in a Haitian home?**
Louverture Poisson, *The Lesson*, c. 1946–47.
Oil on masonite, 14 5/8" x 20 1/4" (37 x 51.4 cm). Milwaukee Art Museum, Gift of Mr. and Mrs. Richard B. Flagg (M1979.229).

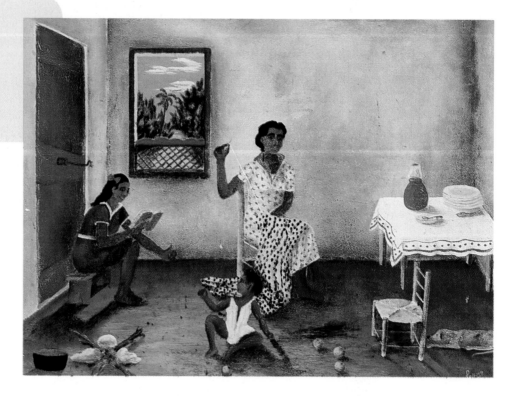

108

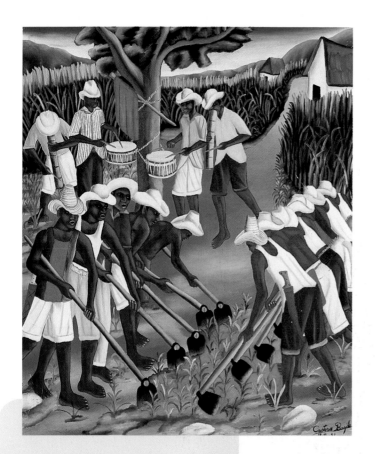

Visual Histories

Haitian painters, most of whom are self-taught, are faithful recorders of events as they unfold. They look at the activity around them and fill their canvases with scenes of everyday life. Because their paintings are about what people have in common, the works speak to all the people.

Some painters use both humor and sadness to recreate the visual histories of faces and events. Generally, the paintings are portraits of people and families. Other paintings show farming and work, celebrations and carnivals, and crowded markets. Look at the daily-life activities shown in Figs. 2–19, 2–20, and 2–21. How did each artist show what life is like in Haiti?

Fig. 2–20 **Coumbite is Haitian Creole for "communal activity." How did the artist place light and dark areas to give you a feeling of rhythmic movement? What else did the artist do to create a sense of rhythm and movement?** Castera Bazile, *Coumbite Communal Fieldwork*, 1953.
Oil on masonite, 24" x 19 ¼" (61 x 49 cm). Milwaukee Art Museum, Gift of Mr. and Mrs. Richard B. Flagg (M1991.106).

Fig. 2–21 **Music and dancing are favorite pastimes in Haiti. Rhythm and movement can be shown in art by the use of repetition. What lines, shapes, and colors are repeated in this painting?** Philomé Obin, *Bal en Plein Air (Outdoor Dance)*, 1958.
Oil on masonite, 24" x 29 ½" (61 x 75 cm). Milwaukee Art Museum, Gift of Mr. and Mrs. Richard B. Flagg (M1991.142).

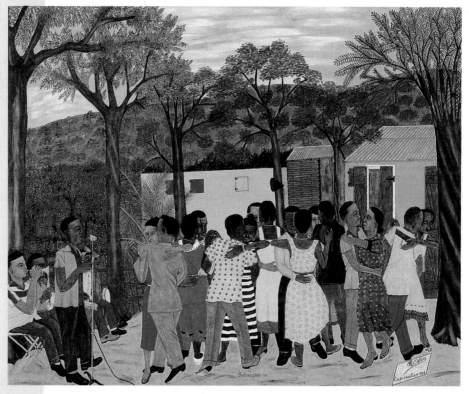

A Recorder of Haitian Life

"I paint the Haiti of my childhood, everyone working together to help each other."
Inatace Alphonse (born 1943)

Courtesy of the artist and the Haitian Art Collection, Del Ray Beach, Florida.

The subject matter of Haitian paintings today continues to be dominated by scenes of daily life. This art is popular with gallery owners, collectors, and tourists. That is why a talented artist like Inatace Alphonse can pursue art-making as a full-time career.

Alphonse was born in 1943 in Port-au-Prince, the capital of Haiti. Like many self-taught artists before him, Alphonse pursued another trade while he worked on his hand-painted postcards of market scenes. He learned the trades of shoe maker, carpenter, and blacksmith.

Fig. 2–22 **Compare this painting of communal workers with the one by Castera Bazile on page 109. How is the sense of movement different in each work?** Inatace Alphonse, *Harvest with Cows*, 1990s.
Acrylic on canvas, 11" x 14" (28 x 35.6 cm). Courtesy of the artist. Reproduced with permission.

Fig. 2–23 **Note how the figures fill the canvas. How did the artist use dark and light values to give the figures three-dimensional form?** Inatace Alphonse, *Market*, 1990s.
Acrylic on canvas, 12" x 12" (31 x 31 cm). Courtesy of the artist. Reproduced with permission.

Studio Connection

Haitian artists are faithful recorders of daily life. They use dark and light values to make flat shapes look three-dimensional. They also pay attention to the direction of light. If you were to paint a daily-life activity, what would you show? To begin, make sketches, and plan your composition in pencil. How will you make dark and light values? What will be the direction of the light? Where will you put shadows?

Colorful Records

Alphonse used his background in black-smithing to advantage to create sheet-metal sculptures. However, he soon learned that his real talent was in capturing the movement and action of the human figure on canvas. He returned to painting colorful scenes of daily life. Before long, people in Europe, Africa, South America, and the United States were collecting his work. One critic has called Alphonse the Haitian Bruegel, referring to the European Renaissance artist Pieter Bruegel (whose work is shown in Fig. 2–28), a painter of daily-life scenes.

Alphonse's paintings are beautiful records of Haitian life. His paintings are also bright: the colors are high intensity with strong highlights and carefully blended values. In such works as *Harvest with Cows* and *Market* (Figs. 2–22 and 2–23), he captures the hustle and bustle of people going about their daily activities.

Lesson Review

Check Your Understanding

1. Use what you know about the history of Haiti to explain what cultures might have influenced Haitian art.
2. Who are the painters in Haiti, and what do they usually paint?
3. Describe how Haitian painters use dark and light values to create the illusion of three-dimensional forms in their daily-life scenes.
4. Why, do you think, are scenes of Haitian life so popular with collectors in other countries?

Still-Life Drawing

The Objects of My Life

Studio Introduction

If someone found your book bag and emptied its contents, what clues to your life would those contents provide? We rarely think about objects as historical records, but archeologists and historians often rely on them as they piece together evidence of how people once lived.

In this studio lesson, you will draw a still life that "says" something about you. Pages 114 and 115 will tell you how to do it. A **still life** is an arrangement of objects that are not alive and cannot move. You will select and arrange objects that suggest who you are, how you live, and what you care about. You could choose items from home and school, such as knickknacks, a favorite cup, a book, photographs; or natural objects, such as shells, rocks, and twigs. Open up your imagination, and find things that really tell about you.

Studio Background

A Record of Time

To record people, places, and events, artists usually include objects found in society at the time of their work. These objects provide clues to how people lived and what they cared about. Many artists have directed all of their attention to such objects.

Pop artists of the 1960s often focused on everyday popular objects. These artists sometimes expressed a point of view about how daily life is surrounded by an ever-increasing assortment of products to buy and use. Artist James Rosenquist sometimes layered his still-life objects. In other paintings, he painted objects individually around the canvas.

Fig. 2–24 **Have you ever wanted to paint something as ordinary as dishes in a dish drainer? What does this painting tell us about life in the mid-1960s?** James Rosenquist, *Dishes*, 1964.

Oil on canvas, 50" x 60" (127 x 152.4 cm). © James Rosenquist/Licensed by VAGA, New York, New York.

Fig. 2–25 **Look carefully at this still-life drawing. What does it tell you about the artist?** Eben Bein, *Lit by a Candle*, 2001. Colored pencil, 8 5/8" x 11 3/8" (22 x 29 cm). R. J. Grey Junior High School, Acton, Massachusetts.

Fig. 2–26 **How did the artist use color in her still-life drawing?** Maura Gordon *Stuff I Like*, 2001. Colored pencil, 8 3/4" x 10" (22 x 25.5 cm). R. J. Grey Junior High School, Acton, Massachusetts.

Drawing in the Studio

Drawing in the Studio

Drawing Your Still Life

You Will Need

- drawing paper
- pencil and eraser
- markers, colored pencils, or pastels
- variety of objects
- flashlight or other light source (optional)

Try This

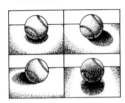

1. Begin by arranging your objects. As you decide where to place them, think about the parts of the arrangement that you want to emphasize in your drawing. Try shining a light onto the arrangement from a particular direction, such as from above or one side. How can you use the light to create shadows and contrast? Experiment!

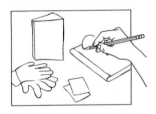

2. When you are satisfied with the arrangement and lighting, create a pencil sketch. Focus on the main shapes and forms first. Lightly sketch the outlines. Then add smaller shapes and forms as needed. Don't worry about details at this point, as you will focus on those later. Fill the paper with your sketch.

3. Next, add color and detail. How can you use color to help emphasize the important parts of your drawing? How can you use value and contrast to direct your viewer's eye? As you work, decide which details of the objects to show. Will you include all of the details or just the most obvious ones?

Check Your Work

Share your drawing with one classmate or more. Talk about the objects in your drawing and how you decided to show them. What do the objects say about you? What do they say about the time in which you live? Describe the way you used value and contrast to direct the attention of your viewer.

Computer Option

A computer with a flatbed scanner can be used as a camera to "photograph" a still life. Select some personal objects, such as a photo, jewelry, key ring, hair ribbon, wristwatch, book, or CD. Carefully lay your objects face-down on the scanner glass, overlapping them for a dynamic composition. You might lay a T-shirt or fabric on top, as a background. Scan your still life and save the file. Rearrange the objects and scan again. When you have a scan you are pleased with, use a special effect to change the lighting effects. How might you add contrast?

Value and Contrast

Value Scale

Value is the range of light to dark in a color. Look at the value scale; you will see that the lightest value is white. The darkest value is black. Notice the number of gray values that are between white and black. The number of values can vary from one scale to another. Artists can create a value scale for any color. The color red, for example, may have a light value of pink and a dark value of maroon. Red itself may fall somewhere in the middle of its value scale.

Artists create value by the use of highlight and shadow areas in a drawing or painting.

The gradual change in color from light (highlight) to dark (shadow) helps make objects in the artwork look three-dimensional. To learn more about value, see Lesson 2.2, on page 106.

Contrast can add excitement and drama to an artwork. One way that artists create contrast is the use of strong differences between values. Artists also create contrast by using strong differences between colors, shapes, textures, and lines. Artists use contrast when they want certain parts of an artwork to be the first to catch the viewer's attention.

Look at your artwork and that of your classmates. Where do you see highlight areas? Shadow areas? Contrast?

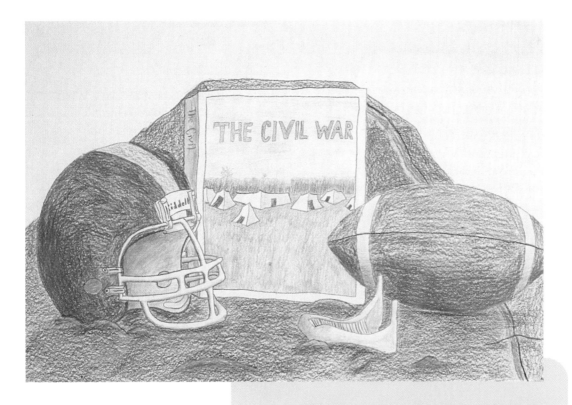

Fig. 2–27 **The things that interest the artist are clearly seen in this drawing. Notice how the red fabric helps create unity in the picture.** Phillip Reynolds, *My Favorites*, 2000. Colored pencil, 12" x 18" (30.5 x 46 cm). William Byrd Middle School, Vinton, Virginia.

Connect to...

Careers

What do you think **art historians** do? If you think they spend their days giving lectures about old paintings in dusty art museums, you need to update your thinking. As museums have increased in number and expanded their art collections, the career of art historian has also changed. Today's art historians may work as curators in museums or teach at colleges and universities. They may also write for journals, textbooks, and other books, as well as develop videotapes, video and laser discs, CD-ROMs, and other forms of interactive media. All are concerned with the history of art and its impact on our culture. Art historians usually earn a graduate degree in art history. Often, they become experts in a particular subject, style, culture, time period, art form, or media.

Fig. 2–28 **Art historians can learn much from artworks such as this sixteenth-century painting. Compare this painting with the work of Inatace Alphonse (pages 110 and 111). What could an art historian learn from each work?** Pieter Bruegel the Elder, *The Wedding Dance*, 1566. Oil on panel. City of Detroit Purchase, Detroit Institute of Arts (30.374).

Other Arts

Music

Have you thought of **music as a record** of a specific time or place? Music often reflects a unique culture or moment in history. For example, the blues are an African American musical invention. Blues musicians used their music to record the life and culture of black America. The blues began in the South but eventually spread throughout the country during the Great Migration of the early twentieth century. The blues probably grew out of earlier field-work songs and ballads that told stories of life in the rural South.

Daily Life

People keep many kinds of records. What kinds of records of *you* do you think your school and parents have? Your school probably has grade reports, test scores, school photos, and letters from your parents and teachers. Your parents most likely have your birth certificate, medical records, photographs, and special keepsakes from your childhood. What kinds of records do you keep for yourself?

Internet Connection
For more activities related to this chapter, go to the Davis Website at **www.davis-art.com.**

Other Subjects

Language Arts

Writing has long been a method of recording events, people, and beliefs. For ancient Mesoamerican and South American people, writing was a way to record religious beliefs and keep track of time. These people created books, called codices, whose pages were made from bark paper or deerskin arranged like a folding screen. They used signs and pictures, rather than words, to record what was important to them. When they arrived in the sixteenth century, the Spanish destroyed many of the books of the Mesoamerican and South American people. Why might the conquistadors have wanted to destroy such books?

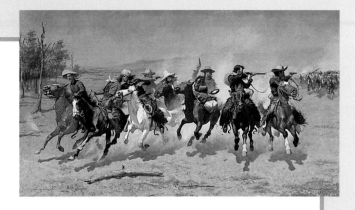

Fig. 2–30 **Artist Frederic Remington probably knew of Muybridge's research. In this painting, Remington depicted galloping horses with all their hooves off the ground.** Frederic Remington, *Dash for the Timber*, 1889. Oil on canvas, 48 1/4 x 81 1/8" (105 x 206 cm). Amon Carter Museum, Fort Worth, Texas.

Fig. 2–29 **Ancient peoples also carved their writing on statues and architectural features.** Pre-Columbian Guatemala, *Zoomorph P from Quiriga*, c. 300–630. Courtesy Davis Art Slides.

Science

Do you think a running horse ever has all four feet off the ground at once? Photographer Eadweard Muybridge (1830–1904) settled this debate when he **recorded positive proof** in the late 1800s. Using cameras with fast shutters, Muybridge took the first successful sequential photographs of a fast-moving horse. The resulting photo sequence was an international sensation that earned Muybridge a place in the history of photography. For the rest of his life he continued to record rapidly moving subjects through his unique photographic methods.

Mathematics

How do we record numbers? What symbols do we use? The decimal place-value system used in much of the world needs only ten symbols: 0, 1, 2, 3, 4, 5, 6, 7, 8, and 9. The system is based on the concept that each symbol has a fixed value and, at the same time, an infinite number of values when placed in different positions. Do you think the origin of our counting system is derived from counting on our fingers? The word *digit*, used for the ten numerals 0–9, is from the Latin word for *finger.*

Portfolio

"I am a figure skater. When I painted this, I was thinking about getting back on the ice, practices, and competition. The most difficult part was painting the fingers, because I'm not that good at drawing hands. I had to be very careful because the fingers are very small." **Justine Kirkeide**

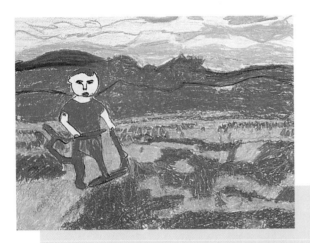

Fig. 2–31 **How does this artist use simple details to make her picture look like a skating rink?** Justine Kirkeide, *Skate Practice*, 2000. Tempera, 18" x 12" (46 x 30.5 cm). Plymouth Middle School, Plymouth, Minnesota.

Fig. 2–32 **Inspired by an old family photograph, this student artist made a drawing of her father as a toddler, walking with the help of a baby stroller or walker. What can you learn about the daily life of this child by looking at the environment around him?** Jaime Farley, *Happiness*, 2001. Pastel, marker, 12" x 16 ½" (30.5 x 42 cm). Victor School, Victor, Montana.

"This artwork shows a picture of my dad when he was young. It shows the happiness of the person and that he would go in his stroller in the day time." **Jaime Farley**

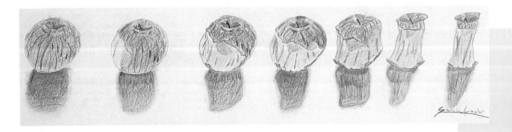

Fig. 2–33 **The simple act of eating an apple is conveyed in a series of drawings. The use of shadow makes the object appear more three-dimensional.** Sara Lawler, *Apple Study*, 2001. Colored pencil, 5 ¾" x 24" (14.5 x 61 cm). Camels Hump Middle School, Richmond, Vermont.

CD-ROM Connection
To see more student art, view the Personal Journey Student Gallery.

Chapter 2 Review

Recall

What are genre scenes?

Understand

Explain the importance of selection in recording scenes from daily life.

Apply

Use what you have learned about value and contrast to create a drawing of ordinary objects.

Analyze

Select one photograph by Dorothea Lange and compare it with photographs by James VanDerZee (Fig. 2–11, *shown below*) and Carrie Mae Weems. Consider what the artists selected to show and how they chose to show it. Also compare their use of dark and light values and contrast.

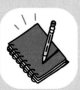

For Your Sketchbook

Make a section in your sketchbook where you keep a list of words and phrases that describe events and situations in your daily life. Also include photographs of everyday life. You may use words and images as ideas for subject matter in future artworks.

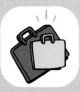

For Your Portfolio

From this book, choose an artwork that you think clearly records daily life. Write a detailed description of the work. Tell what the artist selected to record and how he or she used value and contrast to emphasize certain parts. Date your report, and add it to your portfolio.

Synthesize

Plan a storyboard for a video production that records a week of activity in your school. Remember that you must select your subject matter. For example, you may choose to focus on the routine of a custodian, the third grade, your own classroom, or the school office. Your storyboard must also show what you think is most important to record about this activity.

Evaluate

From this chapter, choose two artworks that you think best record daily life in two different ways; for example, at work and at play. Give reasons to support your selections.

Page 103

Artists as Designers

Fig. 3–1 **In his creative designs, Issey Miyake thinks of new and creative ways to use fabrics. In designs such as these, he emphasizes the need to recycle.** Issey Miyake, *Laboratory Starburst,* 1999–2000.
Photo by Yasuaki Yoshinaga. From "Issey Miyake, Making Things," 13 Nov. 1999–29 Feb. 2000. Ace Gallery, New York. © Issey Miyake, Inc.

Focus

- How do people show that they care about the look and use of objects?

- How do artists design the things we see and use?

Have you considered that most things you see and use every day were once ideas in someone's imagination? Our school desks, cars, dinner plates, toys, and tools are all products designed by artists who started with a problem and some ideas about how to solve it.

Designers need to think about how a product will be used, as well as how it will look. The look may sometimes be the more important consideration. Take the clothes we wear. People want their clothes to keep them warm or cool, of course, but they also want to get just the right "look." They may shop for clothes that create a certain fashion statement. Fashion designers plan the clothes, shoes, and other items we wear. They sometimes design in familiar styles. Other times, they create designs that surprise, and even shock.

Clothing designer Issey Miyake experiments with new looks and fabrics. His clothing designs shown in Fig. 3–1 are examples of how his products not only cover the body, but also surprise and delight his audience. In this chapter, you will learn more about Miyake and other designers who create products for us to use and enjoy.

Meet the Artists

Issey Miyake
Michael Graves
Toshiyuki Kita

Words to Know

form	proportion
function	graphic
ergonomic	designers
	pattern

Issey Miyake

A Designer of Fashion

"If you take T-shirts or pairs of jeans, they can never cause any sort of surprise, since people always know what to expect from them. I prefer to surprise people, to cause emotion."
Issey Miyake (born 1938)

Photo © Yuriko Takagi.

Issey Miyake's Journey

Issey Miyake was born in 1938 in Hiroshima, Japan. He was interested in clothing design at an early age. While studying graphic design in Tokyo, he presented his first collection of clothing. Miyake's work has taken him all over the world, where he has paid attention to the way people dress and the colors in the landscapes.

Like all designers, Miyake starts with a problem to solve. To him, clothing should be beautiful and always give pleasure to those who wear it and see it. His designs make people stop and think about clothing in new ways. Miyake wants to create clothing that not only covers the body, but also extends it, like a sculpture. In what ways does his *Flying-Saucer Dress* (Fig. 3–2) remind you of a sculpture? How do you think this dress moves when a person walks?

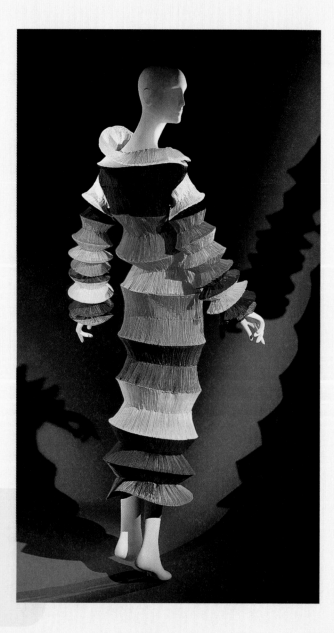

Fig. 3–2 **Miyake often sets trends that eventually show up in mass-produced clothing. In what ways does this dress look like other dresses you have seen?**
Issey Miyake, *Flying-Saucer Dress*, 1994.
Heat-set polyester. Philadelphia Museum of Art: Gift of Issey Miyake. Photo by Lynn Rosenthal and Graydon Wood, 1997.

Exploring Fabrics and Forms

Issey Miyake likes to experiment with fabrics and ways to use them. He plays with the patterns created by crushing, pleating, twisting, shrinking, bleaching, and recycling textiles. His fabrics may be bright and cheerful or soft, natural, and quiet colors.

Early in his career, Miyake created a group of clothes called "A-POC" (Fig. 3–3). Each clothing item was produced mostly from a single piece of cloth—a square of material with added sleeves. The result was clothing that seemed to flow around the body, much like the traditional Japanese kimono.

Miyake also collaborates with other creative people. He often invites artists to plan new fashions and shows with him. In his studio, he works with a team of designers to research ideas and make new creations. Today, Issey Miyake is taking advantage of the newest technologies for creating fabrics and designing clothing.

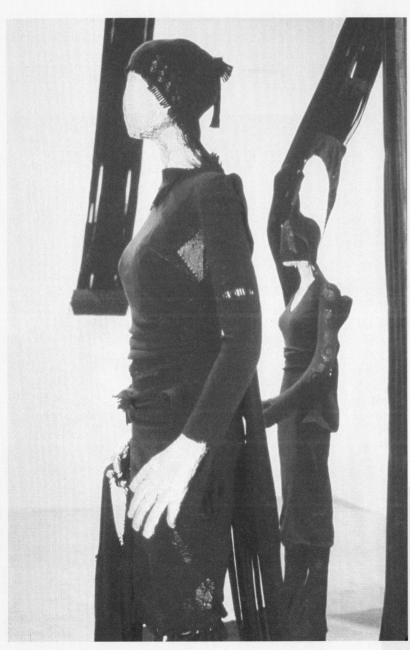

Fig. 3–3 **A-POC stands for "a piece of cloth." People follow the designer's directions and cut a tube of knitted fabric into an entire outfit.** Issey Miyake, *A-POC "King" and "Queen,"* 1999–2000.
Photo by Yasuaki Yoshinaga. From "Issey Miyake, Making Things," 13 Nov. 1999–29 Feb. 2000. Ace Gallery, New York. © Issey Miyake, Inc.

Design Through Time

People have always designed products to meet their special needs. Since the first time someone shaped a piece of stone to use as an ax, people have used available materials to make useful objects. They have also created new materials and developed techniques as they designed new objects to meet their needs.

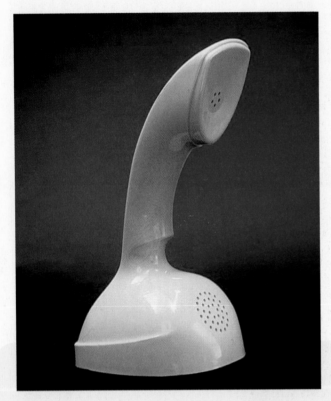

Fig. 3–4 **How is your own telephone similar to and different from this one?** Hugo Blomberg, Ralph Lysell, Gosta Thames, *Ericofon*, 1949.
Plastic and rubber. L.M. Ericsson Sweden.

Fig. 3–5 **Industrial designers must think about safety. This forklift allows the driver to move up with the lift instead of looking up from ground level. How does the look of this forklift compare to that of today's cars and other vehicles?**
Courtesy Teams Design.

Over centuries, people have needed and wanted different things. Look at the telephone in Fig. 3–4. At one time, this design brought thoughts of a future world. Who could have known that people someday would want a fancy cover for a cellphone?

People have also cared about the way useful objects looked. Even in the ancient world, tools often had decorations that had no specific use. The decorations were added only to give pleasure to those who used the tools. This is an example of how designers have paid attention to the **form** (how it looks) as well as the **function** (how it works) of the objects they design. Like function, form undergoes change, depending on what appeals to people at different times.

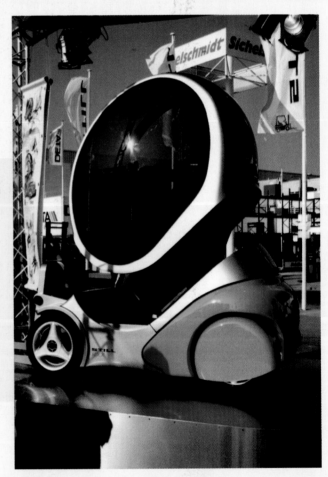

Green Waves detection system

Innovations Showcase

To help you get a feel for the standard of entries we are looking for, we have supplied information about various innovations from last year. Click on one of the icons above to continue.

Clockwork Radio Micromap Low-Vision Enhancement System Green Waves

main menu **the award** the network the site standard version SAATCHI & SAATCHI

Fig. 3–6 **The Internet is filled with work created by Website designers. What kinds of problems would a Website designer need to solve?**
Award-winning Website for Saatchi and Saatchi, designed by AMX Studios.

Designers for Every Need

Many kinds of designers fill our needs. Product designers plan items such as appliances, tools, vehicles, toys, athletic equipment, and furniture. The forklift in Fig. 3–5 shows the work of an industrial designer. Fabric, jewelry, shoe, and accessory designers plan items we use to dress in comfort and style. Interior designers work with the spaces in which we live, work, and play. They may plan with lighting, furniture, and floor and wall coverings. Landscape designers plan with trees, plants, and walkways. Theater designers plan sets, lighting, or costume design. Graphic designers plan all sorts of advertisements, posters, and brochures. And Web designers create what most of us see every time we use the Internet on a computer: Websites, home pages, and electronic ads (Fig. 3–6).

Artists as Designers

125

Drawing on Fashion

Fashion designers create clothing and accessories for a wide variety of people and uses. They experiment with fabrics, colors, and patterns. They also care about how clothing will look and feel to the person who wears it. Fashion designers often look to leaders in their field for their inspiration.

In this studio experience, you will design an outfit or uniform for someone you admire. For what will your outfit be used? What features does it need? Will you create a design that is entirely from your own imagination? Or will you borrow ideas from leading fashion designers?

You Will Need

- lightweight cardboard
- scissors
- drawing paper
- pencil
- markers, crayons, colored pencils
- white glue or cellophane tape (optional)

Try This

1. Choose the person for whom you would like to design an outfit. Will you choose an athlete, movie star, artist, or teacher?

2. Create a paper doll of that person. Draw the outline of the person on lightweight cardboard. Think about body proportions. How long should the arms and legs be? How large should the head be? (To learn more about human proportion, see Lesson 3.2, on page 132.) Cut out the doll.

Studio Background

The Design Process

No matter what they are designing, all designers go through a similar series of steps. At each stage of the process, they ask important questions.

1. Identify the problem. What do the clients want and need? Which is more important: the product's look or the way it will be used?

2. Explore the problem. What designs of the product already exist? Who will use the product? What do the users like and dislike?

3. Brainstorm. What are some possible solutions to the design problem? In this stage, designers make rough sketches or models.

4. Plan. Which idea needs more work? How should the idea be changed or improved? Several people usually are involved in choosing and developing one of the sketches.

5. Produce. How can the product be made? In this stage, a prototype, or sample, is created and shown to the client.

Fig. 3–7 **The artist who made this design for clothing often creates wearable sculpture and performs in what she designs.**
Pat Oleszko, *Jazzmin*, 1994.
Mixed media, for clothing design, 4' x 2' x 7' (122 x 61 x 213 cm). Courtesy of the artist. Photo: Neil Selkirk.

6. Evaluate. How well does the product solve the problem? What parts of the process worked well? How can the product and the process be improved?

3. Lightly trace the doll on drawing paper. Sketch the features of the clothing on the trace. What features—such as puffy sleeves, a sash, or special hat—do you need? Remember to create a front and back view of your design.

4. Color your design and create patterns. Will you create an all-over pattern, areas with different patterns, or simply a border design? Carefully erase any unwanted trace lines. If you want, cut out the clothing and attach it to your doll.

Check Your Work

Write a letter to the person for whom you have designed the outfit. Explain why you designed it the way you did. Tell the person how you used the six steps of the design process as you worked. Share your letter with a classmate.

Lesson Review

Check Your Understanding

1. Give examples of at least three different items that are designed by artists.
2. What are the two things that designers must consider when designing items for our use?
3. Name at least three different kinds of designers.
4. Why is it important for a designer to identify the problem that his or her design will solve?

Design for Living

6th century BC	1932	1985
Hydria	Breuer,	Graves,
	Chair	Tea Set

| **Ancient Greece** | **Early 20th Century** | **Late 20th Century** |

	1919	1980	1986
	Bauhaus founded	Peter Shire,	Graves,
		Peach Cup	Clock

Travels in Time

People have always designed functional objects to meet their basic needs. The urns and vases of the ancient Greeks, such as the one shown in Fig. 3–9, are excellent examples of well-designed functional objects. The function, or use, of a vessel determined how it looked. This is also true today.

Movements in Design

The world changes rapidly. Many things we take for granted today were beyond people's imagination a century ago. The design of objects also changes rapidly.

Throughout the twentieth century, different movements, or schools of thought, influenced the design of objects. One such movement was De Stijl. (See Fig. 3–29 for an example of De Stijl.) De Stijl artists wanted to bring harmony to the design of objects through the use of basic geometric shapes and primary colors. Another school, the Bauhaus, was founded in 1919 by a group of artists, architects, and designers in Germany. Bauhaus designers used modern industrial materials and did not add any decoration. Look at the chair in Fig. 3–10. How does its function determine its form?

Fig. 3–9 **Study this example of a functional, decorated design. Where do you see pattern? How did the artist create the pattern?**
Ancient Greece, Athens (attributed to the Antimenes painter),
Hydria, c. 530–510 BC.
Black-figure earthenware, height: 16 5/8" (42.2 cm). Cleveland Museum of Art, Purchase from the J. H. Wade Fund. 1975.1.

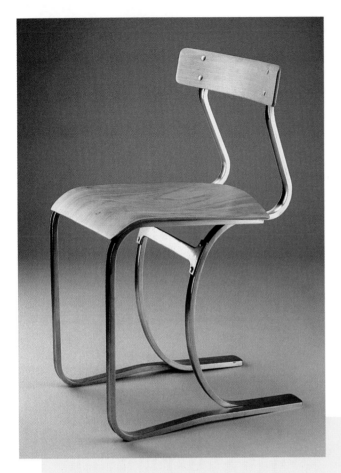

Fig. 3–10 **At first glance, does this chair look as though it would support a lot of weight? What gives this chair its strength?** Marcel Breuer, *Side Chair, Wohnbedarf Model 301*, 1932.
Manufactured by Embru. Aluminum and wood, 29" x 16 1/2" x 18" (73 x 42 x 46 cm). Photo by Bruce White. The Mitchell Wolfson Jr. Collection, The Wolfsonian-Florida International University, Miami Beach, Florida.

Fig. 3–11 **How did the designer use pattern on this cup? What shapes are repeated? How would you drink from this cup?** Peter Shire, *"California Peach" Cup, Memphis*, 1980.
Glazed earthenware. Cooper-Hewitt National Design Museum, Smithsonian Institution/Art Resource, NY. Gift of Denis Gallion and Daniel Morris, 1988-60-3.

Design in Your World

In 1981, the Memphis design group was founded. Their designs included commercially successful furniture, fabric, and ceramics, such as the cup in Fig. 3–11. Although they borrowed from many sources, including the architectural styles of ancient Greece and Rome, the group also used bold colors in new ways.

Since the eighties, many designers have become interested in "people friendly" creations. Their designs are **ergonomic**, built to increase the user's productivity and comfort, usually at work. Designers use their knowledge of the human body to create objects that people can use efficiently and safely. Look around your home and school for examples of ergonomic design.

Designing with Humor

"When I design for clients, I ask, 'What kind of things do you like? What kind of things do you hate?'"
Michael Graves (born 1934)

Designers today also think about how their objects will fit into contemporary society. Designer Michael Graves has an educated eye and whimsy, a kind of humor. He designs objects that are both classic and fun.

As a child in Indiana, Michael Graves loved to draw. "The more I drew, the better I got," he says. As an architecture student, he experimented with product design. He filled his sketchbooks with designs for furniture and other household objects. His sketches were soon made into real products.

Name a product, and Graves has probably created his own special design for it. During the 1980s, he designed for the Memphis group. Today, his whimsical kettles (Fig. 3–12), utensils, and tableware are very popular.

Fig. 3–12 **What visual elements were repeated in this set? Why did Graves put a bird on the spout of the kettle?** Michael Graves, *Whistling Bird Teakettle with Matching Sugar Bowl and Creamer for Alessi*, 1985. Stainless steel and plastic, height (teakettle): 9.5" (24 cm). Courtesy of Alessi.

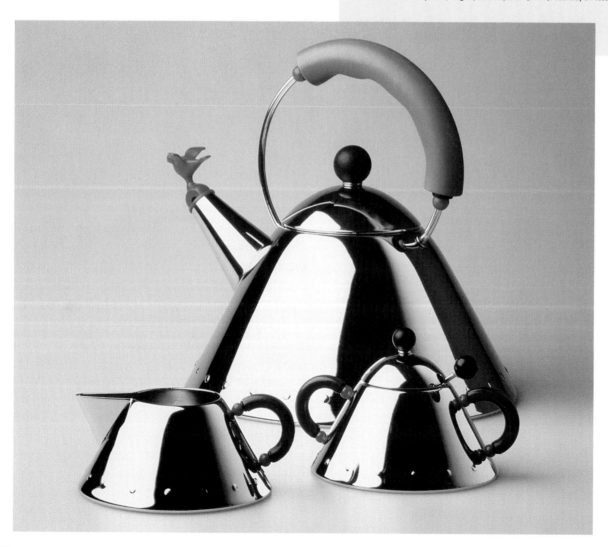

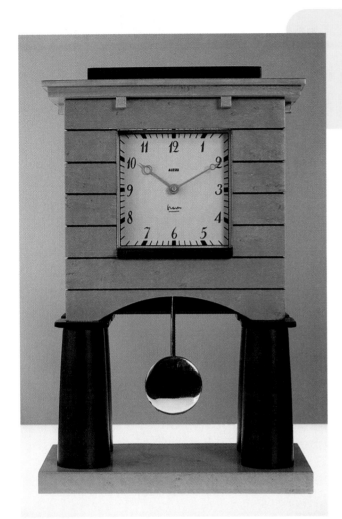

Fig. 3–13 **What classical Greek element do you think Graves had in mind when he designed this clock?**
Michael Graves, *Mantel Clock for Alessi*, 1986.
Ebonized wood, stained birdseye maple, green oxidized metal watch hands, 18k gold dot at center hand pivot, terra cotta numerals, off-white face, 18k gold pendulum with satin finish. Photo by William Taylor. Courtesy of Alessi.

The Art of Design

Michael Graves, who is also an architect, refers to classical traditions of architecture in many of his designs. The clock shown in Fig. 3–13 is an example of how Graves blends classical, simplified styles with his imagination. In this design, Graves created a clock that looks like a building. Many of his products feature symmetry and order, such as this clock. But Graves always adds an unexpected element to create a sense of fun and whimsy.

Lesson Review

Check Your Understanding

1. What does the design of a modern teapot and that of ancient Greek urns have in common?
2. What is one difference between Bauhaus and Memphis design? What is one similarity between Bauhaus and ergonomic design?
3. What qualities does Michael Graves bring together in his designs of products?
4. Usually, products designed by well-known artists are more expensive than products that do not have designer labels. Why do you think this is so? Do you think having well-designed objects is worth the extra money?

Studio Connection

Make two ceramic containers, such as two teacups, each for the same specific purpose. Use slab, coil, and pinch methods, alone or in combination. As you design each container, consider both its function and the form you want it to have. Make one container as simple and functional as possible. In other words, let the function determine the form. Any decorative surface pattern should be functional. For example, a pattern of tea leaves would suggest the use of a teacup. Make the second container functional as well, but be more playful with its design and surface pattern. For example, you could use the slab method to make your teacup out of a three-dimensional "T."

Human Proportions

People differ in many ways. Some may be tall or big-boned, while others may be petite. But most people are alike in their **proportions**, which are the relationship between one part of the body and another. When designers create a chair or a piece of clothing, they make decisions about size and shape based on the typical human proportions. Whether you are drawing a picture of a man, woman, or young child, the same general rules of proportion will help make your drawing seem right.

The Human Figure

Study the proportions shown in Fig. 3–14. Practice your understanding of these proportions by creating several sketches of the human figure. Use a full sheet of paper for each drawing. You might begin with eight very light horizontal lines, all the same distance apart. This will give you seven spaces. The head will fill the top space, and the feet will rest on the bottom line.

First, sketch a standing-up figure from the front. Then sketch a standing figure from the back and one from the side. Next, try sketching a seated figure from the side. Have a classmate pose for you, or work from a photograph. Each time, be careful to use the same proportions.

Fig. 3–14 **Notice that the height of most people age 12 and up is about seven or eight times the height of the head. The hips are about halfway between the feet and the top of the head. The elbows and waist are just above the hips. The shoulders are about halfway between the top of the head and the waist. The knees are about halfway between the feet and the hips.**

Fig. 3–15 **Notice that the eyes are about halfway between the top of the head and chin. The space between eyes is about one eye width. The bottom of the nose is about halfway between eyes and chin. The mouth is slightly higher than halfway between chin and nose. Its corners are directly below the center of each eye. Ears are about parallel to the eyelids and bottom of the nose.**

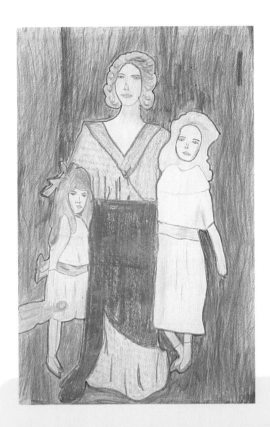

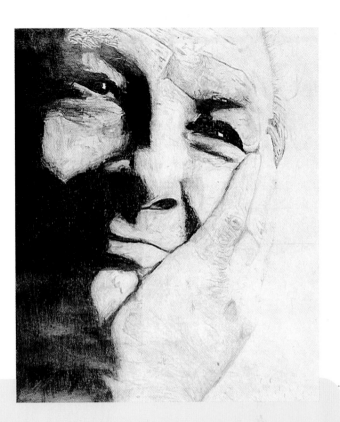

Fig. 3–16 **When making a drawing that shows people of different sizes, what is important to remember when determining proportion?** Rheannon J. Swinney, *Sisters with Mother*, 1999. Colored pencil, 12" x 18" (30.5 x 46 cm). Johnakin Middle School, Marion, South Carolina.

Fig. 3–17 **Once you have an understanding of facial proportion, you can become more creative in your composition. This artist has tipped and turned the face slightly and added the hand.** Christopher Johnson, *Unknown*, 2000. Pencil, 18" x 24" (46 x 61 cm). Chocksett Middle School, Sterling, Massachusetts.

The Human Face

Study the proportions outlined in Fig. 3–15. Practice your understanding of these proportions by creating two sketches of the human face. First, sketch a face from the front. Have a classmate pose for you or work from a photograph. Instead, you could draw yourself while looking into a mirror.

Then sketch a face in profile. When creating a profile view, notice these additional proportions: the top of the ear is about halfway between the eye and the back of the head; and the bridge of the nose and front of the chin are nearly in a straight line, one above the other.

Studio Connection

Draw a detailed portrait of yourself or a classmate. One way to start is to draw an oval shape with light pencil guidelines for the eyes, nose, lips, and ears (as described in this lesson). After these general guidelines are in place, observe the specific characteristics of your subject. Is the face wide or thin? Does your subject have a long nose or a short one? Is the forehead high, or does the hair cover the forehead? Adjust your marks, if necessary, to show these differences.

Lesson Review

Check Your Understanding

1. Define *proportions* in your own words.
2. Why is knowledge of human proportions important to artists and designers?

133

Art of Japan

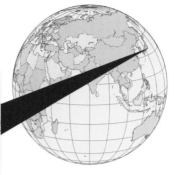

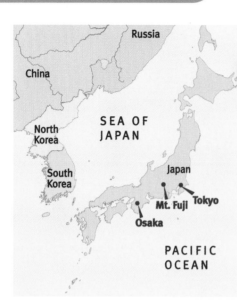

Japan

A Tradition of Design

The design of functional and beautiful everyday objects has a long tradition in Japan. Craftsworkers created by hand the many objects used in the tea ceremony and daily life. They worked with clay, wood, metal, paper, or cloth.

Many artists followed traditional rules and standards of design and beauty. One of these rules is *wabi*, which is the idea of finding beauty in simple, natural things. Wabi also means an appreciation of imperfect and irregular natural objects. Another rule is *sabi*. This refers to timelessness and simplicity. Following the rules of wabi and sabi, an artist would want an object to have uneven, simple shapes and a timeless look. Study the jar and teacup shown in Figs. 3–18 and 3–19. What evidence do you see that these artists followed the rules of wabi and sabi?

Places in Time

Japan is an island nation in the West Pacific. It has an ideal climate and geography for growing tea on steep, terraced hillsides. For centuries, the preparation of tea leaves and the serving of the drink have been performed in a ritual known as the tea ceremony. An important feature of the ceremony is the use of beautifully crafted utensils.

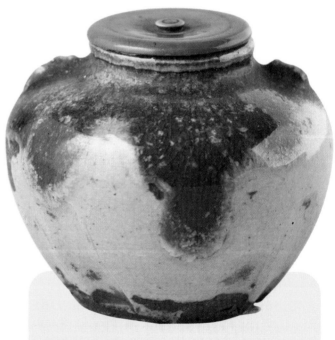

Fig. 3–18 What pattern do you see in this jar? What, in nature, does it remind you of? Japan, Owari province, *Tea Jar*, 19th century.
Pottery, height: 1 ¾" (4 cm). Philadelphia Museum of Art: The Louis E. Stern Collection. Photo by Eric Mitchell, 1981.

Designs Tied to Nature

Today, some Japanese designers maintain the traditions of creating objects for rituals. They want their designs to be beautiful and natural-looking. These designers aim for products with simple shapes, small sizes, and fine details, such as the kettle shown in Fig. 3–20. But many products designed and manufactured in Japan today—such as the high-tech electronic products for the world market—are not tied to tradition. However, what designers do carry over into today's products is a preference for natural-looking, organic forms.

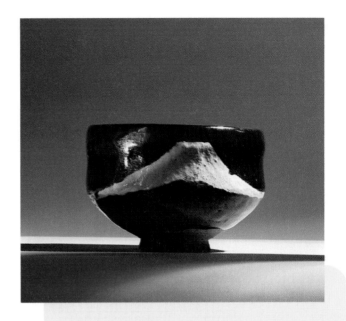

Fig. 3–19 **What was the inspiration for the decoration on this teacup?** Japan, *Teacup with Image of Mt. Fuji*, 18th century.
Pottery, height: 2 ⁷/₈" (7.2 cm). P. Goldman Collection, London. Werner Forman/Art Resource, New York.

Fig. 3–20 **How did the artist create pattern on this kettle?** Japan, *Nanbu Iron Kettle*, 21st century.
Cast iron, height: 5 ¹/₂" (14 cm). Photo courtesy Davis Art Slides.

Designs for Changing Lifestyles

"Design has no national border."
Toshiyuki Kita (born 1942)

Courtesy IDK Design Laboratory, Ltd., Japan.

Contemporary designers in Japan continue to look to the past for ideas for the future. Toshiyuki Kita is a designer who works in Osaka. He took an early interest in traditional Japanese craftwork.

Kita is a careful observer of people's daily routines. He designs his products to be comfortable, functional, and natural looking. Kita combines Japanese and Western ideas about design in clever ways. For instance, his adjustable *Wink* chair (Fig. 3–22) recalls the Japanese practice of sitting on the floor. At the same time, it provides the comfort and support of a recliner chair that is popular in Western design.

Fig. 3–21 **How is the design of this clock functional? What is unusual about the design?** Toshiyuki Kita, *Digital Clock*, 1982. Photo courtesy IDK Design Laboratory, Ltd., Japan.

Fig. 3–22 **Would you be comfortable sitting in this chair? What do you like about it?** Toshiyuki Kita, *Wink Chairs*, 1980. Steel, foam polyurethane, dimensions variable, in upright position: 34 1/2" x 30 1/2" x 37 1/2" (90 x 78 x 95 cm). Courtesy IDK Design Laboratory, Ltd., Japan.

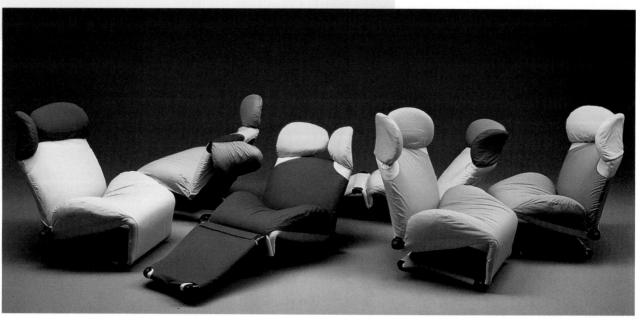

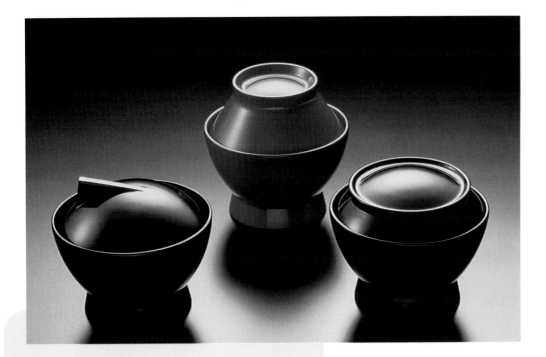

Fig. 3–23 **The use of lacquered wood for tableware is a strong tradition in Japan. What geometric shape did the artist repeat in the design?** Toshiyuki Kita, *Urushi Tableware*, 1986.
Lacquered wood, height: 3 3/16" (8.1 cm), diameter: 5 1/8" (13 cm). Omukai Koshudo Company, Wajima, Japan. Courtesy IDK Design Laboratory, Ltd., Japan.

Designs for the Future

When Kita designs things, he thinks of tools we use daily, and he sees the effect of new technologies on lifestyles and the environment. Because his primary interest is in the harmony of technology and people's lives, his work explores the relationship between people and materials.

Kita thinks about the look of objects from the past, the needs of the present, and meanings for the future. So, when he designs, he tries to hold on to the past while taking a giant step forward. In his designs, such as the tableware in Fig. 3–23, Kita looks to past traditions in Japan while creating products for the future. What is modern about this design?

Studio Connection

Plan for and draw several different views of a high-tech product for the future, such as a cellphone, timepiece, computer, or pager. Use contour lines to show as many features as possible. Consider needs in communication, transportation, entertainment, the home, and so on. Think about efficiency. Who will use the product? How will it be used? How will your design be an improvement over something that now exists? How can pattern enhance the design?

Lesson Review

Check Your Understanding

1. What are two rules of traditional Japanese design?
2. What does the design of Japanese high-tech products have in common with that of traditional everyday objects?
3. Give an example of how Toshiyuki Kita combines Japanese and Western ideas about design. What three things does Kita try to create in a well-designed product?
4. What products can you find in your home that are made in Japan? What distinguishes their design from other products?

Artists as Designers

Creating a Package Design

Marketing in Three Dimensions

Studio Introduction

As you walk down the cereal aisle of your grocery store, which packages catch your eye? Have you ever noticed that the bright and colorful designs of some cereal boxes are directed toward young people? They seem to send a message that says "If you buy this cereal, you will have fun!" Other cereal box designs send messages about how healthy you can be if you eat the cereal inside.

Businesses depend on **graphic designers** —artists who plan the lettering and artwork for packages, posters, advertisements, and other printed material—to help market and sell their products. Many people will select one item over another because the package design appeals to them. With so much product competition, package designs must be as visually appealing as possible.

Studio Background

Designers at Work

In this day and age, there are millions of products and hundreds of stores from which to buy them. Graphic designers have the unique challenge of creating packages that will sell a specific product or promote a specific store. For example, they must try to make one kind of shampoo, one brand of cold medicine, or the corporate image of a particular store stand apart from all the rest. They often create designs to fit a standard container, such as a coffee can, perfume box, or shopping bag. They sometimes custom-design packages that have unusual forms.

Graphic designers need to answer several questions as they create a package design.
1. What size and shape should the package be? What materials should be used? If the product is heavy, the designer must construct a package that will hold the weight.
2. What message should the design communicate? The designer must know the important characteristics of the product or store, and figure out a way to tell the buyer about them through the design.
3. Who is the buying audience? Some messages are aimed at the general public. Others are aimed at

Fig. 3–24 **Why is this a successful example of graphic design?** *"Green Stripe" Fresh Produce Containers*, 1980. Corrugated cardboard. Designer: Jack Gernsheimer, Partners Design, Inc. Photography: Dennis Brubaker, Project Director CrossRoads Studios.

Fig. 3–25 **Do you think the artist thought about the audience for this product? What makes you think so?** *Imaginarium KangarooHop! Package Design.* Art Director/illustrator/design, Earl Gee; photography, Sandra Frank. © 2001 Gee + Chung Design.

specific groups, such as teenagers, car drivers, or people who care about the environment.
4. What kind and style of graphics will best communicate the message? The style may be serious, fun, realistic, or abstract. Lettering styles can also help send messages. Creative use of the elements and principles of design can also attract attention and send the right message.

In this studio experience, you will create a package design for a product or store of your choice. Pages 140 and 141 will tell you how to do it. Choose a product or kind of store for which you would like to design a package. For example, you may want to design a case for a music CD, a shoe box, or a department store shopping bag. Use line, shape, color, and pattern to send a message about your product or store.

Fig. 3–26 **This student artist used simple shapes and just a few colors to express his message.** Barry Knapp, *Barry's Pro Shop*, 2000.
Cut paper, pipe cleaners, height: 16 1/4" (41 cm). Jordan-Elbridge Middle School, Jordan, New York.

Artists as Designers

139

Creating Your Package Design

You Will Need

- cardboard box or shopping bag
- construction paper
- markers
- scissors
- glue
- collage materials

Try This

1. Think about the product or store you want to promote on your container. What images come to mind when you think of your subject? What name, brief saying, or other words can you include to attract the buyers' attention? Refer to the questions in the Studio Background (page 138) for ideas.

2. Notice the shapes and sizes of the front, back, and sides of your container. Remember that the design is seen on all sides of the package. How can you use these spaces to create an exciting design? Where can you use pattern?

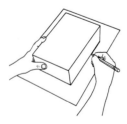

3. To create a background, trace the sides of your container onto construction paper and cut out the panels. Choose one or more paper colors that will best express your message.

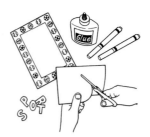

4. Use markers and collage materials to create words and images for your package. Will you create a pattern in the background or in the images and words? Will you create your own images or cut them from a magazine? Will you draw your words, or will you cut letters out of paper and glue them onto the panels?

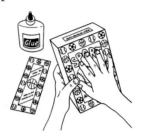

5. Carefully glue the construction-paper panels to the sides of your box or bag.

Check Your Work

When designers complete a project for a client, they present their ideas and explain what they have done and why. Prepare a presentation about your package design. Get together with two of your classmates, and take turns playing the roles of presenter and clients. Be sure to explain how your design decisions fit the audience and your client's intended message.

Computer Option

Using the computer and a slide-presentation program (such as Powerpoint or Hyperstudio), make a brief (3–5 slides) presentation that features your package design. Identify your product, talk about the package design, and share your overall design decisions. Include information about how the design is intended to appeal to the target audience (the people who will purchase the product).

Pattern

Artists create **pattern** in a design when they repeat lines, shapes, or colors. A *planned pattern* is one in which the elements are repeated in rows or some other regular way. Many clothing

fabrics show a planned pattern. When the repeated elements appear scattered in the design, they create a *random pattern*. You can see random patterns in tie-dyed fabric.

An overall pattern can help hold an artwork together visually. Small areas of pattern add interest to an artwork. Look at your own artwork

and the work of your classmates. Which ones show planned or random patterns? Are they overall patterns? Or were they created in certain areas to add interest to the artwork?

Fig. 3–27 **How did the artist use pattern in her design?** Tiffani Hendrie, *Fire 'n' Ice*, 2000. Cut paper, pipe cleaners, 17" x 14" x 5" (43 x 35.5 x 13 cm). Jordan-Elbridge Middle School, Jordan, New York.

Connect to...

Careers

Some **fashion designers** have become celebrities themselves through their creations for music and movie stars. Yet many lesser-known fashion designers work for clothing manufacturers that sell their work through department stores, specialty stores, and mail order or online catalogs. Students interested in a career in fashion design may earn degrees in fashion merchandising or fashion design through college or university art departments or fashion-design institutes.

Fig. 3–28 **Fashion designers may specialize in women's, men's, or children's clothing or accessories. They may design casual, business, or formal clothing.**
Photo © Andres Aquino, FashionSyndicatePress.com.

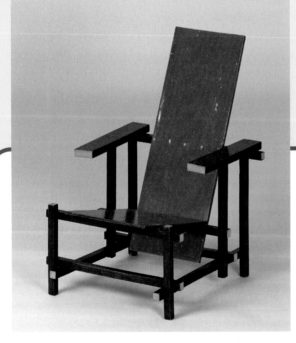

Fig. 3–29 **What elements and principles of design do you see in this chair?** Gerrit T. Rietveld, *Roodblauwe Stoel (Red, Yellow, and Blue Chair)*, 1918.
Painted wood, 34 1/2" x 26" x 32 1/2" (88 x 66 x 83 cm). G. van de Groenedkan, NL–Utrecht. Vitra Design Museum, Weil am Rhein.

Daily Life

Deliberately designed objects surround you, although you may not pay them much attention. The alarm clock that wakes you, the toothbrush you use, the clothes you wear, the cereal box on the breakfast table, and the car or bus in which you ride to school are all deliberately designed objects. They are designed for specific purposes: to work properly, to attract your attention, to make you comfortable, to fit your body, or to encourage you to buy. Take notice of such objects for one day; see how many you encounter.

Language Arts

Do you like to read science fiction? Do you know who was the first person to write it? Though the term *science fiction* wasn't introduced until 1926, French writer Jules Verne introduced science fiction in the late 1800s. He called his books "novels of science." In *From the Earth to the Moon* and *Twenty Thousand Leagues Under the Sea*, Verne described and predicted **technological designs** that did not yet exist. Two of his most astonishing designs were a cannon-propelled spacecraft and a whale-shaped submarine called the *Nautilus*.

Fig. 3–30 **What other objects can you think of that illustrate the concept of cylindrical symmetry?**
Photo courtesy Anette Macintire.

Mathematics

What do hot-air balloons, jellyfish, and umbrellas have in common? They all share a **mathematical concept called cylindrical symmetry**. The top and bottom of an object with cylindrical symmetry may be different, but all distances are the same from its vertical axis. You may remember a childhood toy that included a set of different-sized rings that you placed over a central rod. The rings were different sizes, but they shared a vertical axis, and thus were cylindrically symmetrical.

Science

Have you ever heard the term "ergonomic design"? Ergonomics is an applied science in which objects are designed to work effectively with the human body. For this reason, ergonomics is sometimes called human engineering. One example you may have seen is the ergonomic computer keyboard, which has keys placed to fit the natural movements of the fingers and hands. What examples of ergonomics do you encounter in your daily life?

Other Arts

Theater

Theater requires special kinds of designers, each with an area of expertise. The stage designer creates a set that communicates the mood of the show. Lighting designers decide which parts of the set and which actors to expose or to leave in shadows. The lighting (for example, a spotlight on characters delivering important dialogue) helps direct the audience's attention to what is important. The costume designer uses clothing to help convey the personalities of different characters. What other features do you think add to a theater performance?

Internet Connection
For more activities related to this chapter, go to the Davis Website at **www.davis-art.com.**

Portfolio

"When I was making the birdhouse, I was thinking of a day and night theme. I have always liked suns and moons. The difficult part was making the clay the right width."
Marilyn Kane

Fig. 3–31 **How is the design of this artwork both decorative and functional?** Marilyn Kane, *Ceramic Birdhouse*, 2001.
Clay, glaze, 5 1/2" x 5" x 5 3/4" (14 x 13 x 14.5 cm). Fred C. Wescott Junior High School, Westbrook, Maine.

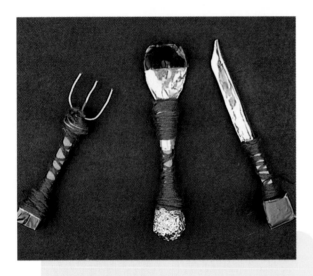

Fig. 3–32 **Product designers often do drawings or models of new design ideas. What does a model show that a drawing does not?** T. L. Tutor, *Geometric Silverware*, 2000.
Wood, wire, yarn, metal, clay 6" to 7 1/2" long (15 to 19 cm). Islesboro Central School, Islesboro, Maine.

"The knife took the longest to make because I did it first. The other ones were easier because I got better each time. I was trying to make them all relate to each other, so I got the idea to make them all have a shape at the end." **T. L. Tutor**

Fig. 3–33 **Labeling certain items shows the level of planning in the mind of the artists. It also helps convince the viewer that this could be a design for a real invention.** Aaron Burnett, Diego McCombs, *Sub. Limo. 14*, 2001.
Pencil, markers, 9 1/2" x 13 1/2" (24 x 34 cm). Thomas Metcalf Laboratory School, Normal, Illinois.

CD-ROM Connection
To see more student art, view the Personal Journey Student Gallery.

Chapter 3 Review

Recall

Name three different kinds of designers, and explain what they do.

Understand

Using the example of the tea jar shown in Fig. 3–18 and below, explain the basic rules of traditional design in Japan.

Apply

Draw a design for a new scooter. To plan your design, answer the questions about the design process on page 126.

Analyze

Choose a designed object and identify its function and decorative features.

Synthesize

Use your knowledge of standard human proportion to design a computer workstation for your classroom. Include the dimensions on your design.

Evaluate

Select a package design, and judge how well the size, shape, and materials hold the product. Also judge how well the design communicates a message about the product. Give reasons for your judgments.

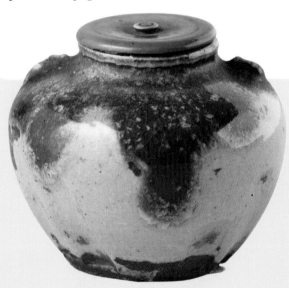

Page 134

For Your Portfolio

Use your portfolio as a place to store your artwork, essays, and other completed work. Whenever you include an artwork, fill out an artist's statement form. Write your name and date, and what media and techniques you used. Identify your artwork's message. Write what you like about the artwork and what things you would change if you reworked the piece.

For Your Sketchbook

Your sketchbook is a place for collecting found images as well as creating your own. On a page in your sketchbook, paste an envelope or pocket for keeping cutouts or clippings of designs that you like.

Artists as Teachers

Fig. 4–1 **Jim Henson could not have known that his character Kermit would be familiar to children and adults throughout the world. What lessons do you remember learning from Kermit?** *Kermit.*
©The Jim Henson Company.

Focus

- Who are the teachers in our world?
- How do artists use their artworks for teaching?

Our first teachers are our parents and siblings. They teach us how to do many things—tie our shoes, eat with utensils, ride a bike, and even to read. In school, we learn from our classmates and teachers. We learn, for example, about important people, events in history, and ideas in science and math. We also learn new skills. Some of the most important things we learn are good habits (such as studying hard) and values (such as the importance of being considerate and of caring for the environment). We also learn from our experiences outside of home and school. Grandparents, neighbors, and people we see on television or listen to on the radio are some of the teachers among us.

The artist Jim Henson created Kermit the Frog (Fig. 4–1) and other Muppets. For over thirty years, his *Sesame Street* characters have taught small children important lessons, such as to count and sound out words, and to be polite and responsible in daily life. In the lessons that follow, you will read about Jim Henson and other artists who have made artworks for the purpose of teaching.

Meet the Artists

Jim Henson
Barbara Kruger
Osman Waqialla

Words to Know

monument	arabesque
mural	poster
calligraphy	proportion

Jim Henson

The Puppeteer as Teacher

"When I was young, my ambition was to be one of the people who made a difference in this world. My hope still is to leave the world a little bit better for my having been here."
Jim Henson (1936–1990)

© The Jim Henson Company.

Fig. 4–2 **The arms or hands of Muppets are attached to rods. The rods are controlled from below by puppeteers.** *Puppeteers Handling Muppets.*
© The Jim Henson Company. Photo: John E. Barrett.

Jim Henson's Journey

When Jim Henson was a boy, he loved to use different art materials and techniques to make things. His grandmother was a painter, quilter, and needleworker. She encouraged her grandson to explore the world around him and always to use his imagination. He particularly liked his art classes and was very active in high-school theater productions. When he saw television for the first time, as a teenager, he knew that he would make a career working with this new and exciting medium.

Henson's interests in art, theater, and television all came together when he landed a job as a puppeteer on a local children's television show. He was only eighteen. One year later, Henson created Kermit, his most famous puppet.

Creativity Through Collaboration

From early on, Henson collaborated. He and Jane Nebel, whom he later married, brought in others to work with them. Eventually, Henson was asked to create a group of puppets for a new show, *Sesame Street.* Henson's work resulted in the "birth" of the Muppets: Ernie and Bert, Oscar the Grouch, Grover, Cookie Monster, and Big Bird. Collaboration is important because it takes many people to operate the Muppets

(Fig. 4–2). The puppeteers all must work together to make a successful show.

Over the years, Henson and his team created many more Muppets for *Sesame Street* and other television shows and movies (Fig. 4–3). Henson's great sense of humor helped his characters teach important information and good habits in a fun and entertaining way.

The Teaching of Traditions

Artists worldwide have created artworks to help people learn important traditions within their own culture. Artworks can also teach community values and facts about history. All teachers must make choices about how to teach. In art, this means that artists make choices about what lesson to teach and how to help their viewers learn that lesson. To do so, artists think about scale (the size of the artworks they will produce). They also think about where and how people will view their artworks.

Dolls and other small-scale objects are very useful for teaching. The Hopi of the American Southwest, for example, use small kachina figures (Fig. 4–4) to help teach children about the spirits and symbolism important to Hopi religious beliefs. Before traditional annual celebrations, Hopi fathers and uncles carve kachinas and present them to the children.

Fig. 4–4 **Hopi children use figures such as these to help them remember each kachina's story and special religious function.** Native American, *Sio Hemis, Kachina,* 19th–20th centuries. Carved and painted wood. Fred Harvey Collection, Heard Museum, Phoenix, Arizona.

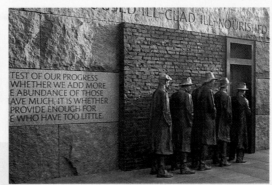

Fig. 4–5 **The FDR Memorial covers more than 7 acres. As visitors move through a series of waterfalls and read inscriptions carved into granite, they go on a journey through time.** George Segal, *Bread Line* (aerial view and closeup), 1997.
Bronze. Room 2 from the Franklin Delano Roosevelt Memorial, Washington, DC. Photo by Lawrence Halprin. © The George and Helen Segal Foundation/Licensed by VAGA, New York, NY.

Fig. 4–6 **Judy Chicago gathered many people together to help her create this installation. When assembled, it fills an enormous room.** Judy Chicago, *The Dinner Party*, 1979.
Mixed media, 48' x 42' x 3' (15 x 13 x 1 m). Collection: The Dinner Party Trust, Photo: Donald Woodman. © 2001 Judy Chicago/Artists Rights Society (ARS), New York.

Teaching for a Better World

Throughout history, artists have created artworks for the walls and other features of religious or public buildings. These artworks remind people of shared values and beliefs. Artists have also created public structures to teach about events and people from the past. One such public **monument** is the Franklin Delano Roosevelt Memorial (Fig. 4–5), in Washington, DC. Lawrence Halprin designed the memorial as a series of outdoor "rooms." Each room represents one of the four terms that Roosevelt served as president. The memorial allows visitors to learn about the important events of his presidency.

Individual artists sometimes use their artworks to teach people to think differently about things—to change their mind or attitudes. In recent times, artists have created artworks to teach us to think differently about issues facing our society. In her installation *The Dinner Party* (Fig. 4–6), artist Judy Chicago teaches about the artistic and other contributions of women throughout history. Each place setting at the table represents an important woman in history. Violence, poverty, the role of women, and racial tensions are some of the other topics addressed by artists as teachers.

A Teaching Puppet

When artists create artworks for the purpose of teaching, they must consider what they want to teach and how they will teach it. **In this studio experience, you will create a puppet that will help you teach something important.** Do you want to teach an event in history, the importance of good habits, or something about caring for the environment?

As you think of ideas for your puppet, reflect on your audience, what you want to teach, and the kind of puppet character that can help you. Write down your ideas. The character you create should have a personality especially suited for the teaching.

You Will Need

- puppetmaking materials
- scissors
- white glue
- markers (optional)
- tempera paint and brushes (optional)

Try This

1. Decide what kind of puppet to make. Will you create a hand puppet or a finger puppet? Will you make an even larger puppet? The scale, or size, of your puppet will be important. A small puppet, for example, will work best with a small audience. A larger puppet might be best for a large audience.

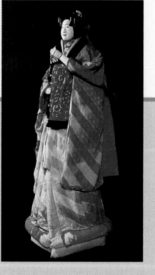

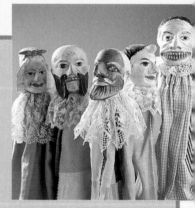

Studio Background

Puppets

For hundreds of years, people around the world have used puppets to tell stories and teach important lessons. In some cultures, puppet theater is almost as popular as television.

Puppets come in all shapes and sizes. Some of the largest puppets in the world can be found in Japan. *Bunraku* is a traditional form of Japanese puppetry used to tell stories about the past. A Japanese *bunraku* puppet is shown in Fig. 4–7. Because the puppets are so large, three people are needed to control each one.

On a smaller scale, hand puppets (Fig. 4–8) are another popular form of puppetry. Perhaps the smallest puppets are finger puppets. In ancient China, children played a game in which their fingers were painted. Today, finger and hand puppets are made from many different materials.

Fig. 4–7 **The puppeteers move the puppet's eyes, eyebrows, and sometimes its mouth, arms, and feet, while other artists play music and tell the story.** Japan, *Bunraku puppet*, 20th century. Courtesy the Sheehan Gallery at Whitman College, Walla Walla, Washington.

Fig. 4–8 **Hand puppets are often used to tell fables and other stories that teach a lesson.** Western Europe, *Hand Puppets,* late 19th–early 20th centuries. Painted wood, average height: 16" (41 cm). Girard Foundation Collection in the Museum of International Folk Art, a unit of the Museum of New Mexico, Santa Fe. Photo by Michel Monteaux.

2. Plan and assemble your puppet. What features will it have? What materials will you use to create the puppet? Choose materials that will suit the size and purpose of your puppet.

3. When the main forms of your puppet are finished, glue on smaller items, such as sequins, yarn, buttons, and the like. How can you use details to create a personality for your puppet? How can that personality help teach your lesson? Add other details as needed with paint or marker.

Check Your Work

Share your decision-making process with your classmates. Why did you decide to make your puppet the way you did? How did the lesson you wanted to teach and your intended audience affect your decisions? How did you use materials and details to create a personality that helped teach your lesson?

Lesson Review

Check Your Understanding

1. What kinds of things do people often teach one another?
2. How was Jim Henson's childhood important to his choice of a career?
3. When artists plan to make artworks for the purpose of teaching, what must they think about?
4. Can an artwork teach us something if the artist did not intend it to do so?

Fig. 4–9 **"This scientist will teach you all you want to know about rainbows. He will teach you the colors of the rainbow, where you can see them, and what special treat waits for you at the end of a rainbow. I hope you enjoy the show."** Maribeth Côté, *The Wacky Rainbow Scientist*, 2000. Sock, pipe cleaners, buttons, height: 12" (30.5 cm). Thomas Prince School, Princeton, Massachusetts.

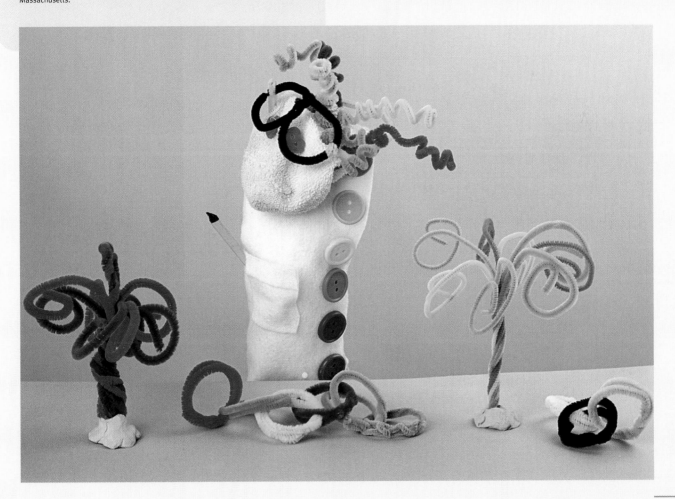

Art and Beliefs

1923
Rivera, *Education Ministry mural*

1987
Kruger, *Hero*

Italian Renaissance	20th Century

14th century
Lorenzetti,
Peaceful City

1967
Wall of Respect

1990
Kruger,
Think Twice

Travels in Time

Throughout history, one use of art has been to teach religious and political beliefs. In the Middle Ages, stained-glass windows and mosaics in churches were reminders of important religious lessons. In the Renaissance, artists used frescoes (Fig. 4–10) and sculptures in government buildings and other public places to teach political beliefs. Today, murals and billboards can teach about social concerns and cultural identities. What all of these art forms have in common is their size: they are all large in scale.

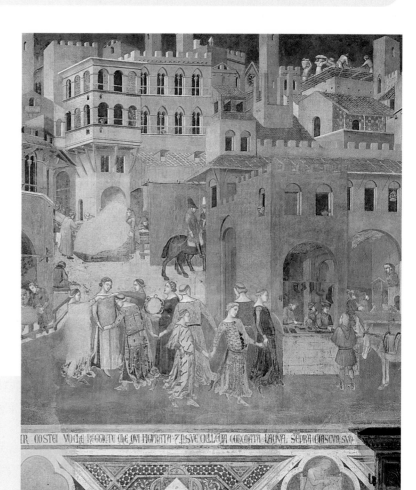

Fig. 4–10 **What lesson do you think this image teaches? This is a detail of a fresco cycle that covers the walls of a large room.** Ambrogio Lorenzetti, *Peaceful City*, from *Effects of Good Government in the City and the Country* (detail), 14th century.
Fresco. Palazzo Pubblico, Siena, Italy. Scala/Art Resource, New York.

154

Murals That Teach

A **mural** is a large artwork that is usually painted on the wall or ceiling of a public building. Murals are one way to remember the people and events that helped shape a nation.Some of the most beautiful murals are those created in the first half of the twentieth century in Mexico City. The large-scale murals by Diego Rivera (Fig. 4–11) are used to teach the Mexican people about their country's history. Rivera was one of a group of Mexican muralists that also included David Alfaro Siqueiros and José Clemente Orozco. These artists painted huge murals with larger-than-life figures.

The *Wall of Respect* in Chicago (Fig. 4–12) was an important teaching mural painted in the second half of the twentieth century. It showed a number of African-American political, historical, and popular-culture figures. Painted in 1967 on an abandoned building, the mural was destroyed along with the building in 1971. But it inspired hundreds of similar murals in neighbor-hoods across America. These murals, like so many artworks before them, teach us about the past and what should be remembered in the future.

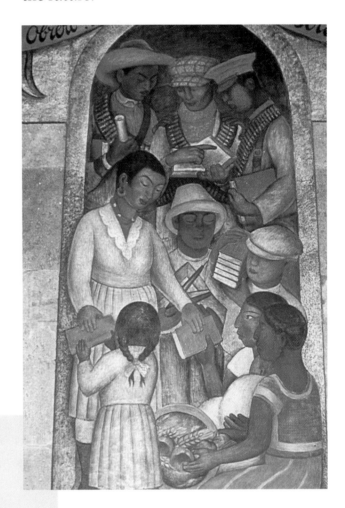

Fig. 4–11 **Diego Rivera's murals remind people of the past and give them hope for the future. How is a mural useful in teaching?** Diego Rivera, *The People Receive Books*, 1923–28. Fresco. Located in the Education Ministry, Mexico City, Mexico. Photo by Mark Rogovin. Courtesy Davis Art Slides.

Fig. 4–12 **How can a mural on the side of a building contribute to your personal journey in the place you live?** *The Original Wall of Respect*, 1967; destroyed 1971. Originally at 43rd and Langley, Chicago, Illinois. © 1967 Robert A. Sengstacke.

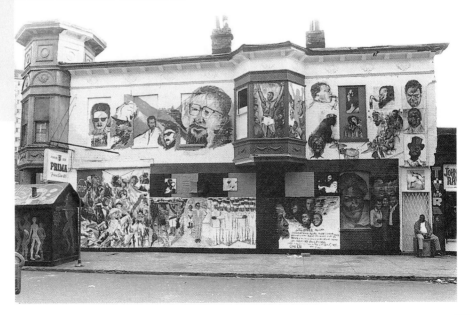

Teaching Through Challenges

"I just say I'm an artist who works with pictures and words."
Barbara Kruger (born 1945)

Photo: Timothy Greenfield-Sanders.

Not all artworks instruct you to follow certain rules or provide you with answers. Barbara Kruger does not say that her artworks teach. But they do teach because they challenge you to think about, and even to reject, a message or idea.

Growing up in New Jersey, Kruger took photographs of buildings and neighborhoods. But she lost interest in that when she started working for magazines. As a graphic designer for a magazine, she learned to look carefully at photographs. She thought about making them larger or smaller, focusing in on one part, and placing type over them. This experience helped her as an artist and gave her the confidence to use "found" images to create her own art.

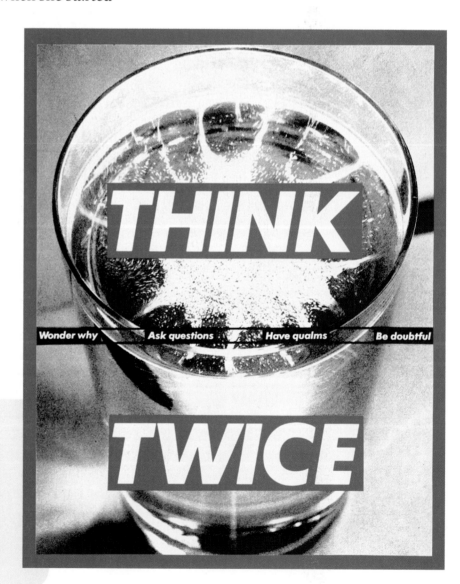

Fig. 4–13 **What lesson is introduced with this large-scale image? How would seeing this image as a billboard differ from seeing it as a small painting on a museum wall?** Barbara Kruger, *Untitled* (Think Twice), 1992.
Photographic silkscreen on vinyl, 102" x 82 1/2" (259 x 209.5 cm). Courtesy of Mary Boone Gallery, New York.

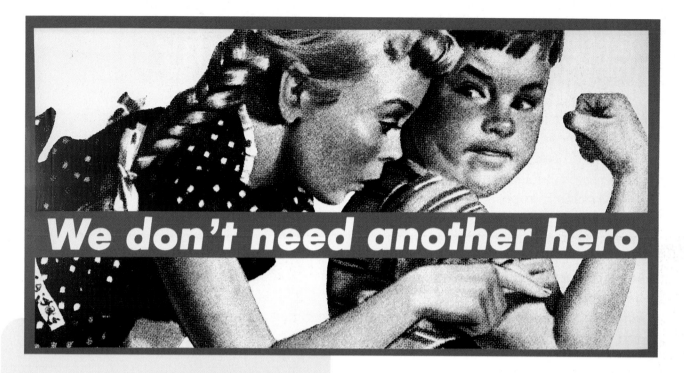

Fig. 4–14 **What, do you think, was Barbara Kruger trying to say with this billboard?** Barbara Kruger, *Untitled* (We Don't Need Another Hero), 1987.
Photographic silkscreen on vinyl, 109" x 210" (276.9 x 533.4 cm). Courtesy Mary Boone Gallery, New York. Emily Fisher Landau Collection, New York.

Teaching with Pictures and Words

Kruger's artworks range from large scale to small. Some of her works, such as those in Figs. 4–13 and 4–14, are billboards. Her artworks are easy to recognize. She places bands of text over black-and-white photographic images to create artworks that look like pages from a magazine.

Kruger's work teaches because she shows stereotypes and clichés (overused sayings). The artist seems to be saying "Here's the issue and what it looks like to me; what do *you* think?"

Studio Connection

Paint a group mural to teach about your school—its history and goals, what makes it a special place, and so on. You may paint the mural on large sheets of paper and display it in the school or community on a temporary basis. Or you may wish to create a mural that is more permanent. Think about where the mural should be: the hallway, cafeteria, gymnasium, a local public building, an outside wall, and so on. Think also about how to teach in visual form. With use of few or no words, how can you convey the important ideas?

Lesson Review

Check Your Understanding
1. What do stained-glass windows, murals, and billboards have in common?
2. What is one kind of lesson that murals can teach?
3. How do Barbara Kruger's artworks teach?
4. Explain what inspired the look of Barbara Kruger's artworks.

Lettering and Calligraphy

Calligraphy is a form of beautiful lettering. Historically, people have used it to record important ideas in books, on scrolls, and in other important documents. During the Middle Ages in Europe, monks and nuns used calligraphy to make copies of religious books. In Japan, there is a long tradition of practicing calligraphy as a form of self-discipline and meditation. In Arab and other Asian cultures, the forms of written communication are so complex that people need calligraphy skills just to write simple sentences.

Today, people still use calligraphy to create special handwritten messages. It is a skill worth developing.

Fig. 4–16 **To help teach important lessons, many artists combine calligraphy with beautiful illustrations.** Jon Brelsford, *Psalm 24:1*, 2000.
Pen, ink, watercolor on paper, 11" x 14" (28 x 35.5 cm). Penn View Christian School, Souderton, Pennsylvania.

Fig. 4–15 **The numbers and arrows surrounding each letter indicate the number, order, and direction of strokes needed to make that letter. Also notice the relationship between one part of a letter and another. This relationship, which is called proportion, is important in calligraphy.**

Calligraphy Practice

Before you begin writing letters, first practice making rows of diagonal, vertical, horizontal, and curved strokes with a calligraphy pen. The pen should have a medium nib and chisel point. Use lined notebook paper or draw parallel lines to help guide your practice. Be sure to hold your pen at a constant angle and pull the nib toward you. This will result in the beautiful thick and thin lines that make calligraphy distinctive.

Now combine strokes to create letters. Look at the alphabet in Fig. 4–15. Practice writing each letter. Make the height of capital letters about seven times the width of the pen nib. The height of small lowercase letters, such as *a*, should be about five times the width of the nib. Tall lowercase letters, like *h*, are the same height as capital letters. The width of letters will vary slightly, but as a general rule, each should be similar to the height of a lowercase *a*.

Fig. 4–17 **Why might graphic designers use mechanical lettering in a poster design?**

Mechanical Lettering

Look at the letters in Fig. 4–17. This is called mechanical lettering, which is different from calligraphy. Graphic designers often use mechanical lettering on posters and billboards. The letters are all capitals. Notice also that each letter is a square—five spaces high and five spaces wide. Some of the parts of individual letters are created by drawing a 45-degree angle from one corner of the square to the other.

Practice writing your name with mechanical lettering. How do these letters compare to the letters used in calligraphy? The next time you plan a poster or design a bulletin-board message, refer to this diagram. You might paint the letters or draw them on construction paper and cut them out.

Studio Connection

Use your lettering skills to copy a short poem, quote, or message that teaches a lesson. With a pencil, draw light guidelines on your work surface to create a layout for the words. Leave a little space between each letter and extra space between each word. Also, plan carefully for the spacing between lines. For example, make sure that lowercase letters like *p* and *y* don't touch any capital letters or letters like *l* or *b* in the line below. Be sure to check your spelling before you begin lettering.

Lesson Review

Check Your Understanding

1. Use your own words to describe calligraphy.
2. If you were skilled in both calligraphy and mechanical lettering, which would you use to write a thank-you note to a friend? Why?

Artists as Teachers

Islamic Art of North Africa

North Africa

Places in Time

The Islamic religion was started in 622 AD by the Arabian prophet Muhammad. Within a century, the religion had spread from Arabia (now Iran) to North Africa. The North African followers of Islam found their guidance in the text of the Quran (or Koran), a holy book (Fig. 4–18). The religion brought about an artistic and cultural unity in the vast desert regions of North Africa bordering the Mediterranean Sea.

Fig. 4–18 **What kinds of lessons, do you think, would be written in calligraphy in this holy book?** North African (Egypt?), *Two Text Pages from Sura 6 of the Koran,* 12th century.
Ink, colors, and gold on paper, 5 1/4 x 6 1/4 (13 x 16 cm). Bequest of Mrs. Margaret McMillan Webber in memory of her mother, Katherine Kittredge McMillan. The Minneapolis Institute of Arts.

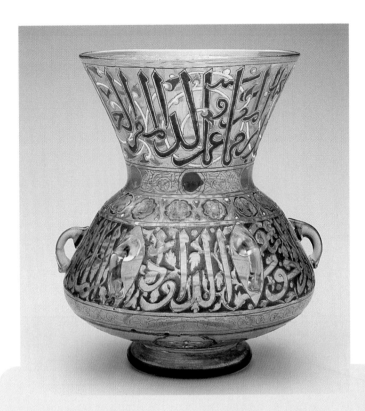

Fig. 4–19 **Why would an artist want to add writing to such an object?** Islamic, Egypt, *Mosque Lamp*, 1331–35.
Blown glass with enamel, gilded; height: 10 13/16" (27.5cm). The Toledo Museum of Art. Purchased with funds from the Libbey Endowment, Gift of Edward Drummond Libbey, acc. no. 1940.118.

Fig. 4–20 **What are the similarities and differences between this writing board and the boards in your classroom?** Africa, Sudan, Omdurman city, *Writing Board*, 19th–20th century.
Wood and ink, 31 7/8" x 11" (81 x 28 cm). The Brooklyn Museum, Museum Expedition 1922, The Robert B.Woodward Fund (22.231).

Lessons in Calligraphy

Calligraphy, the art of beautiful handwriting, is highly developed in Islamic art. It is one of Islam's important artistic contributions. The teachings of Islam are often written in calligraphic script. North African Islamic artists use calligraphy to decorate many kinds of handmade objects, such as the lamp in Fig. 4–19. Decorative writing often covers objects made by blacksmiths, leather workers, dyers, jewelers, and metal workers.

The writing board (Fig. 4–20) is also an important art form associated with Islam in North Africa. Writing boards are made of wood and are used to teach children the sacred writings of Islam. Calligraphers write the lessons in precise, bold, and rounded Arabic script. The Arabic script on writing boards is often richly decorated with geometric designs and calligraphic curves known as **arabesques**.

The Calligrapher as Teacher

"My art teaches about the sacred (religious) and the secular (non-religious)."
Osman Waqialla (born 1926)

Illustration courtesy Tom Miglionico.

Today, many North African artists continue the art of calligraphy. One such artist is Osman Waqialla. He is an artist, poet, journalist, and teacher.

Waqialla was born in Sudan, an African country just south of Egypt. He went to school in Sudan, but under a British system of education. Waqialla's art education was based not only on European influences, but also on African traditions and use of local materials.

In the 1940s, Waqialla studied art in London and then studied in Egypt, at the School of Arabic Calligraphy and College of Applied Arts. Here, he explored Arabic calligraphy and developed his unique style.

Fig. 4–21 **What reason might the artist have had for making some letterforms much larger than others?** Osman Waqialla, *Calligraph: "Deep sorrow defies definition"* (Arabic text from the poem "The Wandering Dervish" by Mohammed Alfeytoori), n.d. Ink on paper, 16 ½" x 23 ⅜" (42 x 60 cm). Courtesy Osman Waqialla/Napata Graphics.

Expressive Teachings

Waqialla has mastered the skills of traditional calligraphy. This mastery allows him to be more expressive in his script. He often varies the size and shape of letterforms, and even overlaps letters to create decorative effects.

In addition to the scripting of sacred texts, Waqialla created a series of nonreligious works of modern poetry. He continues to work with both religious and nonreligious themes. His unique designs and emphasis on Arabic and Islamic identity have influenced a movement in calligraphic style known as the Khartoum School. Like the artists who have followed his lead, Osman Waqialla sees the letters of Arabic script as beautiful forms of artistic expression.

Fig. 4–22 **How did the artist make some shapes stand out?** Osman Waqialla, *Calligraph* (text from one of the gospels), 2001.
Wood writing plaque, 16 1/2" x 23 3/8" (42 x 60 cm). Courtesy Osman Waqialla/Napata Graphics.

Studio Connection

Create a decorative board or plaque that teaches something important, such as a proverb, saying, or rule. Think of an imaginative shape for the plaque. Practice calligraphy and decorative letterforms before applying them to the plaque. Your plaque can be of heavy cardboard, foamcore, or wood. Because the presentation of your written words is important, consider how the plaque will be displayed.

Check Your Understanding

1. How are writing boards used in Islam?
2. How is calligraphy used by Islamic artists in North Africa?
3. How does Sudanese artist Osman Waqialla use calligraphy in his artwork?
4. What objects in your home are decorated with beautiful writing?

Artists as Teachers

163

Designing a Poster

Teaching a Lesson

Studio Introduction

Think of the times you have seen a community-event flyer, a political poster, or a billboard. These are all examples of posters. A **poster** is an artwork that combines one or more pictures with words to send a message or teach a lesson. Posters teach by making us aware of public concerns and events. If you make a list of the kinds of messages you see on posters, your list could include campaign messages, pleas to protect wildlife, advice to parents, warnings against smoking, or many other topics and themes.

In this studio experience, you will design a poster that will teach a lesson. Pages 166 and 167 will show you how to do it. Choose a topic that is important to you. Perhaps your poster will teach about the value of reading, eating well, or exercising. What other ideas come to mind? Think about your audience as you design the poster. Where will your audience see it? How large or small should it be to grab your audience's attention? How can you design the poster to best teach your lesson?

Studio Background

Teaching with Posters

Artists began making posters as a way to communicate to a large audience. The posters you see here were designed for the purpose of teaching. The poster by illustrator Norman Rockwell (Fig. 4–24) reminds Americans about the importance of freedom. Ben Shahn, an artist known for his style and interest in lettering, created a poster to teach others about human rights (Fig. 4–23). The artists involved in the program combined their drawings with poetry to help educate people who rode on buses.

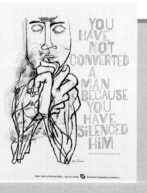

Fig. 4–23 **What did the artist do to alter the proportions of the human figure in this poster?** Ben Shahn, *You Have Not Converted a Man Because You Have Silenced Him,* 1968.
Offset lithograph, 45" x 30" (114 x 76 cm). National Museum of Art, Smithsonian Institution, gift of the Container Corporation of America. © Estate of Ben Shahn/ Licensed by VAGA, New York, New York.

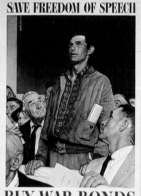

Fig. 4–24 **This poster, from a series of four that Norman Rockwell designed, encouraged Americans to preserve their basic freedoms.**
Norman Rockwell, *Save Freedom of Speech,* 1943.
Color lithograph, 40" x 28 1/2" (102 x 72 cm). Hoover Institute Archives, Stanford University. Printed by permission of the Norman Rockwell Family Trust. Copyright © 2001 The Norman Rockwell Family Trust.

Fig. 4–25 **"I used cut paper to make my poster. I used some comic things like putting my dog in the car, too. Sometimes the paper was hard to fit."** Scott Skophammer, *Seatbelts Work*, 2000. Cut paper, marker, 12" x 18" (30.5 x 46 cm). Saint Paul Lutheran School, Fort Dodge, Iowa.

Creating Your Poster

You Will Need

- sketch paper
- pencil and eraser
- ruler
- large drawing paper
- colored pencils, markers, or crayons

- newspapers or magazines (optional)
- scissors (optional)
- glue (optional)

Try This

1. Choose a topic for your poster. What do you want to teach about the topic? How can you use words and pictures to express your teaching? Will you choose two or three key words, or will you write a longer statement? Will you use one picture or more than one?

2. Plan your design. Decide where you want to place words and pictures. Will you

draw your letters by hand or will you cut them out of a newspaper or magazine? Think about proportion and scale. If you draw your letters, think about the size of one part of each letter in relation to another. How large will your words and pictures be in relation to one another? How can your design decisions make your teaching stronger? Sketch your ideas.

3. Choose the idea that you think works the best. With a pencil, lightly draw your design on drawing paper. Then fill in areas with color. What colors will enhance your teaching? Think about the mood you want to express and how you can use color to express it.

4. If you decided not to draw your words,

cut letters or words from a magazine or newspaper. Arrange the words on the poster. Carefully glue them in place when you are happy with the arrangement.

5. When you are finished with your poster, carefully erase any unwanted lines.

Check Your Work

Display your poster with your classmates' posters. Group similar themes and topics, and discuss the designs. How do the words and pictures work together in each design? Talk about the size relationships between words and pictures. Which ideas work better than others to express the teaching? What improvements could be made?

Computer Option

Design your poster by using either an image-editing program like Photoshop, or a page layout program such as Adobe PageMaker. You will create two versions of your poster using the same topic, text, and images but different designs and use of color. Experiment with size relationships, colors, and type styles. Which version is more effective in portraying the lesson you want to teach?

Proportion

Proportion is the relationship between a part of something and the whole. It compares the size or amount of the part to the whole. For instance, if you saw a sheep, you might say "Wow, for such a big sheep, she sure has a small head!" By saying this, you have noted the size of the head *in proportion to* the size of the whole body. Or suppose you see a painting that is almost entirely yellow and red, with just a small amount of white. You might say "A large proportion of this painting is yellow and red." (To learn about human proportion, see Lesson 3.2, pages 132 and 133.)

Scale is the size of one thing compared to the size of something else. In art, scale may be used to exaggerate an object and thereby surprise viewers. Scale may also add humor to an artwork. Imagine seeing a painting in which an ant is larger than a house!

Artists often use proportion and scale to make a statement, or to make some objects in an artwork more important than others. How have you used proportion and scale in your own artworks?

Fig. 4–26 **"I made this because I live on a beautiful beach, and I think we should keep them clean so future generations can see their beauty."** Jonathon Renuart, *Save the Beaches*, 2000.
Colored pencil, marker, cut paper, 12" x 18" (31 x 46 cm). Laurel Nokomis School, Nokomis, Florida.

Artists as Teachers

167

Connect to...

Careers

What do you think an **art teacher** needs to know and be able to do? Teaching art requires familiarity with a wide range of art materials and media, art periods and styles, and historic and contemporary art. Art teachers may teach at different grade levels, from kindergarten to college, and in public or private schools. They may also be artists and experts in their art field of interest. For training and higher education, art teachers usually pursue degrees in art education. They acquire certification to teach in public and private schools, and may obtain an advanced (doctorate) degree in order to teach in colleges or universities. If you enjoy learning about, making, and teaching through art, you might consider the profession of an art teacher. Ask your own art teacher to share his or her reasons for becoming a teacher.

Other Arts

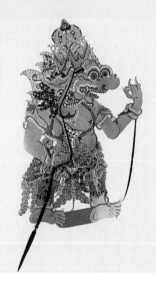

Theater

In many cultures, puppets enact stories that are meant to teach. Performances of famous tales, myths, legends, and reflections of daily living educate audiences about history, morals, values, and beliefs. One of the oldest story-telling traditions is the shadow-puppet theater known as *wayang kulit*, from the Indonesian island of Java. The puppetmaster is called *dalang*. The *dalang* is highly respected by the community, not just for his role as an actor, but also for his role as a historian and a teacher.

Fig. 4–27 **The flat, cutout puppet is attached to rods that the puppeteer uses to move the puppet in front of a light. The audience, seated in front of a screen, sees only the puppet's shadow.** Indonesia, Central Java, *Wayang Kulit* (Shadow Puppet), c. 1950.
Cut, painted leather, height: 31 1/2" (79 cm). Museum of International Folk Art, a unit of the Museum of New Mexico, Santa Fe.

Internet Connection
For more activities related to this chapter, go to the Davis Website at **www.davis-art.com.**

Social Studies

Have you ever wondered if **beliefs and attitudes about learning and teaching differ among cultures**? Most Native American cultures hold the belief that knowledge must be earned rather than given. As a result, the asking of questions is considered rude, because learning is withheld until the right to know is earned. For example, at different stages in their life, Hopi children are given specific kachinas, and they learn the lessons the kachinas teach. The kachinas are not toys to be played with, but are reminders of the knowledge they carry.

Language Arts

Many similar concepts exist between art and language arts. These concepts may best be taught together. Related pairs of terms from art and language arts include meaning/main idea, detail/elaboration, sketch/rough draft, biography/portrait, and drawing/handwriting. Can you make comparisons between each pair of terms?

Science

Have you ever visited or read about the Grand Canyon? In the 1800s, many artists and photographers went on expeditions into the area. They captured the area's natural beauty in hundreds of paintings and photographs. **These artworks were often used to teach people in the East about the West.** They were also meant to encourage people to move into and settle the region.

Fig. 4–28 **This painting was used to encourage the establishment of the first national parks, in order to preserve and protect the region's beauty and natural environment.** Thomas Moran, *Shin-Au-Av-Tu-Weap (God Land), Canyon of the Colorado, Utah*, c. 1872–73.
Watercolor and pencil on paper, 4 13/16" x 14 9/16" (12.2 x 36.9 cm). Smithsonian American Art Museum, Gift of Dr. William Henry Holmes 1930.12.42. Courtesy Art Resource, New York.

Daily Life

The word *teacher* means "one who instructs." There are **many people who serve the role of teacher in your life.** But do you serve that role for anyone else? No matter how young or how old you are, you can teach by example, by instruction, or by working with others. You may be a teacher to younger brothers and sisters, to children you babysit, to neighbors you help, or to friends at school or in clubs.

Fig. 4–29 **What situations can you think of in which you act as a teacher?**
Photo courtesy Gen Gaidis.

Portfolio

"I chose a Giant Panda for my endangered species vest because I was in awe of such a majestic creature. The texture of the fur was hard to paint, but in the end my Panda vest turned out pretty much like I hoped it would." **Kristin Bott**

Fig. 4–30 **How does wearing a picture of endangered animals raise public awareness?** Kristin Bott, *Endangered Species Animal Vest*, 2000.
Acrylic paint on fabric, 25" x 18" (63.5 x 46 cm). Kamiakin Junior High School, Kirkland, Washington.

"I chose to put IMGMNST (I am gymnast) on my license plate because at the time I was taking gymnastic lessons and wanted very much to be a gymnast. The most difficult part was measuring the perimeter to make it all of the same measurements as a real license plate." **Mariel Ryan**

Fig. 4–31 **What does this license plate teach you about Idaho?** Mariel Ryan, *License Plate Design*, 1999.
Marker, 6" x 12" (15 x 30.5 cm). Garfield Elementary School, Boise, Idaho.

Fig. 4–32 **Seven students worked together to paint a mural of scenes from their town's history. Each student chose a scene to represent. In order to teach others about history, the artists first had to learn about it themselves.** Dennis McClanahan, Karina Ruiz, Rokeisha Joiner, Valarie Garcia, Iris Cuevas, Paul Brown, Shanna Nielsen, *Views of Historic Galveston*, 2000.
Latex paint on canvas, 4' x 8' (13 x 26.2 m). Central Middle School, Galveston, Texas.

CD-ROM Connection
To see more student art, view the Personal Journey Student Gallery.

Chapter 4 Review

Recall

Name three artists who have made artworks to teach important lessons.

Understand

Give at least two examples of the kinds of lessons that artists might try to teach with their artworks.

Apply

Produce a series of six drawings that teach good habits. Consider, for example, safety, good grooming, and getting along with other people.

Analyze

You have learned how artists use puppets, such as Jim Henson's Muppets (Fig. 4–3, *shown below*), to teach important lessons. Explain what makes a puppet an effective teacher.

Synthesize

Document examples of visual lessons in your community, and explain what is being taught and to whom.

Evaluate

Imagine that you could choose Jim Henson, Barbara Kruger, or Diego Rivera to create an artwork for your school. State why you think this artist is the best choice to teach an important lesson to students in your school.

Page 149

For Your Portfolio

From this chapter, choose one artwork. In writing, describe it, explain its meaning, and judge its merit as a visual lesson. Remember that you need to use words that create an image in your reader's mind.

For Your Sketchbook

Select one letter of the alphabet. Fill a sketchbook page with variations (fonts) of the letterform. On another page, match letterforms with a particular audience. For example, which of your fonts would be appropriate for an audience of third graders? Of adults?

Artists as Interpreters

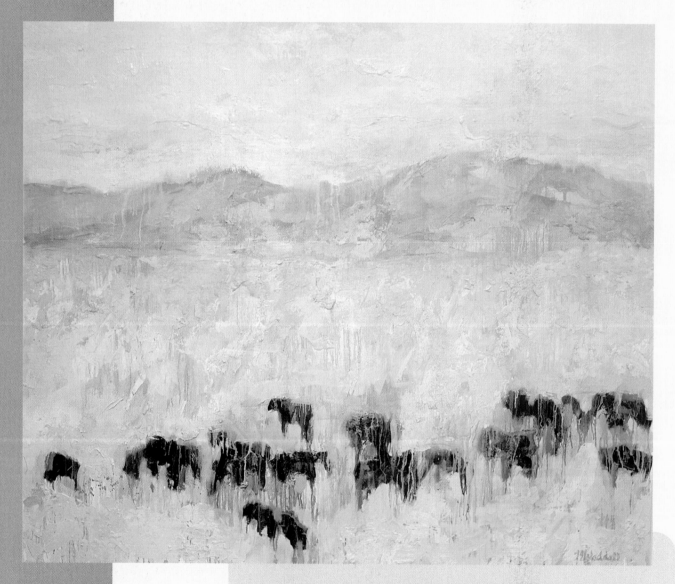

Fig. 5–1 **As Theodore Waddell travels through the wide-open spaces of Montana, he notices how the grazing animals seem to blend into the landscape. How did the artist use paint to show this?** Theodore Waddell, *Monida Angus #7*, 2000.
Oil, encaustic on canvas, 60" x 72" (152 x 183 cm). Courtesy Bernice Steinbaum Gallery, Miami, Florida.

Focus

- How do people think about, or interpret, their connections to the natural world?

- In what ways do artists use color and art techniques to show their ideas about nature?

People react to nature. For example, when you come across a spiderweb, what is your reaction? Do you see it as a nuisance to get rid of immediately? As evidence that an interesting insect is nearby? As a beautiful pattern of lines? One person might exclaim that the web is creepy; another person might show it to friends and talk about its delicate design. The way we react to nature depends on how we think about and explain it—how we interpret it.

Artist Theodore Waddell often looks at animals in the environment. He notes how colors in nature change with the seasons and even with the time of day. Waddell shows how animals seem to merge with their surroundings. His painting *Monida Angus #7* (Fig. 5–1) depicts the two as if they were one. In this chapter, you will learn more about Theodore Waddell and other artists who give us new ways of thinking about what nature provides.

Meet the Artists

Theodore Waddell
April Gornik
Chao Shao-an

Words to Know

expressive color	tint
local color	shade
Romantic	intensity
Realist	complement
luminism	dynasty
primary colors	color spectrum

Theodore Waddell

Landscape Interpreter

"I spend a lot of time observing before I begin painting. How animals move on a plain of green and ochre, constantly changing and yet remaining the same. It is good to be in this place."
Theodore Waddell (born 1941)

Photo by Lynn M. Campion, © 1997.

Theodore Waddell's Journey

Theodore Waddell is an artist and a rancher who grew up and still lives in Montana. Montana is called the land of "big sky" because of its vast landscape. From a distance, Waddell sees creatures and an occasional tree dotting the horizon. From up close, he also observes them in his daily work on his ranch.

Waddell left home to study art in college and graduate school, where he was especially interested in making sculpture. When he returned and took up ranching, he turned to painting because he thought that would be the best medium to show the wide-open spaces of the landscape he loved.

Fig. 5–2 **Waddell has studied how artists throughout history have used paint to interpret the world of nature. The title of this painting refers to the Impressionist painter Claude Monet, who observed and painted the effects of sunlight.** Theodore Waddell, *Monet's Sheep #3*, 1993.
Oil, encaustic on canvas, 18" x 24" (46 x 61 cm). Courtesy Bernice Steinbaum Gallery, Miami, Florida.

Interpreting the Land

Waddell has experimented with ways to use paint. In his early paintings, he applied paint thickly. By doing so, he suggested the forms of animals. To create interesting effects and textures, he has applied paint with a brush, a rag, and the heel of his hand. In his more recent paintings, he uses thinned paint to create his animal forms with quick brushstrokes. He even allows the paint to drip.

Waddell begins slowly, carefully observing. He explores the land and makes notes about the sites he wants to include in his paintings. He notices that things appear differently as the seasons change. Summer light brings out colors not seen in the harsh Montana winters. Horses in the spring reflect the colors of the sky, the grass, and the vibrant sunlight. In winter, their forms emerge through snow that Waddell paints in purples, pinks—even black! Study the artworks in Figs. 5–2 and 5–3. These painted interpretations reveal Waddell's thinking about how, in nature, everything is connected.

Artists as Interpreters

Ideas About Nature

Artists from cultures around the globe have found beauty in the natural world. Some artworks show nature as magnificent, dazzling, or grand; others, as peaceful or calm. Whereas one artist interprets nature as friendly, another may find it dangerous or threatening. What are your ideas about nature?

Images of Nature

Artists interpret nature: they depict animals, insects, plants, and entire landscapes, bringing their own ideas about nature to their work. Each artist thinks about and interprets nature uniquely. When artists observe nature, they look for and see different features. Study the three artworks of horses shown here (Figs. 5–4, 5–5, and 5–6). What features did each artist emphasize? How is each work unique?

You can find interpretations of the natural world in paintings, sculptures, and other types of artworks. Many objects you encounter every day are decorated with artists' images of nature. Notice flowers, birds, bugs, and trees on greeting cards, fabric, and dishes. Whenever you see images of the natural world, try to determine how the artist showed it. Is nature presented as serious or silly? Delicate or bold? Some artists are very careful: they work almost like scientists, showing every detail of a plant or animal. Other artists want to express a general idea about nature. As you look at artworks, pay attention to the use of color and other art elements to express different moods, feelings, and ideas.

Fig. 5–4 **Deborah Butterfield uses wood, metal, straw, and other materials to create life-size sculptures of horses. Each horse sculpture has a different "personality." What words can you use to describe how this artist interprets nature?** Deborah Butterfield, *Cottonwood Creek*, 1995–96. Cast bronze, 81"x 96"x 26" (206 x 244 x 66 cm). Courtesy Buck-Butterfield, Inc. Collection of Art & Sherry Zimand, Orlando, Florida. © Deborah Butterfield.

Fig. 5–5 **We find brightly colored horses on carousels throughout the world. What feelings or ideas are expressed by such bright colors?** *Carousel Horse*, 20th century.
Photo courtesy *SchoolArts* magazine.

Fig. 5–6 **In China, the horse has always been an important part of culture. How does this sculpture show the artist's respect for the importance of the horse?** China, Tang dynasty, *Tomb Figure of a Saddle Horse*, early 8th century.
Earthenware, three-color lead glazes, length: 31 ½" (80.5 cm). Victoria & Albert Museum, London/Art Resource, New York.

Painting in the Studio

Creating Animals with Paint

Before interpreting nature in an artwork, an artist first looks carefully at the natural world. The artist probably has some ideas about nature, such as whether it should be controlled or left alone. As a painter, the artist must decide which techniques and colors will best express those ideas.

In this studio experience, you will create a painting of an animal in natural surroundings. Choose an animal that interests you. What is its environment? How do you feel about the animal and its environment? As you plan, think of ways to show the animal. Do you want it to look powerful and strong or in need of protection? How can you express your feelings and ideas in a painting? As you work, remember that your painting will be viewed as your interpretation of the animal.

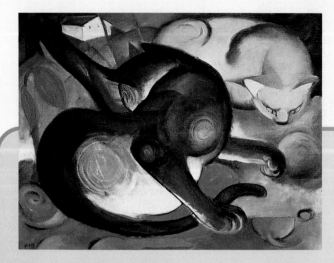

Fig. 5–7 **When painting a scene or object from nature, artists sometimes use expressive colors. What feelings or ideas did Franz Marc express in this painting?** Franz Marc, *Two Cats*, 1912.
Oil on canvas, 74" x 98" (188 x 249 cm). Oeffentliche Kunstsammlung, Basel, Switzerland. Art Resource, New York.

You Will Need

- heavy drawing paper
- pencil and eraser
- white construction paper, 2 sheets
- tempera paint
- variety of paintbrushes
- water
- foam plastic plate

Try This

side above below front

1. On drawing paper, create a sketch of your animal and its surroundings. Sketch the largest shapes first. Think about where you will place the animal on the page. From what angle will you show the animal? Will it be doing something? What kind of background scenery will you include?

2. Experiment with mixing colors of paint on a plate. On a sheet of white construction paper, test the colors you mix. Which colors will best express your ideas? Will you use **expressive color**—color that expresses your feelings or ideas of the subject? Or will you use **local color**—color that you see in the natural world?

Studio Background

Painting Natural Forms

To interpret the natural world in a painting, artists may use any of the elements of art. Painters may use lines that are sharp and clear or soft and blurred. They may decide to use many colors or just a few, and may have them range from light to very dark values. To create a mood, painters may create a work with dramatic lighting and shadows—or one with very little contrast. Painters may also use texture to create what looks to be a rough or smooth surface, or one of many different textures.

fur feathers

sand grass

3. On another sheet of construction paper, experiment making brushstrokes using a variety of paintbrushes. What textures and effects can you create? How can you use them to create the forms and details of your scene?

4. When you have created colors and brushstrokes that you like, begin adding color to your sketch. Paint large areas of color first. When the paint is dry, add details.

Fig. 5–8 **This artist used local color to express her ideas about a bird in a field of flowers. Notice the variety of brushstrokes.** Brittany Walker, *Bird Untitled*, 2000. Tempera paint, 12" x 18" (31 x 46 cm). Central Middle School, Galveston, Texas.

Check Your Work

How did you use paint to create an animal in natural surroundings? Did you experiment with different brushstrokes? How did your use of color and paint help you express ideas or feelings you have about the animal?

Lesson Review

Check Your Understanding
1. Why may two paintings of the same scene painted by two separate artists look very different?
2. Why did Theodore Waddell turn from sculpture to painting when he took up ranching in Montana?
3. Provide two examples of objects that show an artist's interpretation of nature.
4. Why would an artist want to experiment with color when painting an interpretation of nature?

Landscape as Art

Travels in Time

Throughout the history of art, artists have interpreted the land in many different ways. Some have shown the land as a decorative pattern; others, as a dreamlike vision. Dutch painters of the seventeenth century, such as Jacob van Ruisdael (Fig. 5–9), skillfully rearranged the various features of the land on their canvases. They were interested in the quality of light and open space and studied every color and detail. They captured the shifting shapes formed by clouds and the changing effects of sunlight on water. Their interpretations of the landscape were both dramatic (exciting) and natural.

Fig. 5–9 **Note the band of sunlight through the lower third of the painting. What happens to the colors of a landscape when clouds block the sun?** Jacob van Ruisdael, *Wheatfields*, 1670.
Oil on canvas, 39 3/8" x 51 1/4" (100 x 130 cm). Metropolitan Museum of Art, Bequest of Benjamin Altman, 1913 (14.40.623). Photograph © 1994 The Metropolitan Museum of Art.

Interpreting Land and Sea

Many nineteenth-century European and North American artists continued to interpret the character of the landscape. Some **Romantic** artists, including Turner (Fig. 5–11), responded to nature's power and beauty, and painted dramatic, emotional interpretations. **Realist** artists, including Gustave Courbet (Fig. 5–10), concentrated on the realistic appearance of land, sea, and sky.

The study of light on the landscape was very important for a group of American artists in the mid-nineteenth century. Art historians now refer to this interest in natural light as **luminism**. *Sunset over the Marshes* (Fig. 5–12) shows one artist's interpretation of the effects of light at sunset. The American luminist painters were concerned mostly with showing water and sky. Their works were realistic and had no sign of brushwork. Artists carefully blended colors. The artists were precise in showing different textures and the colors created by reflected and direct light.

Fig. 5–10 **What is the dominant, or strongest, color in this painting?** Gustave Courbet, *Seaside at Palavas*, 1854.
Oil on canvas, 10 5/8" x 18 1/8" (27 x 46 cm). Musée Fabre, Montpellier, France. Erich Lessing/Art Resource, New York.

Fig. 5–11 **Why is Turner called a Romantic painter? What colors did he use to show the elements of fire, water, and air?** J. M. W. Turner, *The Burning of the Houses of Lords and Commons, October 16, 1834*, 1835.
Oil on canvas, 36 1/2" x 48 1/2" (93 x 123 cm). Courtesy The Cleveland Museum of Art, Cleveland, Ohio. © The Cleveland Museum of Art, Bequest of John L. Severance, 1942.647.

Fig. 5–12 **How did the artist use variations in color to create a feeling of deep space?** Martin J. Heade, *Sunset over the Marshes*, 1863.
Oil on canvas, 10 1/4" x 18 1/4" (26 x 46.3 cm). Gift of Maxim Karolik for the M. and M. Karolik Collection of American Paintings, 1815–1865 (47.1176). Courtesy the Museum of Fine Arts, Boston. Reproduced with permission. © 2000 Museum of Fine Arts, Boston. All Rights Reserved.

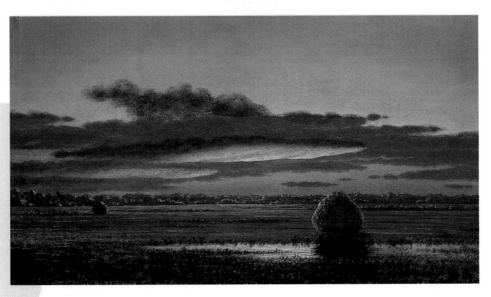

**Landscapes to Experience**

"I really do love beauty."
April Gornik (born 1953)

Photo: Timothy Greenfield-Sanders.

The challenge facing today's landscape artists is finding a balance between observing and interpreting nature. American artist April Gornik achieves that balance by thinking of the outdoors as an inner space. She remembers that as a child in Ohio, she would go outside and look for storms. She saw the sky as a way

to reach beyond the limits of her world. As an artist, Gornik wants her landscapes to have a fictional, "other world" quality. She wants viewers to put themselves into her landscapes and experience the space.

Fig. 5–13 **The artist probably started this work with a series of small sketches. She then worked on one image and enlarged it, with pencil, on a canvas.** April Gornik, *Light at the Equator*, 1991.
Oil on linen, 74" x 131" (188 x 333 cm). Courtesy Edward Thorp Gallery, New York.

Fig. 5–14 **In your opinion, why was April Gornik attracted to this painting?** Jan Vermeer, *View of Delft from the South*, c. 1660–61.
Oil on canvas, 38" x 45 ½" (97 x 116 cm). Courtesy the Mauritshuis, The Hague, Netherlands.

Luminous Landscapes

Once she finished school, Gornik traveled to Europe. In a small Dutch museum, she saw a seventeenth-century landscape painting, Jan Vermeer's *View of Delft* (Fig. 5–14). This was the only landscape Vermeer painted. When she returned to the United States, Gornik started painting landscapes. Years later, when she again viewed Vermeer's work, she realized that elements in *View of Delft* were what she was creating in her own landscapes.

Look closely at Gornik's paintings *Light at the Equator* and *Divided Sky* (Figs. 5–13, 5–15). Notice how her interpretations of nature focus on the pureness of light, color, and the structure of natural forms in the landscape. Her large drawings and paintings are luminous: light seems to shine through her colors. Although her work is often compared to the nineteenth-century American luminist painters, Gornik does not try to capture a specific place, time, or climate. Rather, she sets out to make something extraordinary— a beautiful artwork.

Studio Connection

Using pastels on colored paper, interpret and draw an outdoor scene. What will you draw? How much of your paper will you use for the sky? What colors will you use? How can you show the brightness or gloominess of the sky? How can you show things up close or far away? How can you show where the light comes from? What can you do to show how colors gradually change from light to dark or from one color to another?

Lesson Review

Check Your Understanding

1. How was a Romantic interpretation of nature different from a Realist interpretation?
2. What is *luminism*?
3. What are some similarities and differences between the work of April Gornik and the work of other artists in this lesson?
4. Why are the qualities of light and color important to landscape painters?

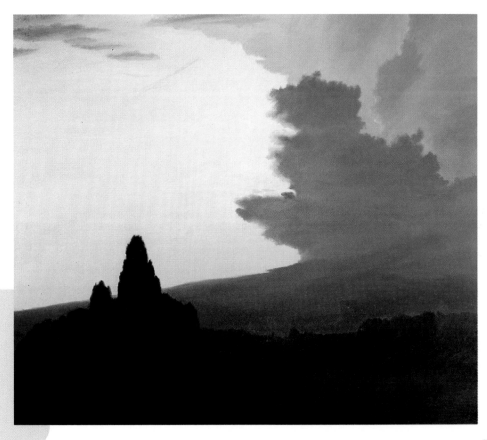

Fig. 5–15 **Have you ever seen clouds like the ones in this painting? What did they make you think of?** April Gornik, *Divided Sky*, 1983. Oil on canvas, 72" x 85" (183 x 216 cm). Jack S. Blanton Museum of Art. The University of Texas at Austin. Gift of Mr. and Mrs. Jack Herring, 1984.

Artists as Interpreters

Color Mixing

This lesson is an introduction to the basic skills and techniques of color mixing. To review color basics: red, yellow, and blue are the three **primary colors**. All other colors are made from various combinations of these three pigments. Adding white makes a color lighter. A lighter value of a color is called a **tint**. Adding black makes a color darker. A darker value of a color is called a **shade**. In art, the word **intensity** refers to how bright or dull a color is.

Practice Mixing

To avoid unwanted colors and to get the colors you really want, you should practice mixing tempera paint. Begin by painting a

small circle of each of the primary colors on a large sheet of manila paper. Then, on a paper plate, piece of cardboard, or disposable palette, mix one primary color with one other primary color. Paint another circle with this color, and label it with the names of the colors you mixed. Continue practicing until you have mixed a variety of combinations, including a mixture of all three colors. Remember to wash, wipe, and blot your brush between colors.

Then practice mixing tints. On manila paper, begin with three small circles of white paint. Add a drop of one color to one circle, and mix. Add two drops of the same color to the second circle, and mix. Add three drops of the same color to the third circle, and mix. Label each circle with the names and amounts of colors you mixed.

mixing primaries

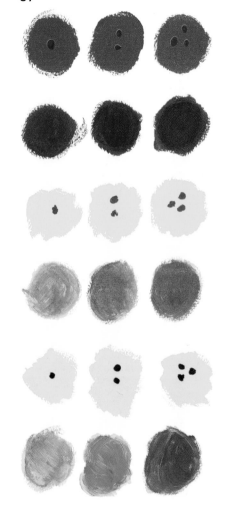

mixing tints **mixing shades**

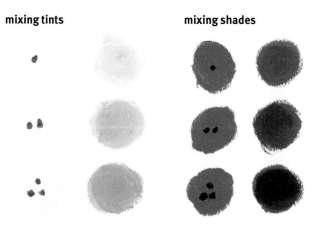

To practice mixing shades, paint three small circles of one color. Add one drop of black to one circle, and mix. Add two drops of black to the second circle, and mix. Add three drops of black to the third circle, and mix. You may be surprised at the small amount of black needed to get a very dark shade. Again, label each circle with paint amounts and names.

Fig. 5–16 **Where do you see tints and shades in this artwork? Where did the artist mix primary colors?** Cherri Moultroup, *Last Bits of Summer*, 1998.
Tempera, 14" x 20" (35.5 x 61 cm). Camels Hump Middle School, Richmond, Vermont.

Changing Intensity

Primary colors are bright colors. To make a color duller, you can add a small amount of its complement. A **complement** is the color opposite a color on the color wheel. For example, green is the complement of red. Adding a very small amount of green to red will make the red duller.

intensity scale

Practice changing the intensity of a color. First, paint three circles of yellow on manila paper. Leave the first circle alone. Add a drop of violet to the second circle, and mix. Add two drops of violet to the third circle, and mix. How do the three circles of yellow differ? Label each circle with colors and amounts of paint mixed. Try the same experiment with red and green, and orange and blue.

Studio Connection

Choose a subject for a small tempera painting on manila paper—for example, you might decide to create a still life, a landscape, or a self-portrait. Mix your own colors. Be sure to include at least one primary color, one tint, and one shade in your composition.

Lesson Review

Check Your Understanding

1. Why do you think it is usually best to begin with white paint when mixing a tint? Why would you not want to start with black to mix a shade?
2. How is the process of changing the intensity of a color different from the process of changing the value of a color?

Artists as Interpreters

Art of China

Places in Time

For thousands of years, China was governed by **dynasties**, powerful family groups who ruled through many generations. Under the dynastic emperors, the arts in China grew. The change of powerful emperors from one dynasty to another often resulted in a change in the look of China's art. This was especially so during the Ming dynasty (1368–1644).

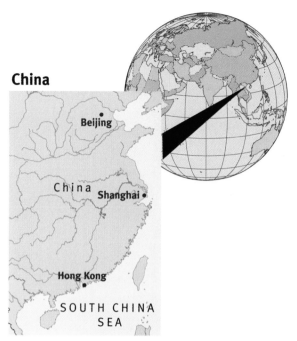

China

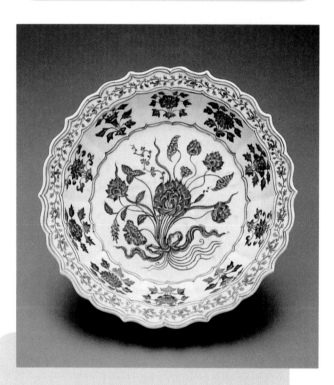

Fig. 5–17 **What is the name of a color scheme that uses only tints and shades of one color?** China, Ming dynasty, Xuande period, *Dish*, 1426–35.
Porcelain with underglaze blue decoration, height: 2" (5.1 cm). Gift of Russell Tyson, 1955.1204. Photograph: Christopher Gallagher. The Art Institute of Chicago, Chicago, Illinois.

Observing Nature

At the beginning of Chinese culture, metalworkers and potters looked to nature for ideas. They decorated bronze and ceramic vessels with images of plants and animals. Professional craftsworkers during the Ming dynasty also studied the natural world to get ideas for decorating precious objects. They often covered objects, such as the dish and incense burner shown in Figs. 5–17 and 5–18, with images from nature.

Painters during the Ming and other dynasties were educated to be scholars. As educated people, they had special rights, led a comfortable life, and were expected to have elegant taste and a strong moral character. An important part of the artists' education was nature painting. The dynastic emperors stressed the importance of harmony between humans and nature. Artists helped by interpreting the beauty of the natural world in their paintings and writings.

Paintings of the Natural World

The Ming artistic rules were based on ideas and methods from a much earlier time. Chinese artists, always aware of the past, were educated to paint the natural world in the styles of the most famous artists of the previous dynasties. Thus, an artist such as Wen Boren (Fig. 5–19) could paint in at least six different styles and produce land-scapes ranging from dramatic and stormy to delicate and peaceful.

Fig. 5–18 **The process of enameling on metal allows for rich and lively color effects. Do you think these are bright colors?** China, Ming dynasty, *Incense Burner*, 16th century.
Cloisonné enamel. Freer Gallery of Art, Smithsonian Institution, Washington, DC. F1961.12.

Fig. 5–19 **What words would you use to describe this artist's interpretation of nature?** Wen Boren, *River Landscape with Towering Mountains*, 1561.
Hanging scroll, ink and color on paper. Eugene Fuller Memorial collection, Seattle Art Museum.

Interpreter of Nature

"I recall fondly a life devoted to books."
Chao Shao-an (1905–1998)

The Avery Brundage Collection, Chong-Moon Lee Center for Asian Art and Culture, Asian Art Museum of San Francisco.

Like artists in the past, contemporary artists in China study the masterworks of Chinese art. Like many young Chinese, Chao Shao-an drew from pictures and old paintings. He was interested in art from an early age and taught himself to paint in watercolors. When he was fifteen, he studied with a master painter and continued to polish the techniques used by the old masters. He also learned new methods of drawing from life. He soon became known as a creative painter of birds, animals, and flowers.

Chao Shao-an's paintings clearly show his strong attachment to the natural world. Before beginning to paint, he made careful studies of subjects in nature. He interpreted his subjects according to his mood or feeling at a certain time. He also based his interpretations on his own ideas about color, light and shade, and perspective. Although most of his compositions appear to be very simple, Chao carefully planned them, arranging positive shapes and negative spaces.

Fig. 5–20 **Note how the artist used his colors. Where are the bright colors? The dull colors? The dark and light colors?** Chao Shao-an, *Gladioli*, 1968. Ink and colors on paper, 13 7/8" x 18 1/2" (32.7 x 47 cm). The Avery Brundage Collection, Chong-Moon Lee Center for Asian Art and Culture, Asian Art Museum of San Francisco (1992.248).

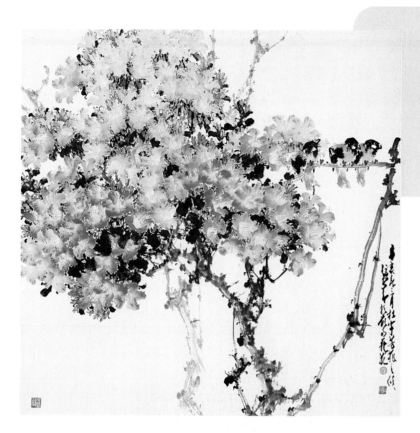

Traditional Landscapes in a Modern Style

Chao Shao-an has been praised for his ability to combine the traditional and the modern. In paintings such as *Gladioli* (Fig. 5–20) and *Azaleas* (Fig. 5–21), he used modern techniques to show traditional subjects. Art critics call attention to the modern look of his energetic and elaborate brushwork. Chao used dry and loose brushstrokes to create textures and catch the natural beauty that most people never notice. He skillfully built up layers of ink and color washes. Strong colors gradually fade into soft tones. His paintings are pleasant reminders of the friendly joining of humans with nature.

Studio Connection
Use the qualities and techniques of watercolor in your interpretation of flowers, leaves, and branches in a vase. How will you arrange your composition to make a colorful interpretation of floral forms? Will your paper be vertical or horizontal? You may first make a light pencil sketch of the shapes and details of the arrangement, and then experiment with watercolor washes and ways to use thick and thin brushstrokes to make leaves, branches, and petals.

Lesson Review

Check Your Understanding
1. Where did Chinese artists get ideas for decorating their pottery and metal vessels?
2. What were artists during the Ming dynasty expected to be able to do?
3. What is at least one similarity and one difference between Chao's education and that of the artists of the Ming dynasty?
4. Is Chao Shao-an a modern artist? Why or why not?

Wood Constructions

From Branches to Animals

Studio Introduction

Have you ever seen a cloud shaped like a walrus? How about tree branches in the shape of a horse? Shapes and forms we see in nature can excite our imagination, and can inspire artists to make fanciful creations. Artists often respond to the qualities—such as shape, form, and color—that art materials offer.

In this studio lesson, you will build a sculptural animal out of wood scraps and branches. Pages 192 and 193 will tell you how to do it. Look carefully at collected scraps of wood. Find interesting wood forms or branches or twigs that have blown down or fallen from trees. Turn the wood pieces and look at all the sides and angles. Do any pieces look like animal shapes? Like the Oaxacan woodcarvers (see Studio Background), let the shapes and forms of the wood inspire you.

Studio Background

Oaxacan Woodcarving

Woodcarving from twisted tree branches is a popular art form among the Zapotec, of southern Mexico's Oaxaca valley. Artists carve animal sculptures, usually ones that show movement and expressive poses. The shapes of the branches help the artists decide what animals to make.

Oaxacans have carved toys and masks for hundreds of years. Today, over 200 Oaxacan families of woodcarvers produce sculptures, such as those in Figs. 5–22 and 5–23. The woodcarvers are mostly farmers. Usually, the men carve the sculptures, and the women paint them. Although the carvers sign the sculptures, the entire family plays a part in their production.

The decorating of the sculptures is as important as the carving. Instead of turning to nature for decoration ideas, the artists use colors and patterns that are brighter, bolder, and more fanciful than those in nature. Imagine seeing a bright-blue lizard with lavender and red flames, or a green-and-orange-spotted antelope with pink hooves!

Fig. 5–22 **Looking at this sculpture, you probably feel a sense of diving or swooping. How did the artist use color and pattern to make the details of the fish imaginative?** Fuentes family, *Untitled (Fish)*, 2000. Carved copal wood, 10" x 3" x 5" (25 x 8 x 13 cm). Photo courtesy Eldon Katter.

Fig. 5–23 **Note the unusual patterns and brilliant colors that were used to decorate this lizard. How would you describe the mood or feeling of this sculpture?** Fuentes family, *Untitled (Lizard)*, 2000. Carved copal wood, 10" x 3" x 5" (25 x 8 x 13 cm). Photo courtesy Eldon Katter.

Fig. 5–24 **"I picked up these two pieces of wood, and I saw the swan. So I started painting,"** said artist Anne Bertollini. **What mood do her color choices suggest?** Anne Bertollini, *The Swan*, 2000.
Wood, paint, 6" x 2" x 5" (15 x 5 x 13 cm). Jordan-Elbridge Middle School, Jordan, New York.

Fig. 5–25 **This student changed an everyday stick into a snake-like monster. Would you describe the color choices as natural or fanciful? Why?** Wesley King, *The Fearless Monster*, 2000.
Driftwood, paint, length: 21" (53 cm). Jordan-Elbridge Middle School, Jordan, New York.

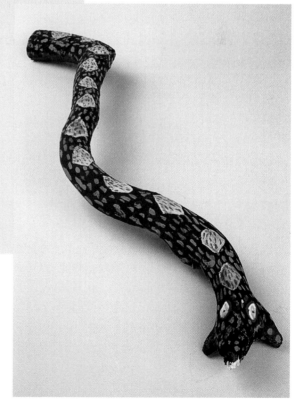

Sculpture in the Studio

Building Your Sculptural Animal

You Will Need

- wood scraps
- small tree branches, twigs, or sticks
- rasps, files, coping saw, sandpaper
- wood glue
- tempera or acrylic paint
- paintbrushes

Safety Note

Rasps, files, and saws can be extremely dangerous when not used properly. If you have not used these tools before, ask your teacher for help. To avoid injury, always handle all cutting tools with extreme care.

Try This

1. Decide whether you will use wood scraps or branches to create your animal. You may use both. Choose one or two pieces from which to create the main form of the animal. How can you arrange and shape the pieces to create movement or an expressive pose? What small pieces can you add to create ears, legs, a tail, or other features?

2. Carefully shape the main form with a saw or other tools. If you use more than one piece of wood, glue the main forms together. Then add the smaller features.

3. After you have assembled your animal, decide whether you will decorate it. Will you leave your sculpture natural, with or without the tree bark? Or will you paint it? If you decide to paint, think about color and pattern. Be as creative as you can! What mood do you want your colors to suggest? What colors can create a happy, scary, dangerous, gentle, or peaceful animal?

Check Your Work

Display and discuss your sculpture with your classmates. How did the shape of the wood add to the shape and pose of your animal? Do the paint colors you chose create the mood you wanted?

Computer Option

You may never have the chance to visit the Oaxaca valley in Mexico, but the Internet can bring the artworks of this culture to you. Browse some Oaxacan sites selected by your teacher. Take special note of the sculptures and read about the artists and their culture. Select two or three images that you find especially interesting. Copy and paste these images, as well as information about them (title, locations, artist, etc.), into a document in a word-processing program. Include personal information, such as why you selected these images. Write four descriptive words that apply to the images you selected.

Color

Our world is filled with **color**. Everywhere we turn, we see bright colors, dull colors, light colors, dark colors—every color you can imagine. You may wonder where color comes from. Color is a 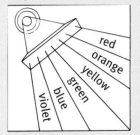 feature of light. When white light is separated into its colors by a prism, or even by a drop of water, a rainbow is created. The rainbow is the **spectrum**, or entire range of colors produced from white light. When white light strikes an object, some of its colors are absorbed by the object and some of its colors are reflected. The object then appears to have color.

Artists can reproduce colors in the environment by using and mixing paints, dyes, or other color pigments. They can use the three *primary colors*—red, blue, and yellow—plus black and white to create just about every color. When artists create a painting or drawing, they choose a *color scheme*, or plan for selecting colors. Color schemes can help artists express mood. An artist might choose a color scheme of bright colors or earth colors. Or an artist might choose a complementary color scheme. *Complementary colors*—such as red and green, blue and orange, and violet and yellow—are directly opposite each other on the color wheel. What mood do you think is created by a bright color scheme? An earth color scheme? A complementary color scheme?

Look at the artworks on pages 190 and 191. What color scheme was used on each sculpture? What mood does each create? Look at your own work or that of your classmates, and answer the same questions.

Fig. 5–26 **This artist added wood pieces to the main form of his sculpture. This is known as an additive process.** Brian Kinney, *Domino the Dog*, 2000.
Driftwood, paint, length: 14" (35.5 cm). Jordan-Elbridge Middle School, Jordan, New York.

Connect to...

Other Subjects

Social Studies

Do you think all people interpret the meanings of colors in the same way? Or do you think colors have various meanings in different cultures? In many countries, including the United States, brides traditionally wear white. In China, however, white is the color worn for grieving. Chinese brides customarily wear red, a color that means happiness in their culture. In other cultures, the color red often symbolizes a warning, and it is used for stop signs, traffic lights, fire engines, and exit signs.

Fig. 5–27 **Champollion determined that each hieroglyph represented one or a group of sounds (letters).**
Photo courtesy Helen Ronan.

Language Arts

How have researchers been able to translate ancient languages? One longtime challenge for them was the **interpretation of ancient Egyptian hieroglyphics**. In 1799, the discovery of the Rosetta Stone—a stone slab with writing carved in it—presented scholars with an opportunity to break the code. Carved into the stone was a passage written in three languages: hieroglyphics, demotic (a shorthand form of hieroglyphs), and Greek. Because scholars knew Greek, they were able to decipher words in the two unknown languages by comparison. French scholar Jean-François Champollion translated the full text on the stone in 1821.

Science

Have you ever made and glazed a ceramic object? Glazes produce a glasslike, waterproof surface on ceramics. **In ancient China, potters used glazes to interpret the beauty of the natural world.** They applied the glazes by dipping or painting. Early glazes were made from such natural chemicals as quartz, sand, iron, cobalt, and copper. The color of a glaze depended on the chemicals used to make it. For example, iron produced a yellow color, cobalt created blue, and copper produced green. Can you find examples of these colors in pictures of ceramics in this textbook?

Fig. 5–28 **In what ways is this wedding ensemble similar to and different from wedding dresses that you have seen?**
China, Qing dynasty, *Wedding Ensemble*, c. 1860.
Silk with embroidery and couched gold threads; robe: 43" x 38" (109 x 97 cm); skirt: 39" x 46" (99 x 117 cm). Pacific Asia Museum Collection, Gift of Dr. and Mrs. Milton Rubini 80.86.1AB. © Pacific Asia Museum.

Careers

Has your artwork ever been criticized? It may not have been a positive experience, yet art critics are typically more concerned with positive than negative views. **Art critics** are art experts who write reviews about contemporary art exhibitions for newspapers, radio, television, textbooks, scholarly journals, and Websites. Because they want to convince their readers to go look at the art, art critics generally write positive interpretations and articles. What do you think an art critic needs to know? Most art critics hold degrees in art history or fine-arts disciplines and are skilled at persuasive writing.

Daily Life

Do you have to **interpret popular culture** to your older family members? Do they know your favorite celebrities or musicians? Do they go to movies aimed at teenagers? What aspects of your life and your preferences would you most like your family members to understand?

Other Arts

Music

Musicians interpret nature in many different ways. Sometimes, nature itself has been used as part of the performance. In 1952, composer John Cage created quite a scandal with his work called 4'33". Rather than playing notes on the piano, Cage sat completely still during the performance, which lasted 4 minutes and 33 seconds. He allowed the silence to be filled with the "music" of the everyday world. Because the performance hall was open in back, nature's noises, along with rustling programs and audience coughs, became the musical score. Do you think this performance would be as shocking today as it was in 1952? Why or why not?

Fig. 5–29 **Some composers have created music based upon the seasons. Can you imagine music inspired by this scene? How would it sound?**
Photo courtesy Anette Macintire.

Internet Connection
For more activities related to this chapter, go to the Davis Website at **www.davis-art.com**.

Portfolio

"When I was painting the flowers, I was trying to capture the flowers as they were and to let the colors flow into the flowers." **Fred Germer**

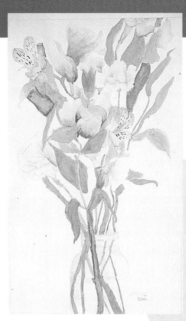

Fig. 5–30 **How is this interpretation of flowers different from the flower interpretation in Fig. F2–3, on page 19?** Frederic W. Germer, *Flowers*, 2001. Watercolor, 18" x 12" (46 x 30.5 cm). Smith Middle School, Fort Hood, Texas.

"I tried to use colors that had lots of light so that it would seem welcoming." **Garrett O'Keefe**

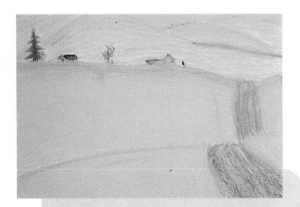

"My abstract garden is placed around a sidewalk in a park. It has multicolored paths and stands for plants. Also it has a lamp post near the front of the path for lighting." **Seth Davis**

Fig. 5–31 **Using very simple lines, this artist creates a strong sense of the land surrounding his grandfather's home.** Garrett O'Keefe, *Sundays at Grandpa's*, 2001. Oil pastel, 12" x 18" (30.5 x 46 cm). Fairhaven Middle School, Bellingham, Washington.

CD-ROM Connection To see more student art, view the Personal Journey Student Gallery.

Fig. 5–32 **This garden model is similar to what a landscape architect might create when planning an actual park.** Seth Davis, *Abstract Garden*, 2001. Cardboard, paper, tiles, found objects, 12" x 12" x 12" (30.5 x 30.5 x 30.5 cm). Thomas Metcalf Laboratory School, Normal, Illinois.

Chapter 5 Review

Recall

List three artists who use animals as the subject matter in their artworks.

Understand

Use examples to explain how artists have interpreted nature in different ways.

Apply

Find a color photograph of a nature scene. Draw or trace the scene, but change the colors to create a different interpretation. For example, use a scheme of complementary colors.

Analyze

Compare and contrast Oaxacan (*see example below right*) and Chinese interpretations of nature in the artworks in this chapter.

Synthesize

Plan a series of posters or a bulletin-board display that shows opposite interpretations of nature: for example, nature as comforting and as dangerous; nature as wild and as tame.

Evaluate

From this chapter, select two artworks, one that is a good example of the use of local color, the other that is a good example of use of expressive color. Write reasons to support your selections.

Page 190

For Your Portfolio

Create two artworks that each show a different interpretation of nature; for example, a humorous interpretation and a scientific interpretation, or a realistic interpretation and a fanciful one. Title your artworks, add your name and date, and put them into your portfolio.

For Your Sketchbook

Use a nature motif to design a border on a sketchbook page. On the same page, write your ideas about nature.

6

Artists as Messengers

Fig. 6–1 **How did the artist create a sense of energy in this sculpture?**
Keith Haring, *Untitled*, 1985.
Polyurethane paint on aluminum.
© The Estate of Keith Haring. Photo: Ivan Dalla Tana.

Focus

- What are the ways that people can communicate with one another?
- How do artists send messages?

Have you ever had a sore throat that made it impossible for you to talk? How did you communicate with family members? Did you write messages on a notepad, draw pictures, or make hand gestures? We rely so much on our ability to speak and write that we sometimes forget how many other ways we can communicate. Just a look will sometimes "speak" a hundred words.

Artists use visual ways to communicate. Throughout history, they have used images to tell stories, to persuade others to act in certain ways, and to tell about the beauty in the world. Like poets or writers, who use combinations of words, artists create combinations of visual imagery to send their messages to their audience.

Keith Haring made playful artworks with serious messages. In such artworks as the sculpture shown in Fig. 6–1, he used images of dancers to send a message about living an energetic and playful life. In this chapter, you will learn more about Keith Haring and other artists who have used visual art to communicate their ideas.

Meet the Artists

Keith Haring
Harry Fonseca
Ada Bird Petyarre

Words to Know

symbol	monoprint
pictogram	relief print
portrait	line
self-portrait	emphasis

Keith Haring

An Artist with a Message

> "I am intrigued with the shapes people choose as symbols to create a language."
> **Keith Haring (1958–1990)**

Photo courtesy the Estate of Keith Haring.

Keith Haring's Journey

As a child, Keith Haring liked to draw with his father and his youngest sister. He also enjoyed looking at cartoons and illustrations. These inspired the simple cartoonlike forms in the drawings, paintings, murals, and sculptures that he made as an adult.

Throughout his life, Haring continued to draw. He often drew the same forms over and over. He used repeated forms as **symbols**, images that "stand for" and communicate certain ideas. One symbol, a glowing or "radiant" baby (Fig. 6–2), represents "how perfect people could be." The baby symbolizes a brighter future. Another of Haring's symbols, a barking dog (Fig. 6–3) represents the family dog, always there to watch what's going on and to protect us. Haring also combined his symbols in such artworks as the vase in Fig. 6–4. Each new combination sent a different message.

Fig. 6–2 **What effect is created by the lines surrounding the figure?** Keith Haring, *Icons* (Radiant Baby), 1990.
Silkscreen with embossing, 21" x 25" (53 x 63.5 cm). © The Estate of Keith Haring.

Fig. 6–3 **How would combining the two symbols of a baby and a dog affect their meaning?** Keith Haring, *Icons* (Barking Dog), 1990.
Silkscreen with embossing, 21" x 25" (53 x 63.5 cm). © The Estate of Keith Haring.

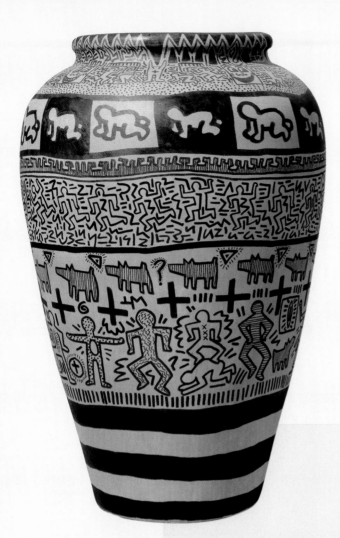

Fig. 6–5 **What makes this a powerful message? What symbols do you see? What do you think they mean?** Keith Haring, *Untitled* (Poster for antinuclear rally, New York), 1982.
© The Estate of Keith Haring.

Fig. 6–4 **Haring studied artworks by the Egyptian, Greek, and other cultures. What evidence of this do you see in his artwork?** Keith Haring, *Untitled*, 1981.
Felt tip pen on fiberglass vase. © The Estate of Keith Haring.

Messages for a Changing World

Haring used his visual symbols to comment on life in the later part of the twentieth century. He said: "I consider myself a perfect product of the space age not only because I was born in the year that the first man was launched into space, but also because I grew up with Walt Disney cartoons." He often drew Disney characters, but also included computers, spaceships, dolphins, and people at work and play. He sometimes surrounded the images with lines to show activity, or energy.

Like many people, Haring was worried about problems he saw. In such artworks as the poster in Fig. 6–5, he sent powerful messages about important issues. His messages were concerned with the environment, the cruelty of some people, and the negative impression that technology and the overbuying of products might have on us. He did not want us to forget about the really important things in life—family and other people we love.

Messages with Symbols

People have long used images to communicate. The earliest forms of writing were actually simple pictures, or **pictograms**, which represented objects. Pictograms were easily recognized and "read" by community members. Many artists throughout history have developed their own personal sets of simple symbols. The painting in Fig. 6–7 shows some of the symbols that artist Bill Traylor created to represent people, houses, and all kinds of animals.

People also learn and read the meaning of pictures. Think about how very young children name objects in picture books. As we develop, we become better able to understand the meanings of images. We know that a certain shape is a symbol for, say, a ball or a cat. We also understand that an image of two people holding hands probably means that they have a caring relationship.

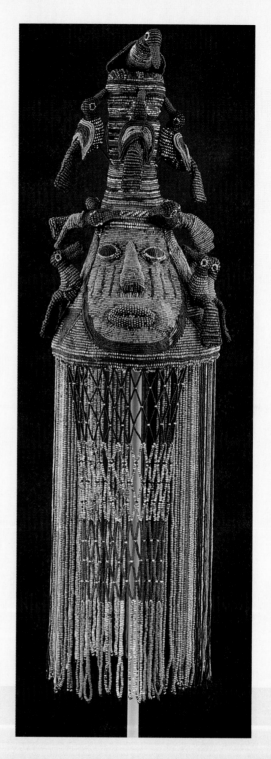

Fig. 6–6 **In nineteenth-century Yoruban culture, the use of beaded objects was limited to only the most important officials.** African, Nigeria (Yoruba), *King's Crown*, 19th century. Beads, leather, canvas, and wicker, height: 30" (76 cm). The Minneapolis Institute of Arts (The Ethel Morrison Van Derlip Fund 76.29).

Fig. 6–7 **Bill Traylor was a self-taught artist. He used simple materials to make thousands of drawings. What message about living together does this image send?** Bill Traylor, *Figures, Construction*, c. 1940–42. Watercolor, pencil on cardboard, 12 11/16" x 11 5/8" (32 x 30 cm). Montgomery Museum of Fine Arts, Montgomery, Alabama. Gift of Charles and Eugenia Shannon. (1982.4.16).

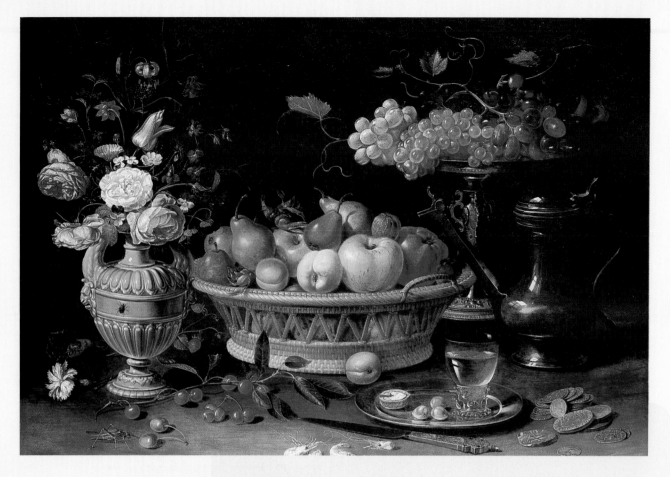

Fig. 6–8 **This painting is an example of a vanitas painting, a kind of still-life painting. The message of such paintings is that, like flowers and fruit, people don't live forever.**
Clara Peeters, *Still Life of Fruit and Flowers*, after 1620.
Oil on copper, signed on knife handle, 25" x 35" (64 x 89 cm). Ashmolean Museum, Oxford. Bequeathed by Daisy Linda Ward, 1939.
© Ashmolean Museum, Oxford.

Understanding the Message

When we study artworks from the past or from cultures other than our own, we do not always understand the artists' symbolism. By looking at the seventeenth-century Dutch painting in Fig. 6–8, you may understand its message to be only "Look at these beautiful things." However, if you had lived in the Netherlands during the time the work was created, you would have known that the artist was sending a different message. Her painting is actually a reminder to viewers that time passes quickly and that life is short.

In the 1800s, an artist in the African kingdom of Yoruba covered a king's headpiece with symbols to send a message about the king's power (Fig. 6–6). The vertical lines on the face symbolize the ruler's family, and the birds refer to his ability to deal with the forces of evil. When the Yoruban people saw the crown, they understood its messages. Whenever artists wish to communicate, they must use symbols or images that others will understand.

Printing Symbols

Do you ever fill notebook pages with playful scribbles or drawings? The shapes and patterns that come into your mind as you doodle can become part of your own set of symbols. Like Keith Haring, you can combine your symbols to send messages.

In this studio experience, you will make a set of symbol stamps and use them to create a print. Without using words in your print, express a message about a social issue. What issues concern you? Develop at least six different symbols that you can use to express your concern. Create a stamp for each one.

You Will Need

- sketch paper
- pencil and eraser
- black marker (optional)
- stiff cardboard
- string, lightweight cardboard, sponges
- scissors
- glue
- newsprint paper
- drawing paper
- stamp pad
- tempera paint
- damp paper towels

Try This

1. Fill a page with doodles. Focus your ideas on your chosen social issue. Choose six doodles that you will improve for your symbols. Create neater drawings of them. What kinds of lines will make the symbols more effective? What positive and negative shapes can you create? You will use your drawings to make your stamps.

Studio Background

Symbolic Messages

Every day, we come upon hundreds, perhaps even thousands, of symbols: words formed by the 26 symbols of the alphabet; mathematics symbols at the grocery store or bank; and traffic lights and other roadway symbols.

But what is the one thing that all symbols have in common? They all send messages. Anyone can create a symbol for any reason. During the Great Depression, jobless workers, who traveled by train from town to town, created symbols (Fig. 6–10) to communicate with one another. For *Toboggan* (Fig. 6–9), artist Henri Matisse expressed his ideas by cutting symbols out of paper and transferring them to his paintings.

Fig. 6–9 **What could the symbolic shapes mean? How did the artist create emphasis?** Henri Matisse, *Toboggan* (plate XX from *Jazz*), published 1947.
Pochoir, printed in color, double sheet, 16 5/8" x 25 5/8" (42.2 x 65 cm). The Museum of Modern Art, New York. The Louis E. Stern Collection. Photograph © 2001 The Museum of Modern Art, New York. © 2001 Succession H. Matisse, Paris/Artists Rights Society (ARS), New York.

Dangerous Neighborhood **Good Place to Catch a Train** **Hit the Road Quick!**

Fig. 6–10 **Jobless workers, one at a time, drew symbols such as these on sidewalks or carved them into trees. Each of the symbols represents a particular direction or warning.**

2. Decide which materials you will use. Will you glue string, cardboard pieces, or sponge onto the cardboard? What sizes will your stamps be?

3. Place about a teaspoon of paint on a stamp pad. Practice stamping on newsprint. Carefully wipe off the stamps between colors.

4. Create your final print on drawing paper. How will you use the size, shape, color, and arrangement of your stamps to create emphasis? How will you use the stamps to best express your message?

Check Your Work

Display your print with classmates' prints. Explain the meaning of your symbols and the message you are sending. How do your symbols compare to your classmates' symbols? Discuss the different ways that you and your classmates used line and shape to create emphasis.

Lesson Review

Check Your Understanding

1. What are some ways that people can communicate without words?

2. What is a symbol?

3. Name two of Keith Haring's symbols, and identify the message that each sends.

4. Why is it sometimes difficult to interpret symbols from other times and places?

Fig. 6–11 **How did this artist use shape and line to send her message?** Candy Collins, *Too Much Technology,* 2001. Ink on paper, 9" x 12" (23 x 30.5 cm). Holy Name Central Catholic Middle School, Worcester, Massachusetts.

Symbolism in Portraits

1533
Holbein, *The Ambassadors*

1946
Kahlo, *The Little Deer*

1981
Fonseca, *Rose and the Reservation Sisters*

16th-Century Germany

18th-Century France

20th Century

1740
Chardin, *The Monkey-Painter*

1981
Fonseca, *Coyote Leaves the Reservation*

Travels in Time

A **portrait**, an artist's likeness of a person, is a way to remember someone. From ancient Egypt to today, portrait artists have used different ways to represent the special qualities of a person. Portrait artists from the fifteenth through the nineteenth century used objects as symbols to tell about a person. The Renaissance portrait *The Ambassadors* (Fig. 6–12) shows how individuals were placed in settings with objects that represented their interests, greatness, or character. In the twentieth century, artists continued to use symbols to portray themselves and others, as well as their culture and their life.

Portraits as Messages

What can you tell about a person by looking at a portrait? What can a portrait communicate? Happiness? Shyness? Portraits—whether painted, drawn, photographed, or in another art form—send messages. Portrait artists usually show more than what a person looks like. They create symbols to send messages about the subjects—what they enjoy, what they do for a living, or what they think.

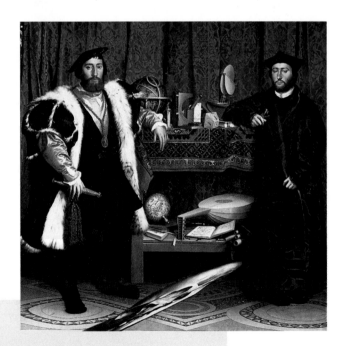

Fig. 6–12 **This painting shows two wealthy French ambassadors in sixteenth-century England. Why do you think the artist showed them surrounded by books, a globe, and other instruments?**
Hans Holbein the Younger, *The Ambassadors*, 1533.
Oil on wood, 81 ½" x 82 ¼" (207 x 209.5 cm). Courtesy The National Gallery, London, England.
© The National Gallery, London.

The Message of Symbols

In the eighteenth century, the French artist Jean-Baptiste-Siméon Chardin painted a **self-portrait**, or a picture of himself (Fig. 6–13). He used a monkey to symbolize someone trained to perform in a certain way and to repeat the same actions. What message was Chardin trying to send?

The Mexican artist Frida Kahlo used plant and animal symbols to tell about her personal life. In her self-portraits and portraits, Kahlo used symbolism to express feelings and emotions. Study *Little Deer* (Fig. 6–14), a self-portrait from 1946. Notice how the artist painted her own face on the body of a deer. What message do you think she was trying to give to viewers?

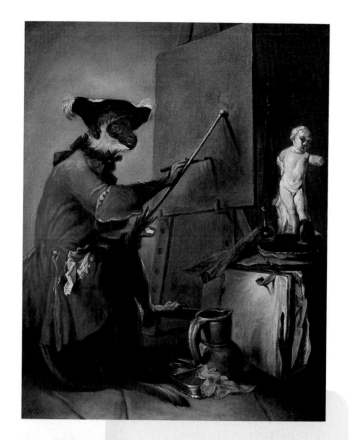

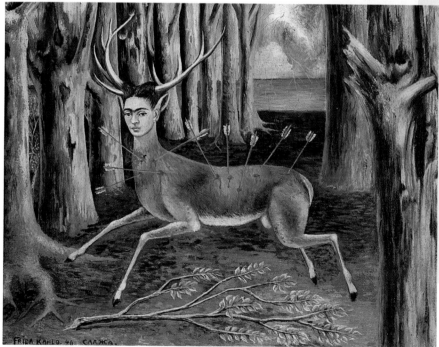

Fig. 6–13 **Chardin was a still-life painter. What clues can you find to tell you that this could be the artist's self-portrait?** Jean-Baptiste-Siméon Chardin, *The Monkey-Painter*, c. 1740.
Oil on canvas, 28 3/4" x 23 1/2" (73 x 59.5 cm). Erich Lessing/Art Resource, New York.

Fig. 6–14 **How does this artwork communicate the idea of pain and suffering? What makes this such a powerful message?** Frida Kahlo, *The Little Deer*, 1946.
Oil on canvas, 8 3/4" x 11 3/4" (22.5 x 29.9 cm). Private Collection, Photo: Hayden Herrera. Courtesy of Mary-Anne Martin/Fine Art. © 2001 Banco de México, Diego Rivera & Frida Kahlo Museums Trust, Av. Cinco de Mayo No. 2, Col. Centro, De. Cuauhtémoc 06059, México, D.F.

Personal Messages

"My work is of the old, transformed into a contemporary vision."
Harry Fonseca (born 1946)

Photo courtesy of the artist.

You have seen how artists of the past used symbols to comment on their personal experiences and society. Contemporary artist Harry Fonseca uses traditional symbols to send humorous messages about modern-day Native Americans.

Fonseca always loved to draw and paint. But it was his high-school art teacher who introduced him to the great masterworks of art history. Although Fonseca studied fine arts in college, he held on to some of the self-taught techniques he developed in his youth. He also researched his Native American background. The combination of his professional training, self-training, and personal interests has resulted in a body of work that is rich in personal and cultural symbolism.

Fig. 6–15 **Here, Coyote is dressed as a singer. Why do artists use humor to send messages about important issues?** Harry Fonseca, *Rose and the Reservation Sisters*, 1981. Oil and glitter on canvas, 30" x 40" (76 x 102 cm). Courtesy of the artist.

Cultural Symbols

The symbols in Fonseca's paintings are influenced by his mixed cultural background: he is of Portuguese, Hawaiian, and Nisenan Maidu descent. One of Fonseca's favorite symbols is Coyote, a trickster in many Native American cultures. To teach safe and responsible behavior, the Nisenan Maidu of northern California tell stories of Coyote's tricks. Fonseca made Coyote's image a humorous symbol of a survivor who knows how to fit in, understand, and even outsmart the non-Native cultures in America. In such artworks as those shown in Figs. 6–15 and 6–16, Fonseca uses the trickster symbol to question and poke fun at cultural stereotypes, or overused images. His artworks send messages about himself and about Native Americans in society.

Fig. 6–16 **Do you think this is a self-portrait of the artist? Why or why not?** Harry Fonseca, *Coyote Leaves the Reservation*, 1981.
Oil on canvas, 72" x 60" (183 x 152 cm).
Courtesy of the artist.

Studio Connection

Think about the ways that artists, including Harry Fonseca, have used animal images to symbolize themselves or their culture in self-portraits. Use colored pencils to create a character, possibly an animal, that sends a message about you, your culture, and what you care about. Include other symbols, such as objects that reflect your interests, feelings, and experiences. To create emphasis, experiment with different types and directions of lines.

Lesson Review

Check Your Understanding

1. What kinds of messages do portraits send?
2. What animals did Chardin and Kahlo each use to symbolize him- or herself?
3. How does Harry Fonseca use traditional symbols in his artwork?
4. Would you want to hang a portrait of yourself as an animal in your home? Why or why not?

Monoprinting

The prefix *mono-* means "one," and a **monoprint** is just that—an edition of only one print. Monoprinting is unlike other methods of printmaking, in which you can make many prints from the same plate. When you create a monoprint, you can prepare the plate in several ways. But the preparations you make on the plate usually do not survive after the first print.

Monoprints allow an artist to experiment and create works that are loose and free. They are also a good way to explore the use of various materials and contrasts, such as the relationship between thick and thin lines or between areas of dark and light.

Methods of Making a Monoprint

You can practice the following three simple methods of creating a monoprint. For the smooth, nonabsorbent surface, you might use a piece of plastic or formica or even a cookie sheet. And remember: your print will be the reverse of the drawing or painting you create on the plate.

Studio Connection

Create a monoprint by using one of the methods discussed in this lesson. Choose a method that works well with your subject. For example, method 1 works well for portraits. Method 2 works well for still lifes or abstract designs. Use copy paper or drawing paper to pull the print.

Method 1

Roll out a thin, even layer of ink on a smooth, nonabsorbent surface. Draw directly into the ink with a tool such as a toothpick,

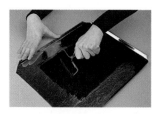

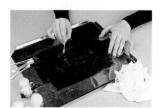

pencil eraser, cotton swab, facial tissue, or old comb. Place a sheet of paper over the design, and rub it evenly but lightly with your hand. Then pull the print by lifting the paper away from the surface.

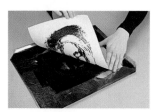

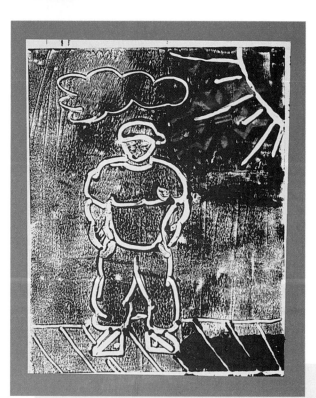

Fig. 6–17 **The act of pulling the print will sometimes create interesting textures in the image. In what other ways might you create textures when using the printmaking technique described in method 1?** Clifton Islar, *A Boy in the Hood,* 2001. Tempera monoprint, 12" x 8" (30.5 x 20 cm). Amidon School, Washington, DC.

Method 2

Paint an image with tempera paint on a smooth, nonabsorbent surface. Work quickly so that the entire painted area stays wet.

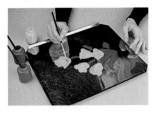

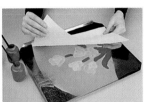

Place a sheet of paper over the painted image, and rub it evenly but lightly with your hand. Then pull the print by lifting the paper away from the surface.

Method 3

Roll out a thin, even layer of ink on a smooth, nonabsorbent surface. Place a sheet of paper over the inked surface, but do not

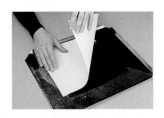

rub it. Using a pencil, draw an image on the paper. Then pull the print by lifting the paper away from the surface.

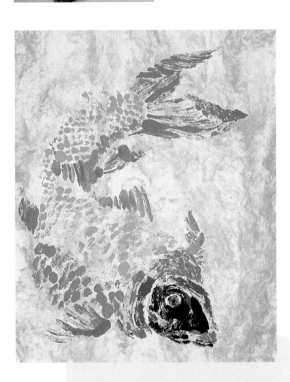

Fig. 6–18 **This artist used method 2 to create his print. How does the mottled sheet of paper add to the impression of a print?** Mike Tordé, *Untitled,* 2001.
Printer's ink on colored paper, 10" x 8" (25.5 x 20 cm).
Camels Hump Middle School, Richmond, Vermont.

Fig. 6–19 **Notice how this artist used four colors to create her print. When you try this method of printing (method 3) for the first time, however, use only one color.** Katherine Leary, *Flower,* 1998.
Ink on paper, 8" x 11" (20 x 28 cm).
Notre Dame Academy, Worcester, Massachusetts.

Lesson Review

Check Your Understanding

1. How is monoprinting different from other types of printmaking?
2. What are the differences in the results that you get with each method of monoprinting?

Aboriginal Australia

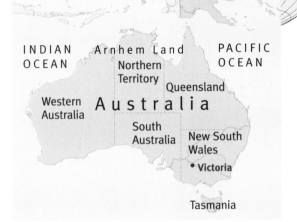

Places in Time

The first inhabitants of Australia probably arrived on the continent many thousands of years ago. The Aborigines spread across the land and settled in many different areas. They formed communities in the tropical regions of the north, the temperate climates of the south, the fertile river lands, and the harsh deserts. Because the vast geography separated the groups, each developed a distinct language and artistic style. However, a common characteristic of Aboriginal art is its importance to Aboriginal life.

Australia

INDIAN OCEAN

Arnhem Land

Northern Territory

PACIFIC OCEAN

Queensland

Western Australia

Australia

South Australia

New South Wales

• Victoria

Tasmania

Statements of Power

In Australian Aboriginal culture, knowledge determines a person's authority in the community. For Aboriginal groups, art is an expression of knowledge, and artworks are statements of authority.

In their artworks, Aboriginal artists use symbols and designs inherited from their ancestors. They use the symbols in order to examine the relationships between individuals and groups, people and the land, and people and their ancestors. Aboriginal symbols and designs usually vary from one family group to another. The paintings in Figs. 6–20 and 6–21 show some of the symbolic designs that are passed down from one generation to the next. These patterns of crosshatched lines identify family groups and ancestors.

Fig. 6–20 Why might outsiders refer to this way of painting as "X-ray" style? Why would the artists want to show the internal organs of the animals in their region? Australian Aboriginal, Western Arnhem Land, *Kangaroo and Hunter*, 20th century.
X-ray style painting on bark. Private Collection, Prague, Czech Republic. Werner Forman/Art Resource, New York.

Messages About the Land

Symbols and designs also vary from one geographical area to another in Australia. A symbol's meaning may depend on where the artist lives. Artists of the Northern Territory, for example, often use dot-and-line designs, such as those in Fig. 6–22. The designs are symbols for special places in the artist's region, such as settlements, hills, or waterholes. A field of dots can symbolize clouds, rain, or fire. Curving lines may indicate the path of a river or animal tracks, whereas zigzag lines may symbolize lightning in the sky. Artists often combine many designs in their artworks in order to communicate a special message that is known only to their Aboriginal group.

Fig. 6–21 **Note the pattern of crosshatched lines, which symbolizes an ancestor of the artist. What different crosshatched patterns could you make to represent some of your ancestors?** Australian Aboriginal, *Painted Tree Bark with Crosshatching Pattern,* 20th century. Courtesy the Archivo Fotografico del Museo Preistorico de Etnografico L. Pigorini, Roma. Photo by Damiano Rosa.

Fig. 6–22 **Do you see dots or lines? Dotted lines often symbolize certain landforms, paths, or trails. The lines may also be decorative.** Rene Ronibson, *Snake Dreaming,* 20th century. Acrylic on canvas. Jennifer Steele/Art Resource, New York.

Artist Ada Bird Petyarre is a spokesperson for her native Aboriginal group. She knows very well the land of her birth—the desert part of Australia's Northern Territory. Petyarre was born in 1930 and is the oldest of five sisters, who are each well-known artists too. Petyarre and her sisters have a common knowledge of stories, dances, songs, and ceremonies. They also share the responsibility of preserving and passing on the symbols of their ancestors.

The Meaning of Patterns

Ada Petyarre has worked in batik, watercolor, woodblock prints, and sculpture. Her most recent works are acrylic paintings on canvas. Each canvas is a pattern of repeated elements—dots, lines, circles. The patterns often have important meaning for her family group. Petyarre also uses plantlike symbols that represent sacred desert plants and grasses or the large number

Fig. 6–23 **Every mark in this painting is a symbol. What symbols do you think you recognize?** Ada Bird Petyarre, *Sacred Grasses*, 1989. Synthetic polymer paint on canvas, 51" x 90 1/2" (130 x 230 cm). Collection: National Gallery of Australia, Canberra.

of wildflowers after a good rain. The painted patterns are her personal statements about her world. In *Sacred Grasses* (Fig. 6–23), the symbols are easy to recognize as plant forms. For her work *Mountain Devil Lizard* (Fig. 6–24), she repeated lines to create patterns. These patterns represent designs that are painted on the bodies of dancers in special ceremonies.

Studio Connection

Make and use stencils to create repeated shapes on one piece of paper. Use the stencils to create a pattern that sends a personal message. Before you create your stencil pattern, practice with a sponge or stiff bristle brush to stipple paint around or through the openings in the stencil shape itself. Consider overlapping the stencils and using different colors for emphasis.

Lesson Review

Check Your Understanding

1. What symbols are used in Aboriginal art? What do they represent?
2. What are two reasons that the meaning of symbols and patterns differ from one part of Australia to another?
3. What are some symbols that Ada Bird Petyarre repeats in her work? What do they represent?
4. Why is Petyarre's work important to her Aboriginal group?

Fig. 6–24 **How would you describe the lines in this painting?** Ada Bird Petyarre, *Mountain Devil Lizard*, 1992.
Acrylic on canvas. Courtesy of the artist and Jinta Desert Art, Sydney, Australia.

A Linoleum Block Print

Send a Message Without Words

Studio Introduction

Most messages that we get are written, spoken, broadcast, or sent by codes and symbols. But messages can also be expressed by artworks. Think of a drawing, painting, or newspaper photograph that caught your eye recently. How did it make you feel? What do you think it means? Your answers likely suggest the message that the artist wanted to express.

In this studio experience, you will create a linoleum print that sends an important message. Pages 218 and 219 will tell you how to do it. First, choose a topic for your message, such as pollution, animal rights, or school dress codes. What kind of image will best express the seriousness, humor, or concern you feel about your topic? How will you get people to notice and understand your message? How will you use lines and shapes to create emphasis? Will you outline the positive and negative shapes? Will you use lines to create patterns and visual texture?

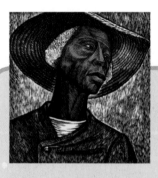

Fig. 6–25 **Elizabeth Catlett is noted for her sculptures and prints that send messages about the strength of African American women. How did she use shape and line to create emphasis in this print?**
Elizabeth Catlett, *Sharecropper*, 1968.
Woodcut, 18" x 16 ½" (46.5 x 42 cm). Spencer Museum of Art: Gift of the Friends of the Art Museum. © Elizabeth Catlett/ Licensed by VAGA, New York, NY.

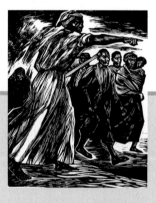

Fig. 6–26 **How did the artist show the heroism and strength of Harriet Tubman? How did she use contrast to emphasize her message?**
Elizabeth Catlett, *Harriet*, 1975.
Linocut, 12 ½" x 10 ⅛" (32 x 26 cm). Courtesy Sragow Gallery, New York. © Elizabeth Catlett/Licensed by VAGA, New York, NY.

Studio Background

Relief Prints

So that many people will see their messages, some artists make prints. Printmaking allows artists to create more than one copy of their artwork. Relief printmaking is one of several basic printmaking processes. A **relief print** is made from a design that is raised from a flat background. Two traditional relief-printmaking processes are woodcuts and linoleum, or lino, cuts. Both involve carving the surface of a block to create an image. The raised areas will create the lines and positive shapes in the print. The areas that are cut away will create the negative shapes.

On the carved block, the artist coats the raised areas with ink and then places a sheet of paper or other material on the inked surface. When he or she presses down on the paper or material, the inked image is transferred to it. The artist then "pulls the print" by carefully peeling the paper or material away from the block.

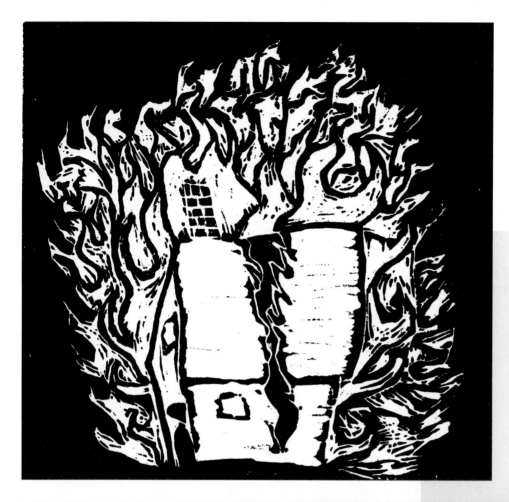

Fig. 6–27 **Describe the artist's use of positive and negative spaces and shapes.** Wil Johnson III, *Broken Home*, 2001.
Linoleum block print, 6 3/4" x 7 1/4" (17 x 18.5 cm). Mount Nittany Middle School, State College, Pennsylvania.

Fig. 6–28 **How did the artist create pattern and texture in this print?** Mathew Wolfgang, *The Countryside*, 2001.
Linoleum block print, 3 1/2" x 7" (9 x 18 cm). Mount Nittany Middle School, State College, Pennsylvania.

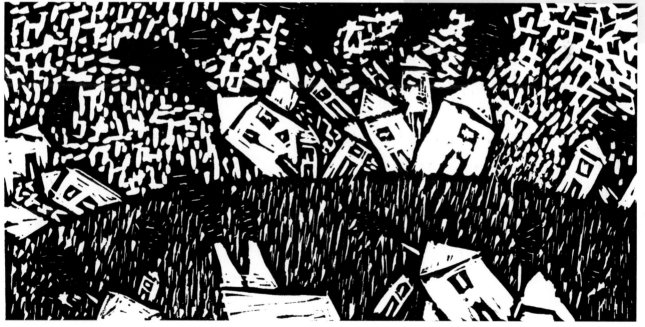

Creating Your Print

You Will Need

- sketch paper
- pencil
- linoleum block
- carving tools
- bench hook
- ink
- brayer
- construction paper

Safety Note
Linoleum-carving tools are extremely sharp! To avoid cuts and other injuries, use them with extreme caution. If you are unsure about how to use the carving tools, ask your teacher for help.

Try This

1. On sketch paper, trace the edges of your block. Use a soft-leaded (#2) pencil to draw your design inside the lines of the trace. How will you use lines and shapes to best express your message? What part of the image will you emphasize? Think about which areas will print and which will be the color of the paper. With your pencil, fill in the areas that will print.

2. Carefully lay your design face-down on the linoleum side of the block. Make sure that the edges of the trace line up with the edges of the block. With your hand, rub the back of the paper to transfer your design onto the block. Check the darkness of the image that is now on the block. Darken any lines that you think are too light.

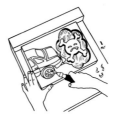

3. Place the block on a bench hook. Carefully carve away the areas of your design that will not print.

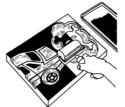

4. Use a brayer to roll a thin, even layer of ink onto the raised surfaces of your block.

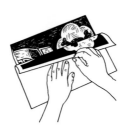

5. Carefully place your printing paper over the block. Gently rub the back of the paper. When you see the faint impression of your design on the back of the sheet, slowly pull the print away from the block.

Check Your Work

Display your artwork. Can your classmates "read" the message of your print? Discuss the ways that you and your classmates used lines and shapes to emphasize your message. What kinds of lines did you use? How did you use lines to create pattern and texture? Where do you see positive and negative shapes?

Computer Option
By using computers, artists can quickly create different versions of the same design. They can also simulate some printmaking characteristics. Using a program with drawing tools, create a line drawing. Vary the thickness of the lines to create a more interesting result. If necessary, reduce the size of the image. Then copy and paste the image four times onto one page—two on the top and two on the bottom—to create a composition of fourths. Change the copies—alter the color and value of each—to create four different versions of your drawing.

Line and Emphasis

In simplest terms, a **line** is a mark that has length and direction. Line is the most basic element of art, yet it is the foundation from which artists can create shape, pattern, texture, space, movement, form, or emphasis in their artworks. A line may start at one point and bend, wiggle, zigzag, wave,

loop, or move straight across an artwork. It can be fat, thin, light, heavy, broken, calm, or energetic. Indeed, line can be used to express any number of moods and ideas in art.

Artists create **emphasis** in artworks by making something—such as an object, shape, or simply white space—more noticeable than other things.

For example, an artist may make the main subject of the artwork the largest thing in an image. An artist may also place the subject in a certain spot. He or she may then use lines or other elements of art to lead the viewer's eye to the subject.

An artist may also use contrast, or strong differences between elements, to create emphasis. With any of these techniques, artists create a *center of interest* in the artwork.

Look at some of your own works of art. What kinds of lines did you use? In what ways did you create emphasis?

Fig. 6–29 **What makes this a powerful image? What message do you think the artist was trying to send?** Sunyoung Park, *Discrimination,* 2001. Linoleum block print, 3 1/2" x 6 5/8" (9 x 18 cm). Mount Nittany Middle School, State College, Pennsylvania.

Connect to...

Careers

Have you ever visited an art museum and found an object that puzzled you? Did you admire it, even if you didn't know what it was supposed to be? If so, you were thinking philosophically about art. **Aestheticians** are philosophers who think about and question the nature and purposes of art. They are concerned with how people think about art, and the messages people send and receive about art. Most aestheticians receive a doctoral degree in philosophy from a college or university. An aesthetician may teach, write, and lecture about art in colleges and universities.

Fig. 6–30 **Thinking like an aesthetician, what questions would you ask about this outdoor sculpture? What message do you think it sends?** Henry Moore, *Nuclear Energy*, 1964–67.
Bronze, height: 23' (3.7 m). Located in Chicago, Illinois. Courtesy Davis Art Slides.

Other Arts

Theater

Specialists in mime communicate without words: they act out scenes without speaking. The word *pantomime* comes from Greek words meaning "all mimic." The art form began in ancient Rome: a single dancer mimed the actions of several characters while a chorus narrated a short version of a Greek or Roman heroic tale. Today, pantomime has become part of many circus clown acts.

Fig. 6–31 **The character of a clown first appeared in early European pantomime plays that mixed music, song, dance, and acrobatic tricks.**
Courtesy SuperStock.

Social Studies

Since the beginning of history, people have used banners and flags to identify friend and enemy, to show allegiance, or to foster pride. The colors, designs, and shapes on the flag or banner often send a message. George Washington explained the **message of the first American flag** in these words: "We take the stars from heaven, the red from our mother country, separating it by white stripes, thus showing that we have separated from her, and the white stripes shall go down to posterity representing liberty."

Language Arts

Why are **secret messages** necessary in times of war? During World War II, an unbreakable code was needed against the Japanese, who were then known for their skill at breaking codes. Because the Navajo language (a complex oral language with no alphabet or other symbols) was spoken by few non-Navajo, agents chose it as their code to send secret messages. During the war, around 400 Navajo served as code talkers; the Japanese never broke the code. Not until 1992 did the United States government publicly recognize the Navajo nation for this significant contribution.

Science

Morse code is a signaling system that uses dots and dashes to signify the letters of the alphabet. The code's best-known message—SOS—does not really mean "save our ship." It was just an easy signal to remember and recognize, even under bad weather conditions. Invented by Samuel Morse in 1838, Morse code was last used in 1999. In that year, the Global Maritime Distress and Safety System (GMDSS) began operation. GMDSS uses radio beacons and orbiting satellites that can pick up signals from anywhere on earth.

Fig. 6–32 **How has the American flag changed over time? What does the flag mean to people today?** Mrs. Mary Pickersgill, Baltimore, *Star-Spangled Banner,* 1813. Cotton, wool bunting, Irish linen, 30' x 34' (originally 30' x 42'). Courtesy Smithsonian Institution.

Internet Connection
For more activities related to this chapter, go to the Davis Website at **www.davis-art.com.**

Daily Life

When older family members were your age, they probably received **personal messages** through the telephone and the mail. How do you communicate with your friends? The mass-production of computer technology has made available communication gadgets such as cellphones, pagers, personal digital assistants, and e-mail. What devices might people use to communicate in 2050?

Portfolio

"We had made cartouches in art using hieroglyphic symbols, and I decided to use the same method to tell my message. I decided to make the symbols symmetrical, with both sides the same." **Alana McConnell**

Fig. 6–33 **Using the title of this artwork as a guide, can you "read" the symbols the artist uses in place of letters?** Alana McConnell, *I Can Reach My Goals*, 2001.
Tempera paint, tagboard, stencil print, 16" x 22" (40.5 x 56 cm). Amidon Elementary School, Washington, DC.

Fig. 6–34 **What do the symbols and images in this artwork tell you about the artist?**
Ryan Johnson, *Untitled*, 2001.
Colored pencil, ink, 12" x 9" (30.5 x 23 cm). T. R. Smedberg Middle School, Sacramento, California.

"I had to think about what I was doing and put it on paper. The best thing I like about my art is that it was very personal. Each part of my artwork explained my feelings and my life." **Ryan Johnson**

"When I was assigned to create a drawing combining the features of an animal with myself, I knew immediatedly that I wanted to somehow transform myself into a panda. I went through this process by thinking of what physical features a panda and I have in common." **Cassie Rogg**

CD-ROM Connection
To see more student art, view the Personal Journey Student Gallery.

Fig. 6–35 **To send a message about yourself, what animal would you choose?** Cassie Rogg, *The Panda in Me*, 2001.
Colored pencil, 18" x 24" (46 x 61 cm). Archie R. Cole Junior High School, East Greenwich, Rhode Island.

Chapter 6 Review

Recall

What is a symbol?

Understand

Explain how portraits may send messages.

Apply

Use pictures as symbols for words in a message to a friend.

Analyze

Make a collection of logos, and explain how each one represents a product, service, or company.

Synthesize

Develop a list of three questions that a viewer should ask in order to understand an artist's message.

Evaluate

Review the artworks in this chapter (*see example below*). Select one that sends a message in a clear and understandable way. Give reasons for your selection.

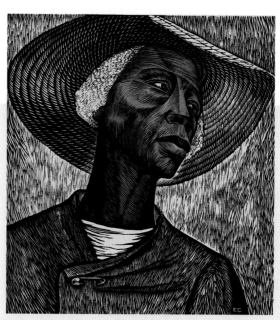

Page 216

For Your Portfolio
Create a symbolic portrait of someone you know well, such as a family member, a television star, or a neighbor-hood shop owner. Write an artist's statement to explain the meaning of your symbols.

For Your Sketchbook
Fill a sketchbook page with many different kinds of lines. Identify those lines that might be used to symbolize or express different moods and feelings, such as energy, calm, or joy.

Artists as Inventors

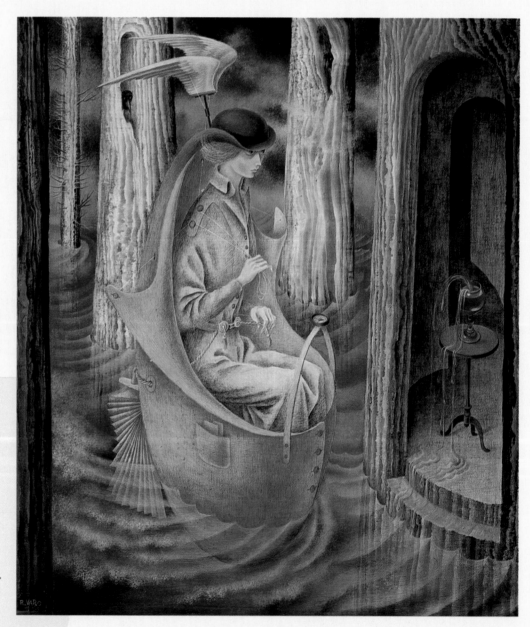

Fig. 7–1 **Remedios Varo often showed imaginary journeys in her paintings. What ordinary item of clothing did she transform into a boat?** Remedios Varo, *Exploration of the Sources of the Orinoco River,* 1959.
Oil on canvas, 17 1/2" x 15 1/2" (44 x 39.5 cm). Private Collection. Courtesy Anna Alexandra and Walter Gruen.

Focus

- How do people use their dreams in order to imagine possible worlds?
- In what ways do artists create the worlds they dream and imagine?

Have you ever played a game in which you created imaginary worlds where things happened in strange or unusual ways? Perhaps you invented a place where weird animals or other creatures roamed the land. Or maybe you pretended to live on a faraway planet, where everything is upside-down or topsy-turvy.

Even in our own world, we may see things that seem both real and unreal. What we see as a wet and slick road may actually be dry. What we have "seen" is a mirage. Our life may sometimes seem bizarre, as if it were fantasy.

Mysterious worlds are often subjects of artworks. Artists, like most of us, are interested in what appears not to be of this world. By focusing on dreams and fantasies, artists may invent imaginative worlds for us to consider. In such artworks as *Exploration of the Sources* (Fig. 7–1), artist Remedios Varo seems to go to secret, dreamlike worlds. They are worlds where objects come alive, people become plants, and nothing is as we expect it to be. In this chapter, you will learn more about Remedios Varo and other artists who invent worlds in which what we know is transformed into what we can only imagine.

Meet the Artists

Remedios Varo
Ellen Lanyon
Lillian Méndez

Words to Know

Surrealist	santos
perspective	space
linear perspective	movement
horizon line	rhythm
vanishing point	

Remedios Varo

An Inventive Artist

> "I took advantage of all that I learned, in painting the things that interested me on my own, which could be called, together with technique, the beginning of my personality."
> **Remedios Varo (1908–1963)**

Photograph by Katy Horna.

Remedios Varo's Journey

As a child in her native Spain, Remedios Varo (1908–1963) often copied her engineer father's detailed mechanical drawings and plans. She also loved fairy tales and magic stories. These stories inspired her to add fantasy-like elements to her drawings.

Varo studied at an art academy for seven years, developing her drawing talent and studying art history. She later journeyed to Paris, where she became familiar with and felt a connection to the **Surrealists**. These artists were interested in dreams and the workings of the subconscious. In the 1940s, Varo fled Paris because of World War II. She moved to Mexico, where she developed her personal artistic style and pursued her interests in magic, fantasy, and science.

Fig. 7–2 **In this artwork, travelers in tiny vehicles make their way through winding waterways. What parts of the scene look invented?**
Remedios Varo, *Spiral Transit*, 1962.
Oil on masonite, 39 3/8" x 45 1/4" (100 x 115 cm). Private collection. Courtesy Anna Alexandra and Walter Gruen. Photo by Javier Hinojosa.

Paintings from Questions

Varo was fascinated with the way things worked. Like a scientist, she focused on mechanical objects, and also insects, plants, birds, and other things in nature. She observed and made detailed drawings of

what she saw. In *Spiral Transit* (Fig. 7–2), Varo carefully painted a walled city like those of the Middle Ages. But then she used her imagination to invent a scene that looks real but could not actually exist.

To create the invented worlds of her paintings, Varo asked questions and then explored possible answers. She would ask, for example, what the moon would look like if someone could capture it and put it into a cage. With her "What if?" questions, she allowed herself to ignore science's explanations of our world. In such artworks as *Creation of the Birds* and *Mimesis* (Figs. 7–3 and 7–4), she created imaginative solutions to her questions. Her paintings provide us with invented worlds to enter and ponder.

Fig. 7–3 **What question do you think Remedios Varo was trying to answer with this painting?** Remedios Varo, *Creation of the Birds*, 1957.
Oil on masonite, 21 1/4" x 25 1/4" (54 x 64 cm). Courtesy Anna Alexandra and Walter Gruen.

Fig. 7–4 **Here, the artist twisted reality around. Chairs and other ordinary objects seem to come to life.** Remedios Varo, *Mimesis*, 1960.
Oil on masonite, 19" x 19 1/2" (48 x 50 cm). Courtesy Anna Alexandra and Walter Gruen.

Art from the Imagination

Remedios Varo was not the first to explore "What if?" questions. Centuries before science would explain much of our universe, people used their imagination to explain what they could not understand. They wondered about the origin of fire or how the sun "moved" across the sky. As they wondered, they asked questions to help them find solutions to the puzzles. They asked "What if all the fire in the world came from a fire-breathing dragon?" or "What if a chariot pulled by a team of horses moved the sun across the sky?" Their artworks showed what they imagined when they asked these questions.

Even after many puzzles in the world were explained by science, some artists continued to invent fantasy creatures in imaginative worlds. These worlds were often based upon dreams. Such artists as Hieronymus Bosch (Fig. 7–5), who lived in the second half of the 1400s, transformed people into creatures and gave humanlike qualities to objects.

Fig. 7–5 **Look closely at this image, a detail of a much larger painting. Note how the artist invented travel machines that could exist only in dreams or nightmares. How are these fantasy vehicles like those invented by Remedios Varo?** Hieronymus Bosch, *The Temptation of St. Anthony* (detail), c. 1500. Oil on panel, central panel: 51 3/4" x 47" (131.5 x 119 cm). Museu Nacional de Arte Antiga, Lisbon, Portugal. Nicolas Sapieha/Art Resource, New York.

Fig. 7–6 **The Surrealists of the twentieth century were fascinated with earlier imaginative paintings. What things from nature can you find here?** Giuseppe Arcimboldo, *Vertumnus*, c. 1590.

Oil on wood, 27 3/4" x 22 1/2" (70.5 x 57.5 cm). Slott, Skokloster, Sweden. Erich Lessing/ Art Resource, New York.

Fig. 7–7 **How did this artist use perspective to create an optical illusion?** M. C. Escher, *Another World II*, 1947.

Wood engraving printed from three blocks, 12 1/2" x 10 1/4" (31.5 x 26 cm). © Cordon Art B.V. - Baarn-Holland. All rights reserved.

Artistic Tricks

Some artists seem to love to fool us with optical tricks. In the mid-1500s, artist Giuseppe Arcimboldo invented a unique approach to fool the eye. The painting *Vertumnus* (Fig. 7–6) shows the technique he developed. Arcimboldo created fantasy portraits by combining images of different fruits, vegetables, and other natural objects.

Artists also may use mathematical and scientific approaches to make their unreal worlds appear real. They create optical tricks through the use of **perspective**, a technique for creating the illusion of depth on a two-dimensional surface. Artist M. C. Escher, for example, distorted perspective and worked with several vanishing points in order to make impossible scenes look real. In his artwork *Another World II* (Fig. 7–7), how many different ways to look into space did the artist create?

Drawing in the Studio

Drawing a Fantasy World

You have seen how Remedios Varo and other artists use their imagination to create invented worlds. Now it's your turn to create a fantasy world, where unexpected things occur.

In this studio experience, you will use colored pencils to create an invented scene from a world where fantasy is combined with reality. As you make your detailed drawing, ask some "What if?" questions: What if people looked like plants? What if birds grew from seeds? Think of ways to draw and arrange lines and shapes to create rhythm and movement. Consider how you could use perspective to create the illusion of both deep and crowded spaces in your scene.

You Will Need

- drawing paper
- pencil
- eraser
- ruler
- colored pencils or markers

Try This

1. Before you begin drawing, make some decisions about how you will create the illusion of deep space in your scene: will you use linear perspective, placement, overlap, size, and/or color? How will you combine methods of perspective to get the look of space you want? If you use linear perspective, lightly draw your guides with a pencil and ruler (see page 236).

Fig. 7–8 **Salvador Dalí was a Surrealist. How did he use perspective to create the illusion of depth?** Salvador Dalí, *Mae West*, c. 1934.
Gouache, with graphite, on commercially printed magazine page, 11" x 7" (28.3 x 17.8 cm). Gift of Mrs. Gilbert W. Chapman, 1949.517. Photograph © 2001, The Art Institute of Chicago, All Rights Reserved. © 2001 Kingdom of Spain, Gala-Salvador Dalí Foundation/ Artists Rights Society (ARS), New York.

Studio Background

Creating the Illusion of Depth

Renaissance artists discovered that parallel lines seem to recede, or move back in space, to a vanishing point. An artist's use of lines to create depth is called linear perspective. (To learn more about linear perspective, see Lesson 7.2, pages 236 and 237.)

Artists may use techniques other than perspective to create the illusion of depth. They may place shapes high on a paper or canvas so that they appear to be far away. Artists may also overlap shapes. By doing so, the topmost shape will appear to be in front of other shapes. The drawing of similar shapes in different sizes is another way that artists create depth. The smaller shapes will seem farther away than the larger ones. Artists also use color and value to give the illusion of depth. Bright colors appear to move forward; light shades and dull colors appear to recede.

2. Sketch the main features of your scene. What buildings, objects, and life forms will you include? Which elements will be from the real world? Which will be from an invented world? Think of ways to draw and arrange lines and shapes to create rhythm and movement. Will your shapes swirl or float in rhythmic patterns? Will they collide and create jerky or jagged patterns?

3. Fill in color and add details with colored pencil. Remember that shapes in the distance have less detail than those close up. How could you use value, or light and dark colors, to add to the illusion of depth?

Fig. 7–9 **How did the artist create a sense of deep space in this artwork?** Anthony Smith, *Atlantis,* 2000.
Colored pencil, 12" x 18" (30.5 x 46 cm). Laurel Central Middle School, Galveston, Texas.

Pair up with a classmate to talk about your completed drawings. Which "What if?" question did each of you explore? What parts of your drawing show things from the real world? What parts are from a fantasy world? How did you create the illusion of space? Where did you create rhythm and movement?

Lesson Review

Check Your Understanding
1. What purpose did Remedios Varo's "What if?" questions serve?
2. Why do we sometimes think of artists as inventors?
3. Explain two ways to create the illusion of depth in a drawing or painting.
4. Why are some people curious about their dreams?

Fantasy in Art

1936	1958	1975
Oppenheim, *Lunch in Fur*	Magritte, *Listening Room*	Lanyon, *The Disguise*

20th Century **Late 20th Century**

1938	1970	1999
Penrose, *Winged Domino*	Lanyon, *Chemistry Versus Magic*	Lanyon, *Dominoes and Dragons*

Travels in Time

The invention of stories and special creatures has always been important to people. These inventions often help people to "explain the unexplained." Throughout history, artists have depicted invented scenes in different ways. In the Middle Ages, for instance, European artists carved grotesque creatures in stone and painted pictures of dragons, even though these creatures did not exist. In the twentieth century, artists made things seem unreal by putting real things in invented, dreamlike settings.

Fig. 7–10 **By changing the usual scale of the object in relation to its setting, the artist invented a dreamlike space. Do you get the feeling that something is about to happen?** René Magritte, *The Listening Room*, c. 1958. Oil on canvas, 15" x 18" (38 x 46 cm). Kunsthaus, Zurich, donated by Walter Haefner. Photo AKG London. © 2001 C. Herscovici, Brussels/Artists Rights Society (ARS), New York.

Fig. 7–11 **Can you imagine trying to drink from this cup? Why does this cup seem to be something from a dream?** Meret Oppenheim, *Object (Lunch in Fur),* 1936.
Fur-covered cup, saucer, spoon; cup, diameter: 4 3/8" (11 cm); saucer, diameter: 9 3/8" (23.7 cm); spoon, length: 8" (20.2 cm). The Museum of Modern Art, New York. Purchase. Photograph ©2001 The Museum of Modern Art, New York. © 2001 Artists Rights Society (ARS), New York/ProLitteris, Zürich.

Fig. 7–12 **The title of this portrait is *Winged Domino*. A *domino* is a type of mask. Do you see a mask in this work?** Roland Penrose, *Winged Domino—A Portrait of Valentine,* 1938.
Oil on canvas. © Estate of the artist.

More Real than Life

Surrealist artworks are based on the idea that dreams and fantasies often seem "more real" than real life. Surrealist artists in the first half of the twentieth century were interested in shocking their viewers. The Surrealists would mix up everyday objects with invented settings. Some artists carefully arranged their odd combinations. Others allowed chance or coincidence to create such surprises.

Visual Tricks

The paintings of René Magritte are like dreams. In such artworks as *The Listening Room* (Fig. 7–10), he made familiar objects seem strange. The objects look real, but what the viewer sees could not possibly be. To play such visual tricks on viewers, Magritte placed objects in invented places or depicted objects in unreal sizes.

Surrealist Roland Penrose also seemed to play tricks on viewers. In a portrait of his wife (Fig. 7–12), he showed her covered with butterflies and birds. He covered normally recognizable features—eyes and lips—with winged creatures.

Other Surrealist artists were inspired to invent new methods by combining materials in unusual ways. For instance, for her artwork shown in Fig. 7–11, artist Meret Oppenheim covered a cup, saucer, and spoon with fur!

Inventing Illusions

"I wanted to make magic on a two-dimensional surface."
Ellen Lanyon (born 1926)

When she was eight, Ellen Lanyon went to the 1934 Chicago World's Fair, where she played in a miniature village that her grandfather had built. She remembers the village as a storybook setting—so very real, yet so very magical. Her memories of that childhood experience influence her work today.

Lanyon taught herself to draw by working from photographs. As a teen, she worked part-time in a company's drafting department, enlarging designs for machine parts. These early experiences helped her to be inventive as a mature artist.

Fantasy Inventions

As part of her artistic process, Lanyon is always on the lookout for postcards and souvenirs. She often copies parts of postcard scenes and puts them into her own paintings. She also draws from a huge collection of found objects, carefully observing their details.

Fig. 7–13 **What did the artist do to make the space seem crowded?** Ellen Lanyon, *Dragons and Dominoes*, 1999.
Acrylic on canvas, 45" x 52" (114 x 132 cm).
Courtesy of the artist and Jean Albano Gallery, Chicago, Illinois.

Fig. 7–14 **Compare this work to *Creation of the Birds* on page 227. How are the two works alike? How are they different?** Ellen Lanyon, *Chemistry Versus Magic*, 1970. Acrylic on canvas, 60" x 60" (152 x 152 cm). The Letitia and Richard Kruger Collection. Courtesy of the artist.

Fig. 7–15 **How would the effect of this picture be different had the artist not overlapped the shapes, but had left more open space between them?** Ellen Lanyon, *The Disguise*, 1975. Private Collection. Courtesy of the artist.

Although her drawings and paintings are realistic, Lanyon often combines images of animals, plants, and found objects into fantasy inventions. Many of her artworks show objects used by people interacting with nature. In such paintings as *Dragons and Dominoes* and *Chemistry Versus Magic* (Figs. 7–13 and 7–14), Lanyon seems to want us to think about our relationship to the natural world.

Lanyon also likes to show transformations in her artworks. By transforming, or changing, things, she created an illusion—things *look* real, yet they are *not* real.

Studio Connection

Use crayons, pastels, watercolors, markers, and collage materials to invent a fantasy environment filled with ordinary objects. You may use crayon resist to create a background for cutouts of your objects. Give them meaning by combining several things that are not always thought of as belonging together. Be playful in the arrangement of your selected objects.

Lesson Review

Check Your Understanding

1. Explain how some artists seem like inventors.
2. Give some examples of what Surrealist artists have done.
3. How are Ellen Lanyon's depictions both real and unreal?
4. What are some things you could do as an artist to create a fantasy environment?

Artists as Inventors

235

Perspective

Practice One-Point Perspective

Linear perspective is a system of using lines to create the illusion of three-dimensional space. Artists use this system to create a sense of depth in a painting or drawing.

Look at the one-point perspective diagram. The **horizon line** represents the eye level of a viewer and is usually located where the earth appears to meet the sky. The **vanishing point** is the place where parallel lines seem to meet in the distance. Notice that the vanishing point is located on the horizon line.

Now look at the two-point perspective diagram. Artists use this system of linear perspective when they view an object or building from an angle or corner. Notice that in two-point perspective there are two vanishing points on the horizon line.

Refer to the one-point perspective diagram for help in setting up your drawing. Use a yardstick to lightly draw a straight line across a sheet of paper. This represents the horizon line. Add a vanishing point at or near the center of the horizon line. Next,

draw a row of buildings, houses, or other boxlike objects that seem to recede—go back into space and get smaller—as they approach the vanishing point. Be sure that all vertical lines remain parallel to the side of the paper. All horizontal lines should remain parallel to the top and bottom of the paper. You may wish to add diagonal guides for lines that recede to the vanishing point.

Fig. 7–16 **Notice the feeling of deep space that is created by the use of one-point perspective. Where do you think the vanishing point is located?** Steven Hudson, *The Final Frontier,* 2001. Colored pencil on paper, 9" x 12" (23 x 30.5 cm). Samford Middle School, Auburn, Alabama.

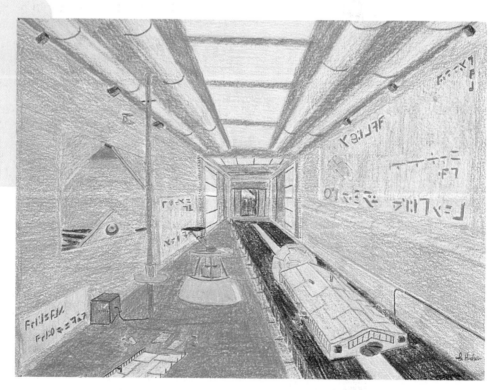

Fig. 7–17 **This artist has used two-point perspective to create this drawing. What other methods of creating space did he use?** Elmo Peterson, *Two-Point Perspective*, 2000. Colored pencil on paper, 12" x 18" (30.5 x 46 cm). Central Middle School, Galveston, Texas.

Practice Two-Point Perspective

Study the two-point perspective diagram for help in setting up your drawing. Use a yardstick to lightly draw a horizon line across a sheet of paper. Add two vanishing points to the horizon line. These should each be about the same distance from the left and right edges of the paper. If the vanishing points have to be placed off the edges of the paper, you can tape your

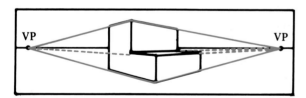

drawing onto a larger sheet. Then extend the horizon line onto the larger sheet and locate the vanishing points.

Next, draw a single building, house, or other boxlike object at the center of the paper. As in one-point perspective, lines above the horizon line slant downward, and lines below the horizon line slant upward. Your subject should be turned so that one corner is closer to the viewer.

Other ways to create the illusion of three-dimensional space include

1. overlapping

2. shading and shadow

3. placement—objects near the top seem more distant

4. size—smaller objects seem more distant

5. color and value—light values and cool, dull colors suggest distance

6. focus—sharp detail suggests nearness

Artists have found inventive ways to combine these methods with one- and two-point perspective.

Studio Connection

Use a yardstick to help you create a perspective drawing, such as a street scene, a cityscape, or a still life that includes boxlike forms (such as milk cartons, blocks, wrapped gifts, or books). You also could choose to draw an imaginary collection of boxes of different sizes as though they were flying in the air, all above the horizon line. Use one-point or two-point perspective as necessary to create the illusion of depth in your drawing. Include other ways of creating the illusion of three-dimensional space where needed.

Lesson Review

Check Your Understanding

1. In your own words, explain the differences between one-point and two-point perspective.
2. Why is a yardstick—rather than a ruler—helpful in making a perspective drawing?

Art of Puerto Rico

Puerto Rico

Places in Time

Puerto Rico—a beautiful, fertile island about a thousand miles southeast of Florida—has a diverse history. Its first inhabitants were the South American Arawak Indians. In the sixteenth century, Spanish colonists established large plantations. They brought Africans to the island to work in the fields and gold mines. In 1898, Puerto Rico became a commonwealth of the United States. Because of their rich heritage, Puerto Ricans celebrate many holidays and festive occasions.

Fantasy in Art

Since the seventeenth century, Puerto Ricans have used colorful masks in their celebrations. The masks add a fantasy-like element to the festivals and parades.

Maskmakers use the traditional materials of papier-mâché and coconut shells to form the masks. Maskmakers in the town of Ponce typically produce masks with long, pointed teeth and tall horns (Fig. 7–18). The masks made in Loiza, however, usually have square mouths, triangular noses, and round eyes. Masks from both areas are colorful and have repeated elements that create visual rhythm and movement.

The addition of costumes to a Puerto Rican celebration is another element of fantasy in the festive events. Costumes (Fig. 7–19) play an important role in carnival, celebrated in February and July. Both masks and costumes help create a feeling of an unreal, dreamlike world.

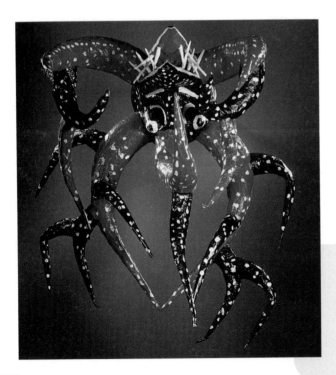

Fig. 7–18 **This mask is made from the traditional material of papier-mâché. It is decorated with the bright colors and patterns that are typical of masks from the town of Ponce.** Puerto Rico, *Ponce Mask*, 21st century.
Courtesy the Smithsonian Institution, National Museum of American History, Teodoro Vidal Collection.

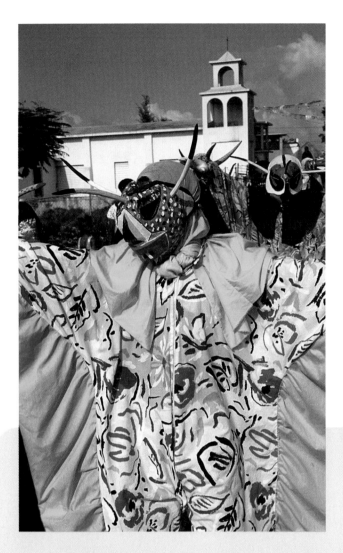

Fig. 7–19 **Why do people wear costumes during celebrations?** Puerto Rico, *Vejigante Celebrant in a Loiza-style Costume and Mask*, 21st century.
Photo © 2001 Mark Bacon.

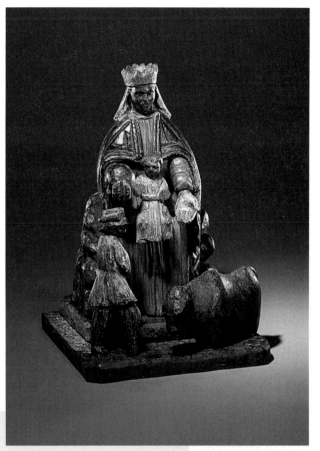

Fig. 7–20 **Carved wooden images such as this are often placed in boxes called niches.** Puerto Rico, *Santos Figure: Virgen de Hormigueros*, c. 19th century.
Carved wood. Smithsonian Institution, National Museum of American History, Teodoro Vidal Collection.

Creative Traditions

Art-making in Puerto Rico has long been a product of the island's racial, ethnic, and cultural mix. This mix has produced a variety of artworks. The elaborate carnival masks and costumes on these pages are examples of fantasy artworks. Artists also create practical artworks, such as musical instruments and delicate lace.

In addition to these artistic expressions, many artists produce spiritual artworks. Since the 1500s, artists have carved religious figures called **santos** (Fig. 7–20). The artists who make such figures are called *santeros*. Because they do not usually have pictures of the saints, who lived long ago, the santeros have invented ways to represent them. They often use symbols to stand for saints and other holy figures from the Catholic religion. The santos have deep religious meaning and are popular in many Puerto Rican homes.

Reinventing Past Traditions

"When you know where you came from, you have a much better understanding of where you are going."
Lillian Méndez (born 1957)

Today, many artists in Puerto Rico continue to use folk-art traditions as inspiration for their artworks. Such artists as Lillian Méndez often balance these traditions with present-day cultural influences.

As an artist, Méndez wears three hats: maker of objects, inventor, and storyteller. The biographical stories of her art describe her personal journey as a Latina raised in Puerto Rico and now living in the United States. Her childhood experiences are what add the colorful and inventive qualities to the objects she makes. Her use of the folk-art tradition of papier-mâché gives her artworks their elaborate form.

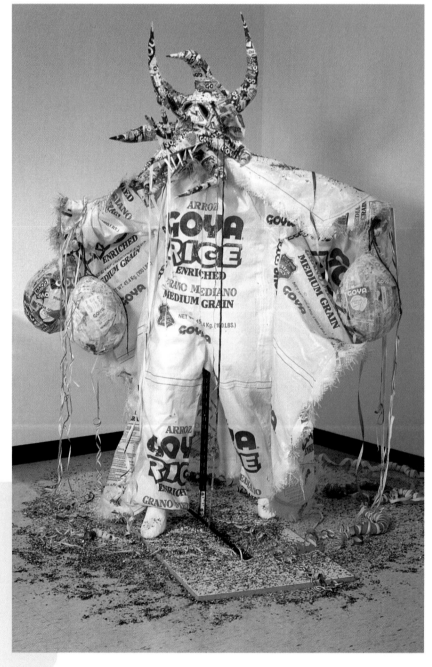

Fig. 7–21 **This sculpture is part of a larger installation. The installation included masks and carnival costumes, as well as drawings and paintings on the theme of carnival.**
Lillian Méndez, *Vejigante Made from Goya Rice Bags,* 1999–2000.
Mixed media, 84" x 48" x 24" (213 x 122 x 61 cm). Courtesy of the artist.

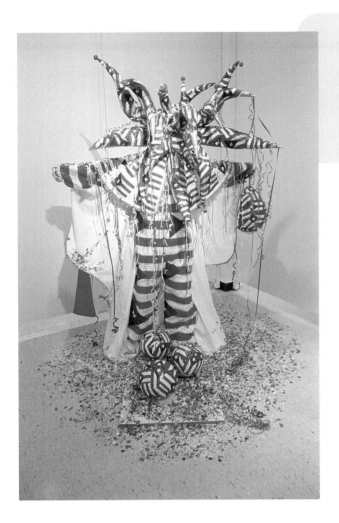

Fig. 7–22 **Do you think the artist meant this sculpture to be humorous? Why or why not?**
Lillian Méndez, *Vejigante Made from Puerto Rican Flags*, 1999–2000.
Mixed media, 84" x 48" x 24" (213 x 122 x 61 cm). Courtesy of the artist.

Studio Connection
Try your hand at maskmaking! Make an elaborate paper mask that is decorative and festive. Use construction paper, and explore a variety of paper sculpture techniques. Be inventive in creating facial features with three-dimensional paper forms and cut-paper shapes. Use staples and/or glue to assemble the parts of your mask.

Lesson Review

Check Your Understanding
1. What are santos, and what role do they play in the lives of Puerto Rican families?
2. What materials are traditionally used by Puerto Rican maskmakers? What are the similarities and differences between the masks of Ponce and the masks of Loiza?
3. What evidence of Puerto Rican artistic traditions do you see in the work of Lillian Méndez?
4. In what way is Lillian Méndez both a story-teller and an inventor?

Inventive Creations

In her childhood, Méndez lived by the ocean in the southeastern part of Puerto Rico. She was an inventor at an early age and used to catch crabs with traps that she designed herself. As an adult artist, Méndez is still inventing. She makes inventive use of materials, such as the decoration of her costumed figures with Puerto Rican flags or packages for Hispanic foods.

Through her art, Lillian Méndez shares her Puerto Rican heritage with others. She has a keen interest in developing awareness of Hispanic/Latino art and culture. Méndez stresses the importance of young people's consideration of their own ethnic background when they make art. She says: "It's important to educate yourself about your culture. The path that your ancestors have traveled is fertile ground for your own imagination to develop and prosper."

Building a Wire Sculpture

The Whole Wired World

Studio Introduction
In this studio experience, you will work with your classmates to create a make-believe world out of wire.
Pages 244 and 245 will tell you how to do it. You have seen how artists can transform ordinary materials into imaginative or dreamlike objects and images. What kind of magical world can you create? With your classmates, discuss possibilities. Will you create a magical jungle or a colorful, weird world at the bottom of an ocean? Will you change an ordinary scene at a shopping mall, amusement park, or your school into one where things are not exactly the way you would expect? Perhaps your imagination will lead your discussion to outer space and the creation of a strange planet full of bizarre forms and peculiar creatures.

Studio Background

The Wire World of Alexander Calder
Alexander Calder was born into a family of artists: his mother was a painter, and his father and grandfathers were sculptors. He once said: "I think best in wire." In 1926, Calder began to work his magic with wire and other materials when he created and conducted performances of a miniature circus. He twisted and wrapped wires to make clowns, high-wire performers, and animals he had sketched while at a live circus.

To capture the spirit of the circus, Calder included just enough detail in his wire sculptures. He was fascinated with movement and, throughout his life, developed ways to balance and move shapes in space. For many of his later sculptures, he welded giant sheets of metal together with heavy rods. Some sculptures, hung from ceilings, were *mobiles*. Others, fastened to the ground, were *stabiles*.

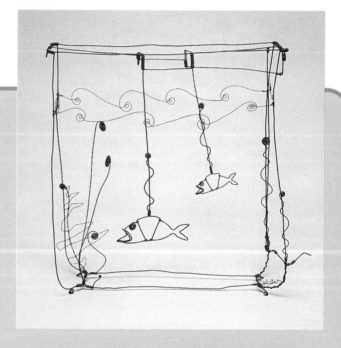

Fig. 7–23 **Note how the artist used wire to suggest the three-dimensional space of a fishbowl. Within this space, he suspended fish, waves of water, and other objects. What techniques did he use to connect the wires in this sculpture?**
Alexander Calder, *Goldfish Bowl*, 1929.
Wire, 16" x 15" x 6" (40.6 x 38.1 x 15.2 cm). Private Collection/Art Resource, NY. © 2001 Estate of Alexander Calder/Artists Rights Society (ARS), New York.

Fig. 7–24 **Student artists used colored wire to help create their circus world. Notice the clever use of corks.** Jayni Butta, Nicole Moss, Adam Harris, Joe Starmer, Jeff Patten, *The Circus*, 2001.
Wire, mixed media; height of sculptures: between 7" to 10" (18 to 25.5 cm). Sierra School, Arvada, Colorado.

Fig. 7–25 **Notice the use of found materials in this work. What is the theme of this sculpture?** Deana Rotti, Sarah Scannell, Arianne DelGuidice, *Fun Things to Do After School,* 2001.
Wire, pipe cleaners, coat hanger, 18" x 18" (46 x 46 cm). Chocksett Middle School, Sterling, Massachusetts.

Making Your Wire Sculpture

You Will Need

- variety of wire
- found materials
- wood for base
- stapler or tacks

Try This

1. With your classmates, choose a theme for your wire world. Discuss the features that the world will have. Will it have people, animals, or imaginary creatures? Will you include other features, such as buildings, mountains, plants, or trees? Which parts will be realistic, and which parts will be fantasy?

2. Decide who will make which features of the make-believe world.

3. Make your sculpture for the make-believe world. Bend and twist lengths of wire into people, plants, animals, or imaginary forms. You may decide to add beads, buttons, pieces of fabric, or other found materials to get the effects you want.

4. With a stapler or tacks, attach your sculpture to a wood base.

5. With classmates, arrange the completed sculptures in a tabletop display. How can the placement of the sculptures help create an overall sense of space in the scene? How can they work together to create rhythm and expressive movement?

Check Your Work

Have a class discussion about the completed wire world. What parts of it are realistic? What parts are purely imaginary? How does the placement of the figures help create a sense of space, movement, and rhythm? Next, discuss what you learned from working with classmates on this project.

Computer Option

Artists can create three-dimensional worlds in a computer's "virtual space." These worlds may be seen from many points of view. Using a 3-D rendering program, create an environment or a creature (person, animal, insect, etc.). Allow your creation to be viewed from two different perspectives. Computer 3-D rendering is a lot like creating with wire, because to achieve the completed rendering you must first create what is called a wire frame. Then add color and texture to the surface of the environment or creature. This is how many animated movies and cartoons are created.

Elements and Principles

Space, Movement, and Rhythm

In art, **space** is the empty or open area between, around, and within objects. *Positive space* is the area filled by a three-dimensional form. *Negative space* is the area surrounding a form. Sculptures

positive space negative space

and architecture fill actual space. For a painting or other two-dimensional artwork, artists create the illusion of actual space. To do this, they can choose from several methods of *perspective*. To learn more about perspective, see Lesson 7.2, pages 236 and 237.

Artists use the principle of **movement** to create the look of action in an artwork. Certain kinds of artwork, such as mobiles, actually move. Artworks can also show movement through the poses of people or animals, or in the way other subject matter is designed. For example, an artist may include bending trees in a painting to suggest a strong wind. Artists can also create *paths of movement* in their compositions. By carefully arranging lines, shapes, or other elements, they can lead the viewer's eye around the artwork.

Rhythm is a kind of movement that is related to pattern. Lines, shapes, and colors that are

repeated in an organized way can create a sense of rhythm. Rhythm can be simple and predictable, such as footprints in the sand. Or it can be complex, such as the grain of wood.

Fig. 7–26 **Student artists took their wire world a step further and added a painted background. Notice how they incorporated pipe-cleaner fireworks into the scene.**
Lindsay Howard and Melissa McCarthy, *Fireworks,* 2001.
Pipe cleaners, foamcore, cardboard, tempera, 12 1/2" x 18" x 12" (32 x 46 x 31 cm). Chocksett Middle School, Sterling, Massachusetts.

Connect to...

Careers

Do you have any jewelry you wear every day or only on special occasions? Does wearing jewelry make you feel special? In many cultures, jewelry has been worn for its protective properties, and has been used for adornment or to indicate royalty, status, or wealth. The success of a **maker or designer of jewelry** is based on the artist's imagination and skill. Jewelry designers may learn their trade through several sources: they may pursue a fine-arts degree, attend a trade school, learn through an apprenticeship with a designer or jewelry-making company, or be self-taught. Skill in drawing and an interest in working on a small scale are needed for a rewarding career as a jewelry designer and maker.

Daily Life

It is possible that a person who was born in 1870 lived long enough to witness the invention of electric lighting, the automobile, and the airplane. In your life, you have already witnessed rapid technological advances in cellphones, pagers, and the Internet. The **inventors** of all of these aspects of technology shared the belief that society would benefit from their discoveries. What other kinds of technological advances do you think you may witness in your lifetime?

Other Arts

Music
Do you know when the electric guitar was invented? The first experiments with electricity and the guitar began in the 1920s, when inventors and musicians collaborated to create guitar sounds that would be louder than the background orchestra. In an electric guitar, the vibrations of the strings are captured by "pickups," magnetic devices that turn the vibrations into electric signals. These signals then pass through an amplifier, an electronic device that increases the sounds of the strings. How do musicians today experiment with new sounds?

Fig. 7–27 **Using the electric guitar in new and inventive ways has allowed musicians to produce fresh sounds in jazz, rock, and other forms of contemporary music.** United States, *Electric Guitar (Flying V model)*, 1967. Mahogany, rosewood, plastic. Manufactured by Gibson, Inc. Smithsonian Institution, National Museum of American History, Division of Cultural History.

Other Subjects

Social Studies

Many cultures have myths and legends that explain inventions or the passing on of knowledge. For example, the Navajo people have a story that explains how they were given the knowledge of weaving. In the story, Spider Woman taught the Navajo how to weave on a loom that Spider Man showed them how to make. What similar tales can you think of that reflect the receiving of knowledge?

Mathematics

Can you think of any mathematical connections with art that might have seemed inventive to its earliest viewers? **Artists have used mathematical concepts to invent systems for creating the illusion of depth on a flat surface.** In linear perspective, for example, sets of implied lines move closer together in the distance until they . Two-point perspective uses lines that lead to two different vanishing points.

Fig. 7–28 **The unicorn was supposedly a pure white horse with a horn in the middle of its forehead. What other fabled creatures can you think of?** South Netherlandish, *The Unicorn in Captivity*, c. 1495–1505.
Wool warp, wool, silk, silver, and gilt wefts, 12' 1" x 99" (368 x 251.5 cm). The Metropolitan Museum of Art, Gift of John D. Rockefeller Jr., 1937 (37.80.6). Photograph © 1993 The Metropolitan Museum of Art.

Science

Do you think the **invented creature the unicorn** ever existed? Though the unicorn was only an imaginary creature, stories about it were based on a real animal called the narwhal. The narwhal is a small whale found only in northern Arctic waters. It has a body about fifteen feet long, a rounded forehead, small eyes, and gray skin. Male narwhals have a long spiraled tusk that is actually a tooth, rather than a horn. During medieval times, traders brought the tusks back to Europe and sold or traded them as unicorn horns, adding to the belief in the mythical creature.

Fig. 7–29 **In the early fifteenth century, Renaissance artists invented a system of drawing called linear perspective.** Lorenzo Ghiberti, *Gates of Paradise* (detail), 1425–52.
Gilt bronze, approx. 31 ½" x 31 ½" (80 x 80 cm). Courtesy Davis Art Slides.

Internet Connection
For more activities related to this chapter, go to the Davis Website at **www.davis-art.com**.

Portfolio

"As I created this mask, I was thinking of a way to express my individuality, as well as my love for art. Each little detail shows how unique I am."
Sara Fischbacher

Fig. 7–30 **The shapes, lines, and colors used by the artist makes this mask appear lively and vibrant.** Sara Fischbacher, *Paper Mask*, 2001.
Paper, tagboard, glitter, 17" x 14" (43 x 35.5 cm). Smith Middle School, Fort Hood, Texas.

Fig. 7–31 **A blend of realistic and abstract images adds interest to this fantasy world.** Jim Hunt, *Under the Sea*, 2000.
Colored pencil, pencil, marker, 9" x 12" (23 x 30.5 cm). Samford Middle School, Auburn, Alabama.

"We were drawing fantasy scenes, and the first thing I thought of was underwater fantasy. I thought my use of color and shading worked well together to create an interesting picture." **Jim Hunt**

CD-ROM Connection
To see more student art, view the Personal Journey Student Gallery.

Fig. 7–32 **The use of mysterious shapes and bands of colors makes the viewer wonder what the artist was imagining.** Cristina Jane Houston, *Wall to Wall*, 2001.
Marker, chalk pastel, fabric, wallpaper, 17" x 11" (43 x 28 cm). Victor School, Victor, Montana.

"It started out as a still life, then I began to fill all the space with wall paper and chalk pastels. It is special because it is like a piece of my mind." **Christina Houston**

Chapter 7 Review

Recall

Name two ways to create the illusion of depth in a drawing or painting.

Understand

Explain why we sometimes think of artists as inventors.

Apply

Produce an artwork that tricks the viewer's eye. (*See example below.*)

Page 235

Analyze

Select one work by Ellen Lanyon and one by Remedios Varo. Compare and contrast the way each artist used both realistic and imaginary features.

Synthesize

Write directions or instructions for how to turn a realistic scene, such as a view of a farm or city, into a surrealistic drawing.

Evaluate

Select five artworks from this chapter, and write their titles. Decide what kind of work each is, and label each as fantasy, surreal, dreamlike, or real. Give reasons to support each decision.

For Your Portfolio

Look through this chapter to select one artwork that especially appeals to you. Write a two-part essay. In the first part, write a detailed description of the work. In the second part, explain how this artwork suggests a world of fantasy. Write your name and the date on your essay, and put your essay into your portfolio.

For Your Sketchbook

Use a page of your sketchbook to transform one object into another in a sequence of six sketches. For example, you might change a flower into a butterfly.

Artists as Planners

Fig. 8–1 **Gehry is known for creating dramatic forms and using materials in new and unusual ways. How does this museum's design compare with that of other museums you have seen?** Frank Gehry, *Guggenheim Museum, Bilbao*, 1997.
Bilbao, Spain. Photo © Ralph Richter/Esto/architekturphoto.

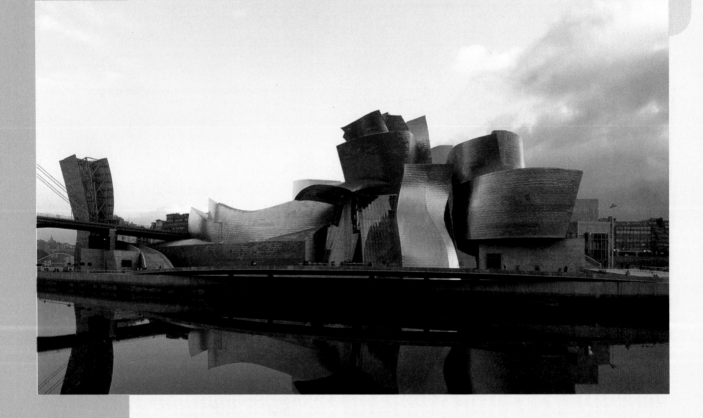

Fig. 8–2 **Many of Gehry's buildings begin as gesture drawings, such as the one shown here. How is drawing helpful in working out ideas?** Frank Gehry, *Guggenheim Museum, Bilbao, Design Sketch*.
Courtesy Frank O. Gehry and Associates, Santa Monica, California.

- How do people plan their living environment?
- How do artists help us plan the spaces and places we use?

People have always planned for ways to use the spaces around them. They may plan temporary spaces like camp-sites. For permanent shelters, people plan ways to organize interiors and exteriors with places for cooking, washing, sleeping, working, and relaxing. They also plan ways to organize appliances, furniture, and other belongings.

Architecture is the art of planning buildings and spaces for people. The architecture of a street or neighborhood is often designed and built through the collaboration of a group of experts. These include city planners, engineers, builders, and architects. **Architects** are artists who design buildings. They also develop neighborhood, town, and city spaces, such as stores, hospitals, and government and other public buildings. Because many people living close to one another must have places to shop, work, and relax, planners must consider the best use of available spaces for businesses, parks, and roads.

Architect Frank Gehry designed the museum shown here (Fig. 8–1). The structure, in the industrial city of Bilbao, Spain, creates a gateway to an area that was once a busy shipyard. In this chapter, you will learn more about the work of Frank Gehry and other architects who plan the spaces and places we inhabit.

Meet the Artists

Frank Gehry
Melinda Gray
Ricardo Legorreta

Words to Know

architecture	architectural
architect	model
cantilever	hacienda
Post-	form
Modernism	balance

Frank Gehry

A Planner from the Start

> "I approach each building as a sculptural object, a spatial container, a space with light and air."
> **Frank Gehry (born 1929)**

Photo by Thomas Mayer.

Frank Gehry's Journey

Frank Gehry grew up in Toronto, Canada. He remembers when, as a child, he made "little cities" out of wood scraps with his grandmother. At 18, he and his family moved to California, where he still lives and works. As an architect, Gehry has produced shopping malls, houses, parks, museums, banks, restaurants—even furniture!

Gehry is noted for his experiments with forms, materials, and construction techniques. He first received national attention for the unusual design of his own home in California (Fig. 8–3). For this structure, he used inexpensive materials, such as plywood, tar paper, chain-link fence, concrete blocks, and corrugated metal. He started with a pink, two-story house. Planning the use of space from inside to outside, he expanded the house upward and sideways. He even wrapped parts with metal and wood.

Gehry wants people to be comfortable in the buildings and spaces he plans. He thinks about how his buildings will be used daily, by ordinary people. He also pays attention to the community in which his buildings will be constructed. This was an important concern when he designed the Bilbao museum (Fig. 8–1), which is part of a newly developed river-front area. The building's metal surface and free-flowing design suggest both the community's industrial past and its eye to the future.

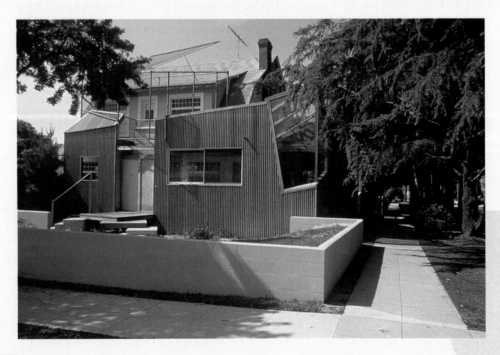

Fig. 8–3 **Gehry's use of inexpensive materials has influenced the plans of many other architects today.** Frank Gehry, *Gehry Residence*, 1978.

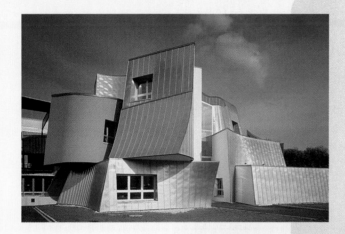

Fig. 8–4 **This building is like a three-dimensional collage. What different forms and materials can you identify?** Frank Gehry, *Vitra Headquarters*, 1994.
Birsfelden, Switzerland. Photo: Tim Griffith/Esto.

Fig. 8–5 **Many people say that some of Gehry's designs are humorous. How does this museum design include humor?** Frank Gehry, *Aerospace Museum*, 1984.
Los Angeles, California. Photo © Michael Moran.

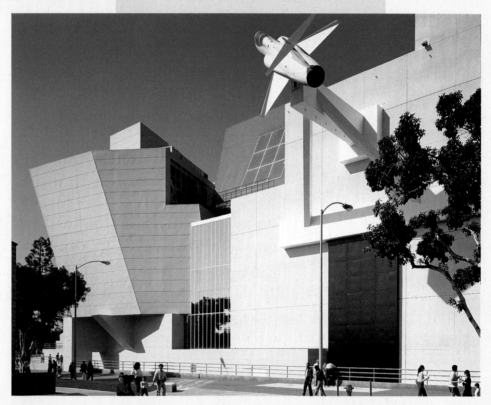

The Planning Process

For Gehry, the planning process is very important. He begins with wild gesture drawings, such as the one shown in Fig. 8–2. Then he creates three-dimensional models of different scales. As he constructs his models, he thinks about them as both sculpture and as a place for people to live or work. Gehry and a team of more than 120 people work to plan and create imaginative spaces for clients.

Like many architects working today, Gehry uses the computer to assist in design. He works with a computer program used in the aerospace industry. The program has allowed him to create surprising-looking buildings whose surfaces bend and ripple. Gehry asks: "How wiggly can you get and still make a building?" Some have called his space-age buildings "biomorphic," suggesting that they seem alive, constantly moving and changing.

Planning Forms for the Future

Imagine that you are asked to plan a new city. What would you include? What kinds of spaces would people need? Where would they live, work, and play? How would they get from place to place? How would you plan for them to get food and other items they need?

The idea of planning a new place from scratch has appealed to people throughout history. For example, such artists as Hieronymus Bosch (Fig. 7–5) have created images of fantasy worlds or cities of the future. Architects and other artists often get ideas for the future from science-fiction stories, futuristic comic books, and children's drawings. They also dream of ways for new technology to meet people's needs in years to come. As cities develop, these visions sometimes become reality.

Fig. 8–6 **American architect Frank Lloyd Wright created a new plan for viewing artworks in a museum: people walk a spiraling interior ramp that echoes the building's exterior shape.** Frank Lloyd Wright, *Solomon R. Guggenheim Museum*, 1956–59.
New York, New York. Courtesy Davis Art Slides.

Fig. 8–7 **A group of British architects created the magazine *Archigram* to show their ideas for a new kind of architecture that was not meant to be permanent. In Plug-In City, separate living units were to be plugged in to a central structure that provided power and water. Why, do you think, was this kind of structure never built?** Archigram–Peter Cook, *Plug-In City*, 1964.
Illustration for *Archigram* magazine. Courtesy the Archigram Archives, London, England.

Fig. 8–8 **This plan for a city combines architecture with ecology. The architect has given the name** *arcology* **to his ideas. An arcology complex contains apartments, businesses, entertainment, and open spaces.** Paolo Soleri, *Arcosanti,* 2001.
Under construction in central Arizona. Photo courtesy the Soleri Archives.

Planning Decisions

Most professional planners, however, do not have the opportunity to plan cities from scratch. Instead, they must plan buildings, parks, and other spaces within neighborhoods that already exist (Fig. 8–6). When architects plan, they consider how the new site will fit what is already there. A new structure may look similar to the other structures, wildly different, or somewhere in between. Planners also consider how the people who currently live or work in the area will be affected by the new plans.

Whether designing whole neighborhoods or just one building, planners must consider future needs. Some planners have created buildings and cities that have contributed to pollution and other environmental problems. Others, though, have sought ways to create new places while also saving the earth's resources. Architect Paolo Soleri has designed a city plan called *Arcosanti* (Fig. 8–8), in which the automobile would not be necessary. All services would be within walking distance of one another. Renewable resources, such as the sun and wind, would provide the city's energy supply.

Sculpture in the Studio

Building an Architectural Model

Before architects plan a building, sketch ideas, and make models, they first analyze what will be the building's use. They ask what activities will take place in it, and what needs it must meet. They think about the building's heating and cooling systems, lights, walls, windows, and so on. They think about how the building will look on the inside and outside. They ask what the building will evoke, or call to mind, about its use. For example, a courthouse could have architectural features that evoke solemnity and justice, such as a broad stairway leading to high-ceiling, vast interior spaces.

In this studio experience, you will build an architectural model for a particular setting. Decide what kind of public building your model will represent. Think about your building's use, appearance, and what it will evoke, or call to mind, about its use. Make decisions about types of forms, such as cylinders, cubes, cones, or pyramids. How will you assemble them to create a sense of balance? Consider how the building's overall form will fit into its setting.

You Will Need

- construction materials, such as Styrofoam™, foamcore board, cardboard, and wood scraps
- scissors
- white glue
- tempera paint (optional)
- brushes (optional)
- water (optional)

Try This

1. Decide what kind of building model you will create. Will you build a model for a skyscraper or a community building that calls to mind what its use will be? For what setting—city, village, forest, ocean, or outer space—will you create your model? How will you use forms to express your ideas? Sketch your plan.

2. Choose the forms you need to construct your model. Will you cut or bend any materials to create forms? Experiment with the arrangement of the forms. How will you create balance in your arrangement?

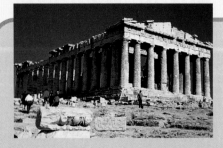

Fig. 8–9 **Because the Greeks thought of beauty as based on perfect proportions and balance, they planned each part of a building to harmonize with the other parts. What buildings in your town show the influence of Greek planning?** Iktinos and Kallikrates (Ancient Greek), *The Parthenon* (northwest view), 448–432 BC.
The Acropolis, Athens, Greece. Art Resource, New York.

Studio Background

Learning from Ancient Planners

For centuries, city and building planners in the Western world have been influenced by ancient Greek and Roman ideas.

The Greeks developed innovative ways to build temples and outdoor theaters. The Romans invented concrete and combined it with stone to build huge domed meeting halls and stadiums. Their city plans included the construction of roads, bridges, and aqueducts (channels that transport water) throughout their vast empire.

3. When you are satisfied with your arrangement, carefully glue the forms together. Will you paint your finished model? Or will an unpainted model better express your ideas?

Check Your Work

Display your architectural model with your classmates' models. Talk about the purpose and meaning of each model. How did you and your classmates create balance? Discuss the way that each model would fit in with other buildings that could be planned for the same setting.

Lesson Review

Check Your Understanding

1. What is architecture?
2. Identify two or more ideas about architecture for which Frank Gehry is known.
3. Name two or more things that architects and city planners consider when they plan buildings and cities.
4. When planning a building, do you think it is more important for the architect to consider the way the building will function or the way it will look? Why?

Fig. 8–10 **Look at the title of this image. See if you can identify the features of this building that suggest its use.** Jonathan Richards, *Aeronautics Museum*, 2000.
Cardboard, tape, tempera, adhesive-backed paper, 19" x 21" x 6" (48 x 53 x 15 cm). Thomas Prince School, Princeton, Massachusetts.

Fig. 8–11 **What forms did the artist use to create his design? How did he create balance?** Matt Hager, *The Olive Hotel with a Mushroom*, 2000.
Cardboard, Styrofoam, masking tape, paper plates, 38 ½" x 12" x 12" (98 x 30.5 x 30.5 cm). Thomas Prince School, Princeton, Massachusetts.

Architecture for Living

1859
The Red House,
Webb

1962
Venturi,
Vanna Venturi House

1992
Gray,
Gluelam House

19th Century

20th Century

1936–39
Wright,
Fallingwater

1996
Gray,
The 13° House

Travels in Time

The first true builders were the Paleolithic hunter-gatherers of 750,000 years ago. Because their source of food was often far from their natural shelters of caves and rock ledges, they needed to find—or build— shelters that were close to lakes and rivers, where food was plentiful. The hunter-gatherers developed ways to construct simple wooden shelters. Over time, as new materials and tech- niques were discovered, people changed the design of their dwellings. Architects have tried to plan for more than just the shelter and comfort provided by a dwelling. Their designs show their concern for the way a house looks and what it says about the person who inhabits it.

Fig. 8–12 **In what ways does this home remind you of castles from the Middle Ages?** Philip Webb, *The Red House*, 1859.
Bexley Heath, in Kent, England. Niall Clutton/Arcaid.

Planning Houses

Of all the kinds of buildings ever built, perhaps none is more interesting than the house. British architect Philip Webb was well known for his plans for private homes in the nineteenth century. One of his best known is the *Red House* (Fig. 8–12), built for William Morris, who was also a designer. Their goal was to create a contemporary look but also to use architectural features from older styles of buildings.

Creating Form

Architects have always created balanced forms. However, in the early twentieth century, architects were able to use such recently developed materials as steel and iron to create new kinds of balanced forms.

In 1939, Frank Lloyd Wright designed the home *Fallingwater* (Fig. 8–13) with a modern look. He used steel to create cantilevered terraces to connect the home with its natural surroundings. (A **cantilever** is a projected beam supported at one end and freestanding at the other end.) The cantilevers allow parts of the building to project over the water and rocks. Wright's use of cantilevers was an exercise in asymmetrical balance.

In the mid-twentieth century, some architects began to plan structures that looked back to the symmetry of traditional architecture. Architect Robert Venturi and others wanted to return to the formal design of carefully organized and symmetrical façades. This new trend in architecture was called **Post-Modernism**, because it broke away from the modern look of earlier decades. In such structures as the *Vanna Venturi House* (Fig. 8–14), Venturi's designs create a playful mix of symmetry and asymmetry.

Fig. 8–13 **The hearth, or fireplace, was the central focus of Wright's homes. In making the fireplace the central focus, what image of family life do you think Wright had in mind?** Frank Lloyd Wright, *The Kaufmann House: Fallingwater*, 1936–39. Bear Run, Pennsylvania. Photo © Thomas A. Heinz, AIA. Heinz & Co.

Fig. 8–14 **Venturi wanted the house to have the look of an ordinary mass-produced tract house, one that looks like every other house on the block. In what way is the façade of this house symmetrical? What features are asymmetrical, or not equally balanced?** Venturi, Scott Brown and Associates, *Vanna Venturi House*, 1962. Chestnut Hill, Pennsylvania. Courtesy GreatBuildings.com © 2001 Kevin Matthews.

A Logical Planner

"I'm really into order. It affects people even if they don't perceive it."
Melinda Gray (born 1952)

Photo by Grey Crawford. Courtesy Gray Matter Architecture.

Melinda Gray was born in 1952 in Chicago, Illinois. Like many of today's architects, she continues the tradition of creating new spaces for homes. After college, Gray studied architecture at the University of California in Los Angeles and apprenticed with a designer of commercial structures.

Gray's approach to architecture is a mix of craftsmanship, logical planning, and experimentation. Because her interest in architecture grew out of a love of geometry, Gray bases her complex plans on geometric principles. She plans her buildings by using geometric shapes and forms that collide and intersect in dynamic ways.

Fig. 8–15 **Melinda Gray plans houses that are full of contrasts, such as curved and straight lines, open and closed spaces, and formal and informal balance.** Melinda Gray, *The 13° House* (exterior), 1996. Santa Monica Canyon, California. Photo by Grey Crawford. Courtesy Gray Matter Architecture.

The Order of Architecture

Gray especially likes to experiment with materials, and she mixes them in fun, unexpected ways. For example, she will contrast the warmth of natural wood with the coolness of steel or glass. She also designs carefully placed courtyards, gardens, balconies, and other outdoor spaces. These spaces visually extend the house and help people move around easily.

To unify her designs, Gray uses grid patterns. For the exterior of homes such as the *13° House* (Fig. 8–15), she repeated patterns of squares and grouped square windows in a variety of sizes. She contrasted the strong vertical and horizontal lines with a curved, vaulted roof. The interiors of the homes she designs are based on cubes and other forms that intersect to create wide, open spaces. When she plans a room, Gray sometimes thinks about ways that two or more rooms can share space but also maintain privacy. Look at an interior view of one of Melinda Gray's homes (Fig. 8–16). What are some possible ways that space could be shared by two rooms?

Fig. 8–16 **Gray creates light-filled interior spaces. Is this a home you would like to live in? Why or why not?** Melinda Gray, *The Gluelam House* (interior), 1992.
Santa Monica Canyon, California. Photo by Richard Cheatte. Courtesy Gray Matter Architecture.

Studio Connection

Draw an elevation plan or a façade of your dream house. Many architectural drawings are done with tools, like a ruler and compass, that help make even lines and shapes. Make decisions about whether you want the front of your dream house to have a formal, symmetrically balanced look or a more informal, asymmetrical look. Before finalizing plans, do some research, and study some architectural floor plans and elevation drawings. Make sketches with pencil before rendering the final drawing with a fine-tip marker.

Lesson Review

Check Your Understanding
1. What do architects do?
2. What architectural feature did Frank Lloyd Wright use to achieve asymmetrical balance?
3. Why did Melinda Gray become interested in architecture?
4. Describe Melinda Gray's approach to architecture.

Three-Dimensional Models

Architects work with many other professionals to plan a building, but they are responsible for deciding how the final building will look. They sometimes plan a building using only a few basic geometric forms, such as a cube for the central space, cylinders for columns, and a pyramid for the roof. In other cases, an architect might decide to combine a great number of forms and shapes, including towers, domes, arches, spheres, barrel vaults, or cones. Look at the drawing of the building. It offers one example of how basic geometric forms can be combined.

During the process of designing a building, architects often create an **architectural model**—a small, three-dimensional representation of the building—from paper, cardboard, wood, or other materials. Some of the techniques they use are similar to the ones illustrated on these pages.

When you make a three-dimensional model, you may decide to use some ready-made boxes, tubes, or spheres, if necessary.

Practice Creating Forms

Use construction paper, scissors, and glue to make a series of three-dimensional forms: a cube, a cylinder, a cone, a pyramid, and an arch. Use a ruler and compass when necessary. Be sure to measure carefully before you cut. Make crisp folds and use glue neatly. For additional guidance, study the diagrams provided on these pages.

Paper-folding techniques

Architectural forms

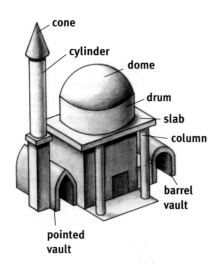

cone
cylinder
dome
drum
slab
column
barrel vault
pointed vault

How to create and assemble a barrel vault

Note: Spheres and domes are not easy to make with construction paper and glue. However, you might try using the diagram below to help you construct a "geodesic dome" by folding and gluing together several circles. To make the dome, fold a circle on three sides to make a triangle with three flaps. Join many of these forms to make a dome.

Folding for geodesic dome

Studio Connection

Work with a small group of classmates to construct a three-dimensional model of a building or even a model of a group of buildings. First, look at pictures of various buildings. Which basic forms did the architect combine in each one? Then discuss what you might create. Make some sketches to show how your building(s) can be created from basic forms. Then use construction paper to create a three-dimensional model of your plan.

Lesson Review

Check Your Understanding

1. What is an architectural model?
2. Why do you think architects usually make three-dimensional models when they design a building?

Fig. 8–17 **What paper forms make up this architectural model?** Group Student Work, *A Model Village,* 2001.
Paper, height: 12" (30.5 cm). Photo courtesy Davis Art Slides.

Art of Mexico

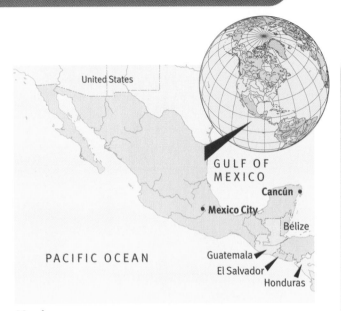

Mexico

Places in Time

Mexico, which is part of the North American continent, borders the United States. Most of the country's natural landscape is marked by hills or mountain ranges broken by plateaus. Deep valleys and canyons lie in contrast to the high mountains. The dramatic contrast that exists in the natural landscape can also be found in the human-made landscape: buildings. Structures range from simple adobe homes to complex stone temples. Mexico has always been a nation of planners and builders. The ruins of pyramids and temples are evidence of the architectural achievements of such early civilizations as the Olmec, Maya, Toltec, and Aztec cultures.

Urban Architecture

Urban architecture in pre-Hispanic Mesoamerica began with the rise of carefully planned ceremonial centers. In these urban centers, large groups of people could watch and take part in rituals and other events, both civic and religious. Early Mexican planners developed an architecture of gently sloping walls, as well as plazas, platforms, ramps, and stairs (Fig. 8–18). Builders used local resources and raw materials for the building of stucco-covered stone walls.

The styles and structures of pre-Hispanic archaeological sites often have inspired modern architects, including Pedro Ramírez Vázquez. For the National Museum of Anthropology (Fig. 8–19), Vázquez wanted a place where Mexican people could honor their heritage. He designed the museum around a large central plaza that was protected, yet open, and where people could come and go as they pleased.

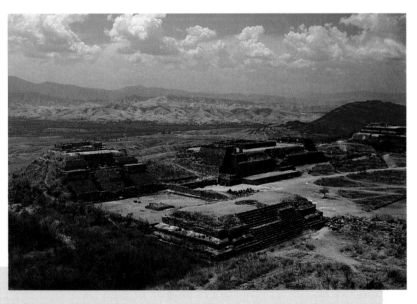

Fig. 8–18 **What is the overall plan of the placement of these structures? What evidence do you see that shows that the planners were thinking about having large groups of people moving about?** Mexico, *Teotihuacán*, 1st century AD.
Photo courtesy Karen Durlach.

Fig. 8–19 **Why does the overall plan of this space seem balanced?** Pedro Ramírez Vázquez, *The National Museum of Anthropology*, 1964.
Mexico City, Mexico. Photo courtesy Eldon Katter.

Fig. 8–20 **Barragan was known for the simple style of his buildings. Notice his use of color and asymmetrical balance.** Luis Barragan, *Casa Antonio Galvez*, 1954.
San Angel, Mexico. Courtesy Elizabeth Whiting & Associates, London.

Rural Architecture

In the sixteenth century, Spanish settlers in Mexico began to build large agricultural estates called **haciendas**. The buildings and the spaces around them were planned on a grand scale to house hundreds of workers on the plantation. Today, the hacienda continues to be a popular style for homes in Mexico. Architect Luis Barragan planned buildings (Fig. 8–20) in a style that recalls the hacienda's simple, boxlike exteriors. His use of bright colors and such materials as water, stone, and plants resulted in architecture that was in harmony with its natural surroundings.

Becoming an Architect

"You have to go to the roots, to the culture, and design for a place. The challenge is to create architecture that everyone feels good in."
Ricardo Legorreta (born 1931)

Ricardo Legorreta doesn't remember when or how he decided to be an architect. He says that it just happened. His interest in architecture came about in a natural way, from his visits to towns, haciendas, convents, churches, and the Mesoamerican pyramids. Born in Mexico City, Legorreta worked as a draftsman while studying for his degree in architecture at the University of Mexico.

Early in his career, Legorreta looked to the traditional architectural styles of Mexico. He worked with elements from both the Spanish haciendas and the pre-Hispanic ceremonial centers. However, he wanted to avoid the chain-restaurant and Hollywood set-design stereotypes of Mexican buildings. His buildings, therefore, combine the look of historical Mexico with the feel of the modern age.

Fig. 8–21 **What features of this structure remind you of the pyramids at Teotihuacán, pictured on page 264?** Ricardo Legorreta, *Camino Real Hotel*, 1981.
Cancun, Mexico. Photo courtesy Legorreta Arquitectos.

Designing for the Place

Legorreta's many hotels, like the one in Fig. 8–21, are planned to take advantage of the view and terrain. As in ancient Mexican ceremonial centers, they include open, public gathering spaces. But Legorreta also plans for enclosed and private spaces, following the tradition of convents, haciendas, and smaller Mexican houses. He plans other kinds of buildings, such as the corporate complex in Fig. 8–22, with walls of different size and scale. All of Legorreta's buildings are similar in their blending of simple forms, open spaces, natural light, and carefully planned color schemes. His architecture combines monumentality with simplicity.

Studio Connection

Draw a plan or aerial view for a public gathering place, such as a shopping mall or town center. Consider how people and traffic will move through this space. Will there be places for people to sit? Will there be different levels? How could you show this? You may wish to make a 3-D model of your public space.

Lesson Review

Check Your Understanding

1. What kinds of structures were built by the early civilizations in Mexico?
2. What type of agricultural structure was built by the Spanish in Mexico?
3. Describe features that are similar in many of Legorreta's buildings.
4. If you were to plan a building that shows features from both traditional and contemporary Mexican architecture, what are some things you might include?

Artists as Planners

267

Sculpture in the Studio
Corrugated Constructions

Planning Architecture for Thrills

Studio Introduction

For many people, one of life's greatest thrills is the roller coaster, or some variation of it. While riding on a roller coaster, you cannot admire its complex details. But if you look at this ride from the ground, you can see its graceful form and delicate balance.

In this studio experience, you will plan and construct a track for marbles. Pages 270 and 271 will tell you how to do it. How can you build a structure that will direct rolling marbles on a thrilling ride? How will you use form and balance to create a graceful ride for the marbles? Think about curves, gentle and steep rises, and spirals. Think about the kind of motion and speed that these features create.

Studio Background

Coasting, Anyone?

What do you get when you cross a cylinder with a spiral? An exciting, roller-coaster runway for marbles! Even though real roller-coaster tracks are made from wood or steel, you will plan and build your own from corrugated paper or any other flexible, sturdy paper, such as lightweight cardboard.

Corrugated paper can be made of two or three layers of paper. One layer is pressed to form ribs. The other one or two layers are smooth and cover one or both sides of the ribbed layer. You can easily roll corrugated paper into hollow or solid cylinders. To construct square or triangular forms for mazes, tunnels, and platforms, bend the paper across its ribs, which makes it rigid.

You can make a variety of runway forms by cutting corrugated paper into strips and gluing them together. Vary the lengths and widths of the strips to create several exciting features for your ride. Think of the tunnels, loop-the-loops, and spirals of most roller coasters. Now imagine how you can make them for the marbles' ultimate thrill!

Fig. 8–23 (top) **In what ways do you think corrugated paper can imitate the characteristics of a roller-coaster ride?**
Photo courtesy Eldon Katter.

Fig. 8–24 (bottom) **By using the right kind of paper and simple construction techniques, you can create a roller-coaster track for marbles. A well-thought plan is the key to creating a thrilling ride.**
Photo courtesy Eldon Katter.

Construction Tips and Ideas

Runways

• Glue strips of corrugated paper together. The length of the strips will depend on the desired length of your runway. The runway's width will depend on the size of the marbles.

• For a runway that curves left and right, use the edges of the

glued strips as the track surface. For a runway that curves up and down, use the width of the strips as the track surface.

• Create guides to keep the

marbles on track. For a left-and-right-curving runway, cut additional strips to add as walls on each side. For an up-and-down-curving runway, create a groove in the center of the track surface. Add a very narrow strip of corrugated paper along each edge of the surface. The gap between the narrow strips becomes the groove.

• If your runway has many rises or includes a loop-the-loop, make sure the beginning of the track is steep enough to keep the marbles' momentum going!

Spirals and Circular Runways

• Create a sturdy cylinder from a sheet of corrugated paper. Then wrap a left-and-right-

curving runway, in corkscrew fashion, along the length of the cylinder. Attach with glue. To prevent the marbles from falling off the spiral, include a wall on the outside of the runway.

• Tightly coil a long strip of corrugated paper into a large spiral disk. Glue the last

coil directly onto the coil preceding it. Gently push the center of the disk up from the bottom to create a small mound. To make a spiral or circular runway, create banks and tracks by pushing each side of the disk alternately.

Mazes, Tunnels, and Platforms

• Use a sheet of corrugated paper as the "floor" of a maze.

Create vertical walls by gluing the edges of strips to the floor.

• To create free-swinging "gates" for the marbles, leave some ends of the walls unglued.

• To create a tunnel, simply glue a strip of corrugated paper

over the top of any square-walled runway.

• To create a platform, glue several pieces of corrugated paper together. The number of pieces will depend on how high you want the platform. You can also roll and glue strips of corrugated paper. Or you can bend corrugated paper into square or triangular forms.

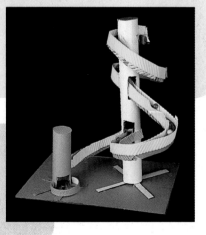

Fig. 8–25 **This spiral runway is a variation of the standard type described in Construction Tips and Ideas.** Skye Lawrence, *Marble Run*, 2001. Corrugated paper and cardboard, 18" x 17" x 11 ½" (46 x 43 x 29 cm). Islesboro Central School, Islesboro, Maine.

Making Your Corrugated Construction

You Will Need

- sketch paper
- pencil
- corrugated paper or other flexible, sturdy paper
- scissors
- glue

Try This

1. Come up with a plan for your marble track. How many features will your ride have? Will you focus on one feature, such as a spiral or a maze? Or will you also include tunnels, gently curved runways, or loop-the-loops? Think of ways to create balance in your work. Sketch your ideas.

2. Construct your runways and other features. See Construction Tips and Ideas on page 269. Do you need to make any platforms to support rises in the track? Remember that your track forms must be sturdy enough to hold marbles.

3. If you have made more than one feature, assemble your forms. Arrange them to create the balance you desire. Attach the parts with glue, or simply lay them end to end. When you are finished, send some marbles on a test run!

Check Your Work

Demonstrate how your ride works. Explain how you came up with your ideas. What kinds of forms did you include? How did you create balance? What would change if you made another marble track?

Computer Option

Using a 3-D design or a drawing program, create a full roller-coaster design or another ride of your choice. Show both the inner structure (skeleton) and the outer façade of your design. You may also add color and texture to the outer layers of your ride. Show how your ride would look in an amusement park. Give your ride a creative name.

Form and Balance

Sculptures and architectural works, such as buildings, bridges, and even roller coasters, are

made of one or more **forms**. A form has height, width, and depth. If you could add depth to the height and width of a square, you would create a cube. Like shapes, forms can be geometric or organic.

Forms are solid and fill space. The space that a sculpture or building fills is the *positive space*. The space surrounding the inside and outside edges of a sculpture or building is the *negative space*.

Look at a sculpture that is familiar to you. Let your eyes wander over its forms. How would you describe the positive space? Where do you see negative space?

Artists create **balance** by giving the parts of an artwork equal visual weight. Choose any artwork in this book, and imagine drawing a line through its center. If the two halves are mirror images, the artwork has *symmetrical balance*. If the two halves are not mirror images but still look visually balanced, the artwork has *asymmetrical balance*. The third kind of balance is *radial balance*, in which the parts of the design seem to radiate, or spread out, from the center of the artwork.

symmetrical asymmetrical

radial

Fig. 8–26 How would you describe the form and balance in this maze?
Eric Benson, *Marble Maze,* 2001.
Corrugated cardboard, height: 10" (25.4 cm). Fred C. Wescott Junior High, Westbrook, Maine.

Connect to...

Daily Life

What would you need to do to **plan a trip**, especially to view artwork in another country? You might start by conducting online research about the country and its museums. You might need to obtain a guidebook or phrasebook, depending on the language of the country you plan to visit. Of course, you also would want to apply for a passport and make airplane reservations. What are the advantages to careful planning?

Other Arts

Dance

Dancers, like three-dimensional artworks, interact with the space around them. Dancers move through space and create a dynamic relationship between themselves and the surrounding area. **The person who plans and arranges the different steps and movements of a dance is called a choreographer.** Choreographers may be inspired by a piece of music to create an abstract design. Or they may be inspired by a dramatic idea and create a dance whose movements tell a story. Choreographers work with or without music, and either use traditional steps (from ballet or folk dances) or create new steps and movements.

Fig. 8–27 **Printmakers often combine techniques and processes in their work. This artist combined intaglio, collage, and pastel to produce this portrait.** Mary Ellen Wilson, *L'Autre*, 1996.
Ink and pastel on paper, 8" x 10" (20.3 x 25.4 cm). Courtesy the artist.

Careers

Have you ever watched a **printmaker** transfer an image onto a shirt? Although this is an example of commercial printing, it still involves processes used by fine-art printmakers. Printmakers use different techniques to produce prints that are original, usually limited in number, printed by hand, numbered, and signed. They may use such age-old techniques as intaglio (etching), relief printing, and lithography, or newer processes like screen or stencil printing, collagraphs, or photoetching. Many universities offer a fine-arts degree in printmaking. Graduates of such programs may teach in a college or university.

Social Studies

What kind of careful planning is needed to conduct an archaeological dig? First, researchers must recognize and locate an archaeological site and learn about it through additional research. Next, they use special techniques to uncover objects and make a detailed site survey. They preserve their discoveries through record keeping and carefully pack the recovered artifacts. Why is each of these steps important to a successful dig?

Fig. 8–29 **What are the similarities between planning a work of prose (writing) and planning an artwork?** Photo courtesy Nancy Walkup.

Fig. 8–28 **Careful archaeology has uncovered and preserved many sites of the ancient Mesoamerican and South American cultures.** Precolumbian Mexico, Palenque (Maya), *Palace* (general view), c. 720–783 AD. Photo courtesy Karen Durlach.

Language Arts

What steps do you follow to **plan a written work**, such as a piece of persuasive writing? You probably choose a topic, and then generate ideas through such writing strategies as brainstorming or graphic organizers (webs and mind maps). Next, you may develop a draft by categorizing your ideas and organizing them into paragraphs. Last, you complete a final draft by revising, elaborating on, combining, and rearranging the text.

Mathematics

Carpenters use the expression "measure twice, cut once" as a reminder of the **importance of measurement in planning**. Do you know the source of the units of measurement we use? Originally, the measurement of a foot was the length of a man's foot from the heel to the big toe. This length was divided into 12 inches. In 1305, English king Edward I ordered that 1 yard equaled 3 feet. This measurement was the distance from the tip of his nose to the end of his outstretched hand.

Internet Connection

For more activities related to this chapter, go to the Davis Website at **www.davis-art.com**.

Portfolio

"I've always liked to draw buildings. These particular buildings were harder than my others because of the amount of detail I put into them, but I liked this piece because it was a nice mix of colors." **Emil Harry**

Fig. 8–30 **An aerial viewpoint and careful use of one-point perspective gives this drawing a strong sense of depth.** Emil C. Harry, *Cityscape*, 2001.
Colored pencil, pencil, 8 1/2" x 11" (21.5 x 28 cm). Hillside Junior High School, Boise, Idaho.

Fig. 8–31 **How is building a model house different from drawing one?** Ed Birkey, *Grandma's Front Porch*, 2001.
Corrugated cardboard, mat board, paper, 13" x 17" x 15" (33 x 43 x 38 cm). Manson Northwest Webster Community School, Barnum, Iowa.

"This took lots of planning, drawing 'blueprints' and then figuring out scale. I decided which materials would work best. I looked for textures that worked well together. I had a blast doing this project and was pleased with my sculpture from all sides." **Ed Birkey**

"I like the hovercraft spaceship and the mushroom-shaped buildings. I used yellow-orange because it looks like a fiery planet with a lot of things happening, kind of like the sun, always glowing." **Keane Warren**

CD-ROM Connection
To see more student art, view the Personal Journey Student Gallery.

Fig. 8–32 **A science-fiction drawing needs realistic-looking architectural forms to be convincing. A sense of perspective and depth strengthens the illusion.** Keane Warren, *Cloud: A City in Orange*, 2001.
Colored pencil, 9" x 12" (22.8 x 30.5 cm). Samford Middle School, Auburn, Alabama.

Chapter 8 Review

Recall

Name two different kinds of architectural structures in Mexico, one pre-Hispanic and the other built during Spanish settlement.

Understand

Explain ways that an architect can plan for a new building to fit in with existing buildings in a neighborhood.

Apply

Draw two different plans for the façade of a house. Create one plan with symmetrical balance and the other with asymmetrical balance.

Analyze

Make a diagram by looking at a sketch or photograph of a building in your community or a photocopy of a building depicted in a magazine or book. Your diagram should show how the building is composed of basic geometric forms.

Synthesize

Imagine that you are the head of a design team charged with planning a new city from scratch. Develop a list of issues that you would have to consider.

Evaluate

Of Frank Gehry, Melinda Gray (Fig. 8–15, *shown below*), and Ricardo Legorreta, whose buildings are shown in this chapter, recommend one architect as the best choice for designing your family's dream home. Explain your choice.

Page 260

For Your Sketchbook
Consider what buildings mean to their owners or users. Fill a page in your sketchbook with designs of buildings that evoke an important quality, such as security, wisdom, strength, courage, peace, honesty, or creativity. For example, you could evoke security with a building that has features of a combination lock. Be playful in your designs, and have some fun!

For Your Portfolio
Keep your portfolio organized. Always date and clearly identify each item in your portfolio, and place a sheet of tissue paper or newsprint between each piece. On a regular basis, check the contents, and decide what to remove and what to keep.

9

Artists as Pioneers

Fig. 9–1 **In this work, the artist included only the state names that are Native, or indigenous, words. For example,** *Kansas* **is a Sioux word meaning "south wind people." Some words are also the names of tribes. How does this information change the way you view this map?** Jaune Quick-to-See Smith, *State Names #2*, 2000.
Oil and collage on canvas, 48" x 72" (122 x 183 cm). Courtesy Bernice Steinbaum Gallery, Miami, Florida.

- How do people explore new directions?
- In what ways are artists pioneers?

Imagine traveling to a new "territory," perhaps as far away and as fictional as a new galaxy—or as close and as real as a problem in math class today. Many scientists are pioneers: they can never be sure where their exploration may lead. Consider scientists Watson and Crick, who determined the structure of DNA and pioneered the route to the mapping of the human genome. To move into new territories, scientists take risks. They think about what they know and then experiment in new directions. Scientists—and others—enthusiastically go forward and chart new territory for others to follow: they have a "pioneering spirit."

Many artists have also been pioneers. As each age sees developments in technology, artists explore new materials and techniques for making art. Some of their experiments have even resulted in new art forms. Pioneering artists also explore new ideas and present them as messages in their artworks. In doing so, they have encouraged us to think about, see, and experience the world in new ways.

Jaune Quick-to-See Smith is an art pioneer. In such works as *State Names #2* (Fig. 9–1), the artist challenges how some people have thought about Native Americans. Many of her works also remind us that our natural environment is fragile. Smith asks that we think about our behavior in the past and how we could live in the future. In this chapter, you will learn more about Jaune Quick-to-See Smith and other artists with a pioneering spirit.

Meet the Artists

Jaune Quick-to-See-Smith
Jesús Bautista Moroles
Nomi Wind

Words to Know

pictogram	site-specific
petroglyph	sculpture
assemblage	casting
collage	relief sculpture
collagraph	artisan
	texture

Jaune Quick-to-See Smith

A Pioneer in Art

Courtesy Bernice Steinbaum Gallery, Miami, Florida.

Jaune Quick-to-See Smith's Journey

Born in Montana in 1940, Jaune Quick-to-See Smith spent much of her youth traveling. She lived with her father, a rodeo rider and trader, and moved on and off various reservations in the Northwest. She often worked as a farmhand and used her earnings from work to enroll in a correspondence art course.

Smith earned a college degree, something few Native Americans of her generation had done. Her artworks today show the influence of twentieth-century artists, including Robert Rauschenberg (see page 54), who looked to and commented on popular culture. In addition to making and exhibiting her own artworks, Smith has organized exhibitions of the artworks of other Native American artists. Her pioneering spirit has helped her create ways for us to see and appreciate their artworks.

Fig. 9–2 **Smith often points to the ways that Native Americans have been depicted. What stereotypes did she explore here?** Jaune Quick-to-See Smith, *Trade (Gifts for Trading Land with White People)*, 1992.
Oil, collage, mixed media on canvas with objects, triptych: 60" x 70" (152 x 178 cm). Courtesy Bernice Steinbaum Gallery, Miami, Florida.

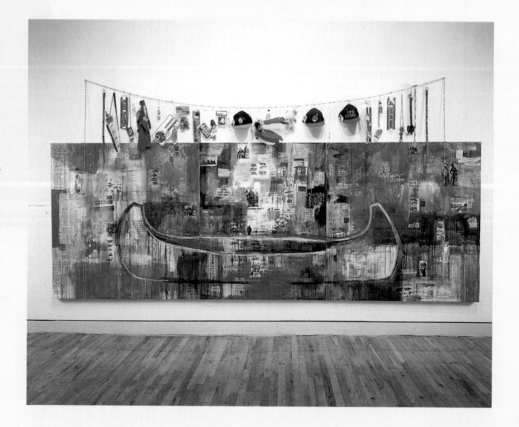

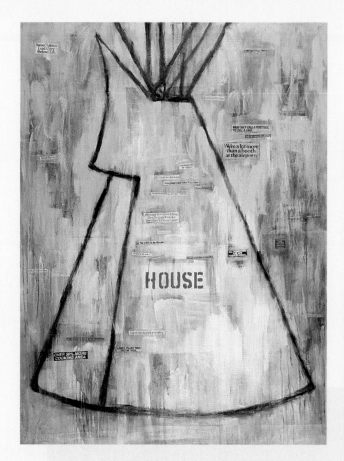

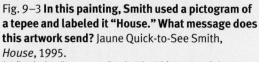

Fig. 9–3 **In this painting, Smith used a pictogram of a tepee and labeled it "House." What message does this artwork send?** Jaune Quick-to-See Smith, *House*, 1995.
Acrylic, mixed media on canvas, diptych: 80" x 60" (203 x 152 cm). Courtesy Bernice Steinbaum Gallery, Miami, Florida.

Fig. 9–4 **Smith placed a funeral spray of flowers above her painting. How does this highlight the slow death of our environment?** Jaune Quick-to-See Smith, *Requiem*, 1990.
Oil and beeswax on canvas, silk flower wreath, 60" x 50" (152 x 127 cm). Courtesy Bernice Steinbaum Gallery, Miami, Florida.

Changing the Way We Think

Smith believes that most children learn about Native Americans as if they lived only in the past. As a pioneer of new ways to think about her people, Smith says, "We are very much alive." She challenges over-simplified beliefs called stereotypes, such as those that all Native Americans live in tepees, wear feathered headdresses, or travel in canoes. Some of her artworks show how Hollywood movies, television, textbooks, and tourist shops fail to depict Native Americans as they really lived in the past and are living today.

Like her ancestors, Smith has deep ties to nature. Her paintings often send a message that all things, including humans, belong to the earth. Many of her paintings, such as *House* (Fig. 9–3), include **pictograms**—symbols of plants, animals, humans, and objects. These simple line drawings look like **petroglyphs**, the rock carvings created by Native Americans hundreds of years ago. Smith also layers paint with pictures and words from magazines and newspapers. She says that the use of familiar images and words creates a way for viewers to see what they already know—but in different ways.

Pioneering Questions About Art

Jaune Quick-to-See Smith, like many pioneers, looked around, thought about what she saw, and experimented with new ways to think, work, and act. Other artists have also been pioneers. Marcel Duchamp was among many early-twentieth-century artists who wanted to present new thinking about art. In artworks such as *Bicycle Wheel* (Fig. 9–5), Duchamp took ordinary objects, or a group of objects, and presented them as art. At first, people were shocked by art made from everyday things. But Duchamp's ideas made people think differently about what art is. Today, many artworks, including assemblages, combine found materials. An **assemblage** is a sculpture of combined objects, such as boxes, pieces of wood, and parts of old machines.

Pioneering Materials and Scale

In the second half of the twentieth century, artists continued to experiment with materials and the scale of their artworks. In the 1960s, Louise Nevelson began to make large-scale assemblages (Fig. 9–6). Because few women at that time were making large-

Fig. 9–5 **Why, do you think, have some people referred to Duchamp's work as junk sculpture?** Marcel Duchamp, *Bicycle Wheel*, 1963.
Readymade: metal wheel mounted on painted wood stool, height: 49 ¼" (125 cm). Collection of Richard Hamilton, Henley-on-Thames, Great Britain. Cameraphoto/Art Resource, New York. © 2001 Artists Rights Society (ARS), New York/ADAGP, Paris/Estate of Marcel Duchamp.

scale sculpture, Nevelson was a pioneer for other women artists. She was also a pioneer because, whereas other sculptors were making sculptures out of welded metal, Nevelson turned to wood. But rather than carving wood, as so many artists had done in the past, Nevelson combined pieces that had been used in furniture and other objects. She built dramatic, huge walls and free-standing structures from found wood scraps. Viewers were amazed by her artworks and felt small in their presence. One critic said: "Her sculpture changed the way we look at things."

Romare Bearden was another twentieth-century artist who made artworks by combining found materials. He combined cut and torn images to create his collage paintings. In *Jazz Village* (Fig. 9–7), for example, he combined images from magazines and other sources. An African American, Bearden pioneered powerful messages about his people. He often showed both the good and bad parts about being African American and living in the city.

Fig. 9–6 **The artist often assembled found wooden objects and painted them all one color—black, white, or gold.** Louise Nevelson, *Royal Tide IV*, 1960.
Wood painted gold, 132" x 168" x 10" (335 x 427 x 25.4 cm). Stadt Köln, Rheinisches Bildarchiv. © 2001 Estate of Louise Nevelson/ Artists Rights Society (ARS), New York.

Fig. 9–7 **This artist often celebrated the importance of music, especially jazz, in African American culture. How do the shapes, colors, and textures connect with the musical form of jazz?** Romare Bearden, *Jazz Village*, 1967.
Mixed media and collage, 30" x 40" (76 x 101.6 cm). © Romare Bearden Foundation/Licensed by VAGA, New York, New York.

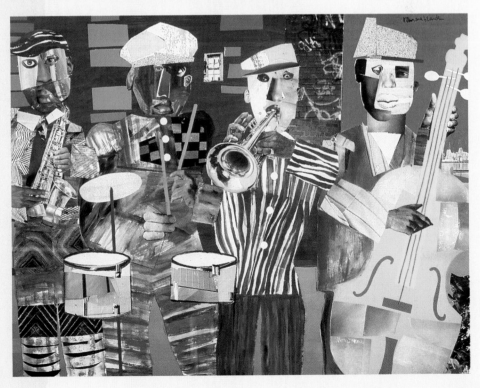

Pioneering the Collagraph

Some artists become pioneers by changing art processes that already exist. Say, for example, that you had made a **collage**, an artwork of bits of paper, fabric, photographs, or other flat materials glued to a flat surface. Then you did something different: instead of gluing *flat* materials, you built up layers of paper and added cardboard, bottle caps, and other found objects. When you finished, you looked at your work and thought, "Hmm. This would make a really cool print." So you made a **collagraph**, a print made from a collage with raised areas.

In this studio experience, you will create a collagraph from a mixed-media collage. Collect materials and objects that have interesting shapes and textures. Think of yourself as a pioneer. Like all pioneers, the collagraph artist never knows exactly what lies ahead!

You Will Need

- corrugated card-board
- collage materials
- glue
- acrylic gel medium
- paintbrushes
- printing ink
- drawing paper, 3 or 4 sheets

Try This

1. To make your printing plate, arrange your collage materials on a piece of corrugated cardboard. Think about texture placement and the message your artwork will send.

Fig. 9–8 **This is one of the first collages ever made. Soon after this experiment, Picasso made many different collages by using scraps of things he found.**
Pablo Picasso, *Glass and Bottle of Suze*, 1912.
Pasted papers, gouache, and charcoal, 25 3/4" x 19 3/4" (65 x 50 cm). Washington University Gallery of Art, Saint Louis. University Purchase, Kende Sale Fund, 1946.
© 2001 Estate of Pablo Picasso/Artists Rights Society (ARS), New York.

Studio Background

Creative Combinations

When most European artists were using traditional materials for sculptures and paintings, Pablo Picasso—and a few others with a pioneering spirit—did some experimentation. They pasted paper and other flat objects to their paintings and invented the collage (from a French word meaning "to glue").

Picasso and the other collage artists paved the way for more experiments with the combining of materials. Such experiments produced the *montage* (a special kind of collage made from pieces of photographs or other kinds of pictures) and the collagraph. Artists who create collagraphs often experiment by adding textures to a collage before printing. After pulling the first print, the artist may add different objects before printing again.

2. When you are pleased with the arrangement, glue the materials in place. Then coat the plate with acrylic gel medium.

3. Brush ink onto the surface of the plate. Then experiment with printing. Place paper on the inked plate, and gently rub the paper with your hand. Remove the paper by lifting the corners and carefully peeling the print away from the plate.

4. Ink the plate again. Then wipe the ink off the plate surface, but leave the ink in the crevices. Place another sheet of paper on the plate, and gently rub the paper with your hand. Then peel away the print as before.

5. Check the results from each method. Which is more interesting? Which better shows a variety of textures? Experiment with different printing colors.

Check Your Work

Display your collagraph printing plate and one of your completed prints with those of your classmates. Make judgments about the prints and the plates. In what ways are they pleasing? Which of the two is more pleasing or interesting? Discuss your experiments.

Lesson Review

Check Your Understanding

1. What is a pictogram?
2. Explain why Jaune Quick-to-See Smith is a pioneer.
3. Identify an artist pioneer other than Smith, and explain how the artist's work showed a pioneering spirit.
4. Why is a pioneering spirit important in making a collagraph?

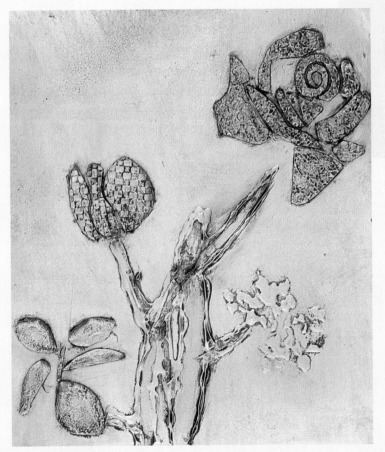

Fig. 9–9 **Notice the variety of textures on this collagraph plate. How, do you think, did the artist create them?** Ryan Glick, *Floral Fantasy Bouquet,* 2001.
Cardboard collagraphic plate, textured wallpaper, spray paint, 9 ¾" x 8 ⅝" (25 x 22 cm). Springhouse Middle School, Allentown, Pennsylvania.

Traditions of Sculpture

1943
Hepworth, *Oval Sculpture*

1999
Dancer,
Fern Hope Hoop

2000
Moroles, *Round Wafer*

Mid-20th Century　　　**Late 20th Century**　　　**Early 21st Century**

1992
Koons, *Puppy*

1999
Moroles, *Granite Weaving*

Travels in Time

The tradition of sculpture as an art form has existed since prehistoric times. Small carved and modeled forms of both human and animal figures, dating from about 30,000 BC, have been found in caves. Large stone sculptures of ancient Egyptian kings still stand in the deserts. Some of the centuries-old techniques of sculpting in stone, wood, and clay continue to be popular today. Modern sculptors, however, often experiment with new media and surface textures, creating new traditions in sculpture.

Pioneering the Modern

In the early 1900s, many artists wanted to break with existing styles, to create truly "modern" art. They experimented with new, human-made industrial materials and embraced advancements in technology. Other artists preferred traditional materials, such as wood, plaster, or stone. They experimented by exploring the texture and surface qualities of these materials. Barbara Hepworth was one of the leading artists in this movement. Her *Oval Sculpture* (Fig. 9–10) is an example of her experiments with different surfaces and textures possible with plaster.

Fig. 9–10 **Hepworth often found inspiration in the natural forms and landscapes of beaches. How does the form of this sculpture look as though it might have been smoothed by sand and ocean waves?** Barbara Hepworth, *Oval Sculpture Number Two*, 1943.
Plaster, 11 1/4" x 16 1/4" x 10" (28.5 x 41.5 x 25.5 cm). The Tate Gallery, London. © Tate, London 2001.

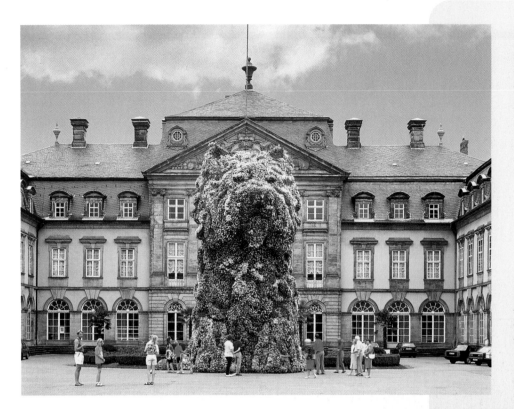

New Materials and Places for Art

In recent decades, sculptors have purposely set out to explore the possibilities of new media and spaces for art. Many artists have started to experiment with materials and surface qualities that are part of everyday life. This approach has turned the attention of some sculptors, including Jeff Koons (Fig. 9–11), from the technical skills of carving and casting to a focus on ideas.

Sculptor Daniel Dancer is part of a group of pioneering artists who create sculpture for a particular outdoor space. Many sculptors in history have looked to nature for inspiration. But Dancer chooses to work directly with his natural surroundings. For his **site-specific sculptures** (Fig. 9–12), Dancer must first consider the site, or location. The site helps determine the form and meaning of the sculpture. In some cases, the artist's purpose is to make viewers more aware of the environment and the textures of natural objects. Although site-specific sculptures can be permanent, many are temporary installations, either outdoors or in museums or other interior spaces. The installations exist, for the long term, only in the form of photographs.

A Pioneer in Sculpture

"I'm trying to just keep going on my own ideas."
Jesús Bautista Moroles (born 1950)

Artists in the twenty-first century continue to pioneer ways of working with materials. They often challenge our understanding of what traditional materials can do. Sculptor Jesús Bautista Moroles tests the limits of stone, often working on a massive scale.

Moroles was born in Corpus Christi, Texas. Growing up, he worked for his uncle, a bricklayer, and he learned carpentry skills by helping his father renovate their home. Moroles credits these early work experiences in carpentry and masonry for his development as a mature artist.

Fig. 9–13 **Notice the over-and-under pattern of a weaving. Compare this sculpture with the Navajo weaving on page 19. Why, do you think, did the artist create a stone sculpture that looks like a weaving?** Jesús Bautista Moroles, *Granite Weaving*, 1999. Fredericksburg granite, 38" x 38" x 6 ¼" (96.5 x 96.5 x 16 cm). Courtesy the artist. Photo: Ann C. Sherman.

Pushing Boundaries

Moroles constantly pushes the boundaries of traditional sculpture. He takes risks and uses his excellent technical skills to discover new sculptural forms and textures. To create his large-scale sculptures, Moroles works with traditional hand tools, such as picks, chisels, and mallets. To cut hard stone and create unusual forms (Fig. 9–13), he also uses nontraditional tools: diamond saws, drills, and grinders.

With the high-tech tools, Moroles can slice, split, chip, grind, or polish the granite to produce sculptures with razor-sharp edges and precise forms. He creates surfaces that are smooth and reflective, or rough and uneven. For his sculpture *Round Wafer* (Fig. 9–14), he pierced a block of stone with many large and small circles. This effect required careful and precise cutting of the stone.

Studio Connection

Create a clay sculpture that will challenge someone to think about a natural form in a new way. Choose a natural form and observe it closely. If you've chosen a closed form, such as an acorn, your sculpture could open it up. If you've chosen a flat, open form, such as a leaf, you could close it up. Focus on surface and texture.

Lesson Review

Check Your Understanding

1. Identify three ways that twentieth-century sculptors pioneered change in sculpture.
2. What is site-specific sculpture?
3. In what way is Jesús Bautista Moroles a pioneer in sculpture?
4. Considering the new things happening in sculpture today, what do you think an artist would need to do to be a pioneer in sculpture in the late twenty-first century?

Casting a Relief Sculpture

Many of the sculptures that you see in parks, museums, and galleries are probably made by casting. **Casting** is a multistep process for creating sculptures in bronze or other materials, such as concrete, plaster, or plastic. Some casting techniques allow an artist to create several identical sculptures from a single mold.

Practice Casting

A **relief sculpture** is a sculpture that is meant to be viewed from one side, like a wall plaque. You can cast a relief sculpture by using wet sand or oil-based clay for the mold. Your final sculpture will be plaster.

First, cut off the bottom of a milk carton or other small box. When it is cut, the box

should be about 3" deep. Reinforce the sides of the box by applying a strip of masking tape around the outside. Then place about 1" of fine, damp sand or oil-based clay into the bottom of the container.

Next, gather one or more textured objects—such as a large seashell, two acorns or unshelled nuts, a small stone, or a piece of thick rope—to make impressions into the

clay or sand. Press the objects into the clay or sand and lift them straight out again. This will create a mold, or negative design, for your sculpture: whatever you press into the clay will appear raised up in the final sculpture.

When your design is ready, mix the plaster. Gently and slowly pour the plaster into the

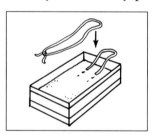

box, as directed by your teacher. If you are pouring into sand, be careful that the plaster does not wash away the sand—you want the plaster to flow over the surface. Pour the plaster to a depth of about 1". (If you would like to hang your small relief sculpture, press a loop of thick string firmly into the wet plaster before it hardens.)

Fig. 9–15 You can use just about any object to create an interesting relief sculpture. How can you use objects and this method of casting to pioneer new ideas in art?
Mary Hankin, *Sandcast*, 2001.
Sand, plaster, found objects, 8" x 10" (20 x 25.5 cm). Jordan-Elbridge Middle School, Jordan, New York.

Fig. 9–16 **The round forms that this artist used help create a theme for the sculpture. How could you create a theme in your sculpture?** Eric Bullard, *My Universe,* 2001.
Sand, plaster, found objects, 8" x 11" (20 x 28 cm). Amidon School, Washington, DC.

After the plaster dries, peel away the box. (If you used sand, place the box inside a

larger box to catch the sand.) Remove the clay, or brush away any sand that sticks to the plaster.

Studio Connection

Make a larger casting by using a variety of textured objects. For the container, use a disposable aluminum pan or a shoe box lined with a plastic bag and reinforced with masking tape. You could try pushing pebbles, shells, buttons, or beads about halfway down into the clay or sand. Leave them there when you pour the plaster. When it sets, the objects will be embedded in the finished relief sculpture.

Lesson Review

Check Your Understanding

1. Explain why the depressions in the mold come out as elevations in the relief sculpture.
2. Why is this method of casting a good way to create a sculpture with a variety of textures?

Artists as Pioneers

Art of Israel

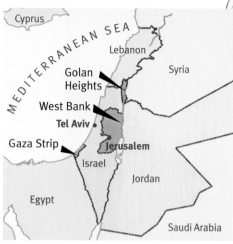

Israel

The nation of Israel, on the eastern shore of the Mediterranean Sea, was founded in 1948. For centuries, however, many cultures have existed in the region. The land has been known as Canaan, Palestine, and the Holy Land (because it is the site of many ancient holy places of the Jewish, Christian, and Moslem religions). Diverse ethnic groups, belief systems, sects, and cultures continue to populate Israel.

Pioneers of the Ancient World

The artistic traditions of Israel and the rest of the Middle East have existed since ancient times, even before the civilizations of Egypt, Greece, and Rome. Ancient Israelite **artisans** became pioneers in many art forms, including the art of making glass.

It is believed that glassmaking may have been discovered by accident. The earliest glass vessels appeared in the ancient region known as Mesopotamia (present-day Iraq). The Israelite artisans learned to create colorful and complex glass objects and beads (Figs. 9–17, 9–18). Later, when they moved from their homeland, the Israelite artisans carried the craft to other parts of the world.

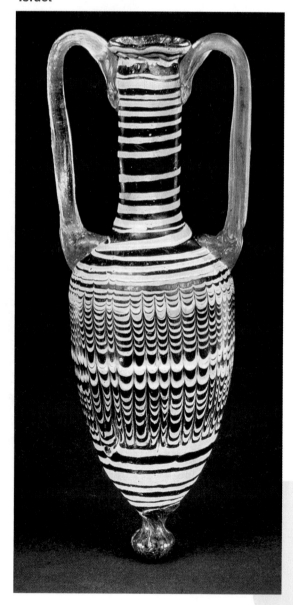

Fig. 9–17 Glass vessels were produced in Eretz Israel, "the land of Israel," for many centuries before the Greeks and Romans had even acquired a word for glass. What can you find out about how glass is made? Eastern Mediterranean (possibly Cyprus), *Amphoriskos*, 2nd–1st centuries BC. Almost opaque yellow-green glass; core-formed, trail decorated, and tooled, height: 10" (24 cm). © The Corning Museum of Glass, Corning, New York.

Preserving Traditions

In ancient times, Israeli artists were also pioneers in the textile arts. They were masters in the production of fine linen and wool cloth, embroidered fabrics, stitched garments, and carpets. Artists wove colorful designs of plants, flowers, and other natural objects. The designs sometimes included scenes and stories from the Bible. The carpets had both domestic and religious functions. They covered floors and furniture, and served as hanging screens in homes and in synagogues.

Artisans today continue the ancient traditions of creating colorful carpets with complex designs (Fig. 9–19). They use traditional materials, such as silk, wool, goat hair, camel hair, cotton, linen, hemp, and jute. As in the past, the carpets can be found in many Israeli homes and religious buildings.

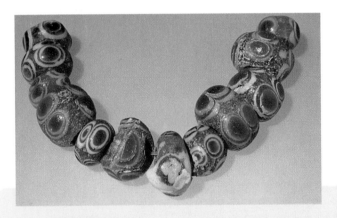

Fig. 9–18 **These are typical of the beads used as trade goods for over 3,000 years. Do you think beads such as these, which perhaps no one other than the Israelites knew how to make, were valuable for trade?** Eastern Mediterranean or Persia, *Composite Eye Beads*, 6th-3rd centuries BC.
Translucent bluish-green, deep blue, and opaque white glass; core-formed, trail decorated, and tooled, diameter: $1/8" – 1/2"$ (9 mm–1.3 cm). © The Corning Museum of Glass. Corning Museum of Glass, Corning, New York.

Fig. 9–19 **Carpets were and continue to be valued possessions of Israeli homeowners.** Israel, Bezalel School, Marvadia Workshop, *"Song of Songs" Carpet*, 1920s.
Wool, 68" x 39 $1/3$" (173 x 100 cm). The Israel Museum, Jerusalem. Photo © The Israel Museum, Jerusalem.

Pioneering Across Boundaries

"The process of my work [begins] with the use of local materials and the search for expression of my place and my self."
Nomi Wind (born 1940)

Many artists in Israel today continue the ancient techniques of weaving and needlework. Some artists, including Nomi Wind, also try to take the art form in new directions. Wind combines old and new techniques, as well as different cultural traditions, to create her fiber sculptures.

Born in West Jerusalem, Wind graduated with a degree in education from Hebrew University. As an Israeli, she was surrounded by the Judaic tradition of women doing needlework as a means of beautifying their home. But in 1967 in East Jerusalem, she came into contact with and was influenced by Bedouin fiber traditions. The Bedouin are a nomadic people who move from place to place in the desert. They use camel and goat hair, as well as plant fibers, to make tents and clothing.

Fig. 9–20 **The artist uses materials other than fiber in constructing her large-scale pieces. How do you think this piece was made?** Nomi Wind, *Defeated Childhood*, 2000. Handwoven Bedouin sheep's wool and paper, height: approx. 72" (183 cm). Courtesy the artist.

Touched by the Desert

The markets, sounds, and smells of the old city of East Jerusalem made an impression on Wind, as did the quiet beauty of the eastern desert. She observed how the Bedouin, in the fashion of their ancestors, pitched tents of camel wool and cared for their herds of camels and sheep. The Bedouin are highly skilled at spinning wool by hand. For Wind, the raw, stained wool they used seemed to hold traces and smells of the desert. She knew this was the material through which she could best express her ideas about her Middle Eastern heritage.

At first, Wind's interest in creating with wool resulted in "art to wear," pieces that allowed her to study the material's possibilities. By seeing people wearing her art, she moved to her next phase: sculptures based on the human form. In turn, these figurative pieces led to her present body of work: large, abstract sculptures influenced by the wild, open spaces of the desert. In these works, Wind has continued to explore the three-dimensional nature of fibers. In addition, she has introduced materials such as stone and iron into her large-scale fiber sculptures.

Fig. 9–21 **Why would the artist title this sculpture** ***Women of the Desert*****?** Nomi Wind, *Women of the Desert*, 1992.
Handwoven Bedouin sheep's wool, rope, 8' 4" x 15" (255 x 38 cm).
Courtesy the artist.

Studio Connection

Be a pioneer, and make an experimental weaving. Explore and experiment with traditional weaving techniques, forms, and materials. Combine traditional weaving techniques with other fiber processes, such as knotting and braiding. Consider creating a weaving that has a geometric (circular, triangular, or rectangular) or other three-dimensional form. Experiment with found materials to create different surface textures and patterns. Try such materials as wire, foil, reeds, plastic, ribbons, and beads.

Lesson Review

Check Your Understanding

1. Name two areas in which the Israelites were pioneers of artistic production.
2. How is the textile art of carpet-making important in Middle Eastern cultures? How are carpets used?
3. What event influenced the direction of Nomi Wind's art?
4. How is it possible to be a pioneer in weaving if it is an art form that has been practiced for thousands of years?

Sculpture in the Studio

Recycling for Sculpture

Pioneering the Art of Trash

Studio Introduction

Isn't the ability to turn trash into art wonderful? Making something from nothing— or finding new uses for old things—can be a real challenge. But not with some creative imagination. Perhaps you once pretended that an empty milk carton was a train engine, or that a wrapping- paper tube was a telescope.

If so, you used your imagination to turn trash into a useful object. Now you just have to turn that object into art!

In this studio experience, you will create a sculpture from recycled materials. Pages 296 and 297 will tell you how to do it. Your challenge is to be inventive with your choice of "junk" materials. Study the materials, and let your imagination pioneer

Studio Background

Recycling Materials into Art

For their artwork, many sculptors today find ideas and materials in trash cans and junkyards. They turn these found and recycled materials into objects of beauty, usefulness, or humor. Many artists see possibilities in disposed packaging, old shoes, pieces of jewelry, broken appliances and toys—in anything that sparks an idea.

Artists who work with discarded materials are inspired by the surfaces, textures, colors, and forms that the materials offer. As they sort through household rubbish and piece together a picture of our society, these artists somewhat become modern archaeologists. Sometimes with humor, sometimes with seriousness, they use found materials in their sculptures to challenge our ideas about art and about society.

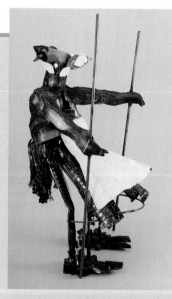

Fig. 9–22 **Camp, a Nigerian sculptor, works with scrap metal and other found materials. Texture, movement, and humor are important elements of her art-works of costumed performers.** Sokari Douglas Camp, *Masquerader with Boat Headdress*, 1995. Steel and mixed media, height: approx. 78" (200 cm). Courtesy the artist. Collection of the National Museum of African Art, Smithsonian Institution, Washington, DC.

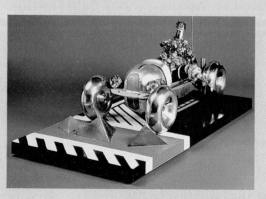

Fig. 9–23 **John Outterbridge, an African American artist from North Carolina, turned his father's junk into marketable artwork. This hobby became a full-time job.** John Outterbridge, *Ethnic Heritage Series: California Crosswalk*, 1979. Metal, wire, cloth, and other mixed media, 3' 10" x 6' x 3' (117 x 183 x 91.4 cm). Collection of the California Afro-American Museum Foundation. © California Afro-American Museum Foundation.

a way to create your artwork. Do the shapes, forms, and textures of the materials suggest an idea or theme? Will your sculpture represent something, such as a bird, or will it be a form with no recognizable subject? Create a sculpture that will help people see old junk in a new way!

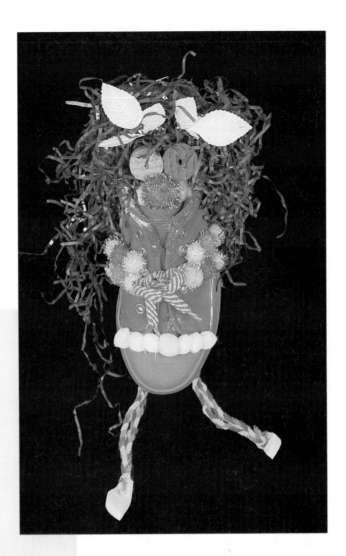

Fig. 9–24 **Look carefully at this sculpture to see the kinds of found materials the artist used to make it. Notice the variety of textures.** Kaileigh O'Neil, *Sherily the Irish Tap Dancer*, 2001.
Shoe, found objects, paint, 13 ½" (34 cm) high. Fred C. Wescott Junior High, Westbrook, Maine.

Fig. 9–25 **Why, do you think, did this artist title his sculpture *My Room*?** Merrick Treadway, *My Room*, 2000.
Found object, mixed media, height: 12" (30.5 cm). Sweetwater Middle School, Sweetwater, Texas.

Making Your Sculpture

You Will Need

- discarded objects, such as old toys, shoes, kitchen utensils, plastic, metal, and cardboard packaging
- small found materials, such as washers, nuts, bolts, screws, soft wire, string, pipe cleaners, plastic lids, feathers, and game parts
- white glue, masking tape,
- glue gun

Safety Note
Do not use a glue gun without your teacher present. The tip of a glue gun and the glue itself get very hot and can burn you.

Try This

1. Choose a main form for your sculpture. Turn the form over in your hands and study it. Does it remind you of any particular subject, such as an animal or person? Or are you simply drawn to its shape, texture, and color? What ideas for a sculpture come to mind?

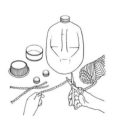

2. Decide which found materials you will add to the main form. Will you create limbs or other recognizable features? Or will you add materials only to embellish the forms and colors that already exist? What kinds of textures can you create?

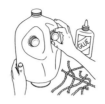

3. Use glue or tape to attach pieces to the main form. As you work, look at your sculpture from all sides. Do you need to make any changes in your plan?

Check Your Work

Display your sculpture with your classmates' sculptures. Take turns explaining why the features of the forms interested you. How did the forms inspire you to create your sculpture? What materials did you use to create interesting textures? How could your sculpture challenge the way people think about discarded materials?

Computer Option
You can use images from magazines to create a two-dimensional "junk sculpture." Use a scanner and photo-manipulation software to scan and resize images and to compose a composite collage artwork. As you work, think about the relationships between the sizes and placement of the images. You could also use a digital camera to photograph objects. Import the image files, and then combine and alter them as you wish.

Texture

Texture is the way something feels to the touch. When you stroke a kitten, its fur feels soft. When you touch a rock, it might feel rough, smooth, or bumpy. Artists can create these textures, and

many others, in two ways. Sculptors, architects, and craftspeople use such materials as fiber, stone, metal, and glass to create *real texture*, texture you can actually feel. Artists who draw and paint use pastel, pencil, paint, and other media to create *implied texture*, the illusion or sense of texture. In a two-dimensional artwork, such as a painting or drawing, you don't actually feel the textures of the objects that are depicted. Instead, your eye senses, for example, the gritty, prickly, and silky surfaces of the objects.

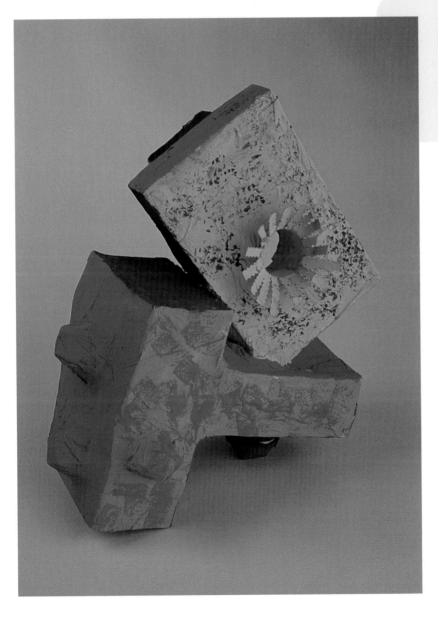

Fig. 9–26 **This artist chose to create a nonobjective sculpture. The variety of geometric shapes are unified by his choice of color and pattern.** Matthew Brady, *Tints and Shades, Red*, 2000. Recycled boxes, papier-mâché, masking tape, tempera, height: 14" (35.5 cm). Fred C. Wescott Junior High, Westbrook, Maine.

Connect to...

Daily Life

Do you see the **creative possibilities of everyday objects**? Many artists have used everyday objects in their artworks in new and inventive ways. By combining objects and presenting them as art, artists challenge us to see things in new ways. Artist Joseph Cornell is known for his inventive use of daily-life objects. He once said: "The question is not what you look at, but what you see." What does this statement mean to you?

Fig. 9–27 **What kinds of objects do you collect? How could you turn them into art?** Joseph Cornell, *A Pantry Ballet (for Jacques Offenbach)*, 1942.
Mixed-media construction, 10 1/2" x 18" x 6" (26.6 x 48 x 15.2 cm). The Nelson-Atkins Museum of Art, Kansas City. Gift of the Friends of Art. © The Joseph and Robert Cornell Memorial Foundation/Licensed by VAGA, New York, NY.

Careers

Do you enjoy fabrics that are unique in color, texture, or form? If so, you share such preferences with fiber artists. **Fiber artists**, or textile artists, work with many kinds of materials and fibers to create fabrics, wall hangings, sculptures, weavings, quilts, or wearable art. They must understand color theory, drawing, design, printing processes, and textile science and technology. Contemporary textile artists are pioneering new approaches in their fields and broadening the scope of the materials they use. A recent development in the profession is the use of computer software designed to aid in developing complex designs and patterns.

Fig. 9–28 **How did this artist use color? How did she create a complex design?** Erika Wade, *Duet*, 1991.
Warp painted and embroidered cotton, 40" x 62" (102 x 157 cm). Courtesy the artist.

Other Subjects

Social Studies

What do you think of when you hear the word *pioneers*? If you're thinking about United States history, then covered wagons, log cabins, settlers, and prospectors might come to mind. The early **settlers who headed west in search of land or gold have been called pioneers**. These settlers believed in Manifest Destiny, a nineteenth-century idea that the United States had the right and duty to expand its territory and influence throughout North America. Under Manifest Destiny, many Native Americans were displaced, buffalo were slaughtered, lands were cleared, and railroads were built. How have our ideas about westward expansion changed over time? Why have views changed? What new perspectives do we have today?

Mathematics

Can you think of artists who pioneered the use of mathematics in their work? Two artists, M. C. Escher and Victor Vasarely, are known for creating tessellations and optical illusions. Tessellations are repeated patterns made up of congruent shapes—shapes that are exactly the same in size and shape. Optical illusions trick the eye and create the impression of three-dimensional space on a two-dimensional surface. Find examples of the work of Escher and Vasarely. What characteristics do they share?

Fig. 9–29 **Fuller once said that he invented objects and waited for people to need them. Why do you think this type of structure never became popular?** Buckminster Fuller, *Southern Illinois University Chapel*, 1950s. Located in Carbondale, Illinois. Photo courtesy Davis Art Slides.

Science

Have you ever seen a geodesic dome? It is a lightweight, domed structure that is formed from triangular segments. Buckminster Fuller, a **pioneering scientist**, writer, and philosopher, patented the design of the dome in 1947. He used advances in technology to help him design projects that helped preserve the earth. In addition to the geodesic dome, his most famous inventions were a doughnut-shaped house and a three-wheeled car.

Other Arts

Dance

The performing arts have had many pioneering artists. One such pioneer was dancer and choreographer Alvin Ailey (1931–1989). An African American, Ailey drew on his boyhood experiences for his works. In 1958, at a time when African Americans were not often accepted in dance schools, Ailey created his own dance company, the Alvin Ailey American Dance Theater. Today, his company continues to perform and also offers dance camps and other outreach programs for young people.

Internet Connection
For more activities related to this chapter, go to the Davis Website at **www.davis-art.com.**

Portfolio

"When I first started this project, I thought it was very hard to find some of the pieces I was looking for, pieces that would make a pattern. Once I found them, it was quite easy from then on."
Samantha Clark

Fig. 9–30 **Six students each made a sculptural box inspired by the work of Louise Nevelson, the artist discussed on page 281.** Juan Cabrera-Tovar, Khiem Nguyen, Evan Cyr, Matthew Tramont, Joe DeMaio, Samantha Clark, *Louise Nevelson Assemblage*, 2000. Wood, cardboard, tempera; each box is 4 1/2" x 3" x 3" (11.5 x 7.5 x 7.5 cm). Sedgwick Middle School, West Hartford, Connecticut. Photo by Phil Zimmerman.

"Once I chose to weave on a keyboard, it wasn't long until I decided to use wire. String or yarn just wouldn't look right. The actual weaving was a bit difficult, because sometimes the wire wouldn't bend very easily."
Stephen Burrows

Fig. 9–32 **Using a photograph that already had a stretched-out subject, the artist created an exaggerated sense of movement.** Kelli Ryder, *Moving on Up*, 2001. Cut black and white photographs on tagboard, 10 1/4" x 3 5/8" (26 x 9 cm). Les Bois Junior High School, Boise, Idaho.

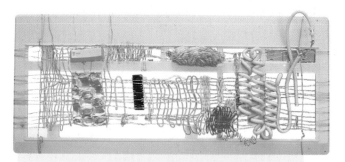

Fig. 9–31 **The use of unusual materials makes this artwork part sculpture and part weaving.** Stephen Burrows, *Keyboard Wiring*, 2001. Keyboard, wire, rabbit's foot, copper foil, 8 1/4" x 19" (21 x 48 cm). Mount Nittany Middle School, State College, Pennsylvania.

CD-ROM Connection
To see more student art, view the Personal Journey Student Gallery.

"The idea for this picture came quickly. As my friend climbed up a tree, I snapped a shot without her knowing. As I cut the strips apart and glued them, I thought it was very difficult, but the end product was great."
Kelli Ryder

Chapter 9 Review

Recall

List three ways that twentieth-century sculptors were pioneers.

Understand

Explain the steps in making a plaster relief sculpture for a clay or sand mold.

Apply

Produce a plan for a site-specific sculpture for the lobby or outside entrance of your school. Give reasons for your decisions.

Analyze

Compare similarities and differences in the way Jaune Quick-to-See Smith, Jesús Bautista Moroles, and Nomi Wind (*see example at right*) have been pioneers in art.

Synthesize

Create a timeline on which you locate each artwork shown in this chapter. Explain how three of the artworks show a new direction in art.

Evaluate

Imagine you are giving the "Pioneering Spirit" award to an artwork from this chapter. Explain your first choice for the award. Then choose a work that you think shows no spirit of exploration. Explain why you think so.

Page 293

For Your Sketchbook

Look through your sketchbook for evidence of a personal style or a change in the way you work. For example, what have you done consistently? Do you seem to favor certain colors? What changes do you see in the way you sketch? Use a page in your sketchbook to comment on what you discover.

For Your Portfolio

What evidence of your personal artistic growth can you see when you look at the works in your portfolio? Use these works to discover where your personal journey in art has taken you. Select four artworks from your portfolio, and write one or two paragraphs that explain how you have grown as an artist.

Acknowledgments

We wish to thank the many people who were involved in the preparation of this book. First of all, we wish to acknowledge the many artists and their representatives who provided both permission and transparencies of their artworks. Particular thanks for extra effort go to Eileen Doyle at Art Resource and Bernice Steinbaum.

For her contributions to the Curriculum and Internet connections, we wish to thank Nancy Walkup. For contributing connections to the performing arts, we thank Abby Remer. A special thanks for the invaluable research assistance provided by Molly Mock and the staff at Kutztown University Library. Kevin Supples's writing and advice were greatly appreciated. Sharon Seim, Judy Drake, Kaye Passmore and Jaci Hanson were among the program's earliest reviewers, and offered invaluable suggestions. We also wish to acknowledge the thoughtful and dynamic contributions made to the Teacher's Edition by Kaye Passmore.

We owe an enormous debt to the editorial team at Davis Publications for their careful reading and suggestions for the text, their arduous work in photo and image research and acquisition, and their genuine spirit of goodwill throughout the entire process of producing this program. Specifically, we mention Nancy Burnett, Nancy Bedau, Carol Harley, and Victoria Hughes Waters. Mary Ellen Wilson, our in-house editor on the project, provided thoughtful and substantive assistance and support.

Our editors, Helen Ronan and Claire Golding, carefully guided the creation of the program, faithfully attending to both its overall direction and the endless stream of details that emerged en route to its completion. We thank them for

their trust and good faith in our work and for the spirit of teamwork they endorsed and consistently demonstrated.

For his trust in us, his vision and enthusiasm for the project, and for his willingness to move in new directions, we thank Wyatt Wade, President of Davis Publications.

Although neither of us has had the privilege of being her student in any formal setting, we owe our grounding in the theory and practice of art education to the scholarship of Laura Chapman. She has been both mentor and friend to each of us throughout the years and especially in this project. We thank her for her loyal support and for providing us the opportunity to continue her work in art curriculum development in this program for the middle school.

We offer sincere thanks to the hundreds of art teachers who have inspired us throughout the years with their good thinking and creative teaching. We also acknowledge our colleagues at Kutztown University, Penn State University, Ohio State University, and other institutions who have contributed to our understanding of teaching and learning.

Finally, we wish to thank our families, especially Adrienne Katter and Deborah Sieger, who have provided loving support and balance in our lives during the preparation of this book.

Eldon Katter
Marilyn Stewart

Educational Consultants

Numerous teachers and their students contributed artworks and writing to this book, often working within very tight timeframes. Davis Publications and the authors extend sincere thanks to:

Monica Brown, Laurel Nokomis School, Nokomis, Florida
Beverly C. Carpenter, Amidon Elementary School, Washington, DC
Debra Chojnacky, Les Bois Junior High School, Boise, Idaho
Terry Christenson, Les Bois Junior High School, Boise, Idaho
Ted Coe, Garfield School, Boise, Idaho
Anita Cook, Thomas Prince School, Princeton, Massachusetts
Dale Dinapoli, Archie R. Cole Junior High School, East Greenwich, Rhode Island
Paula Sanderlin Dorosti, Associate Superintendent, District of Columbia Public Schools
Wendy Dougherty, Northview Middle School, Indianapolis, Indiana
Leah Dussault, Plymouth Middle School, Plymouth, Minnesota
Pamela Flynn, West Hartford Public Schools, West Hartford, Connecticut
Cathy Gersich, Fairhaven Middle School, Bellingham, Washington
Nancy Goan, Fred C. Wescott Junior High School, Westbrook, Maine
Rachel Grabek, Chocksett Middle School, Sterling, Massachusetts
Kerri Griffin, Springhouse Middle School, Allentown, Pennsylvania
Thelma Halloran, Sedgwick Middle School, West Hartford, Connecticut
Lizabeth Lippke Haven, Kamiakin Junior High School, Kirkland, Washington
Grace A. Herron, Hillside Junior High School, Boise, Idaho
Maryann Horton, Camels Hump Middle School, Richmond, Vermont
Anne Jacques, Smith Middle School, Fort Hood, Texas
Alice S. W. Keppley, Penn View Christian School, Souderton, Pennsylvania
Bunki Kramer, Los Cerros Middle School, Danville, California
Patricia Laney, Fletcher-Johnson Education Center, Washington, DC

Publisher:
Wyatt Wade

Editorial Directors:
Claire Mowbray Golding, Helen Ronan

Editorial/Production Team:
Nancy Burnett, Carol Harley, Mary Ellen Wilson

Editorial Assistance:
Lynn Simon, Victoria Hughes Waters

Illustration:
Susan Christy-Pallo, Stephen Schudlich

Marguerite Lawler-Rohner, Fred C. Wescott
 Junior High School, Westbrook, Maine
Karen Lintner, Mount Nittany Middle
 School, State College, Pennsylvania
Betsy Logan, Samford Middle School,
 Auburn, Alabama
Emily Lynn, Smith Middle School,
 Fort Hood, Texas
Patricia Mann, T.R. Smedberg Middle
 School, Sacramento, California
Cathy Mansell, Art Consultant,
 Boise Public Schools, Idaho
Cathy Moore, Sierra School,
 Arvada, Colorado
Phyllis Mowery-Racz, Desert Sands Middle
 School, Phoenix, Arizona
Deborah A. Myers, Colony Middle School,
 Palmer, Alaska
Jennifer Ogden, Victor School, Victor,
 Montana
Lorraine Pflaumer, Thomas Metcalf
 Laboratory School, Normal, Illinois
Sharon Piper, Islesboro Central School,
 Islesboro, Maine
Abby Porter, C. D. Owen Middle School,
 Swannanoa, North Carolina
Sandy Ray, Johnakin Middle School,
 Marion, South Carolina
Connie Richards, William Byrd Middle
 School, Vinton, Virginia
Sandra Richey, Sweetwater Middle School,
 Sweetwater, Texas
Roger Shule, Antioch Upper Grade School,
 Antioch, Illinois
Betsy Menson Sio, Jordan-Elbridge Middle
 School, Jordan, New York
Karen Skophammer, Manson Northwest
 Webster Community School,
 Barnum, Iowa
Evelyn Sonnichsen, Plymouth Middle
 School, Plymouth, Minnesota
Bob Stimpert, South Junior High School,
 Boise, Idaho
Laura Crowell Swartz, R. J. Grey Junior
 High School, Acton, Massachusetts
Ann Titus, Central Middle School,
 Galveston, Texas
Michael Walden, Gate Lane School,
 Worcester, Massachusetts
Diana Woodruff, Director of Visual Arts,
 Acton Public Schools, Massachusetts

Photo Acquisitions:
Jeanne Evans, Lindsay McCabe,
Victoria Hughes Waters

Student Work Acquisitions:
Nancy Wood Bedau

Photographer of Student Work:
Tom Fiorelli

Design:
Douglass Scott, Cara Joslin,
WGBH Design

Manufacturing:
Georgiana Rock, April Dawley

Artist Guide

Acoma (AHK-uh-muh) Pueblo, Southwestern US
Alphonse, Inatace (ahl-fahnz, EE-nah-tahss) Haiti, b. 1943
Amrany, Omri and Julie Rotblatt US, 21st century
Apollodorus of Damascus (uh-POL-uh-dore-us) Syria, active Greece, 2nd century AD
Arcimboldo, Giuseppe (ar-cheem-BOLE-doh, jyuh-SEH-pee) Italy, c. 1530–1593

Barragan, Luis (bah-rah-GAHN, loo-EES) Mexico, 1902–1988
Bazile, Castera (bah-ZEEL, kah-STAIR-ah) Haiti, 1923–1965
Bearden, Romare (BEER-den, ROH-mah-ray) US, 1912–1988
Biggers, John US, b. 1924
Blomberg, Hugo (blahm-burg) Sweden, 20th century
Bosch, Hieronymus (bosh, hee-RAHN-uh-muhs) Netherlands, c. 1450–1516
Breuer, Marcel (BROY-er mar-SEL) Hungary/US, 1902–1981
Brooks, Romaine (roh-MAYN) US, 1844–1970
Brueghel the Elder, Pieter (BROY-gul pee-ter) Flanders, c. 1564–1638
Bryer, Diana (BRY-er) US, 21st century
Butterfield, Deborah US, b. 1949

Calder, Alexander (CALL-dur) US, 1898–1976
Camp, Sokari Douglas (soh-kah-ree) Nigeria, b. 1958
Chao Shao-an (chow shau-ahn) China, 1905–1988
Chardin, Jean-Baptiste Siméon (shahr-DAN, zhahn bahp-TEEST sam-ay-OHN) France, 1699–1779
Chicago, Judy US, b. 1939
Chihuly, Dale (chi-HOO-lee) US, b. 1941
Christopher, Tom US, 21st century
Coin, Willie US, 21st century
Cornell, Joseph US, 1903–1972
Courbet, Gustave (koor-BAY, GOOHS-tahv) France, 1819–1877

Dahomey (duh-HOE-mee) African kingdom
Dalí, Salvador (dah-LEE, SAHL-vah-door) Spain, 1904–1989
Dancer, Daniel US, 21st century
de Saint Phalle, Niki (duh sahn FAHLL, nee-kee) France, b. 1930
De Stijl (duh STILE)
Doolittle, Beverly (DOO-lit-tul) US, 21st century
Duchamp, Marcel (doo-CHAHM, mar-SEL) France, 1887–1968

Escher, M. C. (EH-sher) Germany, 1898–1972

Fallert, Caryl Bryer (FALL-urt) US, b. 1947
Fonseca, Harry (fon-SEE-kah) US, b. 1946
Frey, Viola (fry, vy-OH-lah) US, b. 1933
Fuller, Buckminster US, 1895–1983

Gehry, Frank O. (GEH-ree) US, b. 1929
Ghiberti, Lorenzo (ghee-BARE-tee, loh-REN-zoh) Italy, 1378?–1455
Gornik, April (GORE-nik) US, b. 1953
Graves, Michael US, b. 1934
Gray, Melinda US, b. 1952
Grooms, Red (groomz) US, b. 1937

Halprin, Lawrence (HAL-prin) US, b. 1916
Hare, Frances US, 21st century
Haring, Keith (HAIR-ing) US, 1958–1990
Heade, Martin Johnson (heed) US, 1819–1904
Henson, Jim (HEN-sun) US, 1936–1990
Hepworth, Barbara England, 1903–1975
Hockney, David (HOCK-nee) England, b. 1937
Holbein the Younger, Hans (HOLE-bine) Germany, 1497–1543
Hopi (HOE-pee) Pueblo, Southwestern US
Huichol (hwee-chole) North central Mexico

Iktinos (IK-tih-nus) Greece, active 450–420 BC

Jahn, Helmut (yahn, HEL-moot) Germany, b. 1940

Kahlo, Frida (KAH-loh, FREE-dah) Mexico, 1907–1954
Kallikrates (kah-LIH-kra-tees) Greece, 5th century BC
Kcho Cuba, b. 1970
Kita, Toshiyuki (kee-tah, toe-shee-yew-kee) Japan, b. 1942
Kollwitz, Käthe (KOHL-vits, KAY-teh) Germany, 1867–1945
Koons, Jeff US, b. 1955
Kruger, Barbara (KROO-gur) US, b. 1945
Kuniyoshi (koo-nee-yo-shee) Japan, 1797–1861

Lange, Dorothea (lang, dor-uh-THEE-uh) US, 1895–1965
Lanyon, Ellen (LAN-yun) US, b. 1926
Lawrence, Jacob US, 1917–2000
Legoretta, Ricardo (lay-goh-RAY-tah, ree-CAHR-doh) Mexico, b. 1931
Leissner, Lawrence (LICE-nur) US, 21st century
Leonardo da Vinci (lay-uh-NAHR-doh dah VIN-chee) Italy, 1452–1519
Lewis, Maude (LOO-iss, mawd) Canada, 1903–1970
Lichtenstein, Roy (LICK-ten-stine) US, 1923–1997
Limbourg Brothers (lahm-BOOR) France, 16th century
Liu, Hung (lyoo, huhng) China, b. 1948
Lopez, Yolanda (LOH-pez, yoh-LAHN-dah) US, b. 1942
Lorenzetti, Ambrogio (lawr-en-ZET-tee, ahm-BROH-jyoh) Italy, c. 1290–1348
Lovell, Whitfield (LUHV-ul) US, b. 1959
Lysell, Ralph (lie-sel) US, 20th century

Mackall, Robert McGill (muh-KAWL) US, 1889–1982
Magritte, René (mah-GREET, ruh-NAY) Belgium, 1898–1967
Marc, Franz (mark, frahnz) Germany, 1880–1916
Matisse, Henri (mah-TEESS, ahn-REE) France, 1869–1954
Mattelson, Marvin (MAT-tul-sin) US, b. 1947
Méndez, Lillian (MAYN-dez) US, b. 1957
Metsu, Gabriel (MET-soo, GAH-bree-ell) Netherlands, 1629–1667
Minoan (mih-NOE-un) ancient Greek civilization, c. 3000–1100 BC
Miyake, Issey (mee-YAH-kay, ISS-ee) Japan/US, b. 1938
Moore, Henry England, 1898–1986
Moran, Thomas US, 1837–1926
Moroles, Jesús Bautista (moh-ROH-lace, hay-SOOS bow-TEES-tah) US, b. 1950

Navajo (NAH-vah-hoe) Southwestern US
Nevelson, Louise (NEH-vul-sin) Russia/US, 1899–1988

Oaxaca (wuh-HAH-kah) Mexico
Obin, Philomé (OH-bahn, fee-loh-MAY) Haiti, 1892–1986
Oleszko, Pat (oh-LESS-koh) US, b. 1947
Oppenheim, Meret (OP-en-hime, MER-et) Germany, 1913–1985
Oropallo, Deborah US, b. 1954

Orozco, José Clemente (oh-ROHS-koh, hoh-SAY clay-MEN-tay) Mexico, 1883–1949

Outterbridge, John US, b. 1933

Peeters, Clara (PAY-turs, KLAH-rah) Flanders, 1594–1657

Pei, I. M. (pay) China/US, b. 1917

Penrose, Roland England, 1900–1984

Persian (PUR-zhun) ancient Iran

Petyarre, Ada Bird (pet-YAR) Australia, b. 1930

Picasso, Pablo (pee-KAHS-soh, PAH-bloh) Spain, 1881–1973

Poisson, Louverture (PWAH-sohn, LOO-vair-toor) Haiti, 1914–1985

Pollock, Jackson (POL-uk) US, 1912–1956

Powers, Harriet US, 1837–1911

Quick-to-See Smith, Jaune (zhohn) US, b. 1940

Rauschenberg, Robert (ROW-shun-burg) US, b. 1925

Reid, Bill (reed) Canada, 1920–1998

Remington, Frederic US, 1861–1909

Rockwell, Norman US, 1894–1978

Rodin, Auguste (roh-DAN, oh-goost) France, 1840–1917

Ronibson, René (RON-ib-son, rah-NAY) Australia, 21st century

Rosenquist, James (ROH-zen-kwist) US, b. 1933

Ruisdael, Jacob van (RIZE-dahl, YAH-kop fahn) Netherlands, c. 1628–1692

Shahn, Ben US, b. 1898–1969

Sheeler, Charles (SHEE-lur) US, 1883–1965

Sherman, Cindy US, b. 1954

Shimomura, Roger (shee-moe-MORE-uh) US, b. 1939

Shire, Peter (SHY-ur) US, b. 1947

Siqueiros, David Alfaro (sih-KAY-rohs, ahl-FAH-roh) Mexico, 1896–1974

Soleri, Paolo (soh-LARE-ee, POW-loh) Italy, b. 1919

Thiebaud, Wayne (TEE-boh) US, b. 1920

Tinguely, Jean (tan-GLEE, zhahn) Switzerland, 1925–1991

Tlingit (TLING-it) Northwest Coast, US

Traylor, Bill (TRAY-ler) US, c. 1856–1949

Turner, J. M. W. England, 1775–1850

VanDerZee, James (VAN-dur-zee) US, 1886–1983

Varo, Remedios (VAH-roh, reh-MAY-dee-ohs) Spain, 1908–1963

Vasarély, Victor (va-suh-RAY-lee) Hungary/France, 1908–1997

Vázquez, Pedro Ramírez (VAHSS-kez, PAY-droh rah-MEE-rez) Mexico, b. 1919

Venturi, Robert (ven-TOOR-ee) US, b. 1925

Vermeer, Jan (vur-MAIR, yahn) Netherlands, 1632–1675

Vu, Hoang (voo, hwahng) Vietnam/US, 21st century

Waddell, Theodore (wah-DELL) US, b. 1941

Waqialla, Osman (wah-kee-AHL-lah, ohz-MAHN) Sudan, b. 1926

Webb, Doug US, b. 1946

Webb, Philip Speakman England, 1831–1915

Weems, Carrie Mae (weemz) US, b. 1953

Wen Boren (wun boh-run) Japan, 1502–1575

Wind, Nomi (NOE-mee) Israel, b. 1940

Wright, Frank Lloyd US, 1867–1959

Wyeth, Jamie (WHY-ith) US, b. 1946

Yemadje, Joseph (yeh-MAHD-yeh) Benin, 20th century

Yoruba (YOH-roo-bah) Nigeria

World Map

The best way to see what the world looks like is to look at a globe. The problem of showing the round earth on a flat surface has challenged mapmakers for centuries. This map is called a Robinson projection. It is designed to show the earth in one piece, while maintaining the shape of the land and size relationships as much as possible. However, any world map has distortions.

This map is also called a *political* map. It shows the names and boundaries of countries as they existed at the time the map was made. Political maps change as new countries develop.

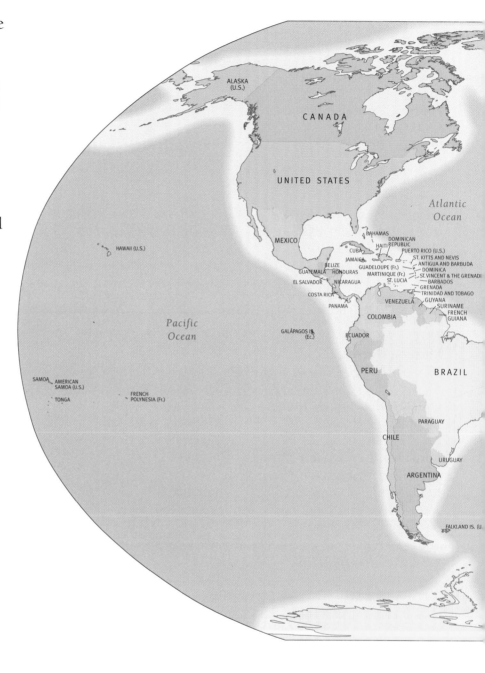

Key to Abbreviations

ALB.	Albania
AUS.	Austria
B.-H.	Bosnia-Hercegovina
BELG.	Belgium
CRO.	Croatia
CZ. REP.	Czech Republic
EQ. GUINEA	Equatorial Guinea
HUNG.	Hungary
LEB.	Lebanon
LITH.	Lithuania
LUX.	Luxembourg
MAC.	Macedonia
NETH.	Netherlands
RUS.	Russia
SLOV.	Slovenia
SLCK.	Slovakia
SWITZ.	Switzerland
YUGO.	Yugoslavia

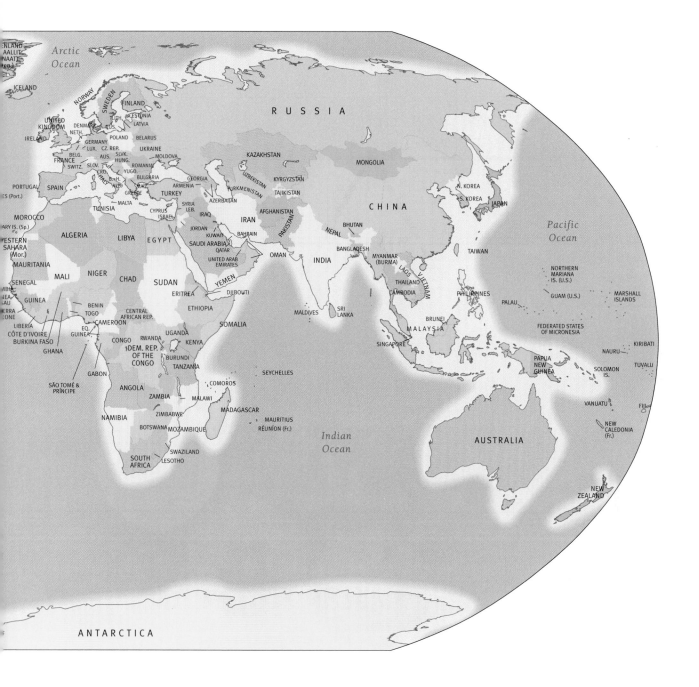

ANTARCTICA

Color Wheel

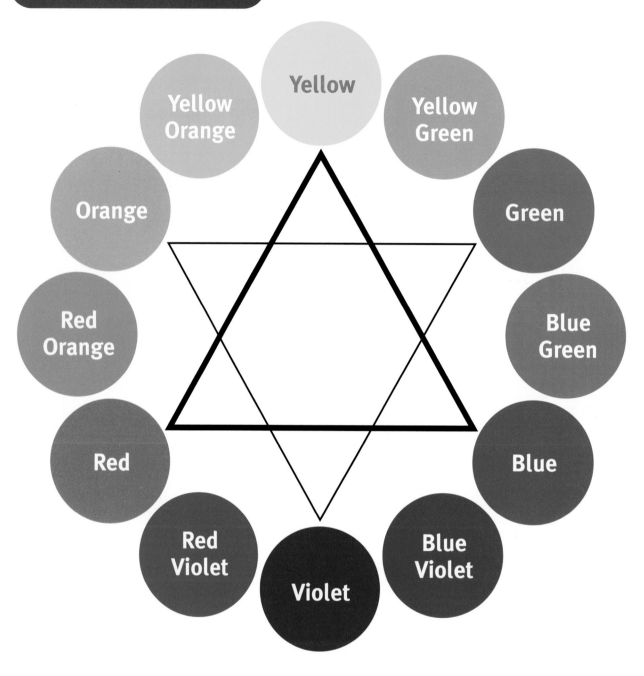

For easy study, the colors of the spectrum are usually arranged in a circle called a color wheel. Red, yellow, and blue are the three primary colors or hues. All other hues are made by mixing different amounts of these three colors.

If you mix any two primary colors, you will produce one of the three secondary colors. From experience, you probably know that red and blue make violet, red and yellow make orange, and blue and yellow make green. These are the three secondary colors.

The color wheel also shows six intermediate colors. You can create these by mixing a primary color with a neighboring secondary color. For example, yellow (a primary color) mixed with orange (a secondary color) creates yellow-orange (an intermediate color). Mixing the primary and secondary colors creates the six intermediate colors shown. Mixing different amounts of these colors produces an unlimited number of hues.

Bibliography

Aesthetics

Grimshaw, Caroline. *Connections: Art.* Chicago, IL: World Book, 1996.

Magee, Brian. *The Story of Philosophy.* NY: DK Publishing, 1998.

Varnedoe, Kirk. *A Fine Disregard: What Makes Modern Art Modern.* NY: Harry N. Abrams, Inc., 1994.

Weate, Jeremy. *A Young Person's Guide to Philosophy.* NY: DK Publishing, 1998.

Art Criticism

Antoine, Veronique. *Artists Face to Face.* Hauppauge, NY: Barron's, 1996.

Cumming, Robert. *Annotated Art.* NY: DK Publishing, 1998.

Franc, Helen M. *An Invitation to See: 150 Works from the Museum of Modern Art.* NY: Harry N. Abrams, Inc., 1996.

Greenberg, Jan and Sandra Jordan. *The American Eye.* NY: Delacorte, 1995.

---------------. *The Painter's Eye.* NY: Delacorte, 1991.

---------------. *The Sculptor's Eye.* NY: Delacorte, 1993.

Richardson, Joy. *Looking at Pictures: An Introduction to Art for Young People.* NY: Harry N. Abrams, Inc., 1997.

Rosenfeld, Lucy Davidson. *Reading Pictures: Self-Teaching Activities in Art.* Portland, ME: J. Weston Walch, 1991.

Roukes, Nicholas. *Humor in Art: A Celebration of Visual Wit.* Worcester, MA: Davis Publications, 1997.

Welton, Jude. *Looking at Paintings.* NY: DK Publishing, 1994.

Yenawine, Philip. *How to Look at Modern Art.* NY: Harry N. Abrams, Inc., 1991.

Art History
General

Barron's Art Handbook Series. *How to Recognize Styles.* Hauppauge, NY: Barron's, 1997.

Belloli, Andrea. *Exploring World Art.* Los Angeles, CA: The J. Paul Getty Museum, 1999.

D'Alelio, Jane. *I Know That Building.* Washington, DC: The Preservation Press, 1989.

Gebhardt, Volker. *The History of Art.* Hauppauge, NY: Barron's, 1998.

Hauffe, Thomas. *Design.* Hauppauge, NY: Barron's, 1996.

Janson, H.W. and Anthony F. Janson. *History of Art for Young People.* NY: Harry N. Abrams, Inc., 1997.

Remer, Abby. *Pioneering Spirits: The Life and Times of Remarkable Women Artists in Western History.* Worcester, MA: Davis Publications, 1997.

Stevenson, Neil. *Annotated Guides: Architecture.* NY: DK Publishing, 1997.

Thiele, Carmela. *Sculpture.* Hauppauge, NY: Barron's, 1996.

Wilkinson, Philip and Paolo Donati. *Amazing Buildings.* NY: DK Publishing, 1993.

Ancient World

Corbishley, Mike. *What Do We Know About Prehistoric People.* NY: Peter Bedrick Books, 1994.

Cork, Barbara and Struan Reid. *The Usborne Young Scientist: Archaeology.* London: Usborne Press, 1991.

Crosher, Judith. *Ancient Egypt.* NY: Viking, 1993.

Fleming, Stuart. *The Egyptians.* NY: New Discovery, 1992.

Giblin, James Cross. *The Riddle of the Rosetta Stone.* NY: Thomas Y. Crowell, 1990.

Haslam, Andrew, and Alexandra Parsons. *Make It Work: Ancient Egypt.* NY: Thomsom Learning, 1995.

Millard, Anne. *Pyramids.* NY: Kingfisher, 1996.

Morley, Jacqueline, Mark Bergin, and John Hames. *An Egyptian Pyramid.* NY: Peter Bedrick Books, 1991.

Powell, Jillian. *Ancient Art.* NY: Thomsom Learning, 1994.

Classical World

Avi-Yonah, Michael. *Piece by Piece! Mosaics of the Ancient World.* Minneapolis, MN: Runestone Press, 1993.

Bardi, Piero. *The Atlas of the Classical World.* NY: Peter Bedrick Books, 1997.

Bruce-Mitford, Miranda. *Illustrated Book of Signs & Symbols.* NY: DK Publishing, 1996.

Chelepi, Chris. *Growing Up in Ancient Greece.* NY: Troll Associates, 1994.

Cohen, Daniel. *Ancient Greece.* NY: Doubleday, 1990.

Corbishley, Mike. *Ancient Rome.* NY: Facts on File, 1989.

Corbishley, Mike. *Growing Up in Ancient Rome.* NY: Troll Associates, 1993.

Hicks, Peter. *The Romans.* NY: Thomson Learning. 1993.

Loverance, Rowena and Wood. *Ancient Greece.* NY: Viking, 1993.

MacDonald, Fiona. *A Greek Temple.* NY: Peter Bedrick Books, 1992.

McCaughrean, G. *Greek Myths.* NY: Margaret McElderry Books, 1992.

Roberts, Morgan J. *Classical Deities and Heroes.* NY: Friedman Group, 1994.

Wilkinson, Philip. *Illustrated Dictionary of Mythology.* NY: DK Publishing, 1998.

Williams, Susan. *The Greeks.* NY: Thomson Learning, 1993.

The Middle Ages

Cairns, Trevor. *The Middle Ages.* NY: Cambridge University Press, 1989.

Caselli, Giovanni. *The Middle Ages.* NY: Peter Bedrick Books, 1993.

Chrisp, Peter. *Look Into the Past: The Normans.* NY: Thomson Learning. 1995.

Corrain, Lucia. *Giotto and Medieval Art.* NY: Peter Bedrick Books, 1995.

Howarth, Sarah. *What Do We Know About the Middle Ages.* NY: Peter Bedrick Books, 1995.

MacDonald, Fiona. *A Medieval Cathedral.* NY: Peter Bedrick Books, 1994.

Mason, Antony. *If You Were There in Medieval Times.* NY: Simon & Schuster, 1996.

Robertson, Bruce. *Marguerite Makes a Book.* Los Angeles, CA: The J. Paul Getty Museum, 1999.

Renaissance

Corrain, Lucia. *Masters of Art: The Art of the Renaissance.* NY: Peter Bedrick Books, 1997.

Di Cagno, Gabriella et al. *Michelangelo.* NY: Peter Bedrick Books, 1996.

Dufour, Alessia Devitini. *Bosch.* ArtBook Series. NY: DK Publishing, 1999.

Fritz, Jean, Katherine Paterson, et. al. *The World in 1492.* NY: Henry Holt & Co., 1992.

Giorgi, Rosa. *Caravaggio.* ArtBook Series. NY: DK Publishing, 1999.

Harris, Nathaniel. *Renaissance Art.* NY: Thomson Learning, 1994.

Herbert, Janis. *Leonardo da Vinci for Kids.* Chicago: Chicago Review Press, 1998.

Howarth, Sarah. *Renaissance People.* Brookfield, CT: Millbrook Press, 1992.

---------------. *Renaissance Places.* Brookfield, CT: Millbrook Press, 1992.

Leonardo da Vinci. ArtBook Series. NY: DK Publishing, 1999.

McLanathan, Richard. *First Impressions: Leonardo da Vinci.* NY: Harry N. Abrams, Inc., 1990.

---------------. *First Impressions: Michelangelo.* NY: Harry N. Abrams, Inc., 1993.

Medo, Claudio. *Three Masters of the Renaissance: Leonardo, Michelangelo, Raphael.* Hauppauge, NY: Barron's, 1999.

Milande, Veronique. *Michelangelo and His Times*. NY: Henry Holt & Co., 1995.

Muhlberger, Richard. *What Makes a Leonardo a Leonardo?* NY: Viking, 1994.

---------------. *What Makes a Raphael a Raphael?* NY: Viking, 1993.

Murray, Peter and Linda. *The Art of the Renaissance*. NY: Thames and Hudson, 1985.

Piero della Francesca. ArtBook Series. NY: DK Publishing, 1999.

Richmond, Robin. *Introducing Michelangelo*. Boston, MA: Little, Brown, 1992.

Romei, Francesca. *Leonardo da Vinci*. NY: Peter Bedrick Books, 1994.

Spence, David. *Michelangelo and the Renaissance*. Hauppauge, NY: Barron's, 1998.

Stanley, Diane. *Leonardo da Vinci*. NY: William Morrow, 1996.

Wood, Tim. *The Renaissance*. NY: Viking, 1993.

Wright, Susan. *The Renaissance*. NY: Tiger Books International, 1997.

Zuffi, Stefano. *Dürer*. ArtBook Series. NY: DK Publishing, 1999.

Zuffi, Stefano and Sylvia Tombesi-Walton. *Titian*. ArtBook Series. NY: DK Publishing, 1999.

Baroque and Rococo

Barron's Art Handbooks. *Baroque Painting*. Hauppague, NY: Barron's, 1998.

Bonafoux, Pascal. *A Weekend with Rembrandt*. NY: Rizzoli, 1991.

Jacobsen, Karen. *The Netherlands*. Chicago, IL: Children's Press, 1992.

Muhlberger, Richard. *What Makes a Goya a Goya?* NY: Viking, 1994.

---------------. *What Makes a Rembrandt a Rembrandt?* NY: Viking, 1993.

Pescio, Claudio. *Rembrandt and Seventeenth-Century Holland*. NY: Peter Bedrick Books, 1996.

Rodari, Florian. *A Weekend with Velázquez*. NY: Rizzoli, 1993.

Schwartz, Gary. *First Impressions: Rembrandt*. NY: Harry N. Abrams, Inc., 1992.

Spence, David. *Rembrandt and Dutch Portraiture*. Hauppauge, NY: Barron's, 1998.

Velázquez. ArtBook Series. NY: DK Publishing, 1999.

Vermeer. ArtBook Series. NY: DK Publishing, 1999.

Wright, Patricia. *Goya*. NY: DK Publishing, 1993.

Zuffi, Stefano. *Rembrandt*. ArtBook Series. NY: DK Publishing, 1999.

Neoclassicism, Romanticism, Realism

Friedrich. ArtBook Series. NY: DK Publishing, 1999.

Goya. Eyewitness Books. NY: DK Publishing, 1999.

Rapelli, Paola. *Goya*. ArtBook Series. NY: DK Publishing, 1999.

Impressionism & Post-Impressionism

Barron's Art Handbooks. *Impressionism*. Hauppauge, NY: Barron's, 1997.

Bernard, Bruce. *Van Gogh*. Eyewitness Books. NY: DK Publishing, 1999.

Borghesi, Silvia. *Cézanne*. ArtBook Series. NY: DK Publishing, 1999.

Crepaldi, Gabriele. *Gauguin*. ArtBook Series. NY: DK Publishing, 1999.

---------------. *Matisse*. ArtBook Series. NY: DK Publishing, 1999.

Kandinsky. ArtBook Series. NY: DK Publishing, 1999.

Monet. Eyewitness Books. NY: DK Publishing, 1999.

Muhlberger, Richard. *What Makes a Cassatt a Cassatt?* NY: Viking, 1994.

---------------. *What Makes a Degas a Degas?* NY: Viking, 1993.

---------------. *What Makes a Monet a Monet?* NY: Viking, 1993.

---------------. *What Makes a van Gogh a van Gogh?* NY: Viking, 1993.

Pescio, Claudio. *Masters of Art: Van Gogh*. NY: Peter Bedrick Books, 1996.

Rapelli, Paola. *Monet*. ArtBook Series. NY: DK Publishing, 1999.

Sagner-Duchting, Karin. *Monet at Giverny*. NY: Neueis Publishing, 1994.

Skira-Venturi, Rosabianca. *A Weekend with Degas*. NY: Rizzoli, 1991.

---------------. *A Weekend with van Gogh*. NY: Rizzoli, 1994.

Spence, David. *Cézanne*. Hauppague, NY: Barron's, 1998.

---------------. *Degas*. Hauppague, NY: Barron's, 1998.

---------------. *Gauguin*. Hauppague, NY: Barron's, 1998.

---------------. *Manet: A New Realism*. Hauppague, NY: Barron's, 1998.

---------------. *Monet and Impressionism*. Hauppague, NY: Barron's, 1998.

---------------. *Renoir*. Hauppague, NY: Barron's, 1998.

---------------. *Van Gogh: Art and Emotions*. Hauppague, NY: Barron's, 1998.

Torterolo, Anna. *Van Gogh*. ArtBook Series. NY: Dk Publishing, 1999.

Turner, Robyn Montana. *Mary Cassatt*. Boston, MA: Little, Brown, 1992.

Waldron, Ann. *Claude Monet*. NY: Harry N. Abrams, Inc., 1991.

Welton, Jude. *Impressionism*. NY: DK Publishing, 1993.

Wright, Patricia. *Manet*. Eyewitness Books. NY: DK Publishing, 1999.

20th Century

Antoine, Veronique. *Picasso: A Day in His Studio*. NY: Chelsea House, 1993.

Beardsley, John. *First Impressions: Pablo Picasso*. NY: Harry N. Abrams, Inc., 1991.

Cain, Michael. *Louise Nevelson*. NY: Chelsea House, 1990.

Children's History of the 20th Century. NY: DK Publishing, 1999.

Faerna, Jose Maria, ed. *Great Modern Masters: Matisse*. NY: Harry N. Abrams, Inc., 1994.

Faerna, Jose Maria, ed. *Great Modern Masters: Picasso*. NY: Harry N. Abrams, Inc., 1994.

Gherman, Beverly. *Georgia O'Keeffe: The Wideness and Wonder of Her World*. NY: Simon & Schuster, 1994.

Greenberg, Jan and Sandra Jordan. *Chuck Close Up Close*. NY: DK Publishing, 1998.

Heslewood, Juliet. *Introducing Picasso*. Boston, MA: Little, Brown, 1993.

Paxman, Jeremy. *20th Century Day by Day*. NY: DK Publishing, 1991.

Ridley, Pauline. *Modern Art*. NY: Thomson Learning, 1995.

Rodari, Florian. *A Weekend with Matisse*. NY: Rizolli, 1992.

---------------. *A Weekend with Picasso*. NY: Rizolli, 1991.

Spence, David. *Picasso: Breaking the Rules of Art*. Hauppauge, NY: Barron's, 1998.

Tambini, Michael. *The Look of the Century*. NY: DK Publishing, 1996.

Turner, Robyn Montana. *Georgia O'Keeffe*. Boston, MA: Little, Brown, 1991.

Woolf, Felicity. *Picture This Century: An Introduction to Twentieth-Century Art*. NY: Doubleday, 1993.

United States

Howard, Nancy Shroyer. *Jacob Lawrence: American Scenes, American Struggles*. Worcester, MA: Davis Publications, 1996.

---------------. *William Sidney Mount: Painter of Rural America*. Worcester, MA: Davis Publications, 1994.

Panese, Edith. *American Highlights: United States History in Notable Works of Art*. NY: Harry N. Abrams, Inc., 1993.

Sullivan, Charles, ed. *African-American Literature and Art for Young People*. NY: Harry N. Abrams, Inc., 1991.

---------------. *Here Is My Kingdom: Hispanic-American Literature and Art for Young People*. NY: Harry N. Abrams, Inc., 1994.

---------------. *Imaginary Gardens: American Poetry and Art for Young People*. NY: Harry N. Abrams, Inc., 1989.

Native American

Burby, Liza N. *The Pueblo Indians.* NY: Chelsea House, 1994.

D'Alleva, Anne. *Native American Arts and Culture.* Worcester, MA: Davis Publications, 1993.

Dewey, Jennifer Owings. *Stories on Stone.* Boston, MA: Little, Brown, 1996.

Garborino, Merwyn S. *The Seminole.* NY: Chelsea House, 1989.

Gibson, Robert O. *The Chumash.* NY: Chelsea House, 1991.

Graymont, Barbara, *The Iroquois.* NY: Chelsea House, 1988.

Griffin-Pierce, Trudy. *The Encyclopedia of Native America.* NY: Viking, 1995.

Hakim, Joy. *The First Americans.* NY: Oxford University Press, 1993.

Howard, Nancy Shroyer. *Helen Cordero and the Storytellers of Cochiti Pueblo.* Worcester, MA: Davis Publications, 1995.

Jensen, Vicki. *Carving a Totem Pole.* NY: Henry Holt & Co., 1996.

Littlechild, George. *This Land Is My Land.* Emeryville, CA: Children's Book Press, 1993.

Moore, Reavis. *Native Artists of North America.* Santa Fe, NM: John Muir Publications, 1993.

Perdue, Theda. *The Cherokee.* NY: Chelsea House, 1989.

Remer, Abby. *Discovering Native American Art.* Worcester, MA: Davis Publications, 1996.

Sneve, Virginia Driving Hawk. *The Cherokees.* NY: Holiday House, 1996.

Art of Global Cultures
General

Bowker, John. *World Religions.* NY: DK Publishing, 1997.

Eyewitness World Atlas. DK Publishing (CD ROM)

Wilkinson, Philip. *Illustrated Dictionary of Religions.* NY: DK Publishing, 1999.

World Reference Atlas. NY: DK Publishing, 1998.

Africa

Ayo, Yvonne. *Africa.* NY: Alfred A. Knopf, 1995.

Bohannan, Paul and Philip Curtin. *Africa and Africans.* Prospect Heights, IL: Waveland Press, 1995.

Chanda, Jacqueline. *African Arts and Culture.* Worcester, MA: Davis Publications, 1993.

--------------. *Discovering African Art.* Worcester, MA: Davis Publications, 1996.

Gelber, Carol. *Masks Tell Stories.* Brookfield, CT: Millbrook Press, 1992

La Duke, Betty. *Africa: Women's Art. Women's Lives.* Trenton, NJ: Africa World Press, 1997.

--------------. *Africa Through the Eyes of Women Artists.* Trenton, NJ: Africa World Press, 1996.

McKissack, Patricia and Fredrick McKissack. *The Royal Kingdoms of Ghana, Mali, and Songhay.* NY: Henry Holt & Co., 1994.

Mexico, Mesoamerica, Latin America

Baquedano, Elizabeth, *Eyewitness Books: Aztec, Inca, and Maya.* NY: Alfred A. Knopf, 1993.

Berdan, Frances F. *The Aztecs.* NY: Chelsea House, 1989.

Braun, Barbara. *A Weekend with Diego Rivera.* NY: Rizzoli, 1994.

Cockcroft, James. *Diego Rivera.* NY: Chelsea House, 1991.

Goldstein, Ernest. *The Journey of Diego Rivera.* Minneapolis, MN: Lerner, 1996.

Greene, Jacqueline D. *The Maya.* NY: Franklin Watts, 1992.

Neimark, Anne E. *Diego Rivera: Artist of the People.* NY: Harper Collins, 1992.

Platt, Richard. *Aztecs: The Fall of the Aztec Capital.* NY: DK Publishing, 1999.

Sherrow, Victoria. *The Maya Indians.* NY: Chelsea House, 1994.

Turner, Robyn Montana. *Frida Kahlo.* Boston, MA: Little, Brown, 1993.

Winter, Jonah. *Diego.* NY: Alfred A. Knopf, 1991.

Asia

Doherty, Charles. *International Encyclopedia of Art: Far Eastern Art.* NY: Facts on File, 1997.

Doran, Clare. *The Japanese.* NY: Thomson Learning, 1995.

Ganeri, Anita. *What Do We Know About Buddhism.* NY: Peter Bedrick Books, 1997.

--------------. *What Do We Know About Hinduism.* NY: Peter Bedrick Books, 1996.

Lazo, Caroline. *The Terra Cotta Army of Emperor Qin.* NY: Macmillan, 1993.

MacDonald, Fiona, David Antram and John James. *A Samurai Castle.* NY: Peter Bedrick Books, 1996.

Major, John S. *The Silk Route.* NY: Harper Collins, 1995.

Martell, Mary Hazel. *The Ancient Chinese.* NY: Simon & Schuster, 1993.

Pacific

D'Alleva, Anne. *Arts of the Pacific Islands.* NY: Harry N. Abrams, 1998.

Haruch, Tony. *Discovering Oceanic Art.* Worcester, MA: Davis Publications, 1996.

Niech, Rodger and Mick Pendergast. *Traditional Tapa Textiles of the Pacific.* NY: Thames and Hudson, 1998.

Thomas, Nicholas. *Oceanic Art.* NY: Thames and Hudson, 1995.

Studio

Drawing Basic Subjects. Hauppauge, NY: Barron's, 1995.

Ganderton, Lucinda. *Stitch Sampler.* NY: DK Publishing, 1999.

Grummer, Arnold. *Complete Guide to Easy Papermaking.* Iola, WI: Krause Publications, 1999.

Harris, David. *The Art of Calligraphy.* NY: DK Publishing, 1995.

Horton, James. *An Introduction to Drawing.* NY: DK Publishing, 1994.

Learning to Paint: Acrylics. Hauppauge, NY: Barron's, 1998.

Learning to Paint: Drawing. Hauppauge, NY: Barron's, 1998.

Learning to Paint: Mixing Watercolors. Hauppauge, NY: Barron's, 1998.

Learning to Paint in Oil. Hauppauge, NY: Barron's, 1997.

Learning to Paint in Pastel. Hauppauge, NY: Barron's, 1997.

Learning to Paint in Watercolor. Hauppauge, NY: Barron's, 1997.

Lloyd, Elizabeth. *Watercolor Still Life.* NY: DK Publishing, 1994.

Slafer, Anna and Kevin Cahill. *Why Design?* Chicago, IL: Chicago Review Press, 1995.

Smith, Ray. *An Introduction to Acrylics.* NY: DK Publishing, 1993.

--------------. *An Introduction to Oil Painting.* NY: DK Publishing, 1993.

--------------. *An Introduction to Watercolor.* NY: DK Publishing, 1993.

--------------. *Drawing Figures.* Hauppauge, NY: Barron's, 1994.

--------------. *Oil Painting Portraits.* NY: DK Publishing, 1994.

--------------. *Watercolor Color.* NY: DK Publishing, 1993.

Wright, Michael. *An Introduction to Pastels.* NY: DK Publishing, 1993.

Wright, Michael and Ray Smith. *An Introduction to Mixed Media.* NY: DK Publishing, 1995.

--------------. *An Introduction to Perspective.* NY: DK Publishing, 1995.

Perspective Pack. NY: DK Publishing, 1998.

Glossary

abstract/abstraction A style of art that is not realistic. The artist often simplifies, leaves out, rearranges, or otherwise alters some elements. One of the four general style categories that art experts use to describe an artwork. (*abstracto/ abstracción*)

aesthetician (*es-tha-TISH-un*) A person who asks why art is made and how it fits into society. One who studies questions about art or beauty. (*esteta*)

analogous colors (*ah-NAL-uh-gus*) Colors that are closely related because they have one hue in common. Analogous colors appear next to one another on the color wheel. (*colores análogos*)

appliqué (*ap-li-KAY*) A process of sewing pieces of cloth onto a cloth background. (*aplique*)

arabesques (*ah-ruh-BESKS*) Geometric designs and curves, often connected with calligraphic writing. (*arabescos*)

architect A person who designs the construction of buildings or large structures. (*arquitecto*)

architectural model A small, three-dimensional representation of a building, often made of paper, cardboard, wood, or plastic. Architects usually create such a model during the process of designing a building. (*modelo arquitectónico*)

architecture Buildings and other large structures. Also the art and science of planning and constructing such buildings. (*arquitectura*)

art critic A person who expresses a reasoned opinion on any matter concerning art. Art critics often judge the quality of artworks and suggest why they are valuable or important. (*crítico de arte*)

art form A technique or method that is used to create an artwork, such as painting, photography, sculpture, or collage. (*forma artística*)

art historian A person who studies the history of artworks and the lives of artists. (*historiador del arte*)

art media The materials used by the artist to produce a work of art. (*medios artísticos*)

artisan A person skilled in creating handmade objects. (*artesano*)

artist A person who creates art. (*artista*)

assemblage (*ah-SEM-blij*) A three-dimensional artwork made by joining together objects or parts of objects. (*ensamblaje*)

asymmetrical balance (*ay-sih-MET-trih-kul*) A type of balance in which things on each side of a center line in a composition are different, yet equal in weight or interest. Also called informal balance. (*balance asimétrico*)

balance A principle of design that describes how parts of an artwork are arranged to create a sense of equal weight or interest. Types of balance are symmetrical, asymmetrical, and radial. (*balance*)

bas-relief (*bah re-LEEF*) A form of sculpture in which portions of the design stand out slightly from a flat background. (*bajorrelieve*)

calligraphy (*kah-LIG-rah-fee*) Precise, beautiful handwriting. (*caligrafía*)

cantilever (*kan-tih-LEE-ver*) A structure, such as a beam or roof, that is supported at one end only. (*ménsula*)

casting A multistep process for creating sculptures in bronze, concrete, plaster, plastic, or other materials. Some casting techniques allow an artist to create several sculptures from a single mold. (*vaciado*)

center of interest The main, or first, thing you notice in an artwork. (*centro de interés*)

ceramics (*suh-RAM-iks*) The art of making objects of fired clay. The clay is baked, or fired, at high temperatures in an oven called a kiln. Ceramics are also the objects made using this method. (*cerámica*)

collage (*koh-LAHZH*) A work of art created by gluing pieces of paper, fabric, photographs, or other materials onto a flat surface. (*collage*)

collagraph (*KOLL-oh-graf*) A print made from a collage with raised areas on its surface. (*colografía*)

color Another word for hue, which is the common name of a color in (or related to) the spectrum, such as yellow, green, or yellow-orange. *See* hue. (*color*)

color scheme A plan for using colors. Common color schemes are warm, cool, neutral, monochromatic, analogous, complementary, and triad. (*gama de color*)

complement *See* complementary colors. (*complemento*)

complementary colors Colors that are opposite one another on the color wheel, such as red and green. When used near each other, complementary colors create a strong contrast. (*colores complementarios*)

contour drawing A drawing that shows only the edges (contours) of objects. (*contorno*)

contrast A great difference between two things. Contrast usually adds drama or interest to a composition. (*contraste*)

cool colors The family of colors ranging from the greens through the blues and violets. Cool colors are often connected with cool places, things, or feelings. (*colores fríos*)

crafts Works of art, either decorative or useful, that are skillfully made by hand. (*artesanía*)

crop To frame an image by removing or cutting off the outer edges. (*recortar*)

cultural style The use of materials, design qualities, methods of work, and choice of subject that is specific to or identified with a culture. (*cultura*)

design The plan for arranging the parts or elements of an artwork. Design can also refer to the work itself. (*diseño*)

dynasty (*DIE-nis-tee*) A group of rulers from the same family or related in some other way. (*dinastía*)

elements of design The visual "tools" that artists use to create an artwork, such as line, color, value, texture, and shape.(*elementos de diseño*)

emphasis A principle of design in which some visual elements are given more importance than others to catch and hold the viewer's attention. (*énfasis*)

ergonomic (*er-goh-NOM-ik*) A design that is built to increase the user's comfort and/or productivity. (*ergonómico*)

Expressionist/Expressionism A style of art in which the main idea is to show a definite mood or feeling. Also, one of the four general style categories that art experts use to describe an artwork. (*expresionista/Expresionismo*)

expressive color Color that communicates an artist's ideas or feelings. (*color expresivo*)

fantasy One of the four general style categories that art experts use to describe an artwork. The images in fantasy art often look like they came from a dream. (*fantástico*)

fiber artist An artist who works with various materials and fibers to create fabrics, wall hangings, weavings, quilts, or wearable art. Also called textile artists. (*artista textil*)

form An element of design; any three-dimensional object such as a cube, sphere, or cylinder. A form has height, width, and depth. Form is also a general term that refers to the structure or design of a composition. (*forma*)

fresco (*FRES-koh*) A technique of painting in which pigments are applied to a thin layer of wet plaster. The plaster absorbs the pigments, and the painting becomes part of the wall. (*fresco*)

function A general term that refers to how the structure or design of a composition works. (*función*)

general style One of four categories that art experts use to describe an artwork: Expressionism, Realism, abstraction, and fantasy. (*estilo*)

genre scene (*ZHAHN-ruh*) A scene or subject from everyday life. (*escena costumbrista*)

geometric shape A shape that is precise and regular in outline, such as a circle, square, triangle, or ellipse. Geometric forms are three-dimensional; they include cones, pyramids, and spheres. (*forma geométrica*)

gesture drawing A drawing done quickly to capture movement. (*dibujo a mano alzada*)

graphic designer An artist who plans the lettering and images for books, packages, posters, and other printed materials. (*diseñador gráfico*)

guild A group of skilled craftspeople. Each guild has a specialty, such as working with metal or carving stone. (*gremio*)

hacienda (*hah-see-EN-dah*) A Spanish word used to describe a large plantation or residence. (*hacienda*)

Harlem Renaissance (*ren-ih-SAHNS*) 1920–1940. A name of a period and a group of artists who lived and worked in Harlem, New York City. The members of the Harlem Renaissance used a variety of art forms to express their lives as African Americans. (*Renacimiento de Harlem*)

historical style The use of materials, design qualities, methods of work, and choice of subject that is specific to or identified with a specific time period. (*estilo histórico*)

horizon line The line where water or land seems to end and the sky begins. (*horizonte*)

hue The name of a color, such as red or blue, based on its position in the spectrum. *See* color, spectrum. (*tono*)

implied line The way objects are arranged so as to produce the effect of seeing a line in a work, but where a line is not actually present. (*línea implícita*)

implied texture The way a surface appears to look, such as rough or smooth. (*textura implícita*)

individual style The themes, use of materials, methods of working, and design qualities that make one artist's work different from that of other artists. (*estilo individual*)

installation art Art that is created for temporary display in a particular site. (*instalación*)

intensity The brightness or dullness of a color. (*intensidad*)

intermediate hue (*in-ter-MEE-dee-it*) A color made by mixing a secondary color with a primary color. Blue-green and yellow-green are examples of intermediate hues. (*tono terciario*)

landscape A work of art that shows a single view of natural scenery. (*paisaje*)

line A mark with length and direction, created by a point that moved across a surface. Lines can vary in length, width, direction, curvature, and color. A line can be two-dimensional (drawn on paper), three-dimensional (a wire), or implied. (*línea*)

linear perspective (*LIN-ee-ur*) A technique that uses guidelines to create the illusion of three-dimensional space on a two-dimensional surface. (*perspectiva lineal*)

local color The representation of colors as they appear in the natural world. (*color local*)

luminism (*LOO-min-izm*) A style of painting, popular in the United States in the nineteenth century, in which artists focused on the realistic depiction of light and its effects. (*luminismo*)

mechanical lettering A clear form of writing in which all letters are capitals and square in shape. Graphic designers often use mechanical lettering for posters, advertisements, and billboards. (*rótulo*)

mobile (*MOH-beel*) A hanging balanced sculpture with parts that can be moved, especially by the flow of air. (*móvil*)

model To shape clay, or another similar material, by pinching, pulling, or other manipulation with the hands. A model is also a person or thing that an artist uses as a subject. It can also be a small copy of a larger object. (*modelo*)

monochromatic (*mon-oh-kroh-MAT-ik*) A color scheme that uses several values of one color, such as light blue, blue, and dark blue. (*monocromático*)

monotype A print that is usually limited to one copy. (*monotipo*)

montage (*mon-TAHZH*) A special kind of collage that is made by combining pieces of photographs or other pictures. (*montaje*)

momument An artwork created for a public place that preserves the memory of a person, event, or action. (*monumento*)

mosaic (*moh-ZAY-ik*) An artwork made by fitting together tiny pieces of colored glass, stones, paper, or other materials. The small pieces are called tesserae. (*mosaico*)

movement A principle of design, in which visual elements are combined to produce a sense of action. This combination of elements also helps the viewer's eye to sweep over the composition in a definite manner. (*movimiento*)

mural (*MYUR-ul*) A large painting or artwork, usually designed for and created on a wall or ceiling of a building. (*mural*)

narrative art (*NAR-uh-tiv*) Art that clearly depicts a story or idea. (*arte narrativo*)

negative shape/space Shapes or spaces surrounding a line, shape, or form. (*forma negativa/espacio negativo*)

neutral color A color not associated with a hue. In art, black, white, and gray are neutral colors. (*color neutral*)

nonobjective art A style of art that does not have a recognizable subject. In a nonobjective artwork, the composition itself is the subject. Also known as nonrepresentational art. (*arte subjetivo*)

organic shape A shape that is often irregular or curved in outline, such as many things in nature. An oak leaf, for example, is an organic shape. (*figura orgánica*)

path of movement The lines that guide the eye over and through different areas of an artwork. (*sentido del movimiento*)

pattern A choice of lines, colors, or shapes that are repeated over and over, usually in a planned way. (*patrón*)

perspective (*per-SPEK-tiv*) A group of techniques for creating a look of depth on a two-dimensional (flat) surface. (*perspectiva*)

petroglyph (*PET-roh-glif*) A line drawing or carving made on a rock or rock surface, often created by prehistoric people. (*petroglifo*)

pictogram (*PIK-tuh-gram*) A picture that stands for a word or an idea. Also called pictograph. (*pictograma*)

planned pattern A pattern thought out and created in an organized way. (*patrón planificado*)

portrait An artwork that shows the likeness of a real person. (*retrato*)

positive shape/space Shapes or spaces that you see first in an artwork, because they stand out from the background or the space around them. (*forma positiva/espacio positivo*)

Post-Modernism A style that reacts against earlier modernist styles, sometimes by using them to extremes. Post-modern architecture often combines some styles from the past with more decoration, line, and/or color. (*Posmodernismo*)

poster A large, printed sheet, usually made of paper or cardboard, that advertises, teaches, or announces something. A poster usually combines pictures and words. (*afiche/cartel*)

primary colors (*PRY-mar-ee*) The three basic colors, or hues, from which other colors can be made: red, yellow, and blue. (*colores primarios*)

principles of design Guidelines that help artists to create designs and plan relationships among visual elements in an artwork. They include balance, unity, variety, pattern, emphasis, rhythm, and movement. (*principios de diseño*)

print An image made from a printing block or other object. The block is covered with ink or paint and pressed onto a surface, such as paper. Most prints can be made over and over again. (*grabado*)

proportion The relation of one object to another in size, amount, or number. Proportion is often used to describe the relationship between one part of the human figure and another. (*proporción*)

radial balance A kind of balance in which lines or shapes spread out from a central point. (*balance radial*)

random pattern A pattern caused by accidental arrangement or produced without a consistent design. A random pattern is usually asymmetrical and irregular. (*patrón al azar*)

real texture The actual surface of an object; it is what you feel when you touch a surface. (*textura real*)

Realism/Realist One of the four general style categories that art experts use to describe an artwork. Realist art portrays subjects with lifelike colors, textures, and proportions. (*Realismo/realista*)

relief print A print made from a design that is raised from a flat background, such as a woodcut. (*grabado en relieve*)

relief sculpture A three-dimensional work designed to be viewed from one side, in which surfaces are raised from a background. (*escultura a relieve*)

rhythm (*RIH-thum*) A principle of design, in which repeating elements create visual or actual movement in an artwork. Rhythms are often described as regular, alternating, flowing, or jazzy. (*ritmo*)

Romantic/Romanticism A style of art whose themes focus on dramatic action, exotic settings, imaginary events, and strong feelings. (*romántico/Romanticismo*)

sabi (*sah-bee*) A traditional rule of Japanese design that refers to the timelessness or simplicity of a design. (*sabi*)

santeros (*sahn-TAY-rohs*) Artists who make santos. (*santeros*)

santos (*SAHN-tohs*) Carved, religious figures, usually made using clay, stone, or wood. (*santos*)

scale The size relationship between two sets of dimensions. For example, if a picture of something is drawn to scale, all its parts are equally smaller or larger than the parts of the original. (*escala*)

secondary hues Colors that are made by mixing equal amounts of two primary colors. Green, orange, and violet are the three secondary colors. (*tonos secundarios*)

self-portrait A work of art in which an artist shows himself or herself. (*autorretrato*)

series A group of related artworks, such as a group of sculptures, paintings, or prints. (*serie*)

shade Any dark value of a color, usually made by adding black. (*matiz*)

shape A flat figure that is created when actual or implied lines meet and surround a space. A change in color or shading can also define a shape. Shapes can be geometric (square, triangle, circle) or organic (irregular in outline). Shape is an element of design. (*forma*)

site-specific sculpture A sculpture created for a particular space, usually outdoors. They may be permanent, but site-specific sculptures are often temporary. (*escultura sitial*)

space The empty or open area between, around, above, below, or within objects. Positive space is filled by a shape or form. Negative space surrounds a shape or form. Space is an element of design. (*espacio*)

spectrum (*SPEK-trum*) The complete range of color visible in a beam of light. (*espectro*)

split complementary A color scheme based on one color and the colors on each side of its complement on the color wheel. Orange, blue-violet, and blue-green are split complementary colors. (*complementario análogo*)

stabile (*STAY-bile*) A sculpture that is similar to a mobile but without any moving parts. (*stabile*)

still life An artwork that shows nonliving things, such as fruit, flowers, or books. A still life is usually shown in an indoor setting. (*naturaleza muerta*)

style The result of an artist's means of expression—the use of materials, design qualities, methods of work, and choice of subject. In most cases, these choices show the unique qualities of an individual, culture, or time period. The style of an artwork helps you to know how it is different from other artworks. (*estilo*)

subject What you see in an artwork, including a topic, idea, or anything recognizable, such as a landscape or a figure. (*asunto*)

Surrealist/Surrealism A style of art in which dreams, fantasy, and the human mind are sources of ideas for artists. (*surrealista/ Surrealismo*)

symbol Something that stands for something else, especially a letter, figure, or sign that rep-resents a real object or an idea. A red heart shape, for example, is a common symbol for love. (*símbolo*)

symmetrical balance (*sih-MET-ri-kul*) A type of balance in which things on either side of a center line are exactly or nearly the same, like a mirror image. Also known as formal balance. (*balance simétrico*)

tapestry (*TAP-iss-tree*) A stitched or woven piece of cloth or fabric, often one that tells a story. (*tapiz*)

texture The way a surface feels (actual texture) or the way it is depicted to look (implied texture). A texture may be described by words such as smooth, rough, or pebbly. Texture is an element of design. (*textura*)

theme The topic or idea that an artist can express and interpret in many ways with different subjects. For example, a work may reflect a theme of love, power, or discovery. (*tema*)

three-dimensional Artwork that can be measured three ways: height, width, and depth. Artwork, such as sculptures or architecture, that is not flat. (*tridimensional*)

tint A light value of a color; a color mixed with white. For example, pink is a tint of red. (*tinte*)

tonal drawing A drawing in which an artist uses value or various tones of color to create the illusion of three-dimensional space. Tonal drawing techniques include hatching, stippling, and blending and smudging. (*dibujo tonal*)

triad (*TRY-ad*) Three colors spaced equally apart on the color wheel, such as orange, green, and violet. (*tríada*)

two-dimensional Artwork that is flat and is measured in only two ways: height and width. (*bidimensional*)

unity A principle of design, in which all parts of a design work together to create a feeling of wholeness. (*unidad*)

value The lightness or darkness of a color. Tints are light values of colors. Shades are dark values of colors. Value is an element of design. (*valor*)

vanishing point In a perspective drawing, the point on the horizon line where the edges, lines, or shapes appear to meet in the distance. (*punto de fuga*)

variety The use of different lines, shapes, textures, colors, or other elements of design to create interest in an artwork. Variety is a principle of design. (*variedad*)

wabi (*wah-bee*) A traditional rule of Japanese design that refers to the idea of finding beauty in simple, natural things. (*wabi*)

warm colors The family of colors that ranges from the reds through the oranges and yellows. They are usually connected with fire and the sun and remind people of warm places, things, and feelings. (*colores cálidos*)

woodcut A relief print created by carving into a smooth block of wood, inking the wood, and pressing paper against the ink. (*xilografía*)

Spanish Glossary

abstracto/abstracción Estilo de arte que no es realista. El artista suele simplificar, recomponer, omitir o alterar algunos elementos. Es una de las cuatro categorías generales de estilo que usan los expertos de arte para describir una obra artística. (*abstract/abstraction*)

afiche, cartel Una hoja impresa de gran tamaño, por lo general hecha de papel o cartón, que anuncia, enseña o avisa algo. Un afiche combina con frecuencia imágenes y palabras. (*poster*)

aplique Es el proceso de coser piezas de tela sobre un fondo también de tela. (*appliqué*)

arabescos Dibujos geométricos y curvas, que suelen estar conectados mediante la caligrafía. (*arabesques*)

arquitecto Persona que diseña la construcción de edificios o grandes estructuras. (*architect*)

arquitectura Edificios y otras grandes estructuras. Es también el arte y la ciencia de planear y construir tales estructuras. (*architecture*)

arte narrativo Arte que describe claramente una historia o una idea. (*narrative art*)

arte subjetivo Estilo de arte que no tiene un tema reconocible. En una obra de arte subjetivo, la composición en sí misma es el tema. (*nonobjective art*)

artesanía Trabajos artísticos, ya sean decorativos o utilitarios, hábilmente realizados a mano. (*crafts*)

artesano Persona experta que crea objetos hechos a mano. (*artisan*)

artista Persona que crea arte. (*artist*)

artista textil Artista que trabaja con varios materiales y fibras para crear telas, cortinas, tejidos, mantas de parches, o arte que se usan como ropa. (*fiber artist*)

asunto Lo que ves en una obra de arte, incluyendo un tópico, una idea o cualquier cosa identificable, como un paisaje o una figura. (*subject*)

autorretrato Obra de arte en la que el artista se muestra a sí mismo. (*self-portrait*)

bajorrelieve Tipo de escultura en que partes del diseño se destacan ligeramente sobre un fondo plano. (*bas-relief*)

balance asimétrico Tipo de balance en el que los objetos que se colocan a cada lado de la línea central de una composición son diferentes, aunque iguales en peso o interés. También se le llama balance informal. (*asymmetrical balance*)

balance Principio de diseño que describe cómo se colocan las partes de una obra de arte para crear un efecto de igual peso o interés. Los tipos de balance son: simétrico, asimétrico y radial. (*balance*)

balance radial Es el tipo de balance en el que las líneas o las formas se distribuyen a partir de un punto central. (*radial balance*)

balance simétrico Tipo de balance en el que las cosas a cada uno de los lados de la línea central son exactas o casi iguales, como en un espejo. También se conoce como balance formal. (*symmetrical balance*)

bidimensional Obra de arte plana que se mide de dos maneras: alto y ancho. (*two-dimensional*)

caligrafía Escritura bonita hecha a mano. (*calligraphy*)

centro de interés Es lo principal, lo primero que uno percibe en una obra de arte. (*center of interest*)

cerámica Arte de realizar objetos a partir de la arcilla tratada con fuego. La arcilla se hornea, o se quema a altas temperaturas, en un horno de calcinación. Cerámicas son también los objetos que se hacen utilizando este método. (*ceramics*)

collage Obra de arte creado pegando pedazos de papel, tela, fotografías u otros materiales sobre una superficie plana. (*collage*)

colografía Impreso hecho a partir de un collage con áreas elevadas en su superficie. (*collagraph*)

color expresivo Color que comunica las ideas o sentimientos de un artista. (*expressive color*)

color local Representación de los colores tal y como aparecen en la naturaleza. (*local color*)

color neutral Un color que no se asocia con un tono. En arte, el negro, el blanco y el gris son colores neutrales. (*neutral color*)

color Otra palabra para tono, que es el nombre común de un color (o relacionado con) en el espectro, como amarillo, verde o amarillo-naranja. *Ver* tono. (*color*)

colores análogos Colores que están estrechamente relacionados porque tienen un tono en común. Los colores análogos aparecen uno junto al otro en la rueda de colores. (*analogous colors*)

colores cálidos Familia de colores que va desde los rojos hasta los naranjas y los amarillos. Por lo general se asocian con el fuego y el sol y recuerdan lugares, cosas y sentimientos cálidos. (*warm colors*)

colores complementarios Colores que están opuestos uno al otro en el círculo de colores, como el rojo y el verde. Cuando se usan uno junto al otro, crean un fuerte contraste. (*complementary colors*)

colores fríos Familia de colores que va de los verdes a los azules y violetas. Los colores fríos se asocian con lugares, objetos o sentimientos fríos. (*cool colors*)

colores primarios Los tres colores básicos, o tonos, con los que se pueden hacer los otros colores: rojo, amarillo y azul. (*primary colors*)

complementario análogo Gama de color basado en un color y los colores que están a cada lado de su complementario en la rueda de colores. Naranja, azul-violeta y azul-verdoso son colores complementarios análogos. (*split complementary*)

complemento *Ver* colores complementarios. (*complement*)

contorno Dibujo que muestra sólo los bordes (contorno) de los objetos. (*contour drawing*)

contraste Gran diferencia entre dos cosas. El contraste, por lo general añade dramatismo o interés a una composición. (*contrast*)

crítico de arte Es la persona que expresa una opinión razonada sobre cualquier materia relativa al arte. Los críticos de arte juzgan la calidad de las obras artísticas y sugieren por qué son valiosas o importantes. (*art critic*)

cultura El uso de materiales, las cualidades del diseño, los métodos de trabajo y la elección de los temas que son específicos o se identifican con una cultura. (*cultural style*)

dibujo a mano alzada Un dibujo realizado rápidamente para captar el movimiento. (*gesture drawing*)

dibujo tonal Dibujo en el que el artista usa valores o varios tonos de un color par crear la ilusión de un espacio tridimensional. Las técnicas de dibujo tonal incluyen el sombreado, el puntillismo, el matizado y el difuminado. (*tonal drawing*)

dinastía Grupo de gobernantes de una misma familia o relacionados de alguna otra manera. (*dynasty*)

diseñador gráfico Artista que diseña las letras y las imágenes de los libros, paquetes, carteles y otros materiales impresos. (*graphic designer*)

diseño Plan para disponer las partes o elementos de una obra de arte. El diseño también puede referirse a la obra en sí. (*design*)

elementos de diseño "Herramientas" visuales que emplean los artistas para crear una obra artística, tales como la línea, el color, la luz, la textura y la forma. (*elements of design*)

énfasis Principio del diseño en el que a algunos elementos visuales se les da más importancia que a otros para captar y mantener la atención del espectador. (*emphasis*)

ensamblaje Obra de arte tridimensional que se realiza colocando objetos o partes de objetos unos junto a otros. (*assemblage*)

ergonómico Diseño construido para aumentar la comodidad del usuario y/o la productividad. (*ergonomic*)

escala Relación en cuanto a tamaño entre dos grupos de dimensiones. Por ejemplo, si una imagen se dibuja a escala, todas sus partes deben ser igualmente más pequeñas o más grandes que las partes del original. (*scale*)

escena costumbrista Escena o tema tomado de la vida cotidiana. (*genre scene*)

escultura a relieve Una obra tridimensional diseñada para ser vista desde un solo lado, en el que la superficie se eleva desde el fondo. (*relief sculpture*)

escultura sitial Una escultura creada para un espacio particular, por lo general al aire libre. Pueden ser permanentes, pero a menudo estas esculturas son temporales. (*site-specific sculpture*)

espacio El área vacía o abierta entre, alrededor, debajo o dentro de los objetos. El espacio positivo se llena con una figura o forma. El espacio negativo rodea a una figura o forma. El espacio es un elemento de diseño. (*space*)

espectro La gama completa de color visible en un haz de luz. (*spectrum*)

esteta Es la persona que se pregunta por qué se hace el arte y cómo se inserta en la sociedad. Estudia los temas relacionados con el arte y la belleza. (*aesthetician*)

estilo El resultado de los medios de expresión de un artista—el uso de los materiales, las cualidades del diseño, los métodos de trabajo y la elección de los temas. En la mayoría de los casos, estas elecciones muestran las cualidades únicas de un individuo, cultura o época. El estilo de una obra de arte te ayuda a saber por qué es diferente de las otras. (*style*)

estilo histórico El uso de materiales, calidad del diseño, métodos de trabajo y elección de temas que son específicos o identifican un determinado período de tiempo. (*historical style*)

estilo individual Temas, uso de materiales, métodos de trabajo y cualidades del diseño que hacen que el trabajo de un artista sea diferente al de otros. (*individual style*)

estilo Una de las cuatro categorías de arte que usan los expertos para describir una obra de arte: expresionismo, realismo, abstracción y fantasía. (*general style*)

expresionista/Expresionismo Estilo de arte en el que la idea principal es mostrar un estado de ánimo o sentimiento. También es una de las cuatro categorías generales de estilo que los expertos utilizan para describir una obra de arte. (*expressionist/Expressionism*)

fantástico Una de las cuatro categorías generales de estilo que los expertos utilizan para describir una obra de arte. Las imágenes en el arte fantástico a menudo son vistas como si vinieran de un sueño. (*fantasy*)

figura orgánica Una forma que a menudo es irregular o curva en su contorno, como muchas cosas en la naturaleza. Una hoja de roble, por ejemplo, es una forma orgánica. *(organic shape)*

forma artística Técnica o método usado para crear una obra de arte, tales como pintura, fotografía, escultura o collage. *(art form)*

forma Elemento de diseño. Cualquier objeto tridimensional, como el cubo, la esfera, el cilindro. Una forma tiene alto, ancho y profundidad. Forma también es un término general que se refiere a la estructura o diseño de una composición. *(form)*

forma geométrica Una forma que es precisa y regular en su contorno, como el círculo, el cuadrado, el triángulo o la elipse. Las formas geométricas son tridimensionales, incluyen los conos, las pirámides y las esferas. *(geometric shape)*

forma negativa/espacio negativo Formas o espacios que rodean una línea, figura o forma. *(negative shape/space)*

forma positiva/espacio positivo Formas o espacios que se ven primero en una obra de arte, porque se destacan sobre el fondo o el espacio alrededor de ellos. *(positive shape/space)*

forma Una forma plana se crea cuando las líneas reales o implícitas se encuentran y rodean un espacio. Un cambio de color o de matiz también puede definir una forma. Las formas pueden ser geométricas (cuadrado, triángulo, círculo) u orgánicas (irregulares en su contorno). La forma es un elemento de diseño. *(shape)*

fresco Técnica de pintura en que los pigmentos se aplican sobre una fina capa de masilla húmeda. La masilla absorbe los pigmentos, y la pintura se convierte en parte de la pared. *(fresco)*

función Término general que se refiere a cómo funciona la estructura o el diseño de una composición. *(function)*

gama de color Plan para usar los colores. Las gamas de colores más comunes son: cálidos, fríos, neutrales, monocromáticos, análogos, complementarios y tríada. *(color scheme)*

grabado en relieve Impreso hecho a partir de un dibujo que se destaca en un fondo plano, como en un taco de madera. *(relief print)*

grabado Una imagen hecha a partir de una plantilla u otro objeto. La plantilla de madera se cubre con tinta o pintura y se presiona contra una superficie, como papel. La mayoría de los grabados se pueden repetir una y otra vez. *(print)*

gremio Grupo de experimentados artesanos. Cada gremio tiene una especialidad, como trabajar el metal o tallar la piedra. *(guild)*

hacienda Palabra española que describe una residencia o plantación de gran tamaño. *(hacienda)*

historiador del arte Persona que estudia la historia de las obras de arte y la vida de los artistas. *(art historian)*

horizonte Línea donde el agua o la tierra parece terminar y donde empieza el cielo. *(horizon line)*

instalación Arte que se crea para ser exhibido temporalmente en un determinado lugar. *(installation art)*

intensidad Luminosidad u opacidad de un color. *(intensity)*

línea implícita Manera en que son dispuestos los objetos para producir el efecto de que se ve una línea, pero en realidad no hay presente una línea. *(implied line)*

línea Una marca con largo y dirección, creada por un punto que se mueve sobre una super-ficie. Las líneas pueden variar en largo, ancho, dirección, curvatura y color. Una línea puede ser bi-dimensional (dibujada sobre papel), tridimensional (un alambre) o implícita. *(line)*

luminismo Estilo de pintura, popular en Estados Unidos en el siglo XIX, en el que los artistas se concentraban en la descripción realista de la luz y sus efectos. *(luminism)*

matiz Cualquier valor oscuro de un color, por lo general se logra añadiendo negro. *(shade)*

medios artísticos Materiales usados por los artistas para producir una obra de arte. *(art media)*

ménsula Estructura, como una viga o un techo que se sostiene por un solo lado. *(cantilever)*

modelo arquitectónico Pequeña representación tridimensional de un edificio, hecho generalmente de papel, cartón, madera o plástico. Por lo general, los arquitectos crean tales modelos durante el proceso de diseñar un edificio. *(architectural model)*

modelo Darle forma a la arcilla u otro material similar amasando, estirando o manipulándolo con las manos. Un modelo es también una persona o un objeto que los artistas utilizan como tema. También puede ser la copia a menor escala de un objeto grande. *(model)*

monocromático Una gama de color que usa varios valores de un mismo color, tales como azul claro, azul y azul oscuro. *(mono-chromatic)*

monotipo Un impreso que se limita a una sola copia. *(mono-type)*

montaje Tipo especial de collage que se hace combinando pedazos de fotografías u otras fotos. *(mon-tage)*

monumento Una obra de arte que ha sido creada para exhibir en un lugar público con el fin de recor-dar a una persona, un suceso o una acción.*(monument)*

mosaico Obra de arte que se realiza colocando unos junto a otros pedacitos de papel u otros materiales. Las piezas pequeñitas se llaman teselas. *(mosaic)*

móvil Una escultura que cuelga y se balancea, con partes que se pueden mover, en especial por el paso del aire. *(mobile)*

movimiento Principio del diseño en el que los elementos visuales se combinan para producir un efecto de acción. Esta combinación de elementos también ayuda a que los ojos del espectador se muevan en la obra de una manera definida. *(movement)*

mural Pintura u obra de arte de gran tamaño, por lo general diseñada en una pared o en el techo de un edificio. *(mural)*

naturaleza muerta Obra de arte que muestra objetos inertes, tales como frutas, flores o libros. Una naturaleza muerta se exhibe por lo general en un ambiente bajo techo. *(still life)*

paisaje Obra de arte que muestra una vista única de un escenario natural. *(landscape)*

patrón al azar Es un patrón que resulta de la disposición accidental o producto de un diseño inconsistente. Es usualmente asimétrico e irregular. *(random pattern)*

patrón Determinada selección de líneas, colores o formas que se repiten una y otra vez, por lo general de manera planificada. *(pattern)*

patrón planificado Patrón pensado y creado de manera organizada. *(planned pattern)*

perspectiva Grupo de técnicas para crear un efecto de profundidad en una superficie bidimensional. *(perspective)*

perspectiva lineal Técnica que usa las líneas para crear la ilusión de un espacio tridimensional en una superficie de dos dimensiones. *(linear perspective)*

petroglifo Dibujo lineal o talla hecha en una roca o en la superficie de una roca, a menudo creada por hombres prehistóricos. *(petroglyph)*

pictograma Imagen que representa una palabra o una idea. También llamado pictografía. *(pictogram)*

Posmodernismo Estilo que reacciona contra los primeros estilos modernistas, a veces llevándolos al extremo. La arquitectura posmoderna a menudo combina algunos estilos del pasado con más decoración, línea y/o color. *(Post-Modernism)*

principios de diseño Guías que ayudan a los artistas a crear diseños y planear las relaciones entre los elementos visuales en una obra de arte. Comprenden el balance, la unidad, la variedad, el patrón, el énfasis, el ritmo y el movimiento. *(principles of design)*

proporción Es la relación entre dos objetos, en cuanto a tamaño, cantidad o número. La proporción se usa a menudo para describir la relación entre dos partes de la figura humana. *(proportion)*

punto de fuga En un dibujo en perspectiva, el punto en el horizonte en donde los bordes, líneas o figuras parecen encontrarse en la distancia. *(vanishing point)*

Realismo/realista Una de las cuatro categorías generales que usan los expertos para describir una obra de arte. El arte realista retrata los objetos con colores, texturas y proporciones semejantes a los de la vida real. *(Realism/Realist)*

recortar Enmarcar una imagen quitando o cortando los bordes exteriores. *(crop)*

Renacimiento de Harlem 1920—1940. Nombre de un período y de un grupo de artistas que vivieron y trabajaron en Harlem, en la ciudad de Nueva York. Sus miembros usaron una variedad de formas artísticas para reflejar sus vidas como afroamericanos. *(Harlem Renaissance)*

retrato Obra de arte que muestra semejanza con una persona real. *(portrait)*

ritmo Principio del diseño, en el que al repetir elementos se crea un movimiento visual o real en una obra de arte. Los ritmos son descritos a menudo como regulares, alternos, fluidos o animados. *(rhythm)*

romántico/Romanticismo Estilo de arte en que los temas se concentran en la acción dramática, los ambientes exóticos, los sucesos imaginarios y la exaltación de los sentimientos. *(Romantic/Romanticism)*

rótulo Clara forma de escritura en que todas las letras son ayúsculas y de forma cuadrada. Los diseñadores gráficos usan a menudo el rótulo en carteles, avisos y vallas publicitarias. *(mechanical lettering)*

sabi Regla tradicional del diseño japonés que se refiere a la intemporalidad o simplicidad de un diseño. *(sabi)*

santeros Artistas que hacen santos. *(santeros)*

santos Tallas, figuras religiosas por lo general hechas de arcilla, piedra o madera. *(santos)*

sentido del movimiento Las líneas que guían al ojo a través de las diferentes áreas de una obra artística. *(path of movement)*

serie Grupo de obras de arte relacionadas, tales como un grupo de esculturas, dibujos o grabados. *(series)*

símbolo Algo que significa otra cosa, especialmente una letra, una figura o un signo que representa un objeto real o una idea. Un corazón rojo, por ejemplo, es un símbolo común para el amor. *(symbol)*

stabile Una escultura que es similar a un móvil pero sin partes que se mueven. *(stabile)*

surrealista/Surrealismo Estilo de arte en el que los sueños, la fantasía y la mente humana son las fuentes de las ideas para el artista. *(Surrealist/Surrealism)*

tapiz Una pieza de paño o tela, bordada o tejida que a menudo cuenta una historia. *(tapestry)*

tema El tópico o idea que un artista puede expresar e interpretar de muchas maneras con diferentes asuntos. Por ejemplo, una obra puede reflejar el tema del amor, el poder, o el descubrimiento. *(theme)*

textura implícita Manera en que luce la superficie, como áspera o suave. *(implied texture)*

textura La forma en que se siente una superficie (textura real) o la manera en que luce (textura implícita). Una textura puede ser descrita con palabras como suave, áspera, o granulada. La textura es un elemento de diseño. *(texture)*

textura real La superficie real de un objeto; es lo que sientes cuando tocas una superficie. *(real texture)*

tinte El valor más claro de un color; un color mezclado con blanco. Por ejemplo, el rosado es un tinte de rojo. *(tint)*

tono Nombre de un color, como rojo o azul, basado en su posición en el espectro. *Ver* color, espectro. *(hue)*

tono terciario Color hecho a partir de la mezcla de un color secundario con uno primario. El azul verdoso y el amarillo verdoso son ejemplos de tonos terciarios. *(intermediate hue)*

tonos secundarios Colores que se hacen mezclando a partes iguales dos colores primarios. Verde, naranja y violeta son los tres colores secundarios. *(secondary hues)*

tríada Tres colores que están separados por la misma distancia en la rueda de color, como el naranja, el verde y el violeta. *(triad)*

tridimensional Obra de arte que se puede medir en tres maneras: alto, ancho y profundidad. Obras de arte tales como la escultura o la arquitectura, que no son planas. *(three-dimensional)*

unidad Principio del diseño, en el que todas las partes de un diseño trabajan juntas para crear una sensación de totalidad. *(unity)*

vaciado Proceso de varios pasos para crear esculturas en bronce, concreto, masilla, plástico u otros materiales. Algunas técnicas de vaciado en yeso le permiten crear al artista varias esculturas a partir de un solo molde. *(casting)*

valor Luminosidad u oscuridad de un color. Los tintes son los valores más claros de los colores. Los matices son los valores más oscuros de los colores. El valor es un elemento de diseño. *(value)*

variedad El uso de las diferentes líneas, formas, texturas, colores u otros elementos de diseño para crear interés en una obra de arte. La variedad es un principio de diseño. *(variety)*

wabi Regla tradicional del diseño japonés que se refiere a la idea de encontrar la belleza en las cosas simples, naturales. *(wabi)*

xilografía Técnica de grabado que resulta de tallar un diseño en un taco de madera suave, por lo general de boj, se le pone tinta y se presiona contra un papel. *(woodcut)*

Index